SCULPTURE
Technique · Form · Content

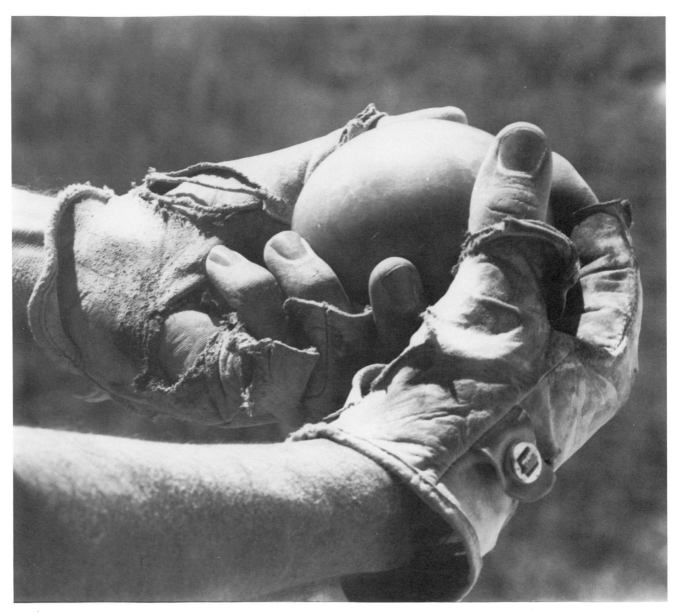

*Portrait of Arthur Williams' hands. (Photograph
by Larry C. Sanders).*

SCULPTURE
Technique · Form · Content

Arthur Williams

Davis Publications, Inc.
Worcester, Massachusetts

Cover: Arthur Williams, *Split Seed* V, 1988. 31″ × 31″ × 31″.

Design: Comprehensive Graphics
Printed in the United States of America
Library of Congress Catalog Card
Number: 88–051737
ISBN: 87192–211–8
10 9 8 7 6 5 4 3 2

CONTENTS

PREFACE

Sculpture is a visual art that often blends the technology of today with traditions of the past. This combination of thoughts and processes can be difficult to understand and practice, but it does not have to be. As an author, my goal is to help the student grasp the basics, understand the process and practice the art. The best approach is to demonstrate sculpture pictorially.

To understand the process, the student must first understand the medium. Consequently, this book is arranged by medium. Chapters progress from fundamental uses of a medium to more difficult processes. The first techniques are the basic traditional methods, progressing to the newer processes and tools and then the very latest in technology. Definitions for new terms are included within the chapter where the term is used. Photographs confirm and support the text visually. Though students may never practice the most advanced processes, they will be introduced to them.

Beginning sculptors should study and find inspiration from a wide range of works. It is helpful to see tools and techniques, but the excitement comes when the final work is viewed—when the content comes to the surface. Content can be elusive and difficult to describe, but it can be partially pictured.

It is difficult to know what to include and what to leave out of a text. Lists of supplies include the basic materials instead of the exotic ones. Detailed technical analyses that can be found in scientific journals are avoided to make way for a broader view of sculpture. I chose to search out photographs of techniques, sculptures and sculptors in their studios—things not otherwise available to the student. These are included in abundance.

The strength of this text is its diversity. Samples of most major types of sculptures are presented. The examples occasionally are student works, but are most often by contemporary sculptors with a reputation in the medium under discussion. The work may be figurative or nonfigurative. The artist may work from a drawing, from a model or totally impromptu. The artist may prefer carving, casting, modeling, fabrication or a combination of techniques. The student is shown a wide range of possibilities.

Safety is paramount, especially when working with sculptures that may require unfamiliar tools, diverse materials and chemical compounds. In order for the reader to work in a safe environment, each chapter includes safety guidelines and suggestions for the technique under discussion. Even so, the reader is advised always to search for the manufacturers' bulletins regarding the tool or material being used.

Above all else, I wish to illustrate photographically that sculpture does not have to be difficult, though it does take time. It is exciting; there are many fine sculptors doing many diverse and wonderful works. As the student of sculpture grows, he or she has much to look forward to.

Acknowledgements

From the first day of my work on this book, I solicited help from others. Hundreds of sculptors, instructors with a multitude of students, and manufacturers provided assistance. Not only did they offer help and advice, but they also sent thousands of photographs. I am in debt to all of them. My only regret is that all of the photographs could not be used.

A special thanks to Jeannie Rollins of T.E.A. for suggesting that Davis Publications contact me. Editors Wyatt Wade and Claire Golding, along with the rest of the Davis staff, have made this book a pleasure to complete.

I am indebted to those who prepared me for this work by helping to shape my personal background. These individuals include George Gurganus, Elizabeth Mason, Don Robinson, Harris Sorrelle, Charles Gross, Orville Winsand and Mel Fowler. Of all those responsible for this book, my wife, Jacqueline LaJune, is invaluable. Without her help and support I could not have begun or finished. — *Arthur Williams*

Arthur Williams, Newborn, *Detail. Serpentine and marble, 15″ tall × 24″ × 14″.*

1

INTRODUCTION

- Origins
- Analysis

Throughout history the culmination of our thinking, expression and handiwork has been preserved in the form of sculpture. It seems to have been a natural impulse to work with three-dimensional materials, clay from the earth, wood from trees, ivory from animal horns and simple found stones. Early sculptures were created specifically for purposes of ensuring fertility, good hunting, sanctuary of the soul and worshipping the gods. These works had definite significance. The artist was inherently creating aesthetically pleasing shapes, but the function or purpose of the artwork was the primary concern.

Today, sculptors have more freedom to chose a purpose for creating. They are not bound by the past and they can be separated totally from the present. The choice of media is diverse, the challenges are endless, new forms are yet to be discovered, and the techniques available present all kinds of possibilities. But even so, today's sculpture often reinterprets the past.

Origins

Sculptural form permeates history. Sculptors of the past have reflected their cultures and influenced those beyond them, including modern sculptors. In order to understand our thinking better, a synopsis of sculptural history is necessary.

Early civilizations relied upon group effort; individual sculptors remained nameless. As time progressed, the sculptor became more individualistic, more important and more remembered.

Stonehenge, a megalithic structure dating back to 1650 B.C., is a forerunner to today's environmental art, though its purposes were vastly different. The megaliths (giant boulders) are over 13

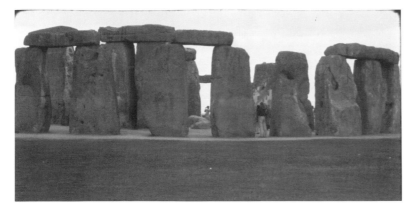

Stonehenge. *Salisbury, England. Stone, 97'
diameter. Photograph: Kenneth B. Williams.*

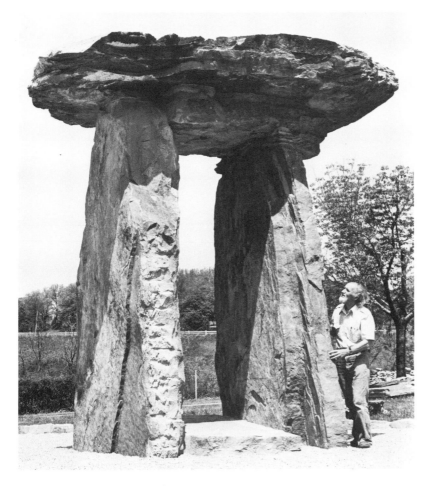

Zeljko Kujundzic, Gate of Life Monument. *Stone,
16' high, Uniontown, Pennsylvania.*

feet tall, stacked without mortar and placed in a 97 foot diameter circle. A large stone in the center lines up with the rising sun. Stonehenge was probably used as an altar in some form of sun worship or could have been used as a large calendar. Today the viewer admires the sheer strength and labor required to create such a structure, for it is in the middle of a plain, miles from the stones required for such a venture. To a sculptor, Stonehenge is breathtaking and evokes a tremendous feeling of content — message or importance — and its ruggedness is still influencing today's sculptors. (See illustration at the end of Chapter 12.) Zeljko Kujundzic's *Gate of Life Monument* is reminiscent of Stonehenge.

The Pyramids, the Great Sphinx, the temples of Rameses and Hatshepsut are well-known examples of Egyptian art. Much gold, alabaster and granite sculpture predominates this period. Craftsmanship was characteristic of the artist's work. Though Egyptian art reflects highly stylized poses, there is much realism in the work. An example of this is the statue of Hatshepsut, a red granite figure from about 1490 BC. The details of the headdress, ear and facial likeness are very realistic. The sculpture is well preserved in the hard stone just as the sculptor left it. Today's sculptors are also concerned about preserving their work.

Aphrodite from Milos of the second century B.C. is an excellent example of feminine beauty based on the Greek ideal. Better known as *Venus de Milo,* this sculpture demonstrates the advancement made toward a more natural, realistic work of art. It demonstrates Greek ideal proportions and beautiful planes. The Venus is the work of a skilled sculptor who carefully joined two marble pieces at the drapery line for a hidden joint. During this period in history, sculptors were known by their works, though the sculptor of *Venus de Milo* remains unknown.

Centuries later, the young artist Michelangelo Buonarroti began as an apprentice painter at the age of fourteen (1489 A.D.) After one year he became a student in a school of sculpture established by Lorenzo de Medici in Italy where he learned the principles of sculpture and began to develop his personal belief that sculpture was the "noblest art." At this time in history, sculptors wanted recognition for their work. Once, when he was viewing his freshly carved *Pieta,* Michelangelo overheard some visitors credit another artist with the work. Angrily, he returned that night and carved on the band across Mary's robe (in Latin): "Michelangelo Buonarroti, the Florentine, made it."

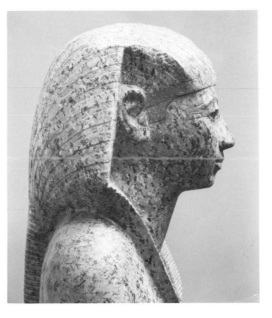

Statue of Hatshepsut. *Seated, detail. Red Granite. Courtesy of the Metropolitan Museum of Art, Rogers Fund and Edward S. Harkness Gift, 1929 (29.3.3).*

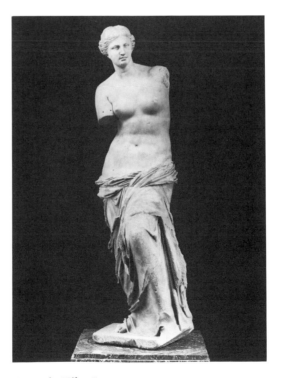

Venus de Milo. *Louvre.*

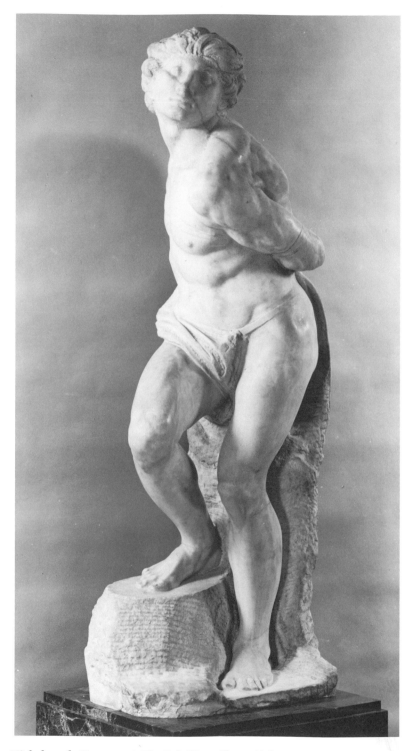

Michelangelo Buonarroti, The Rebellious Slave, *16th century. Louvre.*

The *Rebellious Slave* is a good example of the soul or spirit that Michelangelo created in his works. Not only is it technically correct, but it demonstrates the feeling (content) that Michelangelo could portray. During this age, sculpture was becoming individualistic, giving the sculptor more freedom to interpret. Many scholars prefer to believe that this work was not intended to remain in an unfinished state, but I am not so sure. Michelangelo was ahead of his time reaching for new ways to foster content. Perhaps he found it by leaving parts unfinished.

August Rodin's work was often rejected during his lifetime (1840–1917). Academia refused to accept him as a valid sculptor until near the end of his life. They did not like that his figures were often in fragments, appearing unfinished or torn apart. He was a modeler and planned his most important works to be cast into bronze, though he admitted that Michelangelo's stone carving work had a great bearing upon his own work.

Rodin's *Man Walking* was scandalous at the time it was created. He had been called an executioner and mutilator for showing a work without a head or arms in the process of walking. He was an embarassment to the artists of his age, but history triumphed. Now Rodin is often referred to as the Father of Modern Sculpture.

Contstantin Brancusi's works show a tremendous departure from Rodin. He described Rodin's *Man Walking* as a capital Y upside down with the volume (the body) held in place like a fork with the prongs set into the earth. The description readily demonstrates how Brancusi saw forms in their most basic shapes. His contribution to sculpture was to simplify forms down to their bare essence.

He led a very private life, even refusing to show work in Paris for several years after one of his sculptures was rejected by the Salon as being obscene. (It was a highly abstract portrait entitled *Princess X.*) He worked directly in the sculptural material, even without drawings. *Bird in Space* (1924) shows how his abstractions simplified his subject and utilized his materials to present his ideas. Almost all sculptors after him have been influenced by his reduction of detail.

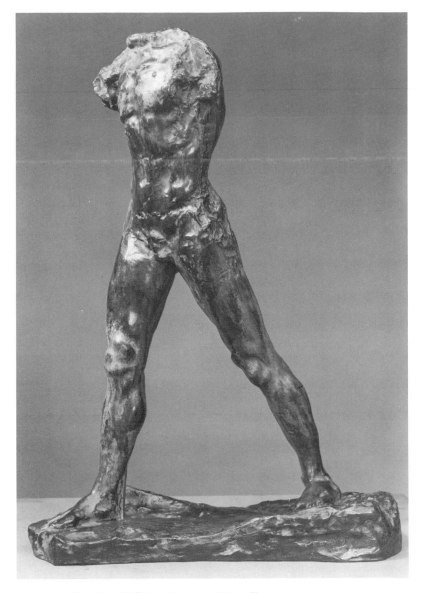

August Rodin, Man Walking. Bronze, 33½″ tall. Courtesy of The Metropolitan Museum of Art, gift of Miss G. Louise Robinson, 1940 (40.12.4).

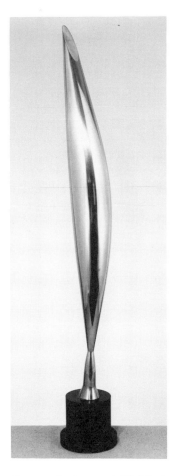

Constantin Brancusi, Bird in Space, c. 1924. Polished bronze, mounted on a marble and oak base, 49¾′ tall. Courtesy of Philadelphia Museum of Art, the Louise and Walter Arensberg Collection.

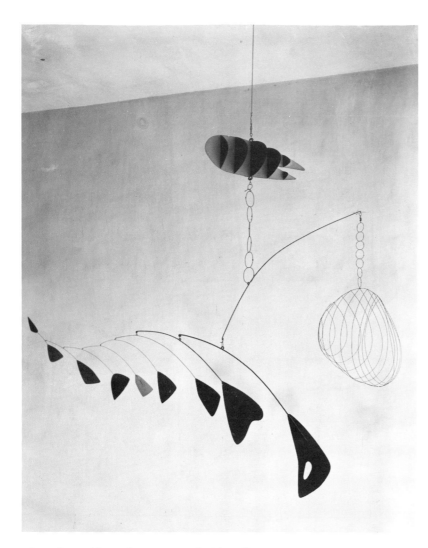

Alexander Calder's father was a sculptor, though his own interests were not the same as his father's. He became interested in the pointing machine that his father used for enlarging small sculptures. The two sculptures (the original and the enlargement) sat on separate turntables and were rotated in the same direction by a bicycle chain on sprockets which directed two separate needles to point at the same place on each sculpture. Later, Calder told of how seeing this machine's movements in space influenced his work with objects in space, his mobiles.

Calder is best known for these mobiles. They are usually brightly colored sheet metal pieces placed on wires and rods, either hanging or mounted, allowing the structure natural movement in space. His *Lobster Trap and Fish Tail* (1939) is a good example of a structure so perfectly balanced that it reacts to any movement of the air. Doing this kind of sculpture, Calder eliminated solids, commanded space, and used kinetic forms. Few sculptors have influenced those who came after as much as Calder has.

Alexander Calder, Lobster Trap and Fish Tail, 1939. Hanging mobile, painted steel wire and sheet aluminum, 8' 6" × 9' 6", Collection, The Museum of Modern Art, New York, Commissioned by the Advisory Committee for the stairwell of the Museum.

Henry Moore's first two exhibits were not only were poorly received, but in 1931, the critics labeled his work as immoral. A newspaper review entitled "Cult of Ugliness Triumphant", stated that he had "utter contempt" for human beauty, depriving it of any expression or aesthetic value. Moore was literally driven out of a teaching job to accept another one elsewhere at a lower salary. He became a full-time sculptor in his mid-forties.

Moore's work is one of space and penetration. Few sculptors so success-ully penetrated the forms as Moore did. He wanted light to pour through, and the viewer to be drawn through the piece. Bringing the outer volume into the sculpture has been one of Moore's greatest achievements. The sculptural term is negative space, however, in Moore's work, the space becomes very positive, a definite part of the sculpture. This phenomenon becomes immediately visible in his reclining figures such as *Reclining Figure II* in bronze. Not only did he successfully work in bronze as a modeller, but he was equally adept at carving wood and stone, especially in his early career because of his tight budget and lack of materials during World War II. The critic who believes traditional materials are out-of-date has not studied Moore's work.

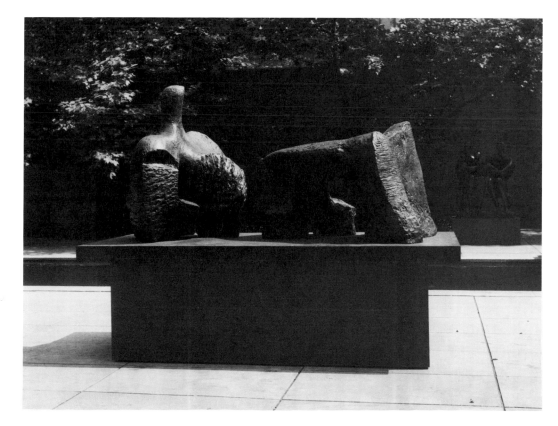

Henry Moore, **Reclining Figure II,** *1960. Bronze, in two parts, 50″ × 34″ × 29″, 36″ × 55″ × 41″; overall length is 8′3″. Collection, The Museum of Modern Art, New York. Given in memory of G. David Thompson, Jr., by his father.*

Analysis

Sculptural Fundamentals

Within the sculpture just presented, the fundamentals of sculpture can readily be seen. These fundamentals are technique, form and content. They are so interdependent that without any one of the three, the work seldom has any importance.

Technique is the combination of physical ability and use of tools and materials. It is the way an idea becomes reality. The sculptor must have a knowledge of the media in order to know what tools to use and must know how to use the tools in order to work with the media. Without technique, most creative ideas can never be shared, since there is no way to bring them into existence.

Form is the shape, the package in which the idea is presented. It is the total design. Form may be the shape of a particular subject or the shape of a non-existent subject. It may or may not be a recognizable object. Without form, there is no way for the technique to be demonstated. Form is the physical demonstration of the elements of design and principles of order (discussed in the following pages).

Content is the feeling, message or importance of the sculpture. An experience with good content may literally evoke cold chills down the viewer's back. A beautiful sunset may cause a sense of wonder at the sight. This feeling is akin to the sense of awe, of inspiration—of content—at seeing a beautiful object. A sculpture designed to show the devastation of war may leave the viewer with a queasy, terrified feeling of disgust—of content. Content varies, but the viewer always knows when strong content is present, even though he or she may not understand it. Without content, the work is a failure.

Technique alone can be likened to an artist who does a beautiful job of polishing sculpture but cannot deal with form and therefore contributes little content. Polishing floors would serve the same purpose. Form by itself is nothing unless it is well executed with a meaning. Content is nothing without shape and the technique to put it into shape. A sculptor with a knowledge of technique and a search for content will utilize form to create a sculpture.

Elements of Design

The elements of design are the visually communicated thoughts of the sculpture taking physical form.

The *shape* of a sculpture is the total of its parts. Shape can be drawn in simple terms like the outline of the sculpture and yet it contains much more. It is the total volume. Shape is how the viewer sees the sculpture, the masses of media and yet the penetrations of space through and about the work. It becomes the form that light and dark patterns are demonstrated upon. The easiest shape to recognize is the human shape as illustrated by Anthony Frudakis's *Female Nude.* The shape of Jan S. Robinson's sculpture is similar and yet the two are not at all alike.

Texture as expressed in sculpture is either natural or human-made. Natural texture includes wood grain, found texture of a stone and the like. John Boomer uses the natural texture of walnut in *Prayer for Man Strapped on an Uneven Plane* as an integral part of his sculpture.

Human-made texture is usually part of a planned design such as the overall

Anthony Frudakis, Female Nude. *Cast bronze.*

Jan S. Robinson, Momento Movi, *1987. Clay, glaze, metal, paint, 62" tall × 10" × 10".*

John Boomer, Prayer for a Man Strapped on an Uneven Plane. *Walnut, ebony, marble, 30" tall × 48" × 6".*

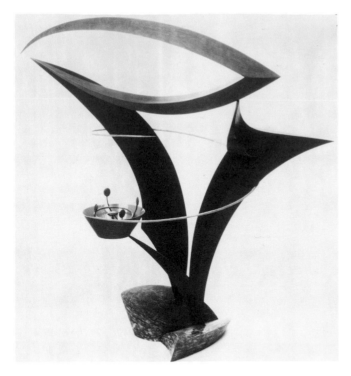

Eric Nelson, **A Father Fears for His Daughter,** *1984. Painted steel, 52" tall × 50" × 36".*

structure of a surface, or the tool marks that remain. Though some textures may be visually exciting, they do not always affect the viewer's tactile (touch) reactions as they do the vision. A good example is a smooth-finished stone with very active visual texture.

The tactile sensations received from touching sculpture are one of the most important aspects of three-dimensional artwork. Often works have been called sculpture for the blind because physical sight is not always necessary for appreciation. Sculptor Mel Fowler had a note in his showroom that stated, "Sculpture should feel good as well as please the eye and mind. Please touch and caress."

Space as used in sculptural terms is the immediate area about the sculpture that is not a mass. It often evokes a sense of depth. Good sculpture demands

Haydn Llewellyn Davies, **Space Composition, Rhymney.** *Fabricated steel, 30' tall × 20' × 18'. Collection of sculptor on loan to Harbourfront Art Gallery, Toronto, Canada.*

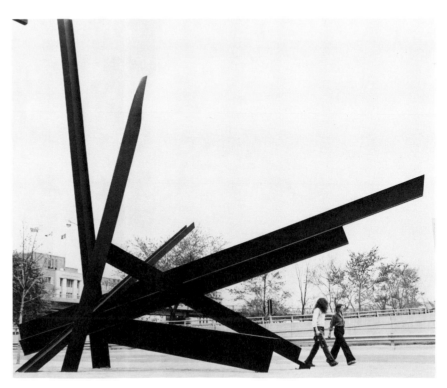

space, an area about it that belongs to it, that it cannot do without. Eric Nelson's *A Father Fears for his Daughter*, demonstrates a good use of space necessary for the sculpture. The viewer knows the space belongs to the sculpture. The sculpture itself has a sense of depth that demonstates space. This can be an illusionary space created by a relief, for example. A linear sculpture can create a feeling of mass by using space. An example would be a world globe, empty except for the horizontal and vertical lines of latiude and longitude.

Planes are surface areas defined by abrupt variations in direction . A cylinder has a top plane, a bottom plane, and a continuous side plane (only one continuous direction). Often the word "line" is incorrectly used instead of "plane." For example, the "lines" of a car should be called the "planes" of a car. (Line tends to be two-dimensional term.) Though sculptures may have a linear quality (shape or space defined by thin material), they are still composed of planes, whether real or implied. Haydn Liewellyn Davies's *Space Composition, Rhymney*, demonstrates long planes. Lines, if used are usually decorations placed on a three-dimensional object.

Value refers to the light or dark areas of sculpture demonstrated by the shadows or lack of them caused by the planes, textures, and shape of the work. Since many sculptures are monochromatic (one color), value is necessary to demonstrate the form. Lighter surfaces allow the greatest use of value since the shadows show up much better, while darker surfaces hide more minute detail. Angela Lane's *Bruce* demonstates value, since it is of one pure color.

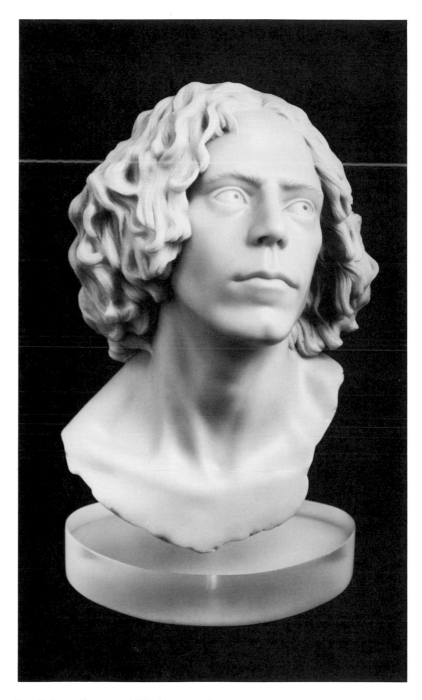

Angela Lane, Bruce, *c. 1983. Epoxy resin, 18" tall × 12" × 12". Photograph: Melville McLean.*

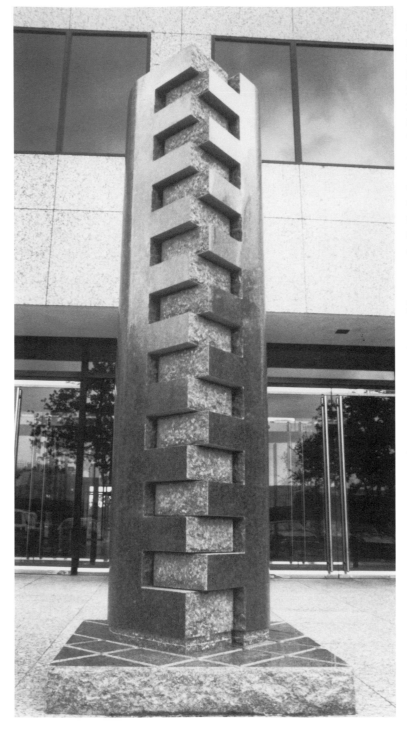

Color in sculpture usually is a natural aspect of the medium, such as natural wood colors, stone colors or clay colors. Sculpture takes up real space, so human-made color is not a necessity as it is with illusionary painting. Sculptors will often intermix media of different hues to create color, rather than resort to paint. John Boomer's *Prayer for a Man Strapped on an Uneven Plane* uses many naturally colored media. Some sculptors add surface color to enhance a medium such as ceramics or steel. Caution must be exercised, however, so the natural beauty of the media is not destroyed.

Principles of Order

To utilize the elements of design, there is an order, an arrangement of the elements that aids the sculptor. This arrangement is known as the principles of order, the organization of the sculptural elements into an aesthetic form. Good sculpture may incorporate all of these principles or very few of the them. The more conscientiously a beginning sculptor works toward these principles, however, the more likely his or her earlier works are to succeed.

Balance is a term used to discuss the form in relation to gravity or the form in relation to the design. Balance in a sculpture is expressed in two ways: as formal balance or asymmetrical (informal) balance.

A formally balanced piece of sculpture is one that appears equal from one side or end to the other, such as a symmetrical form. Jesús Bautista

Jesús Bautista Moroles, Interlocking, *1986. Dakota granite, 10′ tall × 5′ × 5′. National Health Insurance Co., Dallas, Texas.*

Moroles's sculpture *Interlocking* shows a skillful use of formal balance. Geometrical forms such as spheres and squares, have formal balance and by themselves may be a monotonous mass. An asymmetrically balanced piece of sculpture is one that has the appearance of balance but not in equally divided parts. There is a coexistence of parts that creates balance. Several small shapes may balance one larger shape, for example. Aaronel de Roy Gruber's *Steelcityscape* demonstrates informal balance. Formal balance suggests quietness or calmness, while asymmetrical balance exhibits more tension or expectation.

A design is balanced when all parts work together to form a total that is pleasing to the viewer. Balance involves all of the principles of order and design elements.

Proportion, as a principle of order, means a size or ratio relationship within the sculpture. On a representational sculpture it could mean the size of a hand in relation to the size of the head: is it correct? On abstract works, proportion could mean the size of the top of the sculpture in relation to bottom of the sculpture. The proportions of Aaronel deRoy Gruber's *Steelcityscape* vary from top to bottom. Proportion often is used for emphasis, such as a large hand to designate strength or a small part of the sculpture to represent insignificance. Proportion can also mean scale when a sculpture is compared to its model to the environment about it. Davies' *Space Composition* is a good example.

Aaronel deRoy Gruber, Steelcityscape. Steel.
Photograph: Mike Chikiris.

15

Unity occurs when all parts of a sculpture work together to produce a completeness. The sculpture, though composed of different textures, planes and so forth is unifed into a wholeness. A unity, or theme, permeates Lynn Hull's work *Lost and Found.*

Variety in sculpture is the variation or diversity within a work that contributes to its interest. It is the different shapes, textures and so on, within a unified sculpture. Too much variety may result in a disjointed sculpture and too little variety may result in a boring sculpture. Lynn Hyull's work is quite diverse. The variety adds to the interest in her subject matter.

Repetition is the resemblance of the parts to each other in a complete sculpture. They can be larger, smaller or similar in texture, but they all have a resemblance to each other. Good sculpture has a kind of rhythm of parts or themes to lend to the overall support of the design. Jesús Bautista Moroles's work *Interlocking* has an obvious repetition as does Aaronel deRoy Gruber's.

Lynn Hull, Lost and Found. *Assemblage, found objects from a 12-mile stretch of Highway 16, 72″ tall × 86″ × 30″. Exhibit at Nicolaysen Art Museum, Casper, Wyoming. Photograph: Mike and Starla Mammon.*

Movement in sculpture normally is a visual exagerration or symbol indicating motion. A wavy plane implies a brisk motion. A flat plane sumbolizes a restful motion or no movement at all. In order to be effective, the entire sculpture must work together as a unit. Richardson White's *Pulling Work Horse* demonstrates implied motion or tension.

As sculptors become more involved with mechanical devices the sculptures will express real movement delegated by means other than visual indication. Some of the more perpetually involved movements are derived from water, wind or the sun as energy sources. The earlier example of Calder's work demonstrates this type of naturally induced movement.

The elements and principles of order are quite recognizable in many works. Most develop naturally but not without effort. As sculptors progress the fundamentals are always apparent in their sculptures. These basics were achieved through hard work. Technique must be mastered, form must be understood, and content must be sought.

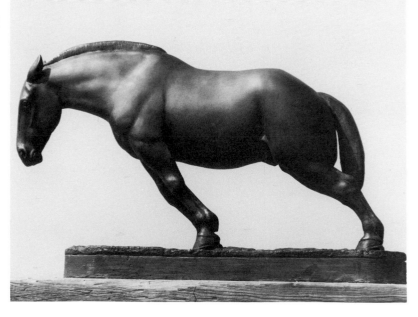

Richardson White, **Pulling Work Horse.** *Bronze, 13" tall × 23". Photograph: Fran H. White.*

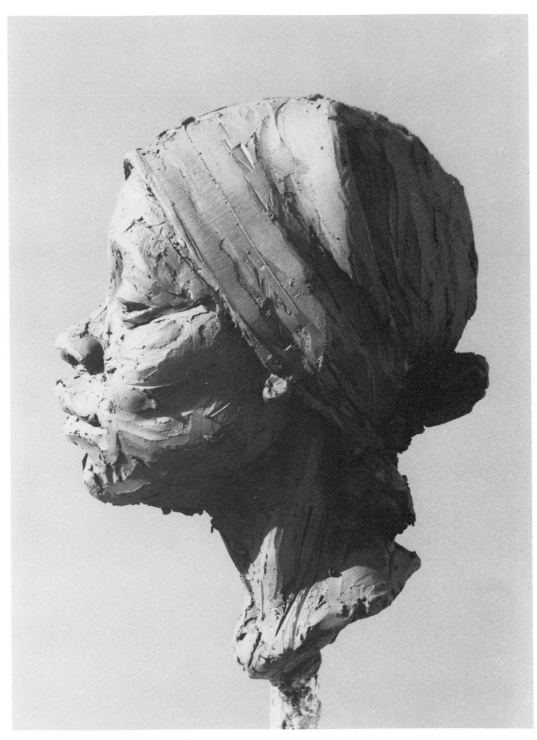

Sheryl McRoberts, Head IV. Clay, life-size.

2

MODELING

- Form
- Abstraction
- Subject
- Series
- Materials
- Methods
- Styles

Beginning artists face many difficult problems: where to start, where to go, what to do, how to do it, how to express personal feelings. Sculptors also must face these questions, but the beauty of it all is that sculpture offers so many more answers than most other art forms. Sculptors are not limited to the illusions of a flat surface. They can touch, move about, walk around, stand on, build up, tear down, destroy and rebuild. They work with what is and not what is perceived.

Sculptors can use any or all of the available sculptural materials. But only through study and practice can sculptors equal the material; otherwise it will master them.

Creating small models for larger works is a good place to start, where great ideas can be sketched into form. Without modeling, little could be accomplished. There would be no direction to go, no way to know what to do, how to do it, or how to express personal feelings.

Making models is fun and being able to handle and maneuver a form is therapeutic. It is like kid's play, oftentimes not taken seriously. Modeling should be relaxing, a time to think, grow and let free the imagination. Seriousness takes over when looking at the new models, the new forms. Which one is best? What medium is best to complete it? As one matures in art, the forms mature.

Modeling also goes beyond the small scale work used as an imprisoned idea. Modeling is used to shape, to manipulate the final idea. It is the molding, the modeling of a shape to completion.

In this chapter, modeling is discussed in two ways: as the process of bringing forth ideas in a visual form and as the process of manipulating a material to produce a sculpture.

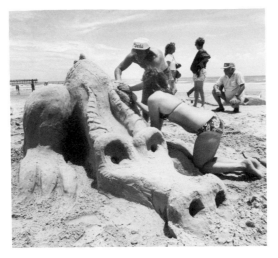

Michael Hults, photograph for the **Brazoport Facts.** *Clute, Texas.*

Everyone at some point has modeled something, and it undoubtedly was terrific fun. Think back. It may have been a sand castle or sand dragon; it may have been a snowman or snowoman; it may have been something modeled from a block of ice; it may have been in mud, cardboard, balsa wood or even dough. I was modeling cars, boats and airplanes before I knew what sculpture was. Modeling offers many possibilities and few limitations—if the sculptor is prepared.

Form

Form implies appearance. Some forms are more pleasing or interesting than others.

In order to arrive at a visually exciting form, planning must take place. Interest must be built. Consider a square and circle as an example. Without planning the shapes are just a square and circle. Turned on end or penetrated, they offer more interest. Changed into a multisided volume or cut into, they require more thinking to grasp what is happening. Form becomes more sculpturally defined because of the planes and values. In brief, the form is becoming more visually active, more stimulating to the eye and mind. It is more three-dimensional, more sculptural. The viewer has to think about it.

To apply this example to a sculptured human shape, imagine the following two forms: 1) A standing figure is facing forward, hands are down at the sides, and there is no movement. Except for the stiffness, there is little expression. 2) A standing figure has one leg bent forward, an arm raised, and the head turned slightly to one side. The eyebrows are arched in a distinct expression. One form is passive, and one

Simple shapes.

Shapes become more interesting when they are turned on end or penetrated.

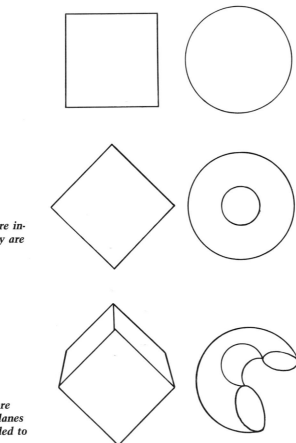

Shapes become more sculptural when planes and values are added to suggest dimension.

is active. The description of the active standing form could begin a statement about Michelangelo's *David.* The passive standing form, however, is boring. Every sculpture does not necessarily need a lot of activity to make it visually stimulating, but it often helps.

Abstraction

Abstraction is something art students may fear, but it is the very thing that they have practiced since starting in art. Abstraction is the personal choice of shapes, colors, textures and so on, as opposed to a completely accurate copy of nature. The abstractions may have been subtle, for example, not drawing every hair on the head, but grouping them together; not painting the sunset orange, but red for effect; making hands on a figure larger for emphasis. A brief definition of creating an abstract artwork is to secure the essence of the subject matter and translate it into personal expression. Sometimes this is natural and easy. Other times it is not. Sometimes it is only the starting point

for a new form with little resemblance to the original.

Natural Objects

To begin a sculptural abstraction, select a simple form from nature, such as a seed, leaf or shell. Avoid objects that are complicated (many-faceted and ornate flowers) and shapes that are too simple (stones). If you select an object of personal beauty to you, it is easier to find ideas to explore. Study the form, feel its texture, examine the minute facets of its beauty, look for the elements of design and principles of order. What is the essence of the object? This evaluation should not be an instant process but should involve substantial time for contemplation.

Use modeling clay since it is easy to manipulate and requires few, if any, tools. Begin making three-dimensional sketches of the object, one is not enough; make several. Refer to the object, visualize the object, handle the object. The sketches should be small and brief, with few details. Each model should demonstrate different aspects of the object. A feeling for the shape should emerge.

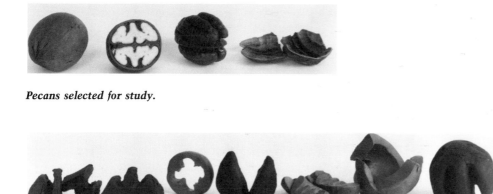

Pecans selected for study.

Quick models of pecans.

Final model of pecan.

Henry Moore, one of the greatest sculptors of all time (Chapter 1), would collect bones and small objects to study. He would spend days working with small models and then enlarge them into more shapes. Finally, he would select the one shape he wanted and then begin the final work, continuously changing it until the final sculpture was completed.

Look at your clay sketches and move them about. Turn them around, over and upside down, and cut some up into new pieces. Then choose one and make it larger and a little more detailed, based on the chosen sketch and parts of the others. A small sketch or model is called a *maquette* or a study for a larger sculpture. Maquettes are rough ideas and not finished within themselves.

As the larger model is completed, remember that it is new, the essence as *you* see it. Someone else could do the same thing, but it would be different. The larger model may not look at all like the original object. It is personal. It is your own expression, your abstraction.

Human-Made Objects

Using a human-made object for abstraction can be more difficult, but it does not have to be. Choose a simple object that you appreciate to make the process easier. As with an object from nature, search for the object's essence. Perhaps it is how the object is intended to function. Is there a way to express this? What about the feel, the texture or the contrast?

After making several small maquettes (models), select one to bring into focus. Make it larger. Never duplicate the small model; improve upon it. Keep it simple but add a better finish or put more detail into it.

Human-made objects tend to conjure up models that are more rigid. They are geometric as opposed to the organic objects that many models from nature evoke. Geometric objects often require the use of tools to produce a more sharp, hard-edged image. Organic objects are more flowing, usually modeled with only the fingers of the artist.

Though these maquettes are in clay, imagine what other sculptural materials would suit them. After the artist masters the use of clay, other media can be explored and mastered.

An excellent example of translating a human-made object into an abstract form is Geoffrey Broderick's *Hammer*, which appears in this chapter under the heading Series.

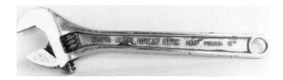

Adjustable wrench for study.

Quick models of wrench.

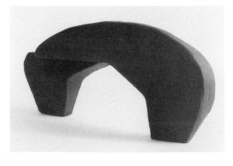

Final model of wrench.

Subject

Subject matter is often misconstrued to mean content, but it is not content. Subject matter is seldom more than the choice of a vessel to demonstrate content. In the earlier history of sculpture, subject was often the sole consideration for a sculpture. Today, this is not true. The subject is sometimes not stated. The form may be from nature, man-made objects, a feeling or from life. The importance lies not in the choice of subject matter, but in how well it is done.

Sculptor Andre Harvey uses live models that would not necessarily be another sculptor's idea for subject matter. One live model cooperated so fully that he entitled one of his sculptures *Portrait Sitter.* Compare the model he completed on location to his final work, *Helen.* Notice that several changes occurred prior to the 475-pound final sculpture.

There is no limit to choices of subject matter or to how it is used. While the most obvious choice is the human form, a creative thinker like sculptor Cynthia Bach-Matthews does not always settle for the ordinary. The sculptor is pictured standing in front of her *Neon Gothic.* Carefully observe her self-portraits in the work itself; with some imagination, it is not too difficult to recognize her. The only human part not hers is her husband's hand holding the neon pitchfork. This sculpture demonstrates that subject matter is not difficult to find, but the sculptor needs to be ready and willing to interpret it in a new way

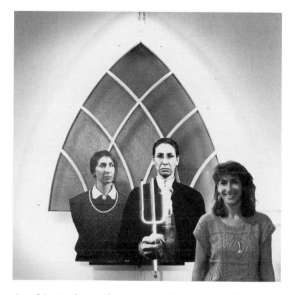

Cynthia Bach-Matthews, Neon-Gothic, a Self Portrait from an idea by Grant Wood. *Assemblage using neon, photography and found objects, 60″ × 60″. The artist is also pictured. Photograph: Larry C. Sanders.*

Sculptor Andre Harvey studying his model (and friend) on location for a sculpture.

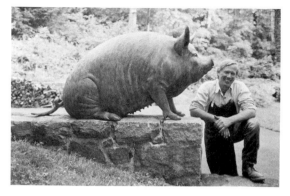

Andre Harvey, Helen. *Cast bronze, 32″ tall × 5′ 3″ × 23″ The sculptor is also pictured.*

*Geoffrey Broderick,
Hammer, 1981. Birch,
26" tall × 16" × 6".
Instructor: Arthur
Williams.*

*Geoffrey Broderick,
Hammer, 1981.
Limestone,
12" tall × 18". Instructor: Arthur Williams.*

*Geoffrey Broderick,
Hammer, 1981.
Alabaster,
19" tall x 30". Instructor: Arthur Williams.*

Series

While it is fascinating for a beginning sculptor to constantly try new shapes and subject matter, it is also beneficial to take one subject and develop it into a series. Once the sculptor is acquainted with the subject, then more thought can be given to each aspect of it. Time can be spent working with new media instead of searching for new subjects.

Geoffrey Broderick, a sculpture student, chose a common hammer to explore in different media. Note the changes he makes in the form as he continues through the series. His first work utilizes birch wood. Few people recognize the subject matter without being told; then it is quite easy to see the two hammerheads joined facing each other. Using limestone, he continues to explore the hammerhead. This time, he creates a less formal work and displays it differently. Next, he chooses

alabaster as a medium. The hammer is more difficult to recognize in this two-piece sculpture. For his last work, he chooses to rejoin the heads, but in a new way. Using elmwood, walnut and caste bronze, he creates a sculpture whose origin is known, but the final work is completely unique. Following this series readily demonstrates how familiarity with a subject eases abstraction and helps with the learning of new media.

Father, Son and Holy Ghost by sculptor Margaret Wharton is a good demonstration of how a man-made object can be modified and used as the work itself. It further demonstrates the exploration of one object in different forms.

Sculptor Constantin Antonovici uses the owl in a series demonstrating different media and different approaches to

Geoffrey Broderick, Hammer. Elmwood, walnut, bronze. Instructor: Arthur Williams. Photograph: Richard Bram.

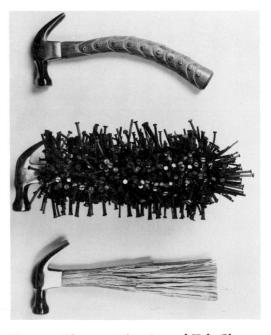

Margaret Wharton, Father, Son and Holy Ghost, 1986. Hammers, life-size. Photograph: William H. Bengtson.

the subject. Though these all are finished works, students are advised to do many models of a specific subject in order to arrive at just one final work.

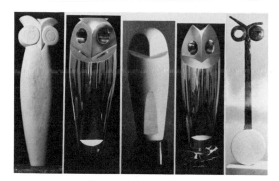

Constantin Antonovici, Owls. *Bronze and marble.*

Materials

All sculptors approach their work in very individualistic ways. Maquettes, for example, record ideas and often reflect the final choice of media.

Drawings

Sculptor John Maul chooses to work from drawings. He is well experienced with laminated wood and fiberglass, so it is easy for him to visualize his final work through sketches. The beginner also is encouraged to keep a sketchbook of ideas. However, without the knowledge of an experienced sculptor, the student should complete small models before attempting final works.

Drawing in sketchbook by John Maul for his work, Untitled.

John Maul, Untitled, 1986. *Laminated fir plywood and fiberglass, 27″ tall × 66″ × 18″.*

Cutout Models

Sculptor Bruce Beasely works with cutout cardboard models. He prefers what he calls a 'direct constructivist' approach that helps him to become involved with and visualize the form. He works with several models at once. Notice how similar his 30-foot stainless steel sculpture is to his final model. His modeling material, cardboard, easily resembles the flattened steel of his finished sculptures.

Wax

Sculptor Chryl L. Savoy uses wax as the modeling medium for her ideas. Wax is more rigid than modeling clay, but it still can be manipulated in a variety of shapes. Though the model is very similar, notice the differences in the completed carving as compared to the model. (See chapter 8 for a discussion about using wax for modeling purposes.)

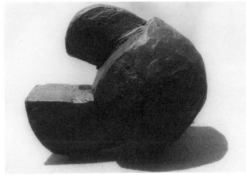

Chryl L. Savoy, study in wax for Lobster. *Approx. 3″ × 4″ × 3″.*

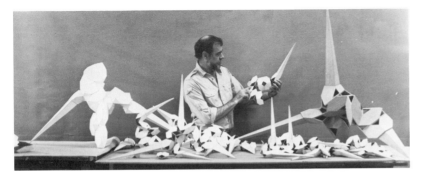

Bruce Beasley working with models.

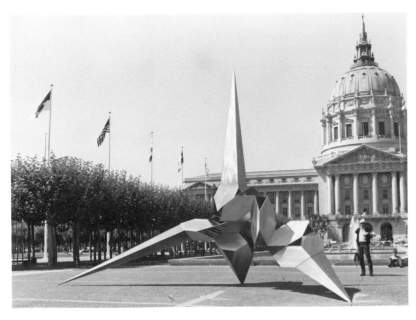

Bruce Beasley, Dorion, *1986. Stainless steel, 20′ tall × 30′.*

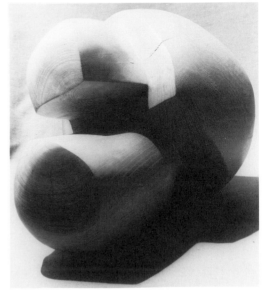

Chryl L. Savoy, Lobster. *Ashwood, 14″ tall × 10″ × 18″.*

Modeling Clay

In order to understand a figure gesture, the modeling material should be plastic (malleable). Though wax and ceramic clay are excellent materials for modeling, oil-based clay, commonly called modeling clay, is often preferred. Sculptor Pamela Gilbreth Watkins shows how an idea can easily be modeled in clay. Though the final work has many more details, the maquette readily gives the feeling for the pose and the attitude of the final work.

Modeling clay is fifteen times more expensive than ceramic clay and five times more expensive than wax. If large quantities are needed, sculptors may prefer to mix their own, using a formula that can be proportionately varied depending upon the amount or hardness needed. Either a heavy-duty mixer or a strong, slow revolution-per-minute electric drill with a heavy wire blade should be used as the mixer.

The following formula makes approximately 150 pounds of clay:

1. Add 40 pounds of microcrystalline wax to a large steel container and heat it unitl the wax melts. (Do not overheat.)
2. Add 9 pounds of inexpensive bearing (axle) grease (nonfibered) and 9 quarts of inexpensive 30-or 40-weight motor oil and stir.
3. Slowly, stir in 90 pounds of ball clay (found at ceramic suppliers).
4. Continue stirring until the mixture is thoroughly blended. Then pour it out in a thin layer on top of sheet plastic to dry.
5. Cut the clay into usable pieces.

This formula can vary depending upon the softness desired. (I often use softer clays in winter and harder ones in the summer.) If a harder mixture is desired, then add up to 20 pounds more clay. Add more grease and motor oil for softer clays. If the mixture is not correct, it can be reheated and new ingredients added. Old clay can be added to a new mix. The standing figure pictured is being made from the homemade clay mixture.

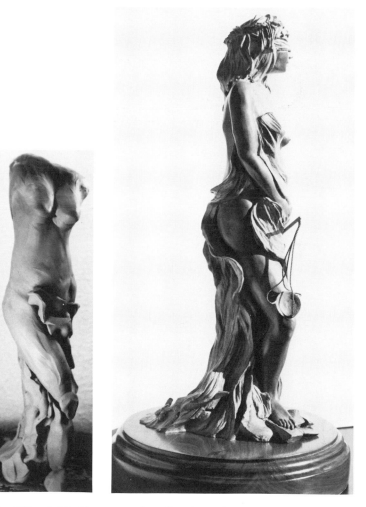

Pamela Gilbreth Watkins, oil-based clay model.

Pamela Gilbreth Watkins, Injustice. Bronze, 15″ tall. Collection of Mr. and Mrs. Donald L. Anderson, Jr.

Tools

The tools for modeling vary with the media. If the modeling medium is terracotta (water based clay), modeling clay (oil-based clay), or wax, then the tools to use are similar. Often the sculptor's fingers are the finest tools available. Still, a specific tool often is needed for fine detail or is necessary for rapid shaping and removal of the modeling medium. Pictured are several tools I prefer. The wire-ended tools on the left are good for carving or removing material. The flat spatula (left center) is handy for smoothing and shaping large concave curves. The boxwood modeling tools (right center) are used for details, and the metal dental tools are used for extremely fine work. The last tool is a homemade one. This flattened welding rod is my favorite general-purpose, detail-modeling tool. Sculpture catalogues abound with modeling tools, so the sculptor should choose the ones that best suit his or her ideas, medium and the size of work. All sculptors have individual preferences.

Calipers are measuring instruments with two jaws that can be adjusted to determine thickness, diameter and distance between surfaces. The calipers pictured on the left are used for exact measurement from models. The adjustable proportional calipers on the right show the sculptor how to enlarge or reduce a model in exact proportion. Both types of calipers can be used for inside or outside measurement.

In addition to these implements, a turntable is an excellent tool for small works. A modeling stand is normally used for large works.

Methods

Relief Sculpture

Relief sculpture appears to be a natural place to start for beginners, since most beginners are familiar with drawing. However, a relief sculpture is not a drawing; often, it has no lines at all. Reliefs are not a pure illusion as two-dimensional work is, but have some depth, however minute. Depth must create a real form and must be a reference to imagined form. Good examples of relief sculptures are demonstrated on coins. Though the relief is very shallow, the careful manipulation of space creates an image that is readily recognized.

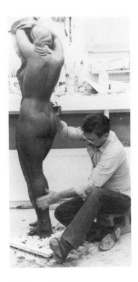

Arthur Williams uses homemade modeling clay to finish a standing model in clay for the completed work Illusion in Stone. *notice the clay wall to the left of the piece that will be part of the molding process.*

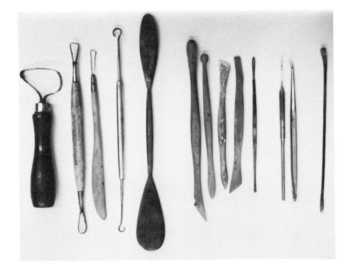

Modeling tools.

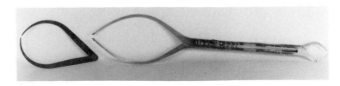

Calipers used for exact measurements (left) and for enlarging or reducing a model (right).

The accompanying series of photos illustrates a wall relief I created using wax as the modeling medium. I chose wax since the work will have a rather smooth surface and fine details.

A large flat board covered with a sheet of wax serves as the support. More wax is added to establish the heights of the relief. Good lighting is very important to see how the shadows are forming, because shadows give a sense of depth. The desired shape is attained by modeling and carving the wax, smoothing the surface and working with the design. The actual relief height is 5/8 inch from the background surface. (This work is shown being placed in a mold in chapter 4.)

If moist modeling clay is to be used for relief work, then the relief support must be coated with a moisture barrier such as shellac or counter topping (Formica) in order to keep the clay from drying out. Also, the work must be tightly wrapped when it is not being worked on. Otherwise, the piece will dry out, resulting in shrinkage and cracking.

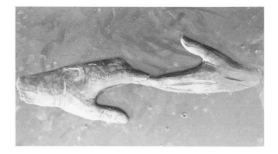
The basic form and height are suggested.

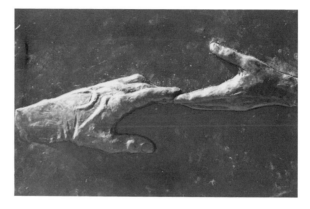
The wax is carved and modeled to achieve the desired shape.

Armatures

Free-standing sculpture almost always has an inner support or framework on which to apply the sculptural material. This framework is called an armature and can be constructed from all kinds of materials—Styrofoam, steel and wood, for example. An *armature* is designed depending upon the size required and the medium used. Throughout this text, various armatures are pictured.

The traditional armature for small works is stiff but malleable wire held upon a base by a steel support. The one pictured is made from pipes, fittings and wire bought in a hardware store.

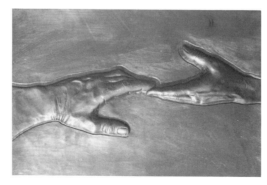
Arthur Williams, The Touch. Wax, 18″ tall × 24″.

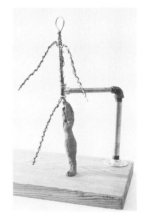
A small wire armature.

After the proportions are determined, a wire is wrapped over the work to hold the modeling medium in place. On large works *butterflies*, small blocks of wood suspended from the frame, are used in order to support the clay. A portrait bust armature is constructed in a similar fashion using wadded paper inside the head to eliminate the weight and bulk of clay that would otherwise be required. A butterfly is used for supporting clay on the lower head.

Very large armatures are often constructed from steel, especially steel re-bar (concrete reinforcement), if the sculptor is capable of welding. An ex-

Seiji Saito building an armature.

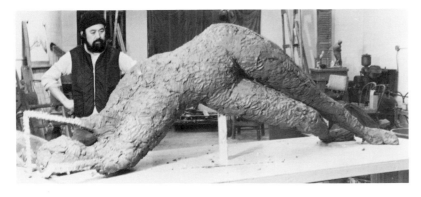

Seiji Saito adding modeling clay to the armature.

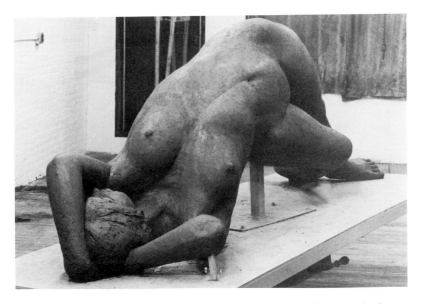

Seiji Saito, Wave. *Modeling clay, 9′ long. The completed clay is ready for molding in preparation for a casting.*

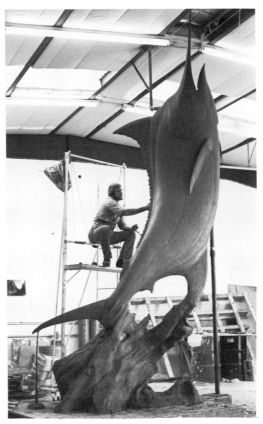

Kent Ullberg sculpting Boardwalk Blue *in modeling clay for molding and casting into bronze.*

ample of the use of steel re-bar is the standing figure made of homemade clay, pictured earlier. The steel armature is welded to a turntable. (See chapter 3 for heavier armatures.) Sometimes a combination of wood and steel is used. The accompanying illustrations demonstrate the preparation for a large body of clay to be placed on an armature. The model would collapse without such strong support. Care must be taken to place the armature so that it will not protrude into the surface of the mold. Sculptor Kent Ullberg's armature, completely hidden, literally is welded to the ceiling to hold the many hundreds of pounds of clay he uses.

Sculptor Pamela Gilbreth Watkins uses a Styrofoam armature for her sculpture *Bulldog.* The Styrofoam is partially shaped, then glued together and placed on an anchored steel pipe for support. The Styrofoam is refined further, then modeling clay is applied to the entire work, beginning at the top. She uses calipers for exact details. A cardboard cutout is placed alongside the nearly completed work to check on the shape. The final work will be molded and cast into bronze.

Sculptor Sheryl McRoberts begins with a simple pipe armature with wrapped clothesline wires for arms for her portrait work. The head has a series of wires and includes a butterfly for the chin. Inside the wires are wet newsapers, since the sculptor prefers to use terra-cotta (water-based clay) for her modeling medium. She pays special attention to the front and side profiles as she adds clay. Once the profile is obtained, she fleshes out the work, checking proportions against the live model. The details are added last. A noticeable quality of her work is the surface texture created by using terra-cotta in a very free manner.

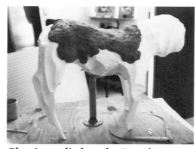

Clay is applied to the Styrofoam armature, which is supported by a steel pipe.

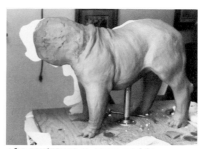

The sculpture is compared to a cardboard cutout to verify the shape.

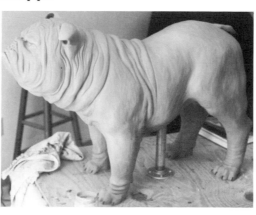

Pamela Gilbreth Watkins, Bulldog. Modeling clay, life-size.

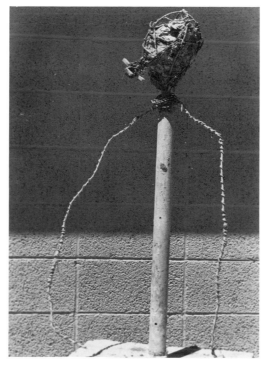

Armature for Kristy. Notice the wet newspapers inside the head area and the butterfly where the chin will be.

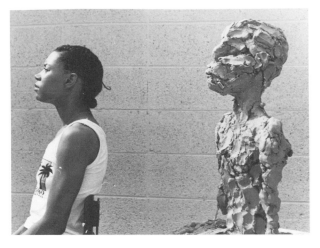

The work is compared to the live model to verify proportions.

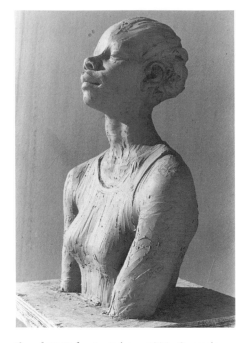

Sheryl McRoberts, Kristy, 1986. Ceramic clay, 24" tall, life-size, model for a finished bronze.

Styles

Novice sculptors unnecessarily worry about style. Some are disturbed that their work is not unique enough to be easily recognizable as to style. Often a particular "look" is contrived by a beginner. This is not a good practice because it results in more of a copy than an original work.

Style refers to the particular characteristics acquired from technique, subject matter, skill, instruction and time. Seldom is a style obtained early in a sculptor's career, even though that sculptor's work may be of good quality. Styles are not to be aimed for artificially, but naturally acquired and evolved. As sculptors experience materials and methods and mature in

ideas, their styles will emerge as natural, personal and identifiable as their own handwriting.

As a student, I studied various styles and modeling techniques, trying to find a way to approach my own work. As a teacher, I refer students to different examples of styles.

In order to facilitate the beginner's work, a number of busts are placed together here for comparison of modeling methods and style. (Other examples appear throughout this book.) These examples represent subjects of different ages, sexes and nationalities. The works have been completed in different media, but still the modeling is evident. These should be studied and learned from, but not copied.

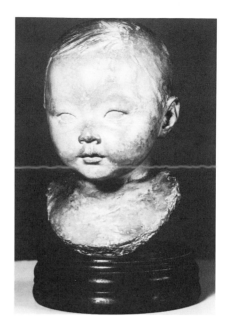

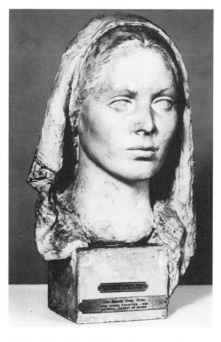

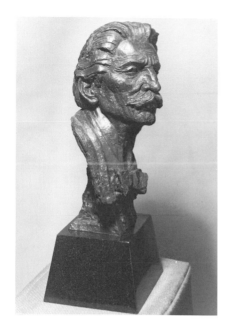

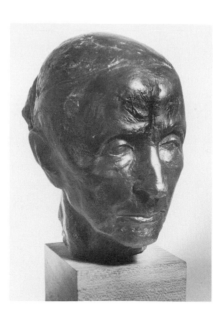

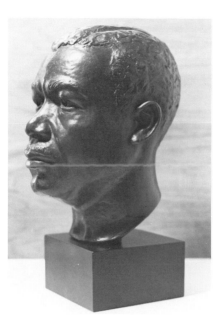

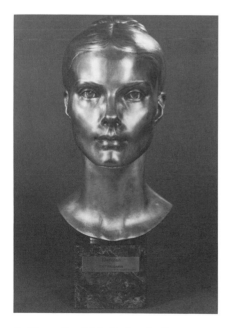

Linda Wu, Baby Chang. *Plaster with patina, life-size. Courtesy National Academy of Design, New York City. Photograph: Yardley Chan, Jr.*

Jean Donner Grove, Steelworker. *Bronze, life-size.*

Charles Umlauf, Portrait, Dr. Schweitzer, 1978. *Bronze, 26″ tall (including base) × 11″ wide. Photograph: Mears.*

Leonda F. Finke, Portrait of Georgia O'Keeffe. *Bronze. Collection of National Portrait Gallery, Smithsonian. Photograph: Otto E. Nelson.*

Linda Wu, The Virgin. *Plaster with patina. Life-size. Photograph: Yardley Chan, Jr.*

Anthony Frudakis, Deborah. *Bronze, life-size.*

Ellen Lowenstein, For C. Plaster, cloth, ash, tempera, lamp black, 55" tall × 36" × 24."
Photograph: C. Neal White.

3

PLASTER

- Plasters
- Gypsum Cements
- Tools
- Mixing
- Working
- Armatures
- Carving
- Demonstrations

Plaster is seldom used as a final medium, but it is one of the most widely used media. Plaster often serves as the model or mold for the final sculpture. It requires few tools and easily converts from a liquid form to a hard substance in a matter of minutes. Even though plaster can easily be colored, the white finish is often sought for its purity of value.

This chapter will discuss plaster as a medium that can be modeled, taken from molds or carved. The plaster work may be finished or it may serve as a go-between medium for the final work. (The actual casting of plaster is covered in chapter 4.)

Plasters

Several different plasters commonly are used by sculptors.

No.1 molding plaster (U.S. Gypsum) is a straight gypsum product. This particular plaster is often called plaster of paris. Its porous nature makes it excellent for modeling. The porous surface creates painting problems, however, since the paint is drawn deep into the plaster. A mixture of no. 1 molding plaster requries 70 parts water to 100 parts plaster by weight; this is 7 pounds of water to 10 pounds of plaster. Hard setting time is from 27 to 37 minutes.

No. 1 casting plaster (U.S. Gypsum) is the preferred plaster for general use, and specifically for casting. It has a unique additive that deposits itself on the surface during drying, which enhances its paintability. The dried surface resembles an egg shell in appearance. A mixture of no.1 casting plaster requires 65 parts water to 100 parts plaster. The hard setting time is from 27 to 37 minutes.

Aaron Royal Mosley, David XX. *Plaster and PVC
saturated with rubbed-in linseed oil,
74" tall × 60" × 40."*

White art plaster (U.S. Gypsum) is very similar to no.1 casting plaster except that it is less chip-resistant and not quite as hard. It has some surface additive but not as much as no.1 casting; therefore, it requires more care in painting. The mixture consists of 70 parts water to 100 parts plaster. Hard setting time is from 27 to 37 minutes.

Construction plasters are available for many purposes. They have varying drying times and strengths, and the colors tend to be grayish. In general construction plasters are not good plasters for sculpting, unless the sculptor has checked the technical bulletins and found an exact purpose for one.

Gypsum Cements

Gypsum cements are used by sculptors and are mixed the same way as plaster. They can be used by themselves or combined with plaster for additional plaster hardness. They expand more than plaster does during the setting period. They also are more expensive than plaster.

White Hydrocal gypsum cement (U.S. Gypsum) is two and a half times harder than plaster, but has all of the modeling characteristics of plaster. It can be mixed in the same manner, and the hard setting time of 25–35 minutes is very similar. The mixture takes 45 parts water to 100 parts Hydrocal. Hydrocal is good for reworking, though it is quite hard. It is often the whitest plaster product available, and is an excellent product for slip casting.

Hydrostone gypsum cement (U.S.Gypsum) is more dense and five times harder than plaster. It remains very fluid and thin until it "snap sets" (no slow thickening or warning of set-

ting). The mixture ratio is 32 parts water to 100 parts Hydrostone. The hard drying time of 17 to 20 minutes is the most rapid of all plasters. Hydrostone is more expensive than the other gypsums and less available. It is not good for reworking and is not useful for slipcasting.

Unused plaster can be stored for long periods of time, but time does have an effect upon the plaster. Storage in a completely dry area for longer than 6 months can slow down setting time when the plaster is used. If the storage area tends to have some moisture, the plaster could harden near the surface of the bag. Over a longer period of time, beyond 6 months, the moist area can cause the setting time of the plaster to accellerate. The ideal storage time is less than 6 months. (U.S. Gypsum recommends only 90 days storage time.) Plaster sealed in plastic garbage bags will have a longer shelf life.

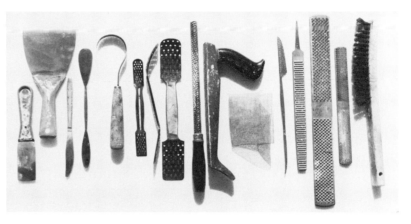

Plaster-working tools.

Tools

Plaster tools are tailored to the individual's use. Those pictured include (left to right) two putty knives, a common table knife, plaster spatula, a carving hook, three plaster rasps demonstrating the range of sizes and shapes, Surform rasps (round and flat), wire screen, large riffler rasp, rat-tail rasp, flat rasp, combination file-rasp and a wire brush.

Power mixers are recommended for mixing larger quantities of plaster. A heavy-duty drill with a homemade blade is a good tool but has only one speed and can mix only limited quantities at one time. The most common type of mixer is an electric one with a stainless steel shaft and blade, which will easily mix as much as 100 pounds of plaster

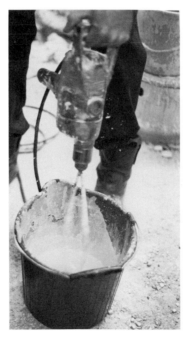

A heavy-duty drill can be used to mix plaster.

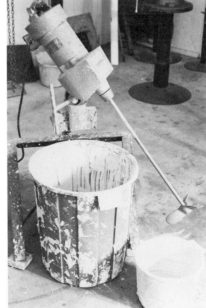

This electric mixer can easily mix 100 pounds of plaster at one time.

at a time. A flexible garbage can is a good mixing container. The most preferable mixer is the pneumatic mixer. It closely resembles the electric mixer, but has the additional advantage of innumerable speed settings, and it will not burn out if it bogs down.

Two cautions should be heeded when using mixers:

1. Remove the blades from the plaster mix before the mixture sets.
2. The mix will set rapidly, so there is very little time to work with the mix, perhaps less than 2 minutes. Sometimes it is preferable to make a slightly thinner mix to allow more working time.

Mixing

Plasters are very safe to use. They are non-toxic and nonallergenic except for floating dust while mixing. The user's skin may dry out, though chapping does not ordinarily occur unless the use is frequent or prolonged. (If one has sensitive skin, rubber gloves may be used during mixing.)

Depending upon the size of the batch, the mixing time affects the dry strength and setting time of the plaster. If it is mixed 1 minute, normal plaster can withstand 1300 pounds per square inch of pressure. If it is mixed 9 minutes, it can withstand almost 2000 pounds per square inch. However, if plaster is mixed too long, it may start setting and the strength is decreased. Mixing for 3 minutes will allow a possible 30 minutes of working time before setting. Mixing for 8 minutes will allow only 12 minutes prior to hard setting.

The setting time of plaster can be controlled by water temperature. Hot water will speed the setting, while cold water will retard the setting. However,

water at 100°F produces the maximum solubility; to use hotter water causes the setting time actually to decrease. (Interestingly, 75°F and 135°F produce the same setting time.) Using less water in the mix hastens the setting time but causes air entrapment in the final work.

Additives also are used to control the setting time. Commercial additives such as Terra Alba (ground gypsum) or sodium chloride (table salt) can be used to accelerate the setting time, but they also reduce the strength. Citric acid (lemon juice) or alcohol will retard the setting time, but the strength is reduced by these additives as well.

Observe the following cautions when mixing plaster:

1. Always mix plaster into water, never water into plaster.
2. Add the plaster in a sifting manner to the water in order to avoid air bubbles and lumps. If the plaster is old, use a kitchen flour sifter to separate the usable plaster from the lumps.
3. Throroughly mix the plaster and water.
4. Never pour a plaster mixture in a sink or drain, since it can set up underwater.

Procedure

It is better to add premeasured amounts of plaster to water, but it is seldom practiced for a small batch of mixture. Thus the following procedure is suggested:

1. Use a flexible container such as a plastic paint pail. Fill it no more than one-third full of water to allow room for the plaster and mixing procedure. Begin sifting plaster through the fingers into the water.

2. As the plaster begins to fill the water, it will finally begin to float.

3. At this time, temporarily stop adding plaster until the plaster in the bucket is dissolved. Slowly add more plaster as it becomes saturated. The mixture should sit for 3 or 4 mintues prior to further mixing. After it sits, proceed by stirring with the hands. More plaster can be added if it is needed, but it is not a good idea.

4. Take care not to add too much or too little plaster and to mix the plaster thoroughly without mixing too long, thereby losing the setting-working time for the plaster. Plaster can be squeezed between the fingers to force lumps apart.

5. When the plaster completely covers the hand to where the skin color no longer shows through, then it normally is ready to use. It is like cream. If the mixture is too liquid, the mixture may not set for a long period and be too weak or soggy to be of value. If the mixture is too thick, it is difficult to use. It will set extremely fast and form a very hard, glassy, unworkable plaster.

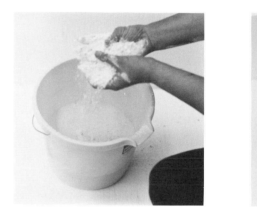

1

2

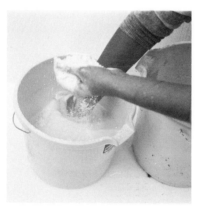

3

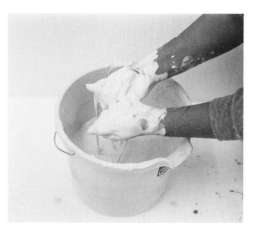

4

5

Cleaning Up

If plaster has been mixed in a flexible plastic bucket, it is easily removed after hardening by twisting the bucket. Cleanup also is made easier if the work surface is covered with sheet plastic. However, plaster attached to a table top or stand can be removed easily by tapping on the work surface after the plaster has hardened. The work surface can be scraped and cleaned with a damp towel, if the spill is quickly noticed. Hands should be cleaned promptly in a bucket of water (never the sink) before the plaster hardens. Use a good hand lotion after washing to prevent chapping.

Working

Plaster goes through six stages after it is mixed with water, and each has different methods of working possibilities.

1. The *liquid stage* occurs right after mixing. It will last from five to 15 minutes depending upon the water ratio and so on. It can be brushed, thrown and poured.
2. The *putty stage* is the very brief stage following liquid. It can be scooped, applied with a putty knife or spatula and modeled much like clay.
3. The *rigid stage* is when the mixture noticeably is beginning to set. The plaster will no longer bend without cracking or crumbling, but can easily be cut and trimmed with a knife or dug into with a spoon. The plaster is extremely fragile and should not be vibrated, dropped or have pressure on it.

4. The *set stage* is when the plaster begins to heat up and become obviously hard. This is not necessarily a good stage to work with, though it can be plaster rasped. Small mixtures of plaster will show little heat build-up, but a large volume will become extremely hot, especially if it has been mixed with little water. The faster the mixture sets, the hotter it becomes. Near the end of this stage, some sculptors prefer to remove piece molds from various modeling substances, because the substance may be more pliable due to the heat, and, consequently, the mold is easier to remove. The heat causes a rapid evaportion of moisture; when the plaster cools back down, it should contain 18.6% water.
5. The *cure stage* lasts from the time the plaster cools from the set stage to total dryness. Working during this time requires hard tools: metal rasps, files and the like. Screen wire is good for smoothing the surface. Since the plaster is still wet, it really clogs tools; they have to be steel-brushed clean quite often. Any additional plaster has to be added to a thoroughly pre-soaked plaster surface in order to take hold.
6. The *dry stage* is when the plaster no longer contains moisture. It is at its maximum strength, though it is brittle. The humidity, water usage and plaster thickness determine how long it will take to reach this stage. The surface is good for slip molding, it can be sanded with sandpaper, or it can be painted. (It is futile to use sandpaper beyond 220 grit because of the denseness of the material.)

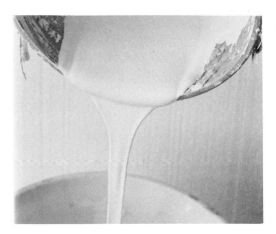

Liquid stage.

Putty stage.

Rigid stage.

Set stage.

Cure stage.

Dry stage.

If more plaster is added to a work, it is best to do it as soons as possible for better bonding. If the surface is dry or nearly dry, it must be completely soaked prior to the addition of more plaster. Without the soaking, the old plaster will pull the moisture out of the new plaster, producing a spot with different characteristics from the rest of the work, or else the new plaster will not adhere. The new plaster needs to be a mix similar to the old plaster or the hardness of the surface will have glossy, glassy spots that do not finish as the previous surface did.

Plaster is not recommended for outdoor display, though sculptors often use it for outdoor purposes after it has been sealed. In order to seal it, it must become completely dry before being finished. Plaster can be painted with lacquers, enamels, latex and acrylics. Good thin, saturating coats are preferred prior to the top coat. Latex pigments can be added directly into the plaster mix for color. Polyester resins can also be used on the surface, but follow the safety cautions given for resin uses. Thinned, boiled linseed oil serves as a good undercoat for an enamel. Sometimes the sculptor prefers to shellac the surface and then wax it. Every pore of the plaster must be sealed in order to avoid the absorption of moisture; even then it will still manage to draw moisture.

Armatures

Armatures, or internal supports, often are required for plaster works. Some provide strength, while others provide weight reduction, volume and a savings of plaster.

Wire armatures traditionally are used in smaller figurative work. They can easily be covered with plaster-soaked burlap, to which more plaster is added for the finished work. The less traditional use of wire is as a form itself. The wire form is wound with plaster-soaked burlap, allowed to set, and then brushed with plaster. It will have a smooth, delicate finish. Wire armatures can be made from heavy gauge aluminum, copper (even shielded copper electrical wire) or no. 9 steel (which is very stiff but good for big bends.) It is wise to shellac uncoated wire to prevent rust.

Chicken wire armatures are used for larger volumes such as life-size torsos. These armatures can easily be formed and connected together by the wire left protruding from the cut ends. Regular pliers or needlenose pliers can then be used to twist the small loops together to draw in the shape for the design. Tin snips or other tools can be used to cut the wire. Plaster-soaked burlap is used to cover the completed armature. Chicken wire comes in rolls of various widths, from 12 inches to many times wider.

Metal lathe (plaster screen) is good for holdng its shape. It is easily bent and will hold putty consistency plaster without burlap. Flat lathe is often nailed to other materials to support a large area and given a flat or stucco finish. (Metal lathe comes in 2 feet-by-8 feet sections.)

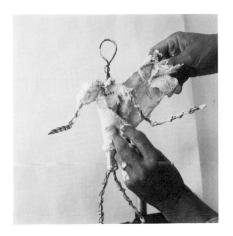

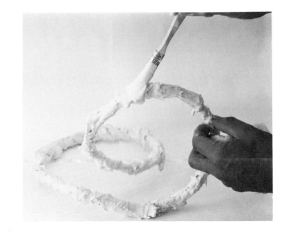

A wire armature is wrapped with plaster-soaked burlap.

A wire form was wrapped with plaster-soaked burlap and allowed to set. Additional plaster is brushed on to create the finished piece.

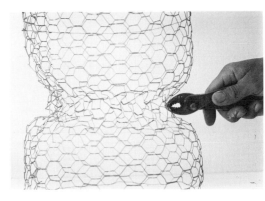

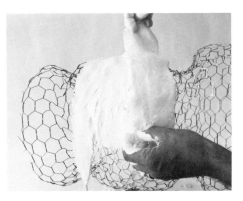

Chicken wire armatures can be shaped by using pliers.

Plaster-soaked burlap is applied to a chicken wire armature.

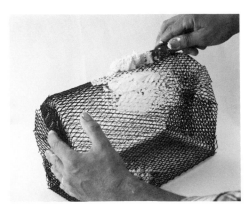

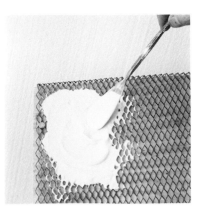

Plaster is applied directly to metal lathe.

Lathe is nailed to a flat surface to provide strength.

Wire screen (window screen) is often used to achieve a more refined, thin-edged shape. The metal screen can be dipped in plaster repeatedly to allow the plaster to build up. Plaster can be more roughly applied by spatula, though the screen does not hold its shape in application very well. The inside of a wire screen armature can be stuffed with newspaper to help support the initial plaster weight.

Foam rubber also can be dipped, but it becomes very limp. After the initial coat, plaster can be applied like putty. Foam is often wrapped around large metal armatures to provide bulk prior to plaster application, as illustrated later in the chapter.

Styrofoam is now a popular plaster armature material (and the one I prefer). It is lightweight, easily shaped and easily removed for a design change. Commercial shapes, such as spheres and wig heads, can be covered or dipped. Even very large shapes in Styrofoam are very lightweight and quite sturdy once covered with plaster. Larger works may use commercial foam insulation, which is blown onto an armature, carved to shape and covered with plaster.

A wire screen form dipped in plaster.

Plaster is applied directly to a wire screen armature. The bottom has been dipped in plaster.

Dipping a foam rubber shape.

Additional plaster is applied like putty.

Styrofoam is a popular armature material.

Carving

Sometimes an armature is not necessary for small work. It can be completely built up in plaster or carved, as the following example illustrates.

Fill a small milk carton with liquid plaster. Tap the filled container to help release any air trapped in the plaster. Allow the plaster to reach the set stage. Once the heat is noticed, immediately remove the carton and shape the piece.

It is easy to carve at this point, but you must work rapidly to remove large pieces. A locking-blade pocket knife or table knife is a useful tool. Once the piece is in the cure stage, carving is more difficult, but other tools can be used to refine the shape.

Some artists add vermiculite to the liquid mix in order to make the carving easier. This quality is especially useful if the work is large. However, the surface will be considerably rougher than that achieved from a pure plaster mix.

Another way to work without an armature is to use broken or pre-cast pieces of plaster. They can be stacked or attached with liquid plaster. This technique is especially good for free-form works.

Pour plaster in a milk carton to form a block.

Remove the carton when the plaster begins to get hot.

Carving the block of plaster.

Demonstrations

Sculptor Ellen Lowenstein uses a rigid armature for her work *Fetch I*. She shapes steel re-bar (a common cement steel available at lumberyards) and welds it together on a steel base. She sprays a coat of paint on the armature to prevent rust from seeping through to the final work, and covers the armature with pieces of Styrofoam.

Using a mixture of Hydrocal and 10% Portland cement (also found at lumberyards), she begins to add to the surface. This mixture is much harder than plaster and not easily reworked, but it is much stronger for a linear work. After the work has been coated, she changes the head size by removing the original Styrofoam head and replacing it with burlap soaked in the plaster mixture.

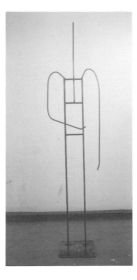

The rigid welded steel armature for Fetch I.

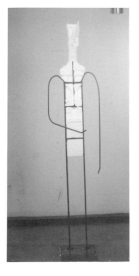

The armature is filled with Styrofoam.

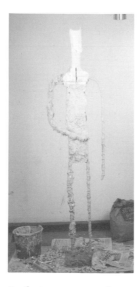

A plaster-cement mixture is applied to the armature.

Ellen Lowenstein, Fetch I. *Hydrocal, life-size.*

The author uses a plaster rasp to help shape the plaster. Though this plaster will remain in a rough stage, notice the work to the left. It was dried and sanded smooth to serve as the model for a bronze work. Both of these torsos have an inner armature of Styrofoam.

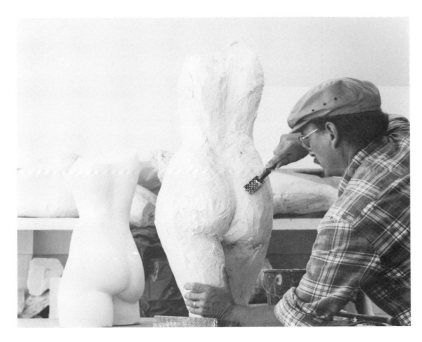

Sculptor Leonda F. Finke creates her armatures as she works, constantly adding and changing. She uses predrilled construction strips, bolting them together in various places for strength and design. The armature pictured is bolted to a 3/4 inch plywood base. She is able to change her designs by chisel-

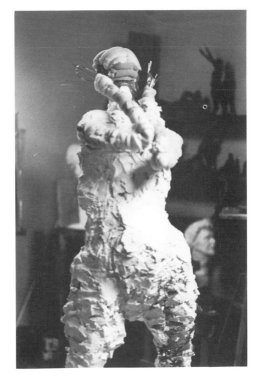

Steel armature for the standing figure in Installation.

Plaster-soaked burlap is applied to the armature. Foam rubber strips are wrapped around the armature to flesh out the form.

ing through the plaster and unbolting the part she wants to modify. She adds foam rubber and plaster-covered burlap for bulk. Wires are wound around the hand and feet areas to add strength and are cut off to the desired size when the piece is finished. Completed work is pictured.

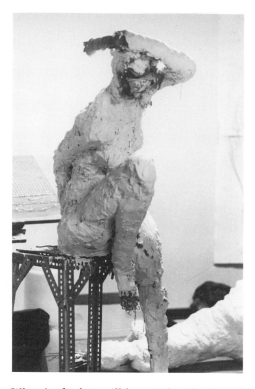

Wires in the foot will be cut after the figure is completed. This gesture was changed late in the work, as shown in the finished piece.

Leonda F. Finke, Installation. Plaster, life-size. *Sculpture Center Gallery, New York.*

Norman Holen, Sarah. **Plaster, 21″ × 13″ × 13.″**

Betty Branch, 1st of the Gift Bearers. Direct plaster on steel, 7′ tall.

Patricia Wasserboehr, Untitled. Cast plaster, painted with shellac then waxed; 32″ tall × 26″ × 41.″

Carole Jean Feuerman, The Runner, *1986. Cast resin and paint,*
37″ tall × 22″ × 33″. Photo: Jeff Rosenbaum.

4

MOLDS

- Castable Materials
- Molds for Casting
- Designing a Mold
- Piece Molds
- Waste Molds
- Flexible Rubber Molds
- Flexible Silicone Molds
- Casting from Live Models

Without molds, many media would be impossible to use. The sculptor depends upon molds to provide a way for many materials to take shape. Among these media are bronzes, epoxies, resins, clays, papers and plasters. Because of the many different requirements of the model, casting media and design, molds are constructed from a variety of materials.

The model or design for the mold is often constructed from plaster, water-based clay or oil-based clay, though those are by no means the only modeling materials. In recent years the human body has become a much-used model for mold making, and molds taken from live models are demonstrated in this chapter.

Castable Materials

Castable *metals* and their specific molds are discussed in chapter 8, Metal Casting.

Castable *plastics* are discussed in chapter 10, Plastics. Molds for plastic casting are specifically discussed in this chapter under Waste Molds and Flexible Silicone Molds.

Castable *papers* are covered in chapter 11, Paper. Most molds from this chapter, however, are useful for paper casting. The relief mold discussed later in this chapter under the topic Flexible Silicone Molds is specifically designed for cast paper.

Castable *clays* are discussed in chapter 5, Clay. Most plaster molds in this chapter are applicable to casting clay. The body and face molds covered later in this chapter are specifically designed for clay pressing.

Craig Lehman, Lady with Cat. *Cast bronze,*
6" tall x 6" × 10".

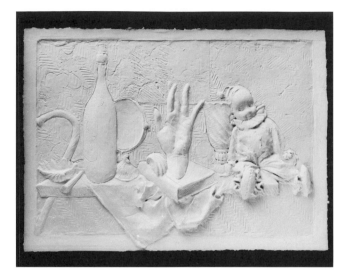

Frank Gallo, Still Life. *Cast paper relief,*
25" tall × 34".

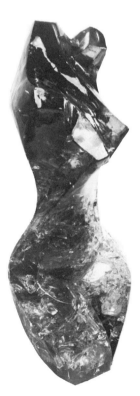

Nicholas Roukes, Xenia.
Polyester resin with
dyes and inclusions,
16" tall.

Jeannie French, A House of Shelter.
Slip cast and handbuilt earthenware
with underglaze, india ink, acrylic
polymer medium.
17" tall × 9" × 7".

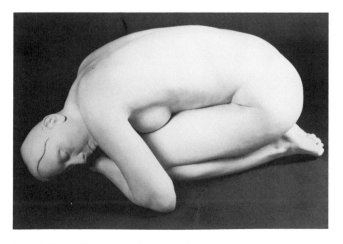

Carole Jeane Feuerman, Cocoon. *Cast stone,*
16" tall × 34" × 20". Photo: Jeff Rosenbaum.

Casting *plaster* and *gypsum* is discussed under Piece Molds, Clay Wall, in this chapter. Molds from this chapter can easily be used in plaster casting.

Casting *wax* is discussed in chapter 8, Metal Casting. Though most molds from this chapter are applicable, a particularly specific technique is described under Piece Molds, Metal Shim.

labor and time that latex requires for applying and drying each thin layer, it is seldom used any more. Polysulfide rubber compounds that chemically cure are popular. Silicones are the best all-around mold material, even though they are often more than three times as expensive as the rubber or urethane materials.

Molds for Casting

The *waste mold* is a fast, easy-to-make mold for one-of-a-kind castings. Often it consists of no more than two pieces made of plaster. The idea is to construct a simple mold and fill it with a medium stronger than the mold material, then literally break the mold off the casting. The drawback is that the sculpture may be lost if the casting is not good, since the mold is destroyed (wasted) in the process.

The *piece mold* is the most common mold. It usually consists of two or more pieces formed from a model. It is a reusable mold most often constructed of plaster. Before flexible molding material was introduced, large plaster piece molds were often a complex myriad of tedious parts. Now plaster piece molds are only used for the more simple shapes.

The *flexible mold* is a popular way to cast. It is used by all metal-casting foundries to ensure good repetitive castings of the waxes used. Flexible molds can have many parts, but they are often two-piece molds. Since they are not rigid, they are reinforced with a supporting mold surrounding them known as the *mother mold*. Flexible molds are made of several materials including latex, urethane elastomers, rubber and silicone. Because of the

Designing a Mold

There are nine primary considerations when planning a mold. These are the draft, undercut, parting line, shim, key, pouring duct, mold binding, withdrawal angle and release agent. If each one of these items has been carefully planned, then the mold should work properly.

A *draft* is the tapering of a mold that allows the mold to be removed from the model or casting. If a draft is not present, the mold and model or casting may fit so snugly that they cannot be taken apart. Since plaster expands as it sets, the draft must be great enough to allow for the additional expansion.

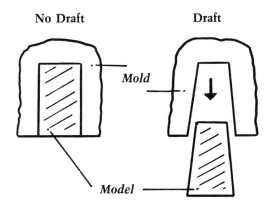

Draft.

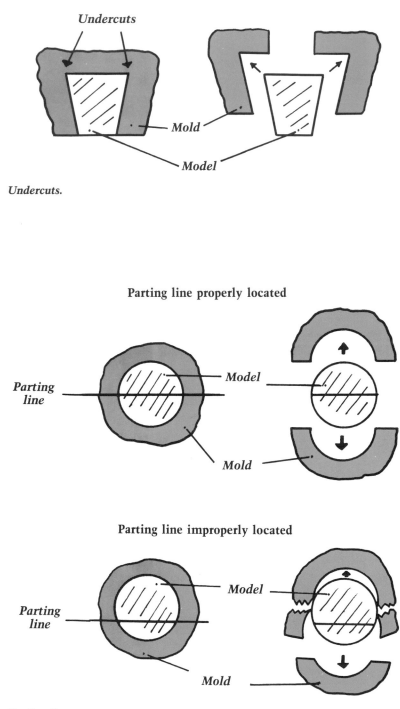

Undercuts.

Parting line properly located

Parting
line

Model

Mold

Parting line improperly located

Parting
line

Model

Mold

Parting lines.

An *undercut* is a protrusion or recess in the mold that hinders draft. When undercuts occur, the mold must be divided in a way to allow draft.

The *parting line* is the line or place where the mold parts meet to avoid undercuts. The ideal situation is to avoid undercuts and yet divide the mold into as few parts as possible. The parting line must be placed accurately, or the mold or casting can be damaged. An easy way to find the parting line is to use a triangle or square. Placed alongside the model, the point where it touches becomes the parting line (illustrated under Piece Molds). Another method to locate the parting line is to get straight-on views (front and back) of the artwork. Any parts of the model not in sight are located behind the parting line; otherwise they will hinder the draft.

Shims traditionally are thin brass or aluminum strips partially inserted in a soft model to section off different parts of the mold. They are placed into the parting lines to ensure exact division in order to prevent undercuts. Any dividing wall placed to separate the mold parts takes the place of a shim, whatever the material.

The *keys* are matched protrusions and depressions in the mold seam or shim that enable the mold to be taken apart and reliably reassembled. In plaster piece molds they are often small V-shaped grooves or round depressions made in the plaster seam of the first mold piece. When the next piece is made, the plaster will assume the key shape. When the pieces are together, the keys not only fit the aligning mold parts, but they also serve to help hold the alignment until the mold can be bound. (Take care not to create undercuts when designing keys.)

The *pouring duct* is the channel or opening into the mold through which liquid media will enter. Without it, the mold would be useless. On most molds, the duct must be placed so that the mold will fill completely, preferably where it will not interfere in the design of the work. Thus the pouring duct must be at a higher level than the rest of the piece when the pour is made. Ideally, it is placed so that a parting line will halve it, allowing complete removal of the casting prior to cleanup. On designs with an open bottom, a pouring duct is not necessary. The casting can easily be poured into the inverted mold.

Mold binding is the method used to hold the mold together. Mold bindings may be rubber bands, rope, bolts, straps, wires, clamps or even a box for encasement. Rubber bands made from inner tubes most often are used for small molds. Bolts are most often used for larger molds. The mold binding must be able to hold the pressure of the casting material and yet not place a crushing force on the mold.

The *withdrawal angle* is the direction that the mold must be removed from the casting in order to avoid draft or undercuts. Even though a mold could be correctly planned and executed, if it is not properly removed, the mold, casting or both could be damaged.

The *release agent* is the substance spread on the interior surface of the mold to prevent the casting medium from adhering to it and to ensure easy mold removal. The release agent is often called the *separator* or *parting agent*. Release agents vary depending upon the mold material and the casting material. They should not affect the casting detail or casting medium.

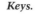

Mold *Keys*

Keys.

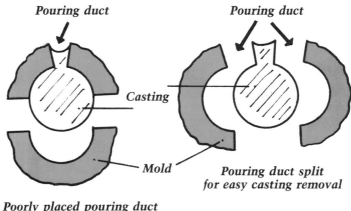

Pouring duct *Pouring duct*

Casting

Mold

*Pouring duct split
for easy casting removal*

*Poorly placed pouring duct
traps casting*

Pouring ducts.

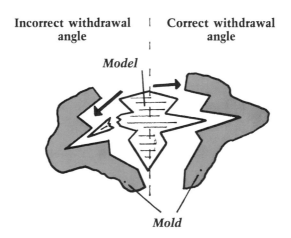

Incorrect withdrawal Correct withdrawal
angle angle

Model

Mold

Withdrawal angle.

The following materials commonly are used as separators:

1. Liquid dish detergents are usually thinned with two parts of water and then applied in three or more coats by brush. Liquid detergent is an excellent separator for a plaster mold and plaster casting, if the mold has been presoaked in water. Most liquid detergents work, but not all. Experiment prior to use.

2. Oil products are natural separators. Petroleum jelly is the one most often used, though care must be taken not to apply too heavy of a coat that will interfere with the mold detail. It is best to thin it with two parts of kerosene. Motor oil also is sometimes used as a separator.

3. Waxes, especially paste wax, are used as separators. They are most often applied over dry molds that have been sealed with shellac for a specific casting medium.

4. Silicone spray is rapidly gaining popularity as a separator. It is easily applied and does not interfere with the mold texture. However, it should be used in a well-ventilated area and, even then, with a respirator to avoid inhaling the spray.

5. Water is used as a release agent for liquid waxes when using a plaster mold. A thoroughly water-soaked mold will not only keep wax from sticking, but it will also hasten its setting time.

There are so many ways to make molds that the sculptor may become confused. To overcome this dilemma, several basic demonstrations with the most common mold-making procedures and materials are featured in this chapter. Often the sculptor must modify the technique to suit particular individual needs.

Piece Molds

Metal Shim

As previously defined, a piece mold is a reusable mold that consists of two or more parts. The following example illustrates how a plaster piece mold is constructed using metal shims and a soft clay sphere as a model.

First locate the parting line in the sphere and score it. Then insert metal shims along the parting line. The shims illustrated are made from thin used printing plates found at a commercial press and cut into small pieces approaching 2 inches square. For a larger work, shims can be cut into larger pieces following the curvature or shape of the surface. They should be inserted with each one overlapping the other. Make the key by bending a shim into a v-groove before inserting it. The parting line runs through the center of the pouring duct, so place the shims in the center of it.

The plaster mold material will be applied in the traditional manner, which is the throwing method. Turn the model so it is standing on its pouring duct and place it on a turntable for easy access from all sides. Select a working location where splashing plaster will not interfere with furniture or other workers. It's also a good idea to cover the surrounding area with plastic

This plaster sphere and soft clay sphere will be used as models. Notice how the parting line is located at the point where the triangle touches the sphere.

Inserting metal shims. The groove will serve as a key.

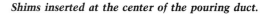

Shims inserted at the center of the pouring duct.

sheeting. Throw the plaster mixture onto the model by a flick of the fingers and wrist. It takes practice to hit the exact desired location (If the model is large or delicate, the first throws should be made to the bottom for support to keep the mold from toppling.) Since metal shims are extremely thin, both sides of the model can be covered at the same time. Once the face coat has

Throwing on the face coat of plaster.

Applying additional plaster by hand.

evenly covered the model, the first coat of plaster is complete. After it has hardened (but not finished setting), the next coat can be thrown or applied by hand. Clean the turntable top between each coat. The metal shims also may need cleaning on the edge in order to remain in sight. Apply the final coat and clean it with a putty knife.

After the mold has set, break it from the table by hitting the table top with a hammer, preferably a rubber or leather hammer, but metal can also be used. This hammering will also free any other plaster remaining on the table. This mold is illustrated being pried apart using metal chisels, even though wood wedges are preferred. The wedges usually are spaced around the mold and hit in a consecutive, systematic manner to avoid too much pressure in any one place. After the mold is opened, remove the shims and take out the clay model.

After the mold has been cleaned and trimmed, it is prepared for hot liquid wax. Soak the mold in room temperature water until it ceases to hold water (3–5 munutes). Discard the excess water

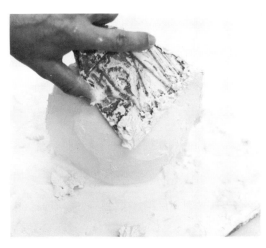

The final coat is cleaned with a putty knife.

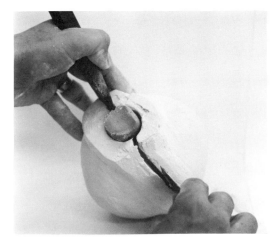

The mold is opened after it has set.

and bind the mold with a rubber band and a tied wire. The mold now is ready for the hot liquid wax. When wax reaches the correct pouring temperature, it forms a skin on the top. At that instant the wax is perfect for pouring into the mold. This is called *slushing,* obtaining a thin wall of a coating of material on a mold wall by pouring. Once the mold is filled, let it set until the desired thickness is obtained. Pour out the excess wax and allow the casting to cool in the mold. To hasten cooling, cold water may be added to the hollow casting and then poured out. The shrunken wax is easily removed once the mold binding is loosened. The mold literally falls open.

Liquid wax may also be brushed into the mold for details or high points on the interior of the mold (which may remain thin after slushing, unless they are brushed). After the mold has been brushed, it may be slushed, though careful brushing alone will work, especially for unusually large or odd-shaped molds.

Pouring hot wax into the mold.

Releasing the cooled wax casting.

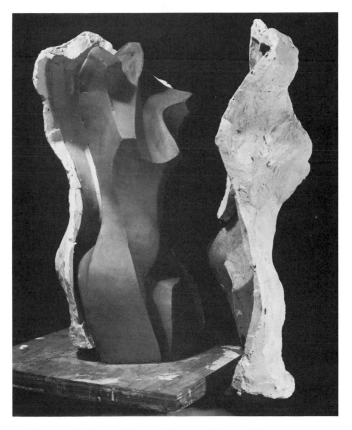

Sculptor Nicholas Roukes used a two-piece mold made with shims (removed in the photo) to cast resin for his work Xenia, which was shown earlier in the chapter. Photograph: Nicholas Roukes.

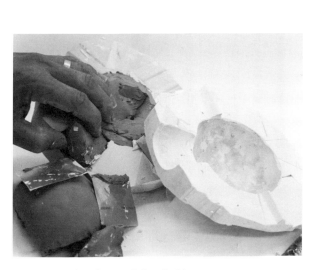

Removing the clay model and shims.

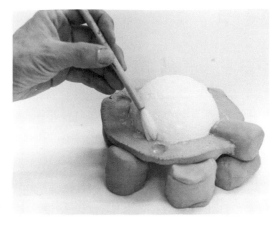

Release agent is applied to the sphere before the plaster is put on.

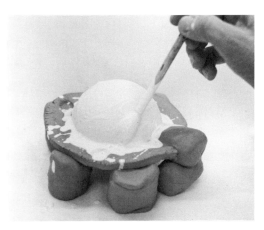

Brushing on the face coat of plaster.

Clay Wall

Piece molds also can be constructed without metal shims. The following example illustrates a piece mold made using a hard plaster sphere for the model. Locate the parting line and place a clay parting wall on the lower half of the model, even with the parting line, in lieu of metal shims. (The shims cannot be pushed into the hard surface.) Place removable pieces of clay under the clay wall to support it during mold making. Fashion the pouring duct out of clay and place it in the center of the wall. Press keys into the clay wall (two are visible in the illustration). Since plaster will be the mold material, soak the sphere in water. (Soaking will keep the model's dry plaster from drawing the water out of the mold and creating a weakened plaster.) The release agent is thinned green liquid soap (Palmolive dish detergent in this example) applied with a soft brush. The clay wall does not need a coating, since it will not affect the plaster.

Using a paint brush, apply the face coat of plaster to secure details. (This step is especially important on intricate works.) Apply the remaining coats of

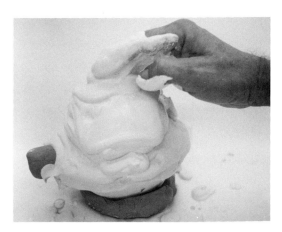

The rest of the plaster is applied by hand.

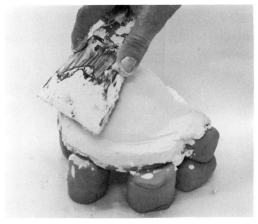

Applying the last coat of plaster.

plaster by hand and finish with a putty knife. After the mold has set, invert it and remove the clay wall. The plaster seam (wall) from the finished side will function as the separating wall.

One-half of the mold is now completed. Sponge the model with water. Even though this procedure is not completely necessary, it does help keep the drier plaster from pulling the moisture from the freshly applied mold plaster. Brush the model and wall with the liquid soap mixture for a release. Reinsert and apply the face coat of plaster by brush, as previously described. Finish the plaster application by hand and with a putty knife.

Allow the mold to complete the set stage and to cool before taking it apart. There are many methods for opening molds, but the ideal way is by using compressed air. A vacuum builds up within the structure due to the swelling of the plaster mold. A high-pressure air nozzle placed on the seam can often open the mold with no other help. (A rubber-tipped nozzle is best prepared since it forms a tighter seal when pressed against the mold seam.)

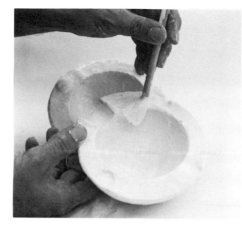

Brushing the mold parts with release agent in preparation for casting.

Pouring in the plaster mixture.

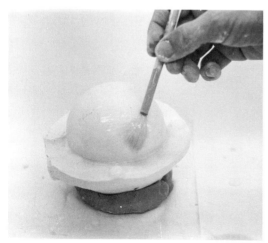

The model and the parting wall are brushed with the release agent.

Compressed air is used to open the mold.

Once opened, the mold is cleaned out and prepared for use. Since the casting medium will be plaster, soak the mold in water and then apply a generous amount of liquid soap to all interior surfaces, mold seams and keys. Put a heavy rubber band around the mold to hold it in place while a metal wire is tied about it for the mold binding.

Pour a mixture of plaster into the mold to produce a solid casting. In order to avoid air entrapment, tap the mold several times to release air bubbles. Once the set stage has passed, the mold can be opened by the high-pressure air nozzle blowing compressed air into the mold seam.

If the sculptor desires a hollow (slush) plaster casting, the same soaking procedure and release agent can be used. After the mold is bound, however, it is half filled with liquid plaster. The mold must be tilted and rotated so that all sides receive the plaster. Continue this slushing action until the entire surface is coated. Any excess plaster is returned to the plaster container. After the coat begins to thicken, the mold is filled partially again and slushed, and the excess plaster is poured out. This process continues until the wall is the desired thickness. On very large works, burlap or hemp may be added to the last coat, if it is reachable by hand.

Another casting material, casting gypsum, works the same as plaster. Hydrocal can be cast the same way or solid cast. Hydrostone should not be slushed since it snap sets in a very short time. It is ideal for strong solid castings.

Waste Molds

Sculptor Michael David Fox uses a clay model to produce a three-piece plaster waste mold for liquid casting resin.

He inserts aluminum shims that are 2 inches by 3 inches into the moist clay model on the parting line. Afterward, he allows the clay to dry to a leather-hard state before applying plaster. The drier model is easier to remove from the mold than the soft clay.

The back of the mold is finished first to better demonstrate the molding process. (Normally, all the parts of the mold would be done at the same time.) His first coat of plaster is a *color coat*, which is a thin layer of plaster with a different color than the plaster added on top of it. Acrylic paint is mixed with cold water and then added to the plaster to produce a color coat. When removing a mold, sculptors need to know when they are near the surface of the casting. With a color coat, they see the different

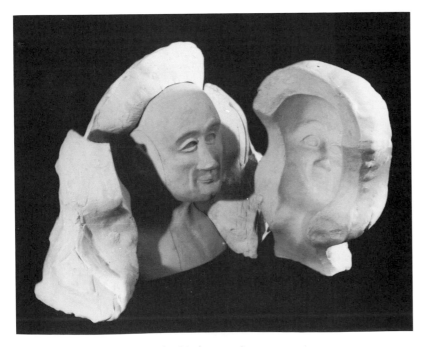

Sculptor William Disbro made this four-section clay-wall piece mold using a ceramic model that was fired to shrink about 15%.

color and know to take care. If the casting has to be chiseled off, this coat is essential. The remaining plaster coats are applied without color until a 1½-inch thickness is obtained.

After the plaster has set, he removes the mold. He pulls the shims first, and then gently pries apart the mold. Once he cleans the mold and allows it to dry, it is ready for assembly and the liquid resin. (See chapter 10 for the completion of this work.) Though the sculptor prepared this mold for casting resin, this same mold could be used for other casting materials with the use of the proper separator.

Clay model for a waste mold.

Aluminum shims inserted along the parting line.

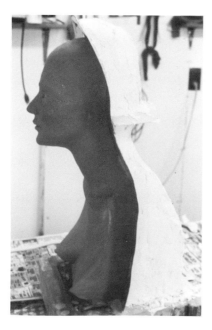

Notice the shims across the back of the head that divide this portion of the mold into two pieces.

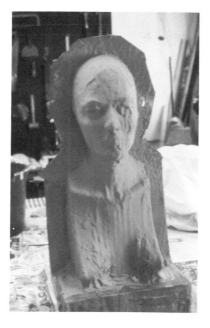

The face coat of plaster is a color coat.

The mold is ready for casting.

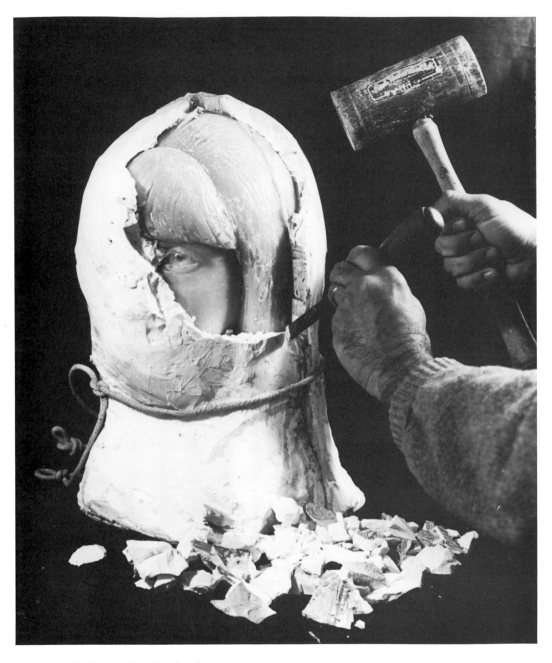

Sculptor Nicholas Roukes chisels off a waste mold that he used for casting resin. Photograph: Nicholas Roukes.

Flexible Rubber Molds

There are many flexible rubber or urethane molding products available with which you should become familiar. Many require exact (to the gram) measurements and several thin applications, which entail expensive scales and additional time. Sometimes the more difficult-to-use compounds are the best for a specific job because of the material being cast. Smooth-On, for example, is a polyurethane molding compound that requires much measuring and preparation, but the results are precise and the cost is reasonable. However, there are easier materials to use such as Por-A-Mold.

Synair's Por-A-Mold urethane molding products are used for the demonstrations in this section of the chapter: spray release agent no.135, which is wax based (not silicone); and Por-A-Mold T.A. flexible urethane troweling compound. Synair's products do not require scales or complicated mixing.

Brushed Method
In order to have mold registration for flexible molds, the wall material is often clay. A groove completely encircling the model can be placed in the clay wall in order to give a tight seal in the final mold.

First coat the model with spray wax. Mix Por-A-Mold according to the manufacturer's directions and brush it on the model. (High-pressure compressed air is often used to blow the mold material into every crevice of finely detailed works.) This coating should be thin. Allow it to set for about 45 minutes. In order to expedite the process, mix Por-A-Mold T.A. troweling compound per instructions to a consistency like thick butter. Add it by

spatula, building it up and smoothing it. Cure the compound overnight at room temperature.

Next add a plaster mother mold on top of the flexible mold to keep the mold rigid. After the plaster has been built up, shaped and allowed to set, turn over the model to begin work on the other half.

The model and the clay wall are sprayed with a wax release agent.

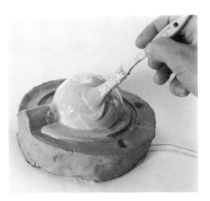

Brushing on the urethane face coat.

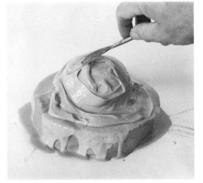

Applying urethane troweling compound.

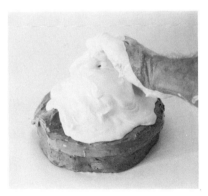

A plaster mother mold keeps the urethane mold rigid.

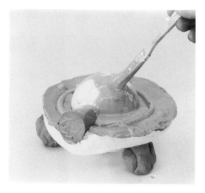

The mold structure is inverted and the face coat of urethane is brushed on.

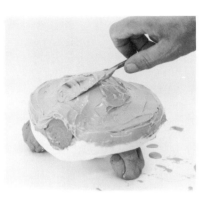

Troweling compound is applied.

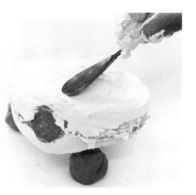

The second half of the mother mold is completed.

Removing the flexible mold.

Remove the clay wall, but retain the pouring duct. Support the mother mold on pieces of clay. Apply the spray release agent to the plaster seam and the model.

Once again, brush on the urethane to achieve the face coat. After 45 minutes, apply the final, thicker mixture with a plaster spatula. After it sets overnight, add the plaster mother mold. After the mother mold is set, it can be opened. Since the mold is flexible, it can easily be pulled off, even over detailed areas, once the mother mold has been removed. The flexible mold is now ready to use.

Poured Method

This pouring demonstration was constructed and photographed by Synair. The mother mold is a plastic-wrapped wooden box with removable sides held together with wood screws.

The model's parting line is in the center of the front and back of the model. Clay is attached to one complete side to serve as the parting wall. The model is placed in the box. The clay wall is completed and the registration keys are added. The wax release is sprayed on the model and the parting wall. The missing side of the box is attached, and it is sealed with clay to avoid leakage of the liquid urethane.

The two parts of Por-A-Mold are mixed together per instructions and poured into the box. It is cured at 70° (room temperature) overnight. The opposite side of the box is removed, and the clay parting wall is taken out. The spray release is now applied to this new side of the model. The side to the box is replaced and the seams are sealed with clay.

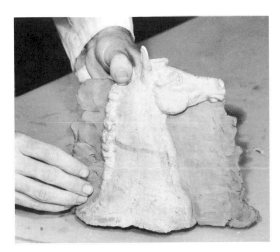

Constructing a clay parting wall.

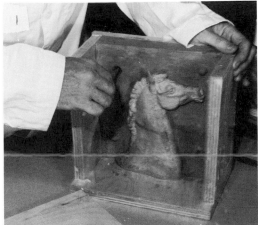

Adding registration keys.

Pouring in the liquid urethane mixture.

The clay parting wall is taken out.

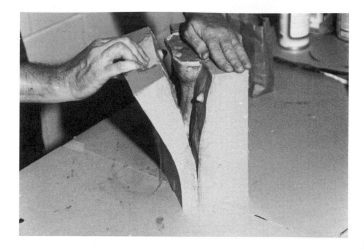

The mold is separated to reveal the model.

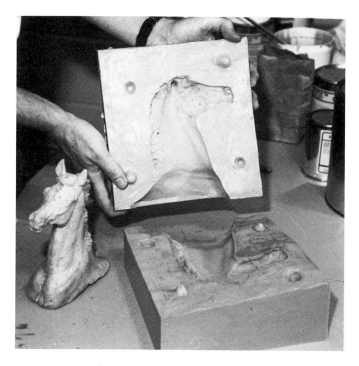

The two-piece flexible mold is ready to accept a variety of casting materials.

Again, the urethane is mixed as before, poured and allowed to set an additional 24 hours. The box is dismantled, and the mold is taken apart to reveal the model. The flexible mold may be reassembled for casting in various materials.

Flexible Silicone Molds

Silicone mold materials are popular because a release agent is not normally required. Partially wet plaster, clay or wax presents no problem with the silicone mold.

Brushed Method

The demonstration of how to make a silicone mold using the brushed method illustrates the completion of a wax relief begun in chapter 2. The wax model was framed for plaster and then cast into plaster.

The plaster artwork is placed in a wooden frame held in place by nailed ends and long wood clamps. Silicone does not adhere to damp objects, so the frame and the plaster artwork are dampened. Absolutely no water droplets can remain or they will cause bubbles in the silicone surface.

The silicone is thoroughly mixed and the first coat is brushed on for detail, then the balance of the mixture is poured into the mold. The silicone is constantly brushed up on the higher parts of the relief, until it begins to set (45 minutes).

Previously made chunks of silicone are used as keys and placed on top of the mold. Silicone will stick to itself until it is completely cured. The keys are spaced out near the edge to hold the silicone in place on the mother mold. Large molds require a number of keys.

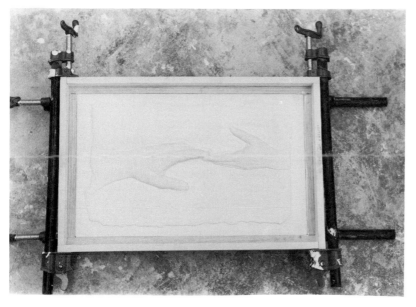

This plaster casting is a model for a flexible silicone mold.

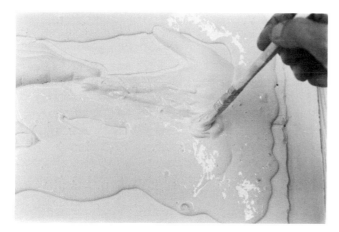

The face coat of the silicone mixture is brushed on.

Silicone keys are located near the edges of the mold.

The plaster mother mold is poured into the frame, and bent welding rods are added for reinforcement. The plaster is allowed to set.

The frames are removed, and the mold is inverted. The silicone mold is released from the model with compressed air. The mold is ready to use as soon as it is cleaned with a damp cloth.

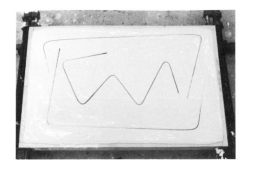

Bent welding rods add reinforcement.

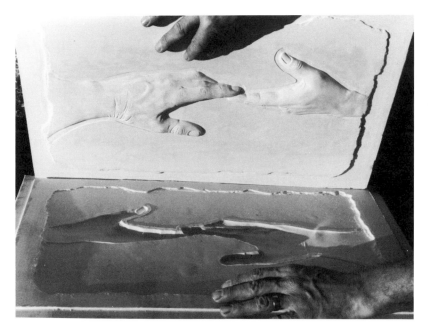

Separating the mold from the model.

Poured Method

This example of mold making demonstrates how to pour a silicone mold using a life-size plaster figure as the model. The figure is fastened to a cut board that will aid in registration. The figure aslo is firmly attached to a base. First the figure is completely

covered with a thin plastic wrap (found at grocery stores) to keep it clean while completing the next step. The wrap can be held in place with masking tape, if necessary. Water-based clay is applied in a prerolled thickness of 7/16 inches. (This thickness is best for this size work to be finished in resin.) An unusually thick 1-inch seam line of clay is added. Long cut metal shims are inserted in the seam, leaving about 1½ inches of shim showing. A pouring duct and an air release duct are added at the top. Several keys up and down the clay shim also are added.

The face coat of plaster is applied by the throwing method. More plaster is added by hand, as well as hemp and plaster-soaked burlap, especially at the seams. The final thickness of the plaster is 2 inches. When the plaster has set, the shims are removed, and the mold is slowly opened by high-pressure air. The clay is removed along with the plastic wrap. The plaster mold is cleaned out and replaced over the original model. Note the special cut board under the figure that provides registration. After the mold is sealed on the seams with plaster soaked burlap, the silicone is mixed and poured in. It is cured overnight, and the mother mold is removed.

After trimming, a razor-sharp knife is used to slit the silicone shim into two equal parts. The two halves are removed. The mother mold is trimmed on the seams to allow the silicone to touch without the mother mold interfering. The mold is now inverted and ready for resin. See chapter 10 for the completed work.

This same process and mold could be used for casting many different media. A seam this big is good for resin, but not necessary for other media. A thin silicone spray is used as a parting agent for resin.

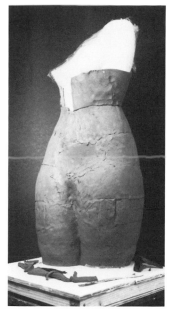

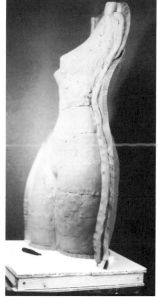

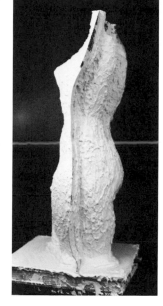

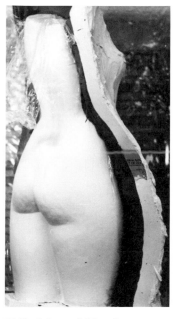

The figure is covered with plastic wrap and water-based clay.

Long metal shims are inserted in the seam line.

Plaster is applied uniformly.

Half of the mold has been removed.

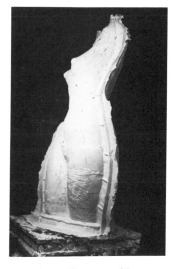

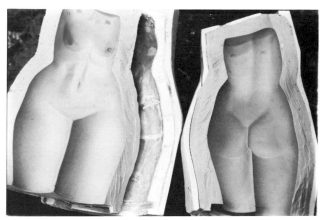

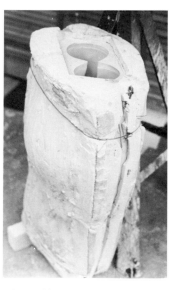

The two-part silicone mold after being trimmed and separated.

One-piece silicone mold. Notice where the silicone ran into the space left by the original metal shims.

The mold assembly is ready for casting.

Casting from Live Models

Casting from the human form is widely accepted and practiced. Some sculptors use the castings for the end product, whether it is a bandage casting or plaster casting. Others prefer to use the castings as an accent or starting point for their work. However used, extreme caution must be exercised when attempting to cast from the human form. Only the most experienced plaster worker should practice or supervise such a casting. (Note the casting from life by Duane Hansen in chapter 10.)

Plaster bandages are plaster-impregnated gauze rolls that normally are used as splints for cracked or broken bones. They are found at drug stores and medical supply houses. It is not recommended that plaster bandages be applied directly to the skin, but it can be done with some precautions.

A good release agent such as undiluted petroleum jelly is a necessity. The part to be cast must be thoroughly coated with the release agent. No hairy part of the body should be cast without a protective covering of plastic cloth or other nonporous material prior to bandaging. Never cover open eyes, mouth or nose. Do not encase fingers or other parts where the bandage cannot be safely removed by simply lifting it off or cutting it loose.

Plaster bandages come in rolls from 2 to 6 inches wide and in casting times of 2 to 8 minutes. They are simple to use. If an entire roll is to be used, it can be submerged, unrolled in a pail of water at room temperature for about 5 seconds. Squeeze out the excess water and apply the bandage, usually in an overlapping, wrapped coat. Keep the coat thin because a thick casting is difficult to remove and can become hot in the set stage.

The setting time is quick, but the model must remain still beyond the setting time to ensure mold strength. The mold can be removed within 30 minutes. A thin cast can completely dry in a 48 hour period. Normally, little heat is generated in the set stage if the bandage is kept thin.

Plaster bandages are easiest to remove at the set stage prior to the dry stage. A pair of round-nosed scissors made of stainless steel will suffice. (If hair is caught, there will be some pain involved in removal.) Observe the warnings given for plaster bandages, especially in body preparation for casting.

Liquid plaster secures a better surface than plaster bandages but is also more hazardous. More body hairs will be trapped, and the plaster generates more heat during the set stage.

Apply petroleum jelly liberally.

Plaster bandages are soaked in water.

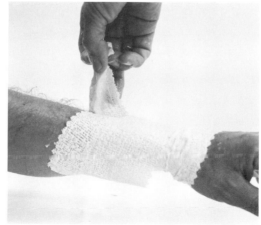

Wrap the bandage in an overlapping manner.

Use a blunt-ended scissors to cut off the casting.

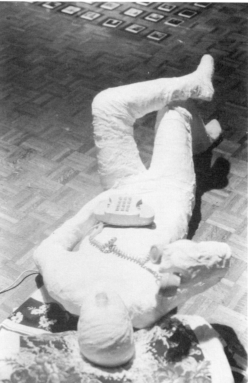

A class project in using plaster bandages. Instructor: Carolyn White-Travanti.

The casting is ready to use.

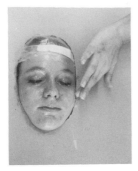

A model is prepared for a case casting.

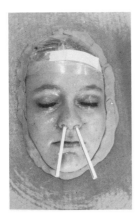

Drinking straws embedded in soft clay balls are used for breathing.

Face Casting

Casting a face is reserved for a model who is not the least bit squeamish or claustrophobic and a well-experienced, trusted applicator. It is necessary to have a third person present for additional help and to comfort the model.

To begin, cut a cardboard sheet into the shape of the head and place it in front of the ears, but not too tightly against the skin. The model should have all hair covered; a swim cap is ideal for this purpose. The head should rest on a firm but soft pad. Support the cardboard on the underside by objects (boards) to either side of the face; otherwise, the weight of the plaster will push down the cardboard.

Apply a heavy coating of release agent (petroleum jelly) to the face, especially over the eyebrows and eyelashes. Place soft clay around the head to seal it to the cardboard and prevent leaks. Place weights on top of the cardboard to help hold it in place prior to adding plaster. Insert paper soda straws through small clay balls, then insert them into each nostril with great care (the nasal membrane is very sensitive).

It is preferable that the helper holds the straws in place until the plaster sets.

Mix the entire batch of plaster in one sitting in a normal-to-thick mixture with room temperature water. Begin to apply plaster at the base and work up. Do the eyes next to last. Do the nostril holes the very last to ensure that the plaster is thick enough not to drain down.

Apply the plaster thinly, never more than 1 inch thick at any place on the face. This keeps the weight down and helps prevent the face from sagging. It also prevents excessive heat in the set stage. Allow the plaster to go into the set stage, but not completely through it. Once the mold is warm, remove it by lifting the straws out of the nostrils and raising the cardboard, tilted toward the chin. This withdrawal angle avoids undercuts from the chin and nose.

Give the model immediate attention. Clean tissue and water should be ready as well as a mirror. It is best that the model clean her or his own face.

The mold can be trimmed, cleaned and used for a multitude of purposes. (Most often, clay pressings are done.)

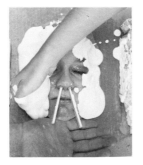

Plaster first is applied at the base.

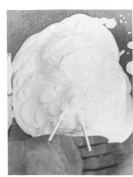

The face is completely covered with a thin coat of plaster.

The model with the completed mold.

Body Casting

Sculptor Jack Thompson demonstrates his procedure for body casting culminating in a press mold for earthenware.

First the body is thoroughly coated with a release agent such as petroleum jelly. Next he begins to apply wide plaster gauze that he has precut for the molding process. He divides the body into sections, working on one section at a time.

After the gauze has been applied, he lightly coats the entire section with additional plaster in order to strengthen the mold. Being careful not to connect the sections and yet keep them close together, he continues until the figure has been completed. The mold is carefully removed and let set to dry in preparation for the clay pressing.

The sculptor presses clay into each of the halves, and then joins the mold halves. He continues to add clay from the inside, joining the clay at the seams. After some curing, the mold is removed for further working. No armature is ever used.

Jack Thompson uses pressings for the beginning of works, adding many different ingredients for the final sculpture. This body casting is illustrated along with a detail of the final piece.

Instructor Joseph Hadley of Oxbow High School in Bradford, Vermont works with his sculpture students in a most unique way. They begin by group brainstorming, considering various concepts and configurations before the sculpture is begun.

Each model is thoroughly greased, even the clothes. Plastic wrap is placed on the hair and surgical tubes are provided for breathing. Each model has an individual student assistant with whom to keep close communication throughout the 30 minute project. The models are positioned on a padded surface surrounded by additional plastic wrap.

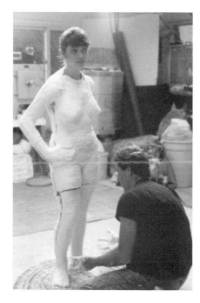

The body mold is applied in sections.

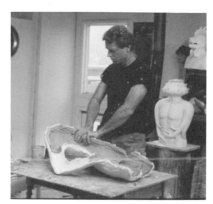

Pressing clay into each section of the mold.

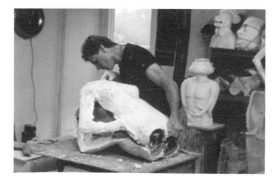

The mold parts put together.

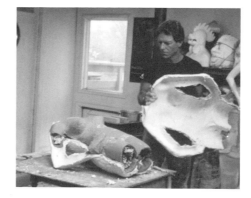

Removing the mold.

An ingredient that will be added to the body casting.

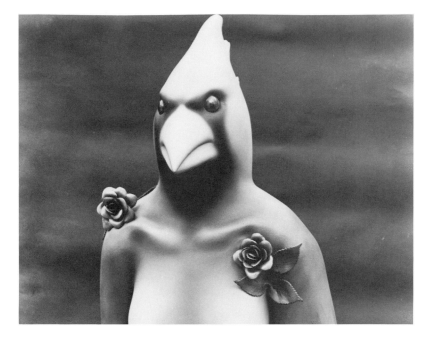

Jack Thompson, La Rosa Del Cardinal, 1985, close-up detail. Painted ceramic, life-size. Courtesy Marian Locks Gallery, Philadelphia, Pennsylvania.

The plaster is mixed in a large, shallow trough and the fabric sheet is soaked in the trough. The models are covered with this sheet. No undercuts are allowed, so that each model can later get out from under the sheet. Each aid cuts a hole in the plaster-soaked sheet for the air tube of his or her model. As the sheet sets, plaster-soaked burlap patches are added. Once two layers are set, the entire piece is lifted off the models and allowed to dry.

The piece is inverted to serve as a mold and is coated with petroleum jelly. Plaster is added with plaster-soaked burlap patches. After the plaster is dry, it is removed from the mold. The casting is completed by sanding and adding previously molded ceramic face masks.

The instructor says the project is an art adventure that teaches cooperation and trust. A total of twenty-five students participated.

Brainstorming a group project.

Preparing for the application of plaster.

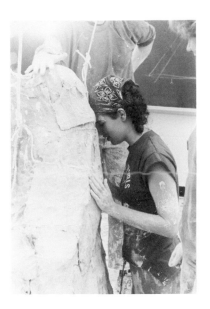

Aide and model maintain constant communication.

Masks Off, *nearly finished. Instructor: Joseph Hadley.*

Carole Jeane Feuerman, work in progress. Photograph: Ken Spencer.

Barbara Grygutis, Baseline. Stoneware, 9′ high. Photograph: Tim Fuller.

5

CLAY

- Sculptural Clays
- Clay Additives
- Sculptural Methods
- Finishing
- Demonstrations

Clay was one of the earliest materials used by sculptors, especially before they discovered how to make molten metals. Because of its plasticity (workability) and inexpensive price, clay is often used for modeling works that are later to take form in a more permanent material. A mold is built around the clay model and then used for other works that will ultimately be cast metal, resin, cement and so on. In this chapter, however, clay will be considered as the permanent material, once it is fired (baked) into a hardened state in a kiln (clay oven).

Sculptural Clays

Terra cotta literally means baked earth. It is usually a special mixture of earthenware. Traditionally, it is the term used for fired, but not glazed, clays that are of a red or reddish brown color. Terra cotta is most often a low-temperature fire clay with a coarse texture due to large amounts of grog. (Grog is previously fired clay that has been ground into small pieces often the size of sand—in larger sculptures—to a small powder—in smaller works.) Terra cotta is ideal for modeling. The more porous terra cottas are seldom glazed.

Earthenware clays are fired at low temperatures, resulting in a porous body. Earthenware is often a more refined clay than terra cotta modeling mixtures and the colors vary from some form of a red clay to a white body. Bright low-fire glazes can be added to seal the body. This clay is practical for press molding and hand works that require a bright glaze.

Stoneware clays are fired at high temperatures, resulting in a body that is nonporous and they often have a coarse texture. Stoneware is most often used

by ceramists for functional wheel-thrown works, but it is also used sculpturally. Grog can be added to it for additional strength, though it is a much finer clay than terra cotta. The bodies vary in color depending upon the clays and oxides used. High-fire glazes work well on stoneware.

Casting clays (clay slips) are clays designed to stay in suspension and yet flow smoothly when poured into a mold. Sodium silicate and soda ash are used in these clays to help keep the clay particles separated and floating. The clay bodies are smooth and delicate. Clay slip works are often glazed.

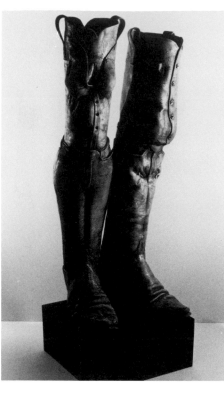

Bob Howell, Steppin' Out. *Clay, underglaze, 34″ × 12″ × 12″.*

Jerry L. Caplan, Firstside Fountain Figures, *before installation at site. Terra-cotta, 32″ high.*

Martha A Holt, Arbor Vitae #6, 1987. *Ceramic relief, 59″ tall × 30″ × 3″.*

Clay Additives

Grog (defined under Sculptural Clays) adds structural strength to the clay while the sculptor is working with the clay. Grog also hastens drying and reduces clay shrinkage. The best clays for the addition of grog are terra cotta and earthenware, though, other clays also have grog in varying degrees. Terra cotta normally has larger grog in larger proportions, while stoneware tends to have finer grog in small quantities. Too much grog or too heavy of a grog will result in a surface roughness; the wet clay will lose its plasticity, and the clay body will become weak after firing.

Burnout additives such as Zoolite, Vermiculite, Perlite or sawdust are added to the clay body to create a rough or porous texture after firing. During firing these particles are burned out, leaving small holes that the shrinking clay partially fills, Thus these additives can actually help reduce cracking, particularly for large, thick works.

Fiberglass can be added to wet clay to help increase the strength while it is being worked on. Less than 1% fiberglass strands allow the clay to be much more flexible in the wet stage. [CAUTION: *Do not add fiberglass to clays that are being wheel-thrown; fiberglass can cut the skin. Fiberglass can also cause cuts and enter the skin in hand-formed works.*]

Nylon fibers have the advantage of not cutting or irritating the skin, but they are not recommended for wheel work. During the modeling stage, nylon fibers add much strength while allowing very thin walls. They burn out during firing, however. Nylon fibers are easy to work with since they are soft and more pliable than fiberglass.

Nicholas Wood, Houses in Motion #5, 1985. *Terra cotta with slips, glazes, and apint, 54″ × 52″ × 6″.*

Clay bodies can be mixed from formulas or purchased ready-to-use. Often, especially in the case of terra cotta and stoneware, the clays are so well prepared and packaged that they can be used straight from the package. Though most clay mixtures can be obtained from textbook formulas, the sculptor should consult a local clay supplier for the best priced clays in the region.

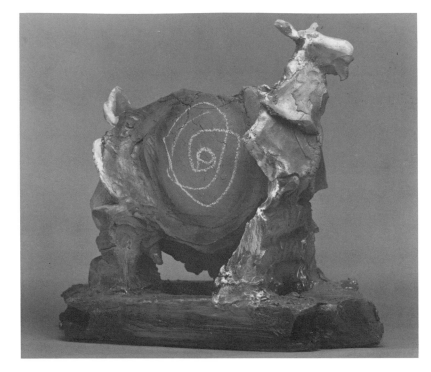

Robynn Smith, Slab O'Goat, *1986. Clay with glaze and oil paint.*

Carole Lewis, Goat. *Terra cotta, 28″ tall × 31″ × 12″. Collection of Dr. and Mrs. Pasqual Terraciaro. Photograph: Otto E. Nelson.*

Sculptural Methods

Clay is extremely plastic (very malleable) and can easily assume most any shape. Some sculptors prefer a very loose, almost unfinished look such as *Slab O'Goat* by Robynn Smith. Others prefer a more detailed work such as *Goat* by Carole Lewis. Whatever the desired result, there is an applicable technique.

Clays can be mixed by hand, but a more thorough, consistent way to mix them is with a clay mixer. The mixer resembles a large concrete mixer, though it actually is slower and stronger. Add powdered clays to a predetermined amount of water as the mixer runs. Good ventilation is a must, since the fine dust readily floats in the air and can cause serious lung problems. A good quality respirator should also be used. Once the clays are mixed, it is best to let them age several days to become more plastic. However, they can be used straight from the mixer, if they are thoroughly wedged.

Clay-mixer.

To *wedge* a large block of clay, cut it in pieces with a wire, throw the pieces together to form a new block and throw the large block down on all sides until it is firm. Repeat the entire process several times. Wedging requires strength, is noisy and should be done without bystanders in the vicinity due to stray pieces of clay flying about.

To *knead* a large ball of clay, push down and forward on the ball using the palms of both hands to spread the clay. Pull up the clay into a new position, and repeat the process, pushing the clay together each time. A rocking motion with the arms held still helps the process. Take care to change the position of the ball by starting from a different side each time to do the kneading. This procedure helps eliminate trapped air bubbles.

Depending upon the clay and the sculptor, wedging and kneading can each take from 5 to 10 minutes to accomplish. Both processes should be completed prior to clay use. (Grog can be added during kneading, but it is better to have the correct amount placed in the original mixture.) All clays should be kept securely wrapped in airtight bags until used to prevent moisture from evaporating.

Modeling tools for clay work are basically the same tools as found in ceramic studios. A sponge is helpful for some surfaces; a cutting wire is used for quick clean cuts. Wire-ended tools are for hollowing, and they and a multitude of other small tools are good for modeling and surface details. Homemade tools such as flattened spoons, table knives, forks and the like are also useful. Perhaps the best tools available to the sculptor are fingers and, especially, thumbs. Some sculptors prefer never to use modeling tools except for cutting and hollowing.

A block of clay is cut with a wire during the wedging process.

The cut pieces are thrown together to be cut again.

Push down and forward with the palms of the hands when kneading clay.

Pull the clay back into a new position for further kneading.

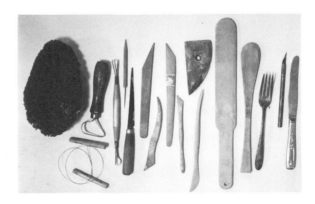

Clay-working tools.

83

Pinch method.

Pinch Method

The *pinch* method involves pinching (squeezing) a ball of clay between the thumb and other fingers until the desired shape and thickness are obtained. The clay must be moist, almost limp, in order to avoid stretch marks. The pinch method is not used often by sculptors, because it is too limiting for the sizes and shapes desired.

Hollowing Method

The *hollowing* method is the process by which a solid or partially solid clay sculpture is hollowed out to a thickness that can be kiln fired without stress cracks. Prior to the hollowing, the clay is usually finished and allowed to dry to a leather-hardness. (The leather-hard stage is when the clay is firm and drying, but not competely dry; there is minimal shrinkage after this stage.)

This form will be hollowed out from the bottom before firing (see next photo.)

Student work. Jeaneen Barnhart, Boy Petting Dog. *Clay, 4′ long. Instructor: Charles Lastrella.*

Some forms must be cut with a hand wire.

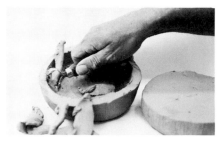

The cut form is hollowed out to leave a shell of even thickness.

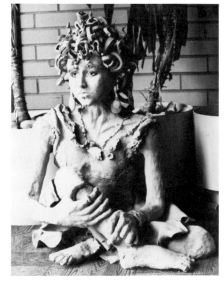

Student work. Lisa Cameron, Untitled. *Hollowed clay with underglazes, life-size. Instructor: Eve Whitcomb.*

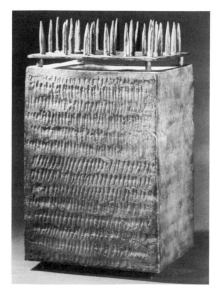

Kevin Lyles, Untitled Pod. *Raku with bronze, 12″ × 8″ × 6″.*

When possible, hollow the form from the bottom. If this is not possible, cut open the form with a hand wire. Remove the inside clay to leave about 1/2 inch of a shell. (Larger shells are left on larger works.) Rejoin parts by incising marks on the joint seams, adding thick slip and placing the two parts back together. The sculpture should be covered as it continues to dry in order to allow the seam some additional drying time.

Coil Method

The *coil* method begins by forming clay into long lengths of even thickness coils, then adding them on top of each other, attaching them by incising a line and adding slip. Most often, the coils are then smoothed out and it is impossible to tell that coils were used. Sometimes, especially with pottery, the coils are kept to add visually to the overall texture and form of the piece. When working with coil, allow the lower part to begin to partially dry as you move up the piece, but do it carefully in order to avoid drying cracks. This partial drying makes it possible to place more weight on the base of the work, and thus the work can be tall without collapsing. Allow plenty of drying time for the entire work in order to avoid cracks.

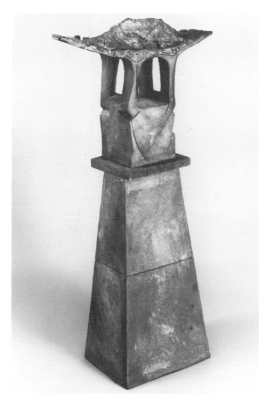

Susan H. Smith-Hunter, **Topographical.** *Ceramic, 4½" tall × 2' × 14". Photograph: Fred G. Hill.*

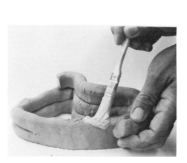

Coil method.

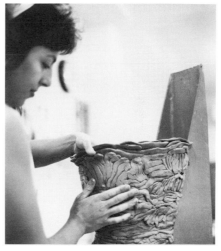

Coils can add to the texture of a piece.

Slab-rolling machine.

Slabs are joined by making incisions at the seam and covering them with slip.

Slab Method

The *slab* method involves pressing the clay into a flat slab to form the work. Use a hand roller or slab-rolling machine to secure an even thickness. The clay can be limp, though firm clay usually is preferred so that the shape will hold better. All the clay slabs should be of the same moisture content to avoid drying cracks. Cut, form and then place the slabs together with a thin coat of slip. Hide the seams by smoothing over or adding a texture to match the rest of the work. If a large work or broad expanse in a work is desired, an armature (support) is helpful. It should be made from combustible material that will give as the clay shrinks upon drying. Crumpled newspaper is ideal. The thickness of each slab piece should be uniform. As the work becomes leather-hard, fine details can be added.

Wheel-Thrown Method

The *wheel-thrown* method involves using a potter's wheel to secure a round shape or a pattern of "throwing ring" texture that the sculptor may want. A sculpture may be entirely wheel-thrown, but it is usually combined with other methods to achieve the final design. Since some prior wheel experience is necessary, this method is not often used by sculptors. Wheel-thrown clay is usually stoneware, and the forms can be quite delicate. Earthenware and porcelain are also used. Use caution when adding wheel-thrown clay to slab, since the wheel-thrown parts often contain more water than slab. Wheel-thrown parts sometimes need to dry slightly before being added to a slab.

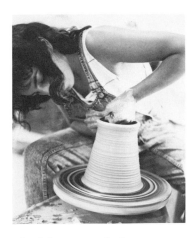

Wheel-thrown method.

Rosemary Taylor, Untitled. Clay.

Press Molding Method

The *press-molding* method is the process of pressing clay into a plaster mold to achieve a design. Plaster life masks often are used as molds. The end result is sometimes added to other parts to achieve the final design. The plaster mold must be clean and dry in order for it to absorb part of the moisture from the clay, thus allowing the clay to be released. Sometimes a very small amount of talc is dusted across the surface to aid in the clay release. Firmly press the clay against the plaster in an even thickness and let the clay partially dry before taking it out in order to avoid disfigurement when removing it from the mold. The mold should be free of undercuts so the clay will not tear. Most available clays will work for this method.

Removing pressed clay from plaster mold.

Betty Branch, Breakthrough. Ceramic, 10" × 10".

Slip-Casting Method

In the *slip-casting method*, liquid clay (slip) is poured into a dry plaster mold and allowed to firm up to a desired thickness of 3/16–3/8 inch. Then the balance of the liquid is poured out to leave the shell. The mold must be completely dry, bound together, and all possible outside leaks sealed with clay prior to pouring. It may take from 10 minutes to 1 hour to achieve the thickness, depending upon the slip, the mold and the size of the work. Large molds may have a drain plug in the lower part to facilitate pouring out the excess slip. When the pieces are removed from the mold, the work is trimmed and slowly allowed to dry. The clay used for slip casting is a special mixture that seldom contains grog.

Slip-mixing machine called a blunger.

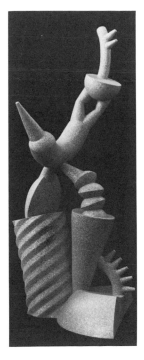

Large mold with a drain plug for draining excess slip.

Douglas Calisch, Architect's Fantasy #1, 1982. Slip-cast construction, 36" tall.

Finishing

Greenware is the term for dried clay prior to firing. Greenware has little strength and will not last if exposed to the elements. It could be coated with some form of protection, but it needs to be strengthened by firing.

Bisque firing is the first firing and should be started after the greenware is completely dry. Often an electric kiln is used, though gas kilns are also used, especially for large works. Sculpture work must be heat-soaked longer than pottery because of the greater thickness and, oftentimes, uneven thickness. After the correct temperature is reached, the clay needs to cool more slowly than typical pottery in order to avoid stress cracks. For terra-cotta that does not require a glaze, bisque firing is the only firing needed.

Vitrification is the process by which clay is fired at high temperatures. The clay becomes hard, compact and nonporous.

Underglazes are mixtures of clays, colorants, fluxes and so on that harden when fired. They are applied to the greenware prior to bisquing. They are often used by themselves with a clear glaze coating added in a later firing for a gloss finish. Underglazes are for hard-edged designs and do not flow like glazes. They can be applied by almost any method, but are often applied with a brush to achieve a brushstroke, or air-brushed to achieve a smooth, even finish. Staining and applying slips are considered to be underglazing.

Staining the clay for highlights can be done in the greenware stage, though it is preferable after the bisque firing. The most common stains are iron oxides for reds and browns, chrome oxides for green and cobalt oxides for blue. Stains offer dark highlights, complementing the clay body, though any underglaze or oxide may be used. Stains are usually mixed with water and applied very thinly by brushing, spraying

A commercially built electric kiln.

A gas-operated kiln built by Bob Howell.

or dipping. A dampened sponge can be used to highlight areas.

Colored slip added to the greenware produces good color results for sculpture. Take care to match the clay body with the proper slip to avoid cracking. Do not apply the slip too thickly, or it could flake off or crack. Colored slips can also be applied to bisque-fired clays.

Surface painting is sometimes chosen by the sculptor, but not generally preferred. Painting is usually done on a bisque-fired piece, though a piece taken to vitrification also can be painted. (See Doreen Barnhart's *Satire on Steel Workers* and Eugenia Yee's *Untitled*.) The paint should be permanent or sealed with a permanent coating.

A glaze is added to some works to add surface color or texture. A glaze is a mixture of ingredients applied in a liquid state to the clay body, usually after bisque firing. The glazed piece is fired in a kiln to harden and fuse the glaze to the clay surface, resulting in a glass-like coating.

Take care to match the clay body to the proper glaze for the correct firing temperature. Several glaze formulas are available to achieve a particular color and these require careful measuring and mixing. Often low-fire glazes are bought premixed to be fired at a certain temperature for a true color. Low-fire clays can reach the widest range of bright colors. High-fire glazes offer much room for experimentation, especially with earth tones. They, too, provide some bright colors but in a more limited range. Glazes can be brushed or sprayed on, or the work can be dipped. The piece must be dry before it is put in the glaze firing, which is done at a higher temperature than the bisque firing.

When glazing—applying the glaze to the clay body—be aware of the hazards of the chemicals being used. When spraying glaze, use a good respirator in a spray booth. It is a good idea to wear rubber gloves when touching the glazes not only for safety, but also to avoid stains.

Student work. Doreen Barnhart, Satire on Steel Workers. *Clay painted after firing, socks, goggles, 24" × 15". Instructor: Charles Lastrella.*

Student work. Eugenia Yee, Untitled. *Clay, painted after firing. 4" tall × 15" × 10". Instructor: Ginger Jackson Jones.*

Scales used to weigh glaze materials.

Pyrometric cones are small, slender pyramid-shaped cones designed to bend and melt at specific temperatures. They are numbered to indicate the temperature at which they will bend. As a rule, three cones are placed side-by-side, embedded in a small pod of clay. One indicates a low temperature, the middle one is for the correct temperature and the third is for a higher temperature (to guard against overfiring). As the kiln reaches the correct temperature, the cones will bend. The kiln operator watches the cones through a peephole in the kiln. The operator is alerted to be ready to turn off the kiln when the lower-temperature cone starts bending. When the middle cone bends and the tip reaches the pod, the correct temperature has been reached and the kiln is turned off.

Cone numbers begin at 022 (very low) and increase through 01 (moderate) to 42 (very high). Some common cones and their equivalent temperatures are 06 = 999°C, 4 = 1186°C, and 9 = 1280°C. The very highest temperature cones, beyond 14, are most often used in industry and not by artists.

Kiln is the term used for an oven (furnace) used to fire clay and glazes. It is very well insulated and is used under controlled conditions to arrive at exact temperatures. Many kiln sizes are available in both gas and electric models. Most low-fire glazes are now fired in electric kilns, while large works and high-fire glazes often rely on gas kilns.

Firing the kiln and formulating glazes takes practice and hands-on help from someone with experience. A textbook dealing with glazes and kilns should also be consulted. As already mentioned, good ventilation and respirators are necessary for many applications. Protect eyes with high-quality welding lenses when looking into a hot kiln. Because many kilns are gas-fired, a knowledgeable operator is necessary to ensure a good and safe firing.

Pyrometric cones after a correct firing.

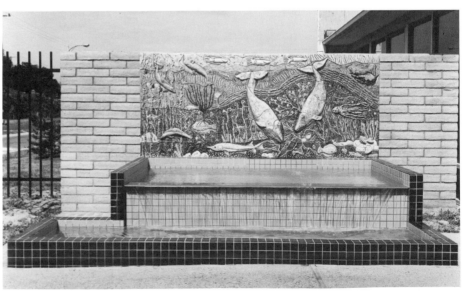

Maria Alquillar, Relief Mural. Clay, 4' × 10'. Water and Sewer Administration building, Sacto, California. The different glazes offer a variety to the design.

Demonstrations

Sculptor Barry Coffin uses the slab method to create one of his stoneware sculptures. He begins by rolling out the stoneware into thin slabs and attaching them together to form a hollow cylindrical body. Working inside, he attaches a carved hand to the form through a slot into the cylinder. Using small tools to finish the details, he completes the face and attaches it to the body by pressing more clay to both parts in the form of hair. Using a coil of clay, he completes the clothing by setting it into place and then pressing it into shape. The sculptor is pictured with his work prior to firing.

Thin slabs are joined together to form a cylinder. Photograph: John Charlton.

A carved hand is attached to the cylindrical form. Photograph: John Charlton.

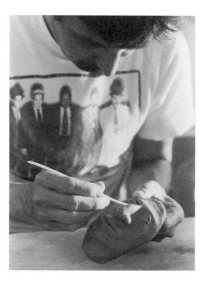

Details are carved in the face. Photograph: John Charlton.

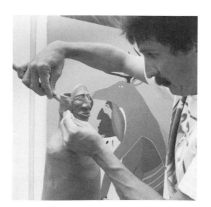

The face is attached to the form. Photograph: John Charlton.

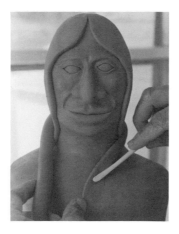

A coil of clay is pressed into shape to form clothing. Photograph: John Charlton.

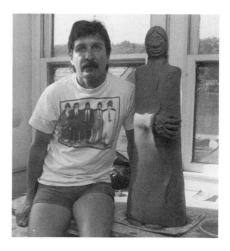

Barry Coffin with sculpture ready to fire. Photograph: John Charlton.

Sculptor Norman Holen uses a clay body with a large amount of manganese dioxide added to create a surface with a variety of dark specks in it. The hotter he fires the work, the more the specks show up. (CAUTION: *Large amounts of colorants added to clays can give off toxic fumes when being fired.*)

He uses the coil method; each coil is about 3/4 inch thick. He presses the coils together tightly, beginning with the base and moving on up the piece. He likes using this because of the flexibility of shape it allows him. Notice that he allows connected air holes throughout his work. As he finishes his sculpture, the surface is refined with details made possible by the use of the thick coils. The final work is illustrated.

The base is formed by coils pressed together very tightly.

Air passages are left throughout the work.

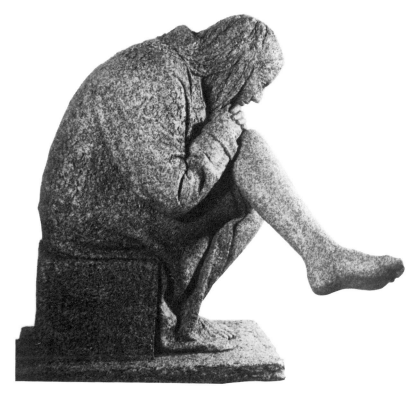

Details are added to the thick clay.

Norman Holen, Adolescent No. 2. Terra-cotta, 17¼″ × 11¼″ × 17½″.

Sculptor Susan H. Smith-Hunter uses the slab method with a newspaper armature (support) to create a six-section maquette (smaller sculpture in preparation for a larger one). She builds the section's walls with a uniformly thick slab (approximately 3/8" thick). Though she often uses her fingers, she adds slip with a wood tool over all the edges, and stuffs the inner part with loose newspapers to support the top. Once the top is added, she trims it, and carefully paddles the points for a tight fit and to achieve her desired shape. When nearly finished, she uses clay stamps to create special textures. Some of the areas are smoothed with a pot-ter's rubber kidney before allowing the maquette to dry. She airbrushes the surface with terra sigillata and fires the clay. To finalize the work, she mounts the work on a wood backing and grouts the six individual sections together. She inserts birch dowels into carefully chosen maple twigs and then places the finished wood into the sculpture for the final design. The final sculpture is illustrated.

Slip is added to all edges. Photograph: Jeff Hatch.

Crumpled newspaper is used as an armature to support the top slab. Phtotograph: Jeff Hatch.

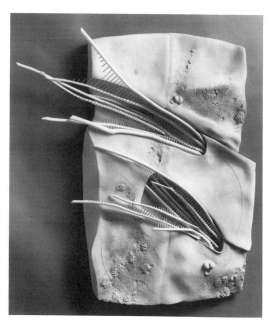

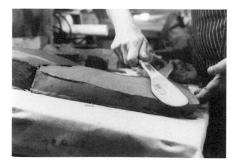

After the top is trimmed, the joints are paddled. Photograph: Jeff Hatch.

Clay stamps are used to create texture. Photograph: Jeff Hatch.

Susan H. Smith-Hunter, Windform, half-size maquette. Clay, wood, air-brushed terra sigillata, low-sodium-fired, air-brushed casein, 22" × 36". Photograph: Fred G. Hill.

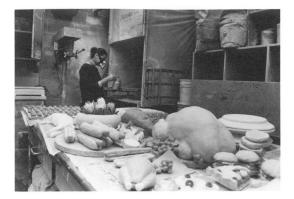

Glaze is sprayed on the ceramic food. Photograph: Arthur Okazaki.

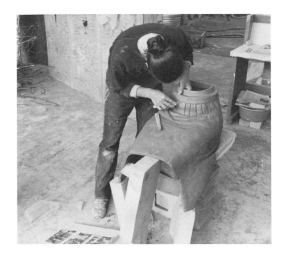

Each figure part is carefully supported with pieces of foam. Photograph: Arthur Okazaki.

Sculptor Marilyn Lysohir demonstates a work made by using a coil-slab-thrown combination with carved details and colored glazes.

She begins by building the 6-foot long clay table top using twenty-four sections. She handbuilds all of the foods, flowers and silverware, and uses a potter's wheel to throw the dishes and candlesticks. These items are all sprayed with underglaze, bisqued and refired with a clear glaze in an electric kiln.

The clothed figures are built with coils and slabs in two parts, the jackets or blouses as one part and the pants or skirts as the other. The parts fit together snugly in the final arrangement. She carefully props up each part as it is worked on. The details are carved into the surface when the clay is leather-hard. When dry, the clothing and tablecloth are stained with a terra sigillata (slip she designed especially for burnishing). These works are then fired in a gas kiln.

To finish the work, she designs a wooden table and chairs to support the figures and table setting. (The final sculpture also appears in color in the Color Gallery.)

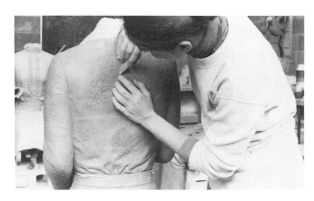

Details are carved when the piece is leather-hard. Photograph: Arthur Okazaki.

The parts are burnished with colored slips. Photograph: Arthur Okazaki.

Marilyn Lysohir, Bad Manners, *1983. Clay, wood, 4'2" × 10'4" × 7'. Collection of Mr. and Mrs. Louis Taubman. Photograph: James Reinke.*

Sculptor Bob Howell uses the slip-casting technique to finish one of his sculptures.

He begins by mixing his slip body with a long paint-stirring paddle attached to a drill. Once the mixture has aged and is in good suspension, he fills his dry mold. The mixture sets until he gets the shell thickness he wants. The setting time varies, depending upon the size of the piece and the thickness. This one is about 3/16 inch thick. After the proper thickness is achieved, he pours out the remainder of the slip and lets the clay dry to a nearly leather-hard stage. At this point, he removes the clay casting, trims the joint, and refines the surface. He adds holes, as in a bowling ball, and allows the work to dry completely.

Slip is poured in the dry mold.

After the bisque firing, he draws the design on the ball with a graphite pencil. He covers the design with a semi-transparent masking tape and carefully cuts around the design with an X-acto knife. Using commercial underglaze, he airbrushes the entire surface, then slowly removes the tape to expose the design surrounded by underglaze. The piece is placed into the kiln on supports made of clay and Nichrome wire and fired. He completes his work by airbrushing it with a clear gloss glaze and firing it again. The piece is now finished and ready to display with the other parts of his work prepared in a similar manner.

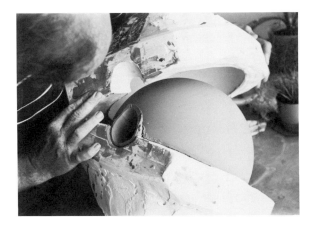

The casting is removed when nearly leather-hard.

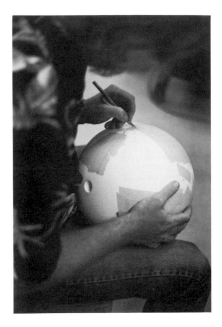

The design is masked for underglazing.

The underglaze is applied with an airbrush.

The mask is removed to reveal the design surrounded by underglazing.

The work is supported in the kiln by stilts of Nichrome wire embedded in clay.

Bob Howell, Games of Chance. *Slip-cast clay, sphere 12″ diameter, missiles 24″ tall.*

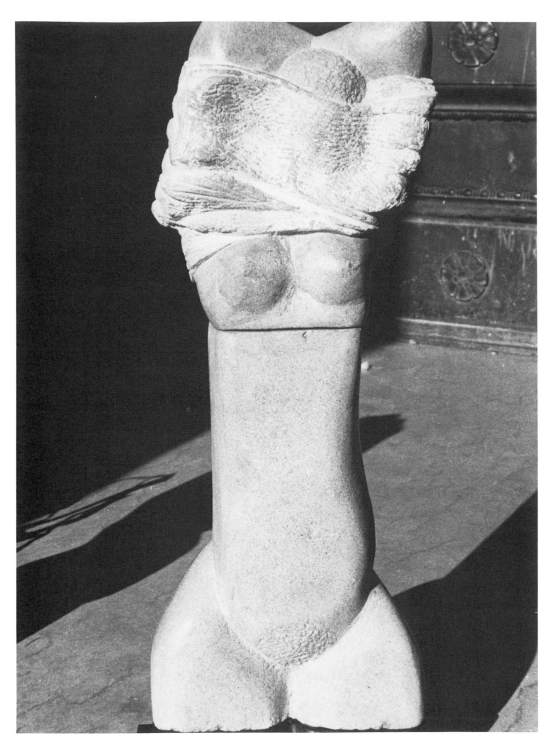

Harris Sorrelle, Figure with Arms Overhead, *1974. Limestone, 30″ tall, Private collection.*

6

STONE

- Stones for Sculpture
- Carving with Hand Tools
- Carving with Power Tools
- Pneumatic Tools

Stonework is the oldest form of sculpture; a wide variety of rock has always been available. Even when we did not carve it, we often positioned it in formations like Stonehenge in England. Stone ranges from soft to extremely hard, from white to black with most colors in between, and from a pure simple color to a multitude of colors and textures within the same stone.

Stone is divided into three categories: sedimentary, metamorphic and igneous. Sedimentary rocks were formed from great pressure on layers of sediment such as sand and shell, and the resulting stone is usually porous. Limestone and sandstone can range from soft to quite hard depending upon the density of the stone. Metamorphic rocks are sedimentary rocks that have been transformed by tremendous heat and pressure into more compact crystalline structures. Some metamorphic rocks are steatite, alabaster, slate, serpentine, onyx, travertine and marble. All of these are considered soft, though in varying degrees. Igneous rock is formed by volcanic activity. Molten magma cools and solidifies into the hardest rock available, which includes granite and basalt.

Stones for Sculpture

The stones described in the following text are listed according to hardness. The soft, easier ones to carve are listed first.

Steatite, often called soapstone because of its slippery talc content, carves easily and can be layered, depending upon the stone. The colors are usually in the grey or green range, though many other colors are available.

Old quarry wall with layer marks from previously quarried marble. Photograph: Enzo Torcoletti.

The softest varieties of this stone can be carved with a pocket knife.

Alabaster is a preferred carving stone primarily because of its beautiful colors. Depending on where the stone originates, it can be translucent or opaque white, pink, green orange or brown; it can be in a pure value or multi-layered and is often veined. In some areas, the stone is found on hillsides near roadways. The rapid carving is often predictable in the most pure values or difficult in the layered stones because the layers often separate. The veined stones also have a tendency to separate at the vein. The finish can be very fine. In fact, alabaster often is mistaken for marble.

Limestone is usually in buff or grey colors, though the color can range from white to faded blueblack. Its best carving quality is its predictability because of seemingly little grain to the stone. The stone can be quite hard, but it is usually moderately soft and available in large layers. However, there are strata limitations, depending upon the region of the quarry. Since most limestone is

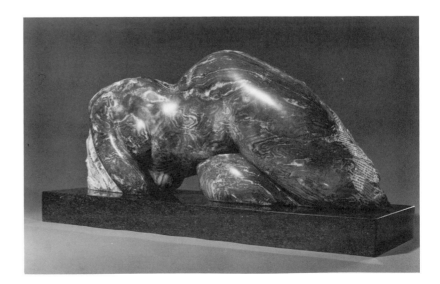

Betty Branch, Mountain Woman. Tigereye alabaster, 22″ long. Photograph: Richard Braaten.

Leonora Arye, Bicicleta. *Polychromed limestone, 17" × 7" × 10".*

Jack Arvin, New Moon. *Alabaster, 14" × 12" × 9". Collection of Richard Lummis. Photograph: Carrington Weems.*

rather porous, the finishes are not reflective. Some limestones have shell fossils throughout that lend to the beauty. Many old building blocks are limestone and make excellent carving materials.

Sandstone is an unusual stone to carve. It tends to follow the strata patterns, often breaking into large pieces. Though good sandstone is moderately difficult to carve, it is quite easy to wet sand to a non-reflective finish. The granular structure of sandstone wears out tools at a rapid pace, even though the stone may disintegrate like dried dirt clods. The colors vary with the region, but are often a red, buff or rust. Sandstone contains a large amount of free silica and should never be carved without a respirator.

Elaine Calzolari, Tundra Walker V, *1983. Sandstone, 8' × 4' × 1½'.*

Serpentine is recognized by its veining and by its beautiful green colors (though the range of colors may include yellow, ochre and black). The carving of the stone can be treacherous, because it often splits along the veining, but just as often does not. It is almost impossible to establish a direction to carve. Carving must be done slowly and with very sharp tools. Serpentine is a difficult stone to carve without power tools. Since serpentine often contains an asbestos contaminant, it is imperative to follow proper carving precautions.

Marble is the most preferred carving stone because of its favorable carving characteristics, its inherent strength, the colors available and the fine finishes that can be obtained. The crystalline structure is reflective and can result in a highly polished piece that sparkles.

Carving is relatively slow, as compared to alabaster, but much more predictable. Finishes are permanent and scuff resistant. The range of colors seems unlimited with nearly three hundred varieties available in the United States. There are marble quarries in Vermont, Alabama, Georgia, Mississippi and Tennessee. Perhaps the best known marble in the world is Italian Carrara marble, which Michelangelo used.

Granite is the hardest stone and the most difficult to carve, but it is the most impervious to weather. Carving tools need to be carbide-tipped, and the sculptor needs much patience and time

Mel Fowler, Die Lorelei II, 1981. Vermont white marble, 3' 6". Collection of Mr. and Mrs. Tim Wright. This sculpture demonstrates an intricate carving; so intricate and lightweight that it is a free-turning hanging sculpture.

Charles Umlauf, Torso, 1979. Portuguese rose marble, highly polished, 30" × 22" × 10". Collection of Jack G. Taylor. Photograph: Mears.

Jesùs Bautista Moroles, Granite Sun, 1984. Texas granite, 18' × 15' × 15'. Old Jail Art Center, Albany, Texas.

Precautions and Guidelines

A health hazard warning has been given with only the most dangerous carving stones listed. However, the carver should always wear a respirator when carving any stone. Good ventilation is a must. Goggles or a face mask are also mandatory. If power tools are to be used, gloves are necessary to protect the hands and ear protectors are necessary to muffle the noise of the power tools.

A sculptor often can find many carving stones locally. Consult state geological departments or the U.S. Geological Survey in Washington, DC, to aid in locating the nearest source of stone. Also, most sculpture supply dealers have a large variety of carving stones in different sizes, shapes and colors and can cut them to order, if desired.

since the particles removed are always very small. Granite is sometimes carved with special thermal torches used to spall the stone in small flakes, which are washed away by a stream of water. The equipment necessary is expensive and is best for large works. The ranges of colors are tremendous; they can vary from white to pure black with reds, blues, greys and many other colors as well. Vermont, Maine, California, Minnesota and Texas are among the many locations for granite in the United States. Granite contains a volume of free silica that can cause serious lung problems so the carver must be properly prepared.

Always wear protective gear when working with stone. Safety goggles usually are adequate, but a safety mask is better for the person with eyeglasses. Gloves help protect hands and a respirator is necessary protection against harmful dust. Ear protectors are essential when working with power tools.

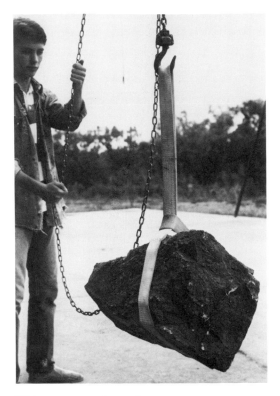

Lifting a stone using nylon straps.

metal. Whatever is used, the smaller stone needs to rest on a sturdy, shock-absorbing surface. Small bags filled two-thirds full of sand are ideal. The bags can be bank money bags or old denim jean pant legs partially filled with sand and then tied at both ends. Some tables are designed with an outer wall to hold a heavy layer of sand in which to set the stone.

Lifting and moving heavy stone can be a problem if there is not adequate help. They can be lifted a corner at a time with a prize bar and placed on steelpipes to be rolled to a new location. A hoist makes handling much easier. Stone can be strapped in with chains, or, even more easily, with nylon straps. These straps can carry tremendous weight and conform to an irregular shape.

Carving with Hand Tools

A small assortment of tools is necessary for stone carving. Then a stone must be selected. The choice of a stone is crucial if the sculptor has a predetermined idea of the shape, texture or color of the final carving.

The stone in this carving demonstration resembled the general shape of the small model prepared by the sculptor. It had a flat bottom that was easily leveled for the base. A drawing of the proposed shape was placed on the stone. A beginner should redraw and redefine shapes regularly.

The alabaster chosen for this demonstration was known to have veining, so the sculptor chose not to try to remove large portions too rapidly due to the irregular placement of the veins, since the carving fragments often follow

A novice carver should select a stone no heavier than can be carried with some ease. (This guideline will also limit the new sculptor to a reasonable beginning project.) A low carving table is preferred since the carving hammers pose a repeated lifting weight. The combined height of the table and the stone should allow the sculptor to raise just the lower arms and hands when using the hammers. The carving process is easier and the sculptor can work for a longer period of time at any one sitting if he or she does not have to work with elbows raised. The table can be anything from a metal drum full of sand to a regular table that has been shortened or a special table made from wood or

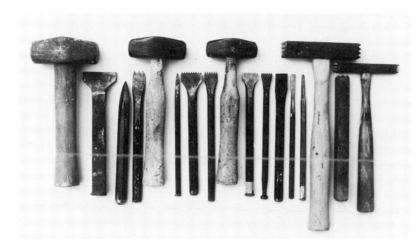

Hand tools for stone carving: left to right; heavy 2½-lb. hammer, bull set, large point, large-tooth chisel, 1½ lb. hammer, small point, wide-tooth chisel, narrow-tooth chisel, 1-lb. hammer, wide flat-tooth chisel, narrow flat-tooth chisel, wide flat chisel, narrow flat chisel, detail chisel, large bush hammer, bush chisel, small bush hammer.

Beginning sculptor's grip on hammer and point. Notice that the thumb is wrapped around the point to avoid a painful stroke if the hammer misses.

Small clay model of sculptor's idea for the finished shape.

A detail of the point and the surface it leaves.

A large point is used to remove large pieces of stone. Notice the sketch of the proposed shape on the stone.

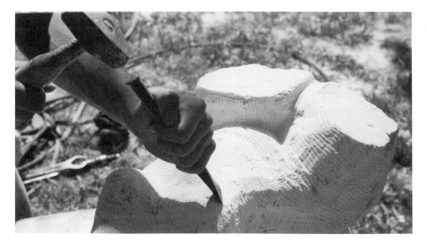

Detail of the flat-tooth chisel and the surface it leaves.

Small flat chisel for detail work.

The sculptor refines the basic design using a wide-tooth chisel.

the veining direction. Great care was taken to choose a direction to carve.

The first tool used is the large point to remove large pieces of stone carefully. Next, the small point is used to define the shape. The point should always be at nearly a 45° degree angle to the surface. Take care not to aim the tool directly in the stone or internal bruising will occur, which could cause the stone to break at a later date or create a light blemish on the final surface due to the compression of the stone. It is preferable for a beginner to carve on all sides of the stone instead of staying in one location and moving down. It is also important to use a hammer that you can control. Heavy tools obtain faster results, if the sculptor is in control and not easily tired by the tool, but it is better to use a lighter hammer than to be overpowered by the weight of the tool. An often-preferred hammer for beginners and soft stones is a 1½ pound soft iron hammer.

Once the shape is well defined, a claw (tooth) chisel is used. A wide tool is preferred; narrow tools are used for tight spots or details. Ordinarily, if the carver is experienced, the tooth marks will follow the form creating a basic design of the shapes.

Next, flat-tooth chisels are used to remove the furrows created by the claw chisel. The tools are held at only a slight angle to the surface. Finally, the flat chisels are used to remove the flat-tooth chisel marks. Larger chisels are for the broad spaces and the smaller ones are for details. Sometimes the sculptor prefers to carve with a chisel without the use of a mallet. The surface is now ready to be rasped.

A good assortment of rasps and files are available to work toward the finish. The more coarse rasps are used first, followed by the smoother files. Riffler

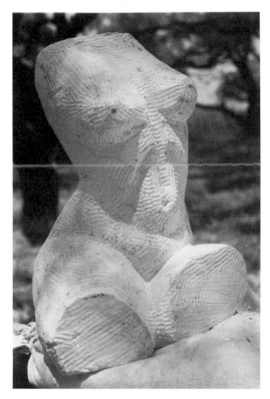

The surface is ready for the flat-toothed chisel.

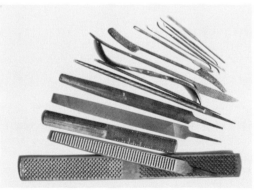

Rasps and files.

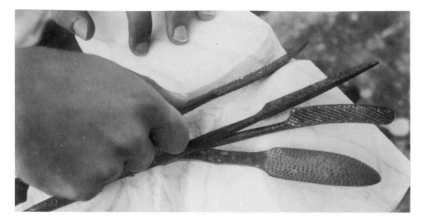

Riffler rasps and files for use in difficult areas.

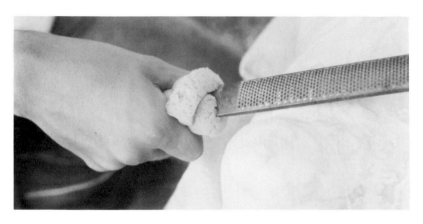

The sponge wrapped about the flat combination file/rasp helps to protect the sculptor's hand.

rasps and files are designed for hard-to-get-at locations and small details. Since so many files and rasps (especially flat combination rasps and files) do not have handles, it is much better to wrap one end with a sponge to protect the sculptor's hands. Without the sponge, even gloves will tear.

The sculpture is ready to be hand-sanded once the surface has been smoothed. The best type of sandpaper available for this purpose is the wet-or-dry type readily available in auto parts stores and hardware stores. The grits range from 40 to 1000, though the most common ones used range from 60 to 600.

It is best to begin with 60-grit on alabaster. Spending ample time to eliminate bruises, pores, scratches and other marks that are not a part of the design. Do not change to a finer grit of sandpaper until the surface is properly shaped or smooth. I prefer to dry-sand the stone with 60, 80, 100 and 150 and then wet-sand with 220-grit. Use a sponge to keep water on the stone and to keep the sandpaper constantly wet. The water lubricates the sanding, prolonging the life of the sandpaper and eliminating dust in the air. Use fresh clean water each time you change grits in order to prevent scratching the stone with some grit remaining from the previous sandpaper. After 220-grit use 320, 400 and then 600. Final polishing can be done with tin oxide, though it is not necessary on alabaster.

After sanding and polishing, the stone is washed and dried. It can then be sealed with a good tile sealer if desired. Be careful not to allow the sealer to dry before wiping it down. Finally, the carving is waxed with a good quality, non-colored wax. Tree Wax products, their tile sealers and clear paste waxes are superior products for these purposes. This stone was a surprise to me because the veining was much more pronounced than originally believed. Notice the progression from the original stone to the chiseled stone to the final stone. The veining became more apparent when wet-sanding began.

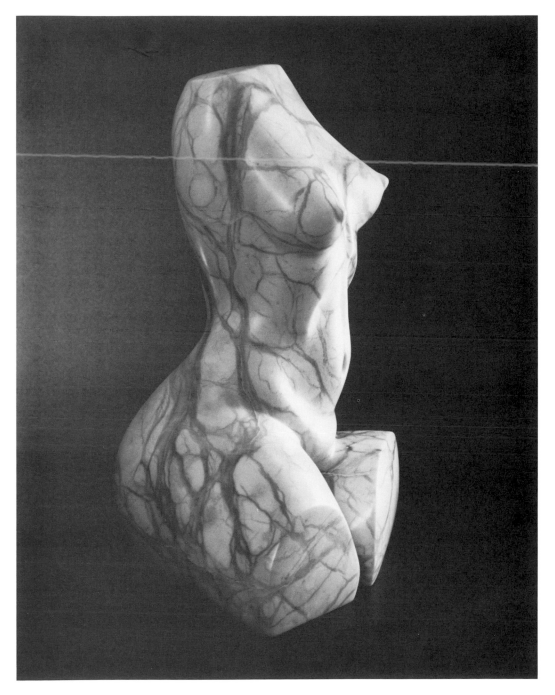

Arthur Williams, Seated Figure. *Utah alabaster,*
*16″ × 11″ × 10″. **This stone is the final product***
of the carving demonstration.

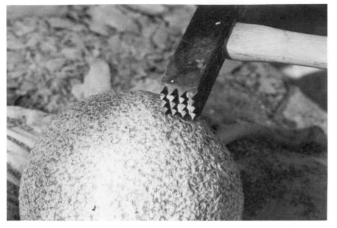

Bush hammers are used for rounding.

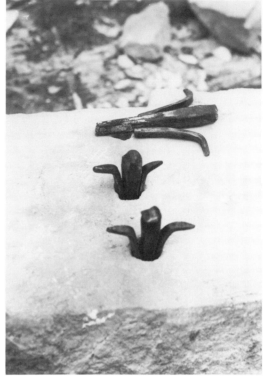

Feathers and wedges are used for controlled breakage.

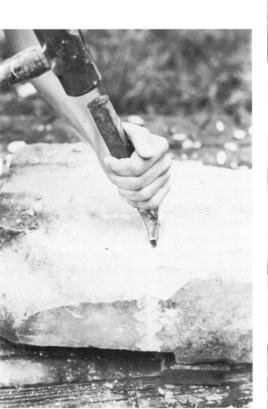

A bull set is used to break off large pieces and to break a stone along a previously chiseled line.

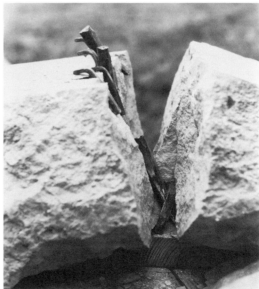

The wedges are struck until the stone breaks.

Bush hammers are used for rounding works, especially when working with veined stones and when crossing the end-grain. Also, they are good for adding texture to the final work. The finer bush hammers, called frosting hammers, have a very fine tooth.

A pitching tool, often known as bull set, is used to break off large pieces of stone. It often takes more than one blow, but the result is a controlled breakage. This tool is used only in the earliest stages of carving. It can also be used for breaking a stone along a chiseled line by repeatedly hitting it up and down the scribed line. In order to speed the breakage, a thin board is often placed under the area to be broken to create additional tension for the break.

Feathers and wedges are used on harder stones where a controlled break

of major size is needed. Holes are drilled in a line, deep enough for the feathers to be inserted, then the wedges (sometimes called plugs) are inserted. Again, a board placed under the area to be broken can facilitate the process. The wedges are repeatedly struck in order until the stone breaks.

Sculptor Kay Hofmann approaches stone carving similarly to the previous demonstration, but without a model; and, instead of carving all over the stone, she begins from the top. Her work, *Cool Breeze,* is in alabaster, 40 inches tall and weighed 850 pounds before she began. She did not use a model, but made a few drawings to get an idea of what she wanted. The block was left on the ground to make it easier to reach and carve, because the sculptor is 5 feet, 2 inches tall. She began with a

An 850-lb. block of alabaster.

The work is kept in a near-finished state.

A wide-tooth chisel is used to rough out work.

wide-tooth chisel instead of a point to rough out the work, which is a common practice when carving softer stones such as alabaster. She kept the surface in a near-finished state as she carved down the stone. (Beginners should carve all over the stone to allow more room for error in their earlier carvings.) The stone was moved onto a stand when it was almost completely roughed out. Her contrasting textures made the stone appear to be of different colors.

As was done in the first demonstration, she constantly drew on the stone as it was being carved. The most unusual aspect of her work is that she carved a stone of this size entirely by hand with no power tools, not even to polish the work.

The work is moved onto a stand.

Contrasting textures create the appearance of different colors on the stone.

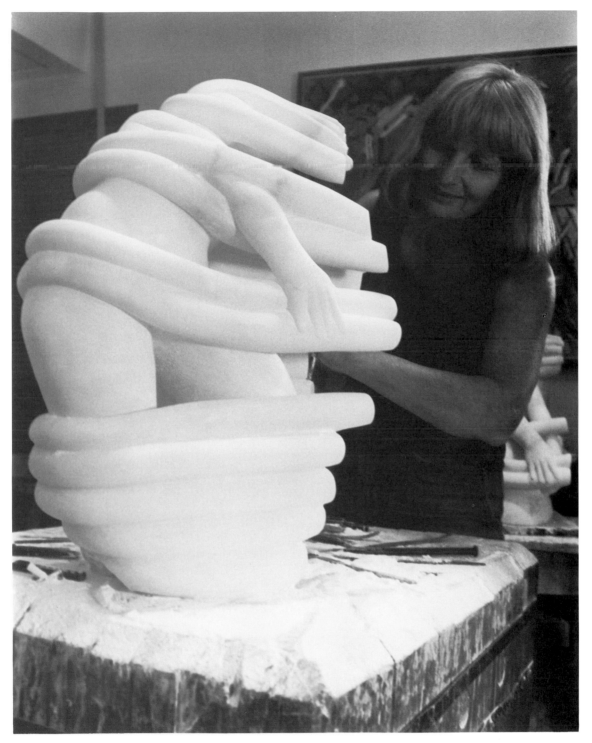

Kay Hoffman, Feeling Free. *Italian alabaster, 26" tall.*

Electric die grinders that can be used for stone carving.

Sculptor Jane B. Armstrong uses small electric sander-grinder to smooth out her carving.

Carving with Power Tools

Power tools offer another approach to carving once the sculptor has mastered basic carving techniques. Power tools, especially air tools, can speed up the carving process from two to ten times, depending upon the sculptor, tools, design and stone. Though softer stones are easily carved by hand, carving harder stones is greatly aided by power tools. On small sculptures, the finish or small details still must be done by hand. Larger pieces may never need any kind of hand work.

Electric tools are sometimes used for stone carving, depending upon the situation. Electic grinders are used to help the finishing process, but they are heavy and run hot as compared to air tools. Large and small grinders are used for sanding but they also are heavy and run hot. The electric sanding tools listed in Chapter 7 for wood carving can also be used for stone carving. However, when possible, air tools are preferred since they operate better in a carving environment. They last longer and do not burn out because they do not have a motor.

When using power tools, eye protection, heavy-duty respirators, gloves and ear protectors are mandatory.

The following discussion demonstrates how to carve with power tools. The chosen stone is alabaster with a pronounced grain. The stone weighs 225 pounds. No model or drawing is used. This is very direct carving.

I begin the work with a dry-cut diamond saw blade mounted on a large electric grinder with a flush-cut blade, to make deep cuts. I prefer to work on all sides of the stone, breaking off the top cuts and then continuing on down the stone. It takes little time to cut the alabaster. If more intricate cutting

A 225-lb. block of alabaster.

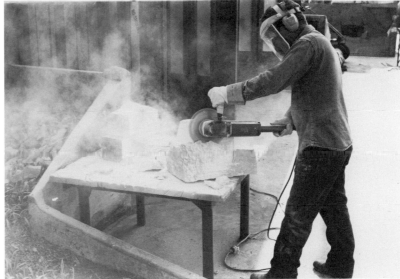

A diamond saw blade is used to make deep cuts on all sides of the stone. Notice that the stone is sitting on sandbags.

needs to be done, much smaller diamond saw blades can be used.

Once the stone is trimmed with the saw, a handpiece (air hammer) will be used for the actual carving. Air hammers are noisy, they often run hot, and the constant vibration may cause temporary damage to the circulation in the hand. In fact, long continuous use can cause permanent damage. However, used properly, they are a good tool to use to carve extremely fast and accurately. They are especially useful for stones that cannot withstand the heavier blows of the handheld hammer.

Using a 1-inch handpiece (air hammer), I continue carving on the outer parts with a large-tooth chisel. The sculpture requires much stone to be removed from both sides of the midsection and the preliminary work is easily accomplished with a handpiece. After much of the inside is removed, I redefine the outside shape.

A very large tooth chisel is used for the broad plane of the work. Almost all of the outside roughing is done prior to opening the inside. I drill several holes through the center with an air drill and a large cement bit. Continuing with a

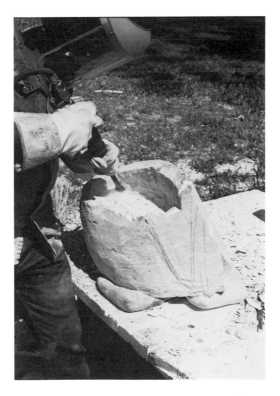

A handpiece and large-tooth chisel are used first.

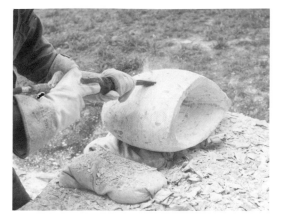

A very large tooth chisel is used to refine the shape.

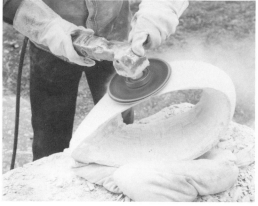

Smoothing the outside surface with a sanding disk.

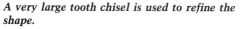

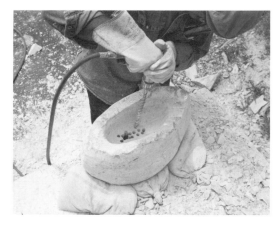

Holes are drilled through the center of the stone opposite the opening.

Smoothing the inside surface with a coarse stone grinder.

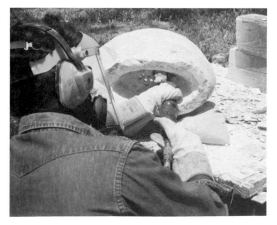

The stone between the holes is chiseled out to open the pieces.

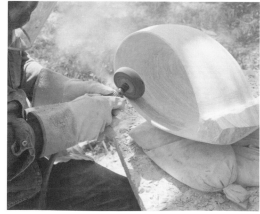

Smoothing the inside surface with a flap wheel. The outside has already been sanded.

1-inch air hammer, the inner structure is removed cautiously by removing the parts between the holes.

When the stone has been chiseled out, the outside is again refined. Then, though not shown, a 3/4 inch air hammer is used to finish roughing the inside. I use several sizes of air hammers, so I can use the largest hammer possible, then switch to a smaller one as needed. (If a student can afford only one, a 3/4 inch air hammer is used to finish roughing the inside. By installing a pressure regulator in the air hose a few feet from the hammer, the student can control the air output to allow delicate carving when necessary.) A 7-inch air grinder with a 16-grit disk is used to clean the surface. Seldom are chisels, except the tooth chisel, used in air hammers. This is the only air chisel that I used for this sculpture. An air die grinder with a rough stone bit is used next. The one pictured is a large 3/8-inch-shaft tool.

Finally, an air grinder with a 4-inch, 60-grit flap wheel is used to help clean the inside. The end of the work is left unfinished; I will remove it later. Prior to this step the outer surface was sanded with a 5-inch air sander and an 80-grit disk (not pictured).

The diamond saw blade is used again to completely open the carving. Extreme caution is exercised during this procedure. (Notice the body bracing for the tool to ensure steadiness.) The cut is finished with the section cut off still pictured.

An orbital sander with a 5-inch, 80-grit disk is used on the outer surface (not shown) to complete the work done with power tools. The piece is now ready to hand-sand.

Works often require more intricate carving than illustrated in the previous demonstration. When necessary, high-

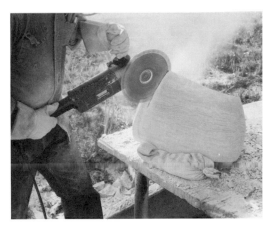

The carving is opened with a diamond saw blade.

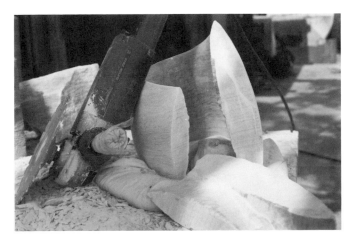

The cut is completed and the sculpture is ready to be sanded by hand.

Arthur Williams, Mother and Child. Alabaster, 13″ × 16″ × 12″. The final carving has another stone added for design.

This photo of the author after using the grinder illustrates why safety glasses, ear protectors and a respirator are needed. Photograph: Larry Sanders.

speed rotary files and rasps are used for these details. Though good quality steel tools (found at hardware stores) will work on softer stones, carbide-tipped tools will remain sharper and last much longer. Only carbide-tipped tools will work on harder stones.

Cutting large stones to a carvable size can be done in many ways. Quarries use large drills to remove heavy slabs. Later the slabs are more closely shaped by cutting with a diamond wire saw blade. Quarries can be requested to use this saw to cut to the sculptor's specifications. Sculptors working with very large stone often have their own equipment, such as this 40-inch diamond saw blade being used in Jesús Moroles' studio. Moroles often leaves his saw marks as part of the design. (See *Granite Sun*, pictured earlier in this chapter.) Since most sculptors work with smaller stones, a small 4-inch diamond blade is usually used.

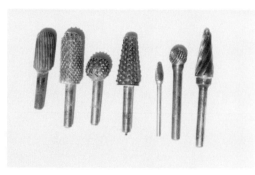

Rotary files and rasps: from left to right, the first four tools are regular steel in common shapes, the last three have carbide tips.

A rock drill, drilling a specific thickness of marble slab. Photograph: Enzo Torcoletti

Diamond wire saw blade in operation. Photograph: Enzo Torcoletti.

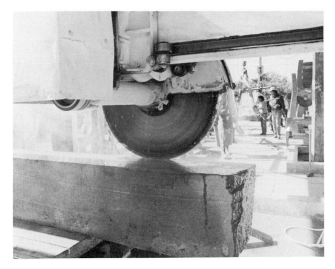

This 40″ diamond wheel blade is one of three large saws operating in the Jesús Bautista Moroles sculpture studio.

A 4″ diamond saw blade.

Tool Maintenance

Stone carving tools require occasional sharpening which can be done on an upright electric grinder. Always use eye protection when using a grinder. Take care not to dig the tool into the wheel. A tool rest, like the one pictured, helps maintain a steady angle with the tool. A water container should be kept close to the grinding wheel. In order not to lose the temper (heat-treated edge), the tip and end of the tool must be submerged in water after every two seconds of grinding. This takes time, but the hard edge will remain. The non-working end of tools also requires attention. When the end of a tool has been constantly hit, a "mushroom" end occurs. This needs to be ground off in the same manner as sharpening the tool. If the sharp flared out ends are not removed, they can cut the hand or be dangerously glanced off.

The tip has broken off this point so it is being sharpened.

Mushroom ends must be ground off to prevent injury.

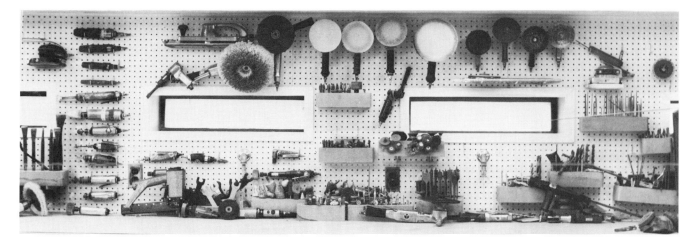

Some of my air tools. All of them have quick-release valves for rapid tool changing. The manufacturers recommend a short leader hose attached to the tool with quick-release coupling on the end. It might save on some worn threads in air tools; however I use and store so many air tools that such short lines prove to be impractical. Also, some sculptors prefer a pressure-control valve mounted on the air line just a short distance from the tool. These are especially useful for personal air regulation if several workers are on the same line. Notice the handy air line ends just beneath the windows. Since this studio was custom-designed, air lines are located every 4 feet in order to avoid long lines or a drop in pressure.

Pneumatic Tools

Pneumatic air-powered tools are the preferred tools for sculptors. They have several advantages over electric tools. They operate cooler, are lighter in weight, do not have an electrical risk factor and seldom need servicing, even after years of use. It is probable that they also are less expensive to operate.

The basis for air-powered tools is the air compressor. There is no perfect size for everyone, but the most useful size for a classroom is a 10 horsepower (HP) electrical compressor or larger. The 10 HP usually offers 37 cubic feet of air per 90 pounds pressure per square inch (psi). For an individual, a 7.5 HP or larger compressor is necessary to operate all of the tools available without a strain. A 7.5 HP electrical compressor delivers 29 cubic feet of air at 90 psi. Often sculptors choose a 5 HP electrical compressor to use with electrical hookups already at the site. These will work most tools, but will not operate some larger air grinders. The

A 5 HP air compressor. Courtesy of TESCO Equipment Co., Abilene, Texas.

Water trap and pressure regulator.

Tool changing is easy with a quick release coupler.

A ¾ " pneumatic handpiece.

A 1" pneumatic hand-piece. Above and right, courtesy Trow and Holden Co.

tank size of the compressor is also important. When possible the larger tanks should be obtained because they allow the compressor more cooling time between operating cycles. (Before selecting a compressor, take note of the available electrical wiring and the installation costs for the location of the compressor.)

Between the tank and the hose is a water trap and pressure regulator. The water trap catches moisture while the regulator allows the sculptor to set the proper air speed for the tools. The most commonly used speed is 90 psi.

Gasoline compressors of the same horsepower do not provide the same air pressure as electrical compressors. For example, a 10 HP gas compressor delivers about 18 cubic feet of air at 90 psi. A 10 HP electrical compressor gives double the air delivery.

Tools are coupled to the compressor by air lines with 3/8 inch inner diameter hoses or larger. On the end of the hose is a quick-release coupler that is

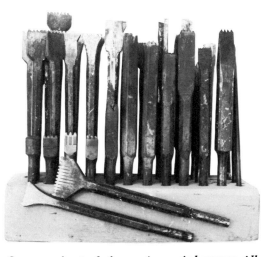

Some carving tools for use in an air hammer. All have ½" shanks to use in 1", ¾" or ½" hammers. The shorter tools on the left are carbide-tipped bush heads, used much the same way as a hand bush hammer.

designed to fit the smaller ends placed on the air tools. This arrangement provides a very easy method of changing tools and retaining the air supply.

Pneumatic air hammers (handpieces) come in several sizes, and are catagorized by the size of their pistons.

The most common size handpieces are 1-inch, 3/4-inch and 1/2-inch. The 1-inch is generally used for larger stones or for rough work. Some more experienced carvers cut down the air supply and use the tool for fine work. It weighs about 3 1/4 pounds, uses 1/2 inch shank tools and uses 6 cubic feet of air at 90 psi. It is about 8 inches in length. The 3/4 inch is a more common size for beginners and is usually the one found in the classroom. It uses 1/2 inch shank tools, weighs about 2 pounds and uses only 4 cubic feet of air at 90 psi. It is about 7 inches long. The 1/2-inch is for fine work, though it still uses 1/2-inch shank tools. At a mere 1 1/4 pounds, it requires only 3 cubic feet per 90 psi and is only 6 inches long.

Sculptor Enzo Torcoletti carved an 18-inch model from styrofoam and painted it black to resemble his idea for a finished work. He went directly to a Tennessee quarry to select the marble he wanted for his sculpture. At the quarry, a diamond wire blade was used to cut the marble to shape as described earlier. The smooth sides of the stone he is roughing out were made by the diamond wire. Notice that the work area is at a good height for carving. The sculptor leaves clay chisel marks on the final work as part of the overall texture.

The styrofoam model is painted black to resemble the finished marble color. Photograph: Enzo Torcoletti.

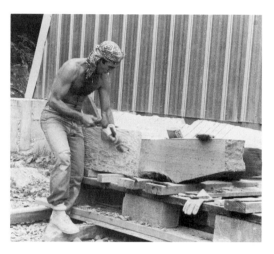

The sculptor roughs out the piece of marble. Photograph: Enzo Torcoletti.

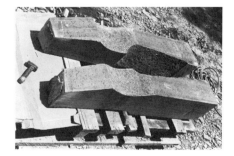

The work is nearly complete. Chisel marks are left as texture. Photograph: Enzo Torcoletti.

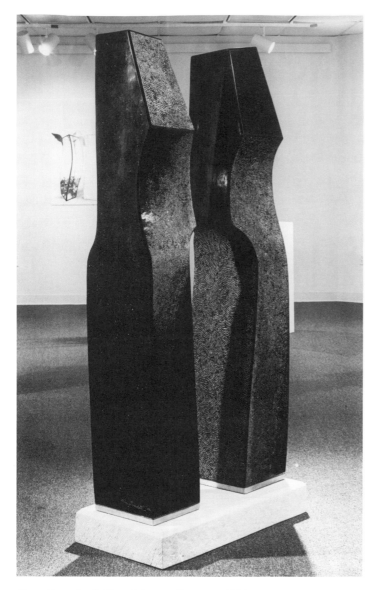

Serena Tallarigo, Vertical Three. *1985–86. White P and black Marguinia marble, 23″ × 30″ × 16″.*

Enzo Torcoletti, Shared Spaces-Gateway, *1986. Imperial black marble, 69″ tall, 1800 lb. Photograph: Paul Karabinis.*

Andrea Grassi, Draped Woman's Bust, *1977. Carrara marble, 35″ × 28″ × 16″.*

Gerald Balciar, Buster. *Colorado yule marble, 16″ × 17″ × 13″.*

Jane B. Armstrong, Nocturne, 1983. *Vermont marble, 28″ × 30″ × 6″. Courtesy of Northern Telecom, Inc.*

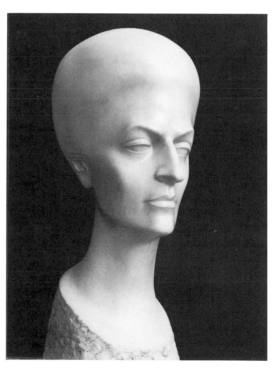

Lorenzo Garaventa, Ritrallo di Calchi Childs, *1973. Marble, life-size, Courtesy of Childs, New York. This work demonstrates how detail can be reduced to an abstract shape while still retaining a representational portrait.*

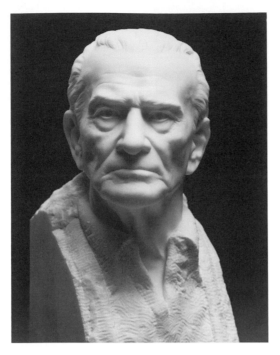

William Behrends, Mr. Bell, *1984. Marble, lifesize. Private collection. Marble can be carved to a very fine state with almost every life-like detail.*

Bradford Graves, The Drowned Cathedral II, *1986. Limestone and copper, 18″ × 16″ × 43½″.*

Charles Herndon, Florentine Variation. *Slate and marble, 8″ high. This work is laminated from two different stones for a dramatic effect. Bonding agents are available for this purpose.*

Shirley Klinghoffer, Column Maker, 1986. Marble, iron and wood. 87″ × 20″ × 14″. This work demonstrates a mixture of media with careful stone carving to fit it together.

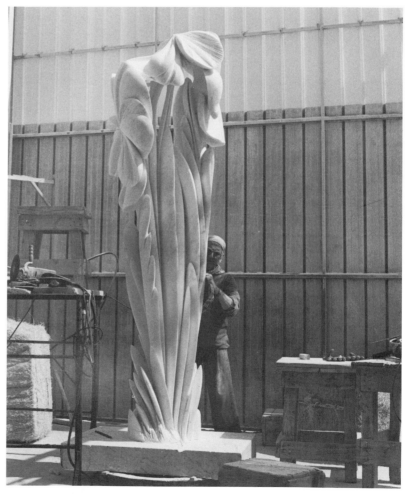

Sculptor Gigi Guadagnucci completing a very delicate Carrara marble carving, Fiori, 1987. This sculpture demonstrates some of the great possibilities of stone.

James Killy, U Bolts, *1983. Black walnut, 24″ × 12″ × 12″.*

7

WOOD

- Wood for Sculpture
- Carving with Hand Tools
- Sharpening Tools
- Carving with Power Tools
- Power Tools and Safety
- Wood Lamination and Fabrication
- Wood Relief
- Polychromed Woods

Wood is one of the most natural and beautiful materials available to the sculptor. Though the colors vary, wood tends to radiate a warmth not usually found in other materials. Most finished wooden sculptures seem to invite touch. Often a non-artist can accept a shape in wood that he or she would not otherwise be drawn to.

Wood for Sculpture

Carving woods are easy to find because most woods can be carved. The more immediate task is to match the best wood available to the sculptors idea and skill. The wood should be dry, though there are processes available for carving green woods.

This following text lists the more common wood varieties available for carving.

Ash is found in brown, a soft white and a hard white variety. The colors vary from a light white, almost brown through a blond color to a dark nearly black value. Often the same piece of wood will have a variety of colors. The soft white is the weakest wood and the darker values tend to be more brittle. Though ash is difficult to carve, it finishes well.

Birch is a strong wood, difficult to carve, that is usually light brown in color. The final surface can be quite smooth. It is readily available in plywood form, though quite expensive. It is excellent for plywood lamination.

Cedar varies in color depending upon the region in which it is found. Usually it is a red value and is known for the knots it contains. Though it is fibrous when green, a dry piece tears easily. It cannot be finished with an oil, but a natural or urethaned finish works well.

Student work. Cherie Heck, Pair of Socks. *Wood, 12" tall. Instructor: Larkin Maureen Higgins.*

William Anderson, Solace. *Black cherry.*

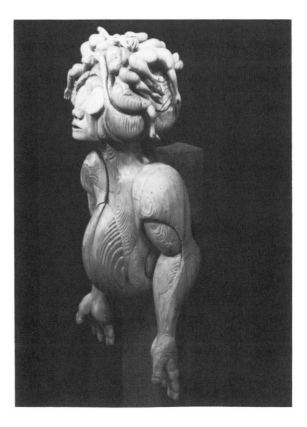

Wayne Forbes, Medusa Clone Fix VI. *Fir and pine. 48" × 17" × 19". The soft grain of this work was removed with a wire brush.*

Cypress varies in color from yellow to brown. It is a soft wood that also tears easily. The color is normally a beautiful blond. It is difficult to finish with oil. Depending upon the idea of the sculptor, it can be left natural or finished with urethane.

Fir is very light brown in color. It carves poorly, because is splinters easily. It is also difficult to finish; oiling is not recommended. It is a lightweight construction wood and is also the most common plywood used for cabinet-making. A polychromed surface is recommended.

Mahogany is either African mahogany or Honduras mahogany. As the names imply, they are imported woods. Both carve well, except for the lightest colored African mahogany which often has the characteristics of a lightweight balsa wood. The Honduras is usually a red color, while the African is more brown in color. Both laminate extremely well. Mahogany is a recommended wood for beginners because of the predictability of carving and the beautiful finish that can be obtained.

Maple is generally difficult to carve, but it finishes beautifully to a brownish red, almost creamy color. It can be obtained in large pieces, though it splits quite readily while aging.

Oak ranges in color from white to dark brown. It is difficult to carve without power tools but comes to a nice finish. It is also ideal for larger, rough-finished work, though the cracks are often pronounced.

Pine is available in white or yellow with much difference between the two. White pine is white in color to very light brown. It is easy to cut with machinery but lacks strength and the ability to take an oil finish. Yellow pine is yellow in color and often contains much resin, making the wood sticky and difficult to finish. (Do not use oil as a finish.) It is a much stronger and heavier wood than white pine. Both are easily obtained in lumber yards. Yellow pine is used as building material and white pine is generally used as a finishing material to be stained or painted. Yellow pine is also made into the most common construction plywood available.

Redwood ranges from blood red to reddish-brown. It splinters easily and is difficult to finish because of its softness. Its best asset is that it can easily be obtained in larger thicknesses at most lumber yards. It does not take oil well; a natural finish is best.

Walnut, often called black walnut, is a beautiful wood with a color range that moves into the dark browns to almost black. The seasoning of walnut is unusual since it rots on the outer surface, leaving the heart for carving. Though it is a hard wood, it carves well and takes a fine oil finish. It is a preferred carving wood, especially for smaller works.

John Boomer, **Underwater Dancing, 1982. Walnut, wenge, spruce, Malaysian mahogany, rawhide, piano wire. 73″ × 17″ × 11″. Photograph: Peter L. Boomer.**

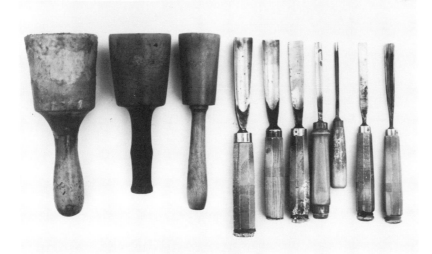

Wood carving tools: from left to right. 2½-lb. mallet, 1¾-lb. mallet, 1-lb. mallet, large deep sweep gouge, large middle-sweep gouge, large flat-sweep gouge, small gouge, very small gouge, flat chisel, parting chisel. These tools normally are required for carving, though the largest mallet is not always used.

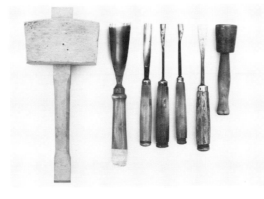

Special wood-carving tools: from left to right, 3-lb. block mallet, large fishtail gouge, gooseneck gouge, spoon gouge, back-bend gouge, fishtail flat chisel, ½-lb. finishing mallet. These tools are not necessary for most carving purposes, but they are good to have available.

If you do not have dry (aged) logs to carve, you can begin your own curing processes. With green wood, it is best to remove the bark to avoid housing bugs and unnecessary moisture. Always leave the log at the longest possible length. This will allow more freedom to choose a design when it has dried, and also less waste will be removed from the end cracks. The ends should be treated, preferably with wax, though heavy coats of oil-based paint, mixed with linseed oil will also work. Store the logs in a dry, well-ventilated area. They can be kept outdoors, but some may rot or otherwise be lost to the elements. Large logs may take many years to cure. A good formula for curing time is to allow one year for every 2 inches of the diameter of the log. (This rule of thumb can vary depending on the climate and strorage conditions.) If the log is not completely cured before carving, the sculpture will continually crack creating an uneven, unsightly and less tactile surface. This cracking is especially noticeable if the wood has been stained or painted.

It is important to choose a suitable carving table for your work. It should be rather short or at a height where you will only have to bend your lower arm without raising your elbows. This keeps fatigue to a minimum. Use clean, loosely-filled sandbags for holding the wood in place unless the piece is quite small; then a wood vise can be used to hold the work.

Carving with Hand Tools

Once a log has been selected, the outer surface must be trimmed. The log chosen for our demonstration is walnut, so the outside area needs more removal than on most woods. A large gouge is used for this purpose, though other tools such as a wood adz are helpful. Metal wedges (wood splitters) are useful if a large piece of the wood needs to be removed.

The proposed sculpture is drawn on every side to get the feel of the material. Carving is begun with a gouge. Always use a firm hand grip, usually with the thumb around the handle. Since the mallet is so large, it is unlikely it will miss the gouge. The heaviest controllable mallet is best in order to power the larger gouge. The gouge should be held at slightly less than a 45 degree angle. **Wear goggles or a face mask to protect your eyes from the flying woodchips. Keep the gouge pointed away from your body to avoid a serious accident.**

Since all wood has grain (direction), cut with the grain when possbile, avoiding too deep a cut. If the gouge gets stuck, gently lift out the tool or slightly raise it and change the angle of cut (If it has been driven too deeply, another tool may be required to carve it out.)

Once the carving is almost roughed out, the gouge size is decreased and so is the mallet size. Gouges have different "sweeps" or depths of cut. They range from a half circle to a nearly flat curve. As a work progresses, the sweep becomes more shallow, finally using a completely flat chisel for completion. This work requires the use of a parting tool, but no other special tools are needed.

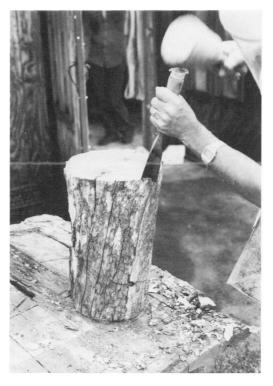

A large gouge is used to remove the outside of the wood.

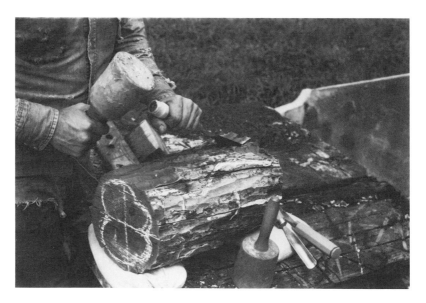

After the planned shape has been drawn on the wood, another large gouge is used to begin the carving.

The gouge follows the wood grain.

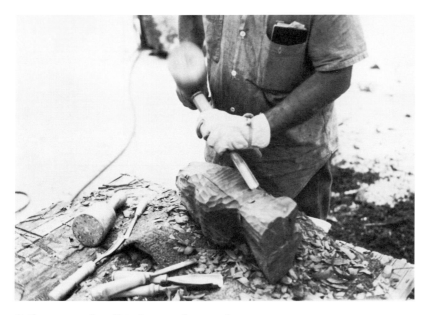

Both gouge and mallet sizes are decreased as carving progresses.

Rasps and files used for carving wood are the same as those used for stone. The same tool will not stay sharp enough for wood if it is also used on stone, so two sets of tools are recommended. Many types of rasps can be utilized for obtaining better curves. Large hand-held rasps are good for the first rasping. The sponge is taped to the handle to protect the sculptor from the sharp rasp teeth. Large riffler rasps are helpful in hard-to-get-at places, and smaller riffler rasps and riffler files are necessary for finishing in tight places. A small respirator is recommended when filing and is required for sanding.

Once the wood has been completely rasped and filed, begin hand sanding. Many sandpapers are available, but wet-or-dry is preferred because of the quality, longevity and consistency of grit. The finishing of this shape is begun with 80 grit and progresses to 100, 150, 220, 320, 400 and finally, 600. Many sculptors do not exceed 320, but the smoothest finishes for oiling require at least 400 grit.

After the sanding is completed, the work is thoroughly dusted and oiled. There are different oils available; the most common is Tung oil. Tung oil does not saturate as deeply as other mixtures so only a small amount is needed. I prefer a mixture of mineral spirits and boiled linseed oil. The first coat can be 50% spirits and 50% oil with a 30 minute saturation time. Next comes a mixture of 30% spirits to 70% oil. Good ventilation is a necessity when using mineral spirits. (**CAUTION: Mixtures such as this can bring about spontaneous combustion. Wiping rags should never be placed in containers where they can incinerate. Submerge used rags in a bucket of water until they can be disposed of properly.**) The last mixture is repeated until the sur-

Many different kinds of rasps are useful on curves.

Riffler rasps are handy for areas not easily reached.

A large rasp is held with a sponge wrapped around it to protect the hand.

Masking tape helps protect the skin while sanding.

The surface is oiled with a mixture of mineral spirits and boiled linseed oil.

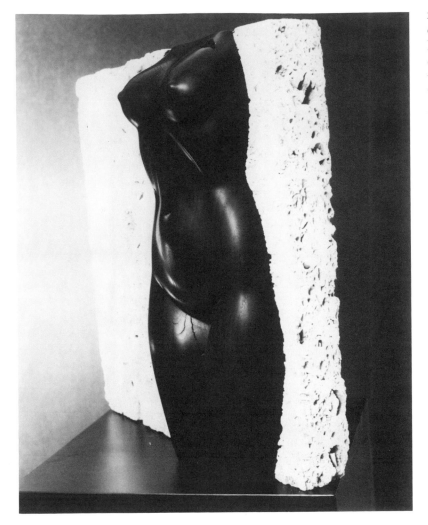

Arthur Williams, Emerging Figure. *Black walnut and Austin limestone, 18" tall × 24" × 6". The final work was cut into two parts prior to oiling and mounting onto fossilized limestone.*

face will no longer take oil. This can be done two or three times a day or in one long period of 3 to 5 hours, applying oil every 15 to 30 minutes. No matter what mixture of oil is used (including Tung oil), the mixture should never be allowed to dry on the surface nor should it be applied near heat or in direct sunlight. Wipe the excess oil off within an hour's time to prevent the formation of a sticky surface gum.

After the final coat of oil is on the piece, throroughly wipe the surface to remove all excess oil, then allow the wood to dry completely. (Three days or longer is best.)

In order to maintain a good surface and gain sheen, a fine quality clear wax is applied. Some sculptors buff their work at this time. Notice the sheen that the wax gives the finished piece.

Sharpening Tools

Keeping wood-carving tools sharp is a primary concern. A dull tool not only tires the carver, but it also damages the wood, often causing compression instead of cutting. A dull tool also may get hopelessly stuck in the wood.

New tools should always be sharpened and honed before they are shipped to the sculptor. Specify it.

If a tool has lost its shape, it can be ground on a power grinder. (**Remember**

always to wear eye protection when using a power grinder.) Reshaping the tool must be done with extreme caution in order to avoid losing the temper (hardness) of the cutting edge. Excessive, prolonged heat will cause the metal to have a dark blue cast indicating that the temper is gone. (Though the tool can still be sharpened and used, it will never again hold the sharpness for a long period of time.) Never hold the tool next to the grinder for over two seconds. Immediately cool the tool in a cup of water kept beside the grinder and repeat until the tool is shaped. A fine, sharp metal file can also be used for reshaping tools, though it takes much longer and leaves a rougher surface to sharpen.

After the tool is shaped, it is sharpened on a stone. The most common sharpening stones are the combination stone, the India gouge and the hard Arkansas stone. The combination stone has a coarse grit on one side and a smooth grit on the opposite side. This is the most available stone and can be used for almost all carving tools, including the gouge. The India gouge is a stone with an inside and outside curve that is made specifically for sharpening gouges. The Arkansas stone is the finishing stone. It is hard and the most expensive. It feels and looks like glass, but the small grit adds a good finish to a tool edge. All of these stones can be used with a lubricating oil to aid in the sharpening. If a tool is kept sharp with a sharpening stone, then it is seldom necessary to use a power grinder to reshape it.

Carving tools are reshaped on the power grinder.

The first step in sharpening is to move the tool forward across the combination stone repeatedly.

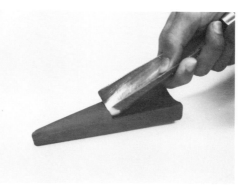

The India gouge can be used as the second stone surface in the sharpening process.

The Arkansas stone is a finishing stone used in the last stage of sharpening.

The method of sharpening preferred by the author is a side-to-side motion.

Side view of two gouges: left, a dull tool with a round edge; right, a properly sharpened tool with a flat straight edge.

The actual sharpening of the gouge is accomplished by using three stone surfaces: the rough side of the combination, then the fine side of the combination, or the India gouge; then the hard Arkansas. Lay the stone on a flat surface and move the tool forward across the stone, keeping the edge bevel always at the same angle. Repeat the process until the bevel is very straight and even. A gouge can also be sharpened from side to side by rotating the tool across the stone as it is being sharpened. This is my preferred method of sharpening. A burr forms on the top edge of the tool during sharpening. From time to time, turn over the tool and remove the burr by gently raking it across the stone. Continue the sharpening until the edge is very straight and obviously sharper. Repeat the process on all three grits until the tooth is razor sharp. If the sculptor stops every 15–20 minutes during the carving process to resharpen the tool, sharpening will take only a few minutes and the tool will maintain a far better edge.

Leather honing strops can be used for extremely sharp requirements; however they are seldom necessary for normal wood carving. (Honing strops were used in the early barber shops for sharpening shaving razors.)

Steve Kramer, Leg Bone. Walnut, 14" tall.
Photograph Eldon Rahmiller.

Walter C. Driesbach, Skeptic. Walnut. Private
collection of Dr. and Mrs. Enrique Kaufman.

John Boomer using a large sander on his sculpture. Photograph: Kenji Kawano.

Carving with Power Tools

Wood carving with power tools proceeds about six to ten times faster than with regular hand tools. Depending upon the design of the work to be carved, power tools can often be used until the work is ready to hand sand.

Electric Tools

Many sculptors use electric tools because of their availability, especially when the studio or classroom does not have access to an air compressor for pneumatic tools. Though a multitude of tools exist, the most common ones are the disk sander and the die grinder (also shown in Chapter 6.)

Sculptor John Boomer demonstrates his carving technique with a piece of walnut. His process includes a mallet

John Boomer increasing details with a die grinder. Photograph: Kenji Kawano.

Sculptor John Boomer wears magnifying lenses when doing detail work. Photograph: Kenji Kawano.

and gouge to rough out the work, a 7-inch electric disk sander to eliminate the gauge marks and an electric die grinder to add smaller details and further clean up the work. He then reverts to hand tools and a magnifying lens to complete the fine details. For these details, he does not use a mallet. He is shown with a finished work that demonstrates his use of texture and detail.

This finished work demonstrates John Boomer's use of texture and detail. Photograph: Kenji Kawano.

Pneumatic Tools

Electric tools work well on wood, but air tools are preferred. They are lighter, cooler, faster and pose fewer mechanical problems. For a more complete discussion on pneumatic tools, refer to chapter 6.

The power tool demonstration begins with drawing the design on every side of the chosen piece of wood. The sides of this log have already been cleared by a chainsaw. The work is shaped by using a midsized gas chainsaw to block the wood into planes. The use of a gas chainsaw requires a great amount of care and control. **(Wear both eye and ear protectors.)** The work is further refined with a small electric chainsaw. Kickback from the saw must be avoided. Kickback is when the saw blade catches on the wood and often "throws" the wood or draws the operator toward the blade.

Remember to redraw the shape constantly in order to keep the proportions correct. Notice how refined the surface became by using the chain saw. The shape is carved with a pneumatic hammer.

An assortment of air tools are used for specific tasks not all pictured. A 3/8 inch die grinder with a large custom long-shaft bit and fine-tooth bit is useful for more refined work. A small sanding disk, followed by a flap wheel, a large rolled sanding end; and a small rolled sanding end help the finishing process. A 5-inch sanding disk is used for larger areas, followed by an orbital sander for the final machined finish.

The work is now ready for hand-sanding. Hand-sanding and oiling are done in the same manner as in the hand-tool carving demonstration.

The design is drawn on the log, which has already been cleared.

A mid-sized chain saw is used to block the wood into planes as preliminary shaping.

A small chain saw is used to refine the shape.

Using a ⅜" die grinder with a large custom bit.

Using a smaller die grinder with a round bit.

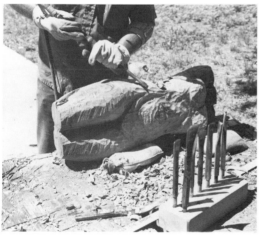

A pneumatic hammer is used for finer carving.

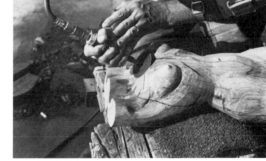

A small sanding disk is used for early sanding.

A flap wheel is used for further finishing.

A small round sanding end is useful for finishing deep curves.

A dual-action orbital sander creates a surface that is ready to hand-sand.

A 5" sanding disk is excellent for smoothing the surface.

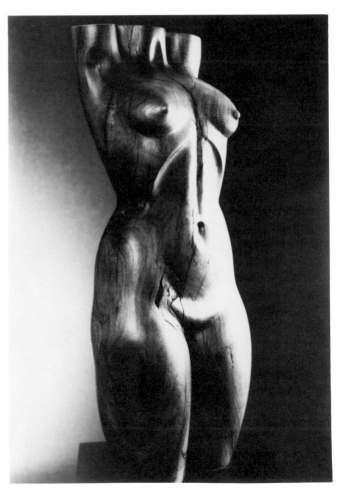

Arthur Williams, Standing Figure. Mesquite, 32" × 11" × 7". I never attempt to hide the original cracks in my works; they add interest.

Power Tools and Safety

Power tools are a great invention for saving time in specific tasks. If used properly, they can provide great pleasure; if improperly used, they can cause much grief to both the project and the sculptor. The following precautions apply to all power tools:

1. Stay alert; do not be distracted.
2. Always take the tool seriously; never horseplay when working with tools.
3. Know how to use your tool or get help from someone who does.
4. Never wear loose clothing around power tools.
5. Never let long hair hang loose when near power tools.
6. Always wear proper eye protection; wear a respirator when needed to avoid inhaling dust particles.
7. Keep your hands and body away from sharp teeth or other moving abrasive parts.
8. Make certain that observers are at a safe distance or are properly outfitted to help.
9. Keep the operating area clean.
10. Be certain the blade or abrasive is sharp and is the correct one for the job.
11. Check that all electrical tools are properly grounded.
12. Never work in water or in wet areas with electrical tools.
13. Familiarize yourself with the tool manufacturer's safety advice and operating procedures.

In addition to these general precautions, the following specific precautions apply to the more common power tools:

1. *Table Saw.* **Always minimize the height of the blade. Never cut more than 1/4 inch above the work. Use proper guards. Use a "pusher stick" when working near the blade. Never reach over a moving blade.**

Table saw.

2. *Circular Hand Saw.* **Do not extend the blade over 1/4 inch beyond the underside of what is to be cut. Keep a firm grip on the saw. Be certain the blade guard rebounds after each cut.**

Circular hand saw.

3. *Band Saw.* Make sure that materials are resting flat against the table top before cutting. Stand to the side of the blade in case it breaks.

Band saw.

4. *Hand Drill.* Always maintain a firm grip on the tool. If the object to be drilled is small, it should be placed in a clamp.

Hand drill.

5. *Drill Press.* Never attempt to slow the chuck while it is turning. Keep a firm grip on the material. Slowly make a hole with a good hold on the drill press handle. Do not attempt to drill a small object without clamping it to the table top.

Drill press.

6. *Belt Sander.* Keep the belt tight in the machine and properly centered. Work near the belt where it is moving away from you.

Belt sander.

7. *Saber Saw.* Be certain that you are not cutting something beneath the work. Unplug the saw while changing blades.

Saber saw.

8. *Radial-Arm Saw.* Never place your arm or hand beneath the blade. Always firmly grip the material being cut. Use the mitre gauge when possible. Hold the saw until the blade quits turning.

Radial-arm saw.

9. *Upright Disk Sander.* Work on the downside of the disk. Be especially careful when holding thin stock to the blade. Do not attempt to sand materials such as glass that will shatter.

Upright disk sander.

These precautions are not intended to be instructions on how to operate a tool. Rather, they are safety guidelines. An experienced operator should be consulted for correct operating procedures.

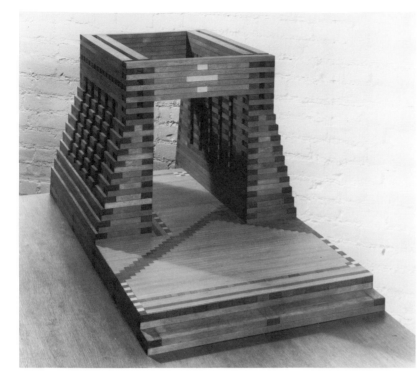

Jackie Ferrara, M255 Traces. *Stained pine and poplar, 17″ × 40″ × 19″. Courtesy of Max Protetch Gallery. Photograph: Roy M. Elkind.*

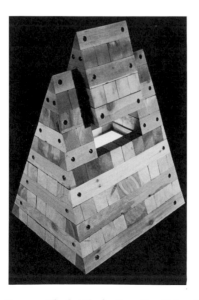

Joanna Clark, Khufu Sees the Light. *Cedar and lights on wheels, 4′ × 3′ × 2′. Photograph : Gloria Choudury.*

Wood Lamination and Fabrication

Lamination is simply pegging or gluing lumber together. It is utilized for artistic design and for creating a sizable piece of wood to carve. The sculpture can be made in several pieces and with different hues or colors of wood. Lamination allows the use of kiln-dried wood that avoids drying cracks. Also, the works can be very large and hollow.

A sculptor's choice of materials for lamination and fabrication depends on the answers to several questions. Is the final piece intended for interior or exterior display? Will it be left natural, stained, painted or oiled?? Will it be combined with other materials?

If the sculpture is to be an exterior piece, then the wood, glue and finish must be able to withstand weather. Suitable materials include plywood marked "exterior" and heavier construction grades of wood. If left natural, redwood, cedar and the like are best. The glue should be a waterproof catalyzed resin or a synthetic rubber such as silicone. Other glues that work well outdoors, assuming that they are protected with paint, are powder-mixed resin and epoxies. These are water-resistant but not waterproof. Any bolts, nails or other materials used with the sculpture need to be made of weather-proof steel or covered with a weather-proof coating, depending upon the design of the sculpture. The final surface treatment should also be weather-resistant (paint, varnish, etc.)

The sculptor has greater flexibility when creating an interior sculpture. Most all glues will work well, especially white carpenter's glue, contact cement and epoxies. There is no limit to lumber except for that designed specifically for outdoor use, such as

wood treated with creosote. This freedom allows the sculptor to demonstrate a very fine finish, especially using small parts, if the design calls for it. While most any finish can be used, the more delicate stains, varnishes and colors are available for an indoor piece. As far as using additional materials with the wood, most anything is possible.

Woods used for laminating should be dry (not green) and of similar densities so that climatic conditions will not cause glue separations. The board to be cut needs to be measured carefully and marked, remembering that the grain must be stacked in the same direction for gluing. (White carpenter's glue is the preferred glue for interior use.) Once the glue clamps have been spread to fit the stack, gluing may begin. The glue can be poured out of a container, then brushed over one laminating layer at a time. Work must be done quickly so that the glue will not set prior to clamping.

Place the clamps on the board snugly opposite each other, until all of them are used. Now tighten the clamps by hand. The glue should squeeze out. It takes practice to know how much glue to use without too much waste. It is better to have too much than too little, however. Though the block will set hard in less than 6 hours, it is better to leave it undisturbed overnight before removing the clamps. (**CAUTION:** *Clean up all glue drips on the furniture and floor before they set.*) Wood also can be cut to shape prior to lamination in order to save lumber and carving time.

Sculptor Floyd Shaman demonstrates his process for laminated sculpture. He begins with a paper pattern of the final sculpture. The paper silhouette is used to make plywood patterns that are used to mark the wood to be laminated. He

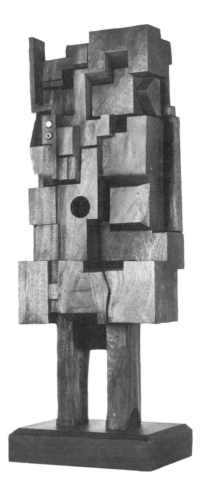

Enrico Pinardi, Sentinel. *Mahogany,*
20″ × 8″ × 4″.

Clamps the author uses for lamination. The longer pipe clamps made from ¾″ steel pipes of various lengths are easy to fit for different sizes of projects. The smaller C clamps are used for very small works.

The board must be measured carefully and marked for repositioning.

When the laminated block has dried, it can be cut to shape with a band saw.

The grain must be in the same direction.

Each lamination has been cut to a more defined shape prior to gluing. This is a good way to work if a bandsaw is not available to make thicker cuts.

Glue has been applied to the pieces and they are clamped together for drying.

A paper pattern (left) was used to shape the laminated piece (center) that was carved for the final piece (right). Photograph: Rachel Brown.

divides the sculpture into two equal parts since the parts can be more easily joined. Later, he joins the two halves.

Once the parts are marked, using the plywood patterns, they are cut out with a band saw, drilled for wood dowels and coated with glue on both sides. Dowels are inserted before the clamps are applied. The dowels keep the boards from slipping while they are being clamped. The sculptor uses a small block of wood between the clamp and the work to avoid pressuring the wood near the surface.

The finishing is begun with a body grinder to remove the unwanted wood quickly. The work is refined with regular wood-carving hand tools. In the final steps a flap wheel is used for sanding. Then varnish is applied to achieve the final surface.

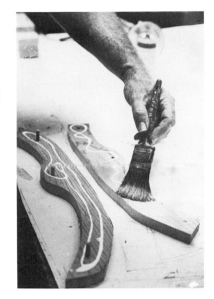

The pieces are covered with glue. They will be clamped together to dry. Photograph: Rachel Brown.

The cut pieces are drilled so that wood dowels can be inserted to keep the pieces from slipping. Photograph: Rachel Brown.

The work being clamped with a small piece of wood under the clamp to protect the work.

A flap wheel is used to achieve more smoothness over the textured surface.

A body grinder is used to remove excess wood. Notice the small block of wood directly beneath the clamp that equalizes the pressure over the top laminated piece. Photograph: Rachel Brown.

A wood gouge is used to add special texture.

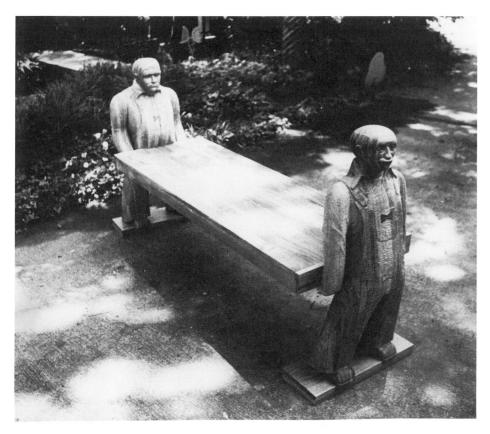

Floyd Shaman, Where do you want it, Lady? *Laminated wood. Collection of State Savings Company, Columbus, Ohio. Photograph: Rachel Brown.*

There are many ways to laminate wood and a multitude of preferences of sculptors. Sculptors often choose plywood since it is already a "plied" wood with laminations. The small laminations add interest and strength to a work. This is readily demonstrated by Kerry Vesper's *Quetzal*. Sculptor Mick Reber adds other materials to his lamination to complete his *Rodeo Queen*. Sculptor Phillip John Evett does not always use clamps to complete his sculptures with laminations occurring in so many directions. Sometimes he just uses tape. Sculptor Floyd Shaman often prefers a variety of wood for lamination; it serves as part of the design and also is used for color. Sculptor Hayden Davies laminates extremely large works with waterproof glues, leaving the inner part hollow. This technique not only saves materials, but it allows the large sculpture to expand and contract with the seasonal climactic conditions.

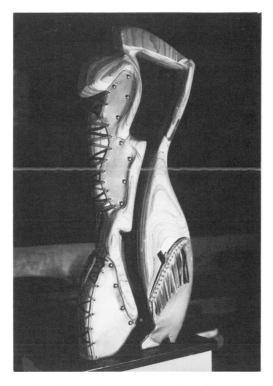

Mick Reber, Rodeo Queen. *Laminated wood and deerskin, 30" tall.*

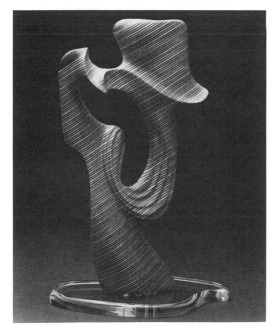

Kerry Vesper, Quetzel. *Birch plywood and African paduak, 17" × 9" × 3".*

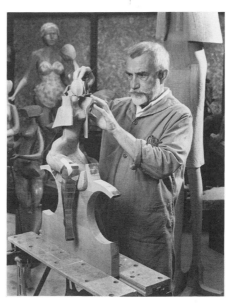

Sculptor P. John Evett is fitting together a laminated sculpture using tape.

153

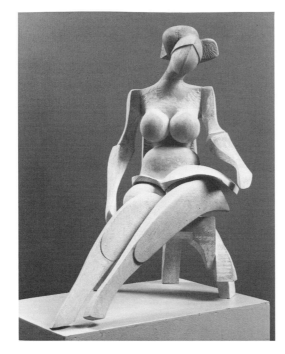

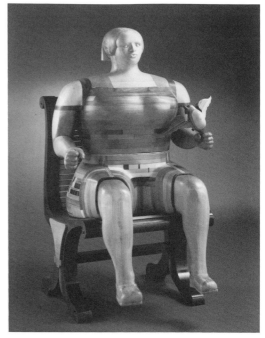

Phillip John Evett, Maisy Willoughby II. Mahogany with color, 23″ tall.

Floyd Shaman, Gretchen. Cherry walnut, sycamore, gum and bass, life-size. Photograph Rachel Brown.

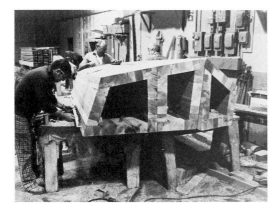

Workers preparing a large section of Homage.

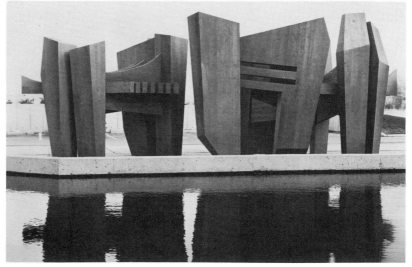

Hayden Davies, Homage. Laminated western red cedar, 11′ tall × 31′ × 12′. Lambton College of Fine Arts and Technology, Sarnia, Ontario. This large sculpture demonstrates the potential of laminated wood.

Wood Relief

Wood often is used for relief sculpture since it is one of the lightweight materials. Sculptor Doug Hudson has perfected his methods for this type of sculpture. His works are readily recognized by his careful choice of wood for color and texture.

He carves with Northwest coast carving knives that he was taught to make by native Northwest carvers. Originally, these knives were designed for carving totems, masks and bowls.

To demonstrate one of his murals, he begins with a heavy contour line design that is transferred to a paper template and transferred to the wood cut out. He uses a band saw to cut out the work.

After the sculpture is placed together to ensure a good fit, he uses the band saw again to further rough out the work. (CAUTION: *Only an experienced saw operator should attempt this.*) Finally, he uses the carving knives and then rasps the wood to smooth the design.

He sands his works with electrical tools and by hand. The pieces are then stained and finished with fine coats of a satin finish marine varnish applied with a sable watercolor brush to avoid brush marks. As the final step he laminates each piece together on a backing for hanging. An example of one of his finished murals is pictured.

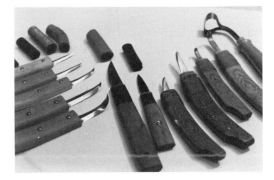

Each Northwest coast carving knife is used according to the curve and surface of the wood.

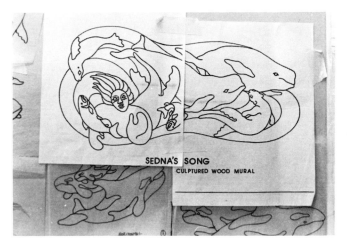

SEDNA'S SONG
CULPTURED WOOD MURAL

A heavy contour line design of the mural is drawn.

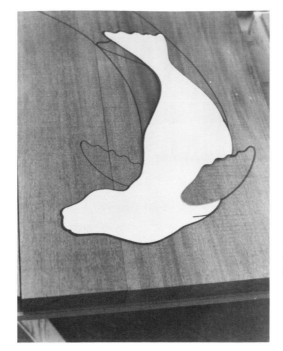

Paper templates are made from the master design and used as patterns for marking the wood.

The pieces are roughed out using a band saw. Only experienced operators should use this technique.

The carving knives are used to refine the shape before the finishing steps.

The shapes are cut out with a band saw and placed together to ensure a proper fit.

Doug Hudson, Southeast Waters. *Honduras mahogany, 4′ × 8′. Collection of Ed Purvis.*

Polychromed Woods

Polychromed wood is wood that is coated with a colored material, usually paint. This technique is excellent when the sculptor desires a different surface from the normal wood grain. This method also allows the use of less expensive woods. The methods used are similar to normal lamination; however, the sculptor often adds fillers and such to the surface since they will not be seen beneath the surface coating.

Though wood fillers such as plastic wood fillers are often used, automotive fillers such as Bondo are preferred, since they can be used in thicker applications, they dry faster and they are easily sanded. (see Chapter 10 for a discussion of the uses of autobody fillers.) For these reasons, the surface is often built up over the wood, almost as if the wood were only an armature for the surface filler.

Automobile body filler. It can be used for texture or sanded smooth. Courtesy Mick Reber.

The final work can be topped with many types of coatings. Sometimes additional texture is painted on, such as in Wendell Castle's *I Think it Works.* However, most often, it is painted with an automotive finish. Mick Reber's *Purple Kind of Lovelock* is so well finished that few could guess that it is made primarily of wood.

Wendell Castle, I Think It Works, *1986. Ebony veneer, maple, cherry, gesso and paint, 48″ × 48″ × 24″. Photograph: Bruce Miller.*

George Mitchell, Freedom, *1976. Polychromed Wood, 18″ tall.*

Mick Reber, **Purple Kind of Lovelock, America's Finest.** *Wood, 4' × 4' × 1'. Photo courtesy Las Vegas News Bureau.*

*James C. Myford, Untitled. **Cast aluminum, 42″ tall × 10″ × 10″.** Photograph: Richard A. Stoner.*

8

METAL CASTING

- Castable Metals
- Foundry Equipment and Operation
- Lost Wax Process
- Sand Casting

Cast metal is one of the best ways to preserve a sculpture form. Often the final work is located outdoors or in fountains. Depending upon the metal, the color can be very warm (bronze) to quite cold (aluminum). Though the wall thicknesses can vary, they are usually about 1/4 inch, regardless of the casting size. The sculptor has nearly unlimited design possiblities. The limiting factors to be considered are the technical skills of the sculptor, casting facilities and the funds available.

The technical processes for metal sculpture casting include the use of sand, plaster and ceramic shell molds. Sand casting involves pouring a metal into a mold generally made of chemically bonded sand. The tightly packed sand mold holds the void left after removing the artworks from the sand. Plaster investment molds usually house wax artworks that are slowly melted out later to be replaced by liquid metal. Ceramic shell casting also utilizes wax artworks that are covered with ceramic materials. The wax is rapidly removed and then replaced by the poured metal. Though each of these casting procedures is different, the results are similar, with the exceptions of thickness and surface detail.

In this chapter, each procedure is demonstrated, and wax usage, furnace operation and finishing the casting are discussed. New terms are defined as they first appear. (CAUTION: *Several foundries furnished photographs that are used throughout this chapter. All the foundries practice safety, although some do not always wear the suggested safety equipment. You are to learn from the process, but are strongly advised always to wear the proper safety clothing.*)

Jean McWhorter, Summer Cyclist. *Cast aluminum. 30″ tall × 29″ × 13″.*

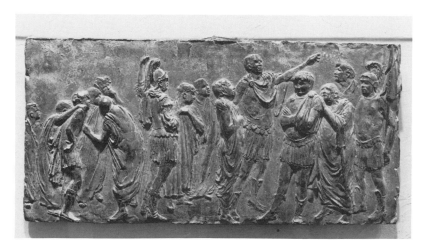

Stanley Bleifeld, Julius Caesar. *Bronze, 13″ × 22″.*

Castable Metals

Many metals can be used for casting. Castable metals are divided into two categories: ferrous, metals containing iron, and nonferrous, metals containing no iron, such as bronze, and their alloys (metal mixtures). The following discussion covers the most popular nonferrous metals.

Note: All temperatures in this chapter are given in Fahrenheit.

Aluminum has a melting point of 1250° depending upon the alloys used. The best casting metals are those obtained from supply houses in ingot (small bar) form, though automobile pistons and other scrap materials can be used as well.

Aluminum is only one-third as heavy as bronze and generally costs less than half as much. Welding aluminum is unpredictable unless the exact alloy is known, however, and the choice of colors of finishes is limited.

Bronze has tin as the primary alloy with some lead and zinc added to the copper. It pours well. The melting temperatures range from under 1400° to over 1900°. The finishes are superb with many color possibilities.

Brass is primarily copper with zinc as the major alloy. Because of the metal makeup, brass is difficult to work and offers fewer finishes than most sculptors desire. The melting temperatures are less than 1600° to over 1850°.

Aluminum bronze is mainly copper with varying amounts of aluminum (up to 20%). The finishes vary from a white brass color to a bronze color. This metal offers good possibilities for alloy experiments. Old copper motor windings combined with aluminum provide inexpensive alloys. After the copper is melted, the aluminum is added (perhaps 10%). The mixture pours fairly well and

has a high melting point due to the copper used (up to 1980°).

Silicon bronze is primarily copper with a small percentage of silicon (1%–3%). It is currently the most popular alloy in art foundries. The finish possibilities are good, and it melts at about 1850°. It pours well and is easily welded with matching rods that are readily available.

Other casting metals are lead, which melts at 625°, gold, which melts at 1950°, silver, 1760°, stainless steel, about 2750°, and iron, between 2400° and 2700°.

Alloys often produce toxic fumes, especially if they include much lead or manganese. Good ventilation is a necessity. Proper clothing (discussed later) is necessary to prevent serious burns.

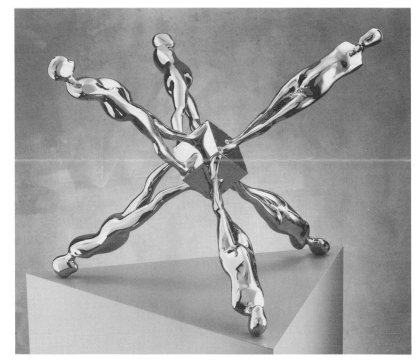

Trova, FM/24″ Walking Jackman, 1985. Stainless steel, 31″ tall × 51″ × 51″.

Foundry Equipment and Operation

A *foundry* is any place where molten metal is cast. The metal can be cast by several different methods, but certain general procedures are followed in all types. The basic equipment needed for casting is also similar from one method to another. The same fundamental safety precautions are applicable to all methods as well. Before specific methods of casting are discussed, these general topics will be addressed.

Safety Clothing
Proper protective clothing must be worn at all times when working near the furnace and molten metal.

1. **Wear safety eye equipment while around the hot furnace and the pour. A welder's helmet with a large glass visor is best.**

Safety attire. Photograph: Dawn Stubitsch.

2. **Wear a heat-resistant leather apron or a suit made of heavy reflective aluminum material to protect the body from flying metal as well as heat. (Asbestos clothing presents health hazards.)**
3. **Wear long sleeves to protect the arms.**
4. **Wear leggings to protect the legs and feet.**
5. **Wear heat-resistant gloves.**
6. **Wear leather shoes or boots in order to protect the feet, not only from flying metal, but from stepping on part of the dross from the crucible. (Dross is the scum of waste that forms on top of the molten metal.)**

Casting Tools

Crucible lifting tongs are simple devices for raising and lowering the pots into the furnace. They grip the pot by the pressure of the crucible weight as they are raised. There are tongs available for one-person and two-person use.

The *crucible shank* is a long-handled tool designed to clamp on the pot to keep it from sliding out while pouring. Shanks also are available in one and two-person models.

Metal pick-up tongs must be used to charge—add fresh metal to—the hot furnace. They should be used with caution since the metal can slip from them if not gripped tightly.

A *base block* is used to set the hot crucible on in the furnace. One also is used for the pot to rest on while the tongs are changed for the shank. These blocks should be silicon carbide or firebrick, and be coated with silica dust or possibly a piece of wet cardboard that forms a carbon barrier in order to keep the hot crucible from sticking to the furnace.

The *plunger rod* is a metal rod with an end designed to hold degassing pellets submerged in molten metal.

A *skimmer* is a metal rod with a cup or spoon on the end. It is used to scrape the dross (floating waste) from the top of hot liquid metal.

Crucible tongs that can be handled by one person. Courtesy of McEnglevan.

Crucible shank for use by one person. Courtesy of McEnglevan.

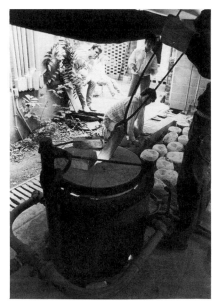

Metal pick-up tongs are used to charge the furnace. Photograph: Bill Martin.

The *ingot molds* are metal trays into which the excess liquid metal left from the casting is poured. They are always preheated to eliminate moisture. They are also used to freeze (solidify) metal into a more usable shape or size for reuse.

The *pyrometer* is a tool used to measure the heat of melting metal. It is hand-held and should be placed into the pot for only a brief period (10 seconds or less) or it could possibly melt.

Ingot molds.

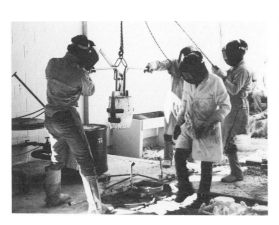

The hot crucible is lowered onto a base block.

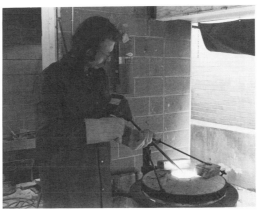

A pyrometer is used to measure the temperature of the molten metal. Photograph: Bill Martin.

Dross is removed with a skimmer. Photograph: Bill Martin.

Crucible

The casting *crucible* is the pot in which the metal is melted. It is made of silicon carbide or graphite. Brand new pots need to be heated slowly (annealed) then cooled slowly before being used. The crucible should be completely dry with no hint of moisture before metal is added. As preheated metal ingots are added, they should not be allowed to hang out of the pot because excessive oxidation will occur; that is, too much air will cause gases to form in the metal. (An ingot is a piece of metal molded in an easy-to-handle size and shape.) Never drop metal pieces into

the crucible because it could crack. The added metal also must be lowered into the pot slowly to prevent splashing the molten metal already in the pot. Also, the pot should be filled in order to avoid oxidation caused by the empty top portion of the pot. After the firing, metal should never be allowed to cool in the pot or the pot could split when reheated due to expansion. All excess metal should be placed in a preheated ingot mold.

Fluxes

Fluxes are materials sprinkled in with the metal that melt and form a thin protective skin on the surface to avoid gas absorption and oxidation. Fluxes need to be added prior to the heating in order to help keep the metal as pure as possible. Also, degassing pellets are added to help reduce the porosity of the molten metal. These should be added after the pot is removed from the furnace for pouring. The pellets must be pushed to the bottom with a plunger, because they will not sink by themselves. The pellets should be stirred only minimally in order to avoid additional gas buildup. (CAUTION: *Do not breathe the toxic fumes.*)

Furnace

Most of the furnaces in use are blast furnaces, which are capable of exremely rapid heating after the initial warm-up. After the furnace is lighted (without the air blower on), the air blower is slowly turned on. After a brief time, the air valve is opened wide, and the gas valve is adjusted only slightly more open. If the mixture is not correct, then the furnace will reduce (not burn all the fuel causing a slow heating situation) or oxidize (becoming dangerously close to going out). Ideally, the furnace operates best with the air wide open and gas adjusted to create the loudest combustion noise. The louder it is, the more effective the heating is. If a green flame shoots out of the furnace, the gas valve needs adjusting back until the green disappears. Once the heat is properly adjusted, it seldom needs additional adjustment except to turn the gas down as the furnace becomes hotter. To stop the furnace, the gas is turned off first, and then the air is turned off. After the

T80 furnace with motorized tilt. Courtesy of McEnglevan.

B-700 Crucible. Courtesy of McEnglevan.

pour is made, the gas is easily re-ignited. The valve controls can be returned to the same setting as they were just prior to turning them off.

The Pour

The pour, very simply, is the process of pouring the molten metal into the pre-ared molds. After placing the pot in the shank, degassing and skimming the top clear of dross, the metal is ready to pour. Thin sculptures need to be cast at a hotter temperature, perhaps as much as 150° to even 200° more than freezing temperature of the metal in order to allow the metal to flow thinner and faster. Thick pieces can be poured cooler at about 100° over the bronze melting temperatures.

Remember the following specific cautions:

1. **Pour the molten metal as quickly as possible in order to avoid a freeze-up.**
2. **Never start a pour unless there is enough molten metal to finish in one pour since the addition of a hot metal over a cold one will result in a bathtub-ring freeze-up caused by a cold mold. Also, a second pour is unlikely to finish the fill, since the runners (narrow channels through which the metal flows) will probably contain frozen metal from the previous pour.**
3. **The pouring cup should be half full at all times until the metal runs out the air vents. This keeps dross from going into the mold (it floats). If the metal flows out of the air vents very quickly, it is a sign of a good casting.**
4. **Immediately pour the excess molten metal into a preheated ingot mold after the last pour.**

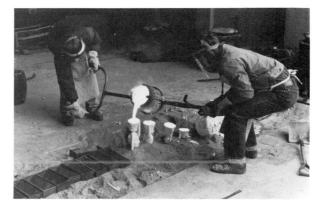

The most common type of pour is a two-person pour with a no.30 crucible. Notice the preheated ingot molds ready for the excess metal after the pour.

Chasing

Once the sculpture is out of the mold, the hard work begins. If the sculpture is an even thickness, if the mold was well made, if the burnout furnace was correctly adjusted and if the metal was properly heated and poured, then the final work should be an excellent casting and easy to finish. If any one of these procedures is not completed correctly, the casting may be only partially acceptable and a problem to complete. Any imperfections must be corrected by chasing. Chasing is the process of removing unwanted metal or reshaping metal.

Some of the more pronounced casting problems are listed: A *misrun* is when the mold is poured too cold and the metal does not fill the molds. A *cold shut* occurs when the pouring was temporarily halted or splashed resulting in two layers of unmatched metal. *Gas pockets* are usually a result of the pouring temperature being too high. *Blow-outs* occur when the moisture in the core is not sufficiently removed.

Misrun.

Gas pocket.

Blowout.

Sculptor Mort Scott cutting gates with a reciprocating saw.

Other problems are *flashes* (thin slices of metal following cracks or layers in the mold) and *shrinkage cracks* (caused by thick sections adjoining thin sections or failure of the metal to stretch over the core). Good chasing can correct many of these problems, especially if they are minor. However, a number of problems (such as large blowouts or large gas pockets) often require the work to be recast.

The gating system (defined later) is removed after the mold has been eliminated from the work. The tools can vary: a hand-held reciprocating saw, a carbon arc (arcing carbon rod with high-pressure air for metal removal), bolt cutters, a grinder or a portable band saw. (An oxyacetylene gas cutting torch or a TIG welder with a heavy tip and high heat will work, but less satisfactorily. See chapter 9 for a discussion on welding.) Avoid cutting into the sculpture surfaces. Stationary vises are useful for holding the work while cutting.

Some casting parts are cast considerably smaller than the final desired work, so they are often joined together by a TIG welder, or an oxyacetylene gas welder. Sometimes welding is used to patch or to change the texture. The metals joined together should be

basically the same thickness and have a clean surface. If the correct welding rod is used and the surface is retextured, the weld will not be noticeable (See chapter 9 for welding instructions.)

Eliminating flashes is generally a minor problem, unless there is a large number of them. They should never be knocked off from the side, but they can be chiseled off with a sharp chisel into the edge. Also, they may be filed or ground off; many finishing bits are available for this purpose.

Wire wheels are a good blending tool. They literally push down the surface eliminating sharp edges. Avoid ruining a good surface by overworking it, though, because the natural surface is usually the best.

Sometimes the sculptor adds texture by chasing tools personally fashioned from metal chisels. Tempered concrete nails furnish an excellent metal for special requirements. These special textures can be an imprint resembling the surface design most often used by the sculptor (this technique helps hide welding marks). Sometimes the specialized chasing tools (resembling leather-tooling implements) are used to produce fine details such as lines or other ornamentation such as tiny flowers.

Sculptor Patrick Villiers Farrow chasing The Leash. *Photograph: Michael Aleshire.*

Chasing with a wire brush. Shidoni Foundry.

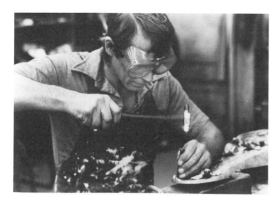

Sculptor Andre Harvey chasing Racing to the Sea.

Patrick Villiers Farrow, The Leash. *Bronze, 12' long, Rutland, Vermont. Photograph: Michael Aleshire.*

Patination

A patina is the finish or color on the metal surface. It can be natural, induced or false. If natural, the work is seldom tampered with; rather, it is just left to "age" for itself. If induced, a chemical generally is used to promote or hasten the patina. Perhaps it is to secure a color not otherwise obtainable. A false patina is one that is not part of the metal itself; rather, it is added to the surface. Paint would fall into this category.

Most of the following patina information applies to induced or human-made patina for bronzes.

The surface must be clean. Some sculptors "pickle" the sculpture in acid, but it is not necessary. A good sand-blasting can produce the same results;

however, touching the surface afterward is a violation because fingerprints affect the patina. When selecting sandblasting sand, choose fine sand (glass beads are ideal) in order to avoid harsh surface treatment. Also, it is preferable to use a sandblasing cabinet (pictured later) in order to capture and re-use the sand. A sandblasting cabinet also reduces the possibility of injury from the hard-hitting sand. Do not use soap to wash the final surface because it will deposit a thin film on the metal that resists a chemical patina.

The type of patination must be chosen. The most common are brush, spray or a combination of these. Brush patination is when the work is painted by brush with a chemical solution; it works well with a heavy brush and a

warm sculpture or solution. Spray is the method using a small sprayer (perhaps a clothes sprayer) to spray the chemical onto the bronze. It works well with hot metal. Take care to use a fine mist when spraying; large droplets of spray could spot the patina. Often the piece is both sprayed and brushed in order to obtain the desired results. This method provides a more fluid surface than spray but better coverage than just brush.

As the chemical is applied, the brush must not become too hot. If it does, it could melt and fuse itself to the metal (Only natural bristle brushes should be used.) A good heat is about 250° or where water will steam (hiss) but not ball up. The chemical should be brushed on evenly. The number of coats applied depends on the color or darkness desired. Be certain that the room is well ventilated. Always wear protective gloves, goggles and a chemical mask.

Basic chemicals for patination and the colors they produce are: sodium thiosulfate, dark brownish red; cupric nitrate, subtle greens, both light and blue-green; liver of sulphur (sulfrated potash), browns that go toward the black; ferric nitrate, light golden brown; ferric oxide, red or rust. These chemicals can be used alone and together, or one on top of another to arrive at new or subtle color values. Between coats, steel wool can be used for highlighting.

Since these chemicals are most often in powdered form, they need to be mixed into a solution of water before they can be used.

The most commonly used patina is *liver of sulphur.* One small spoonful dissolved in one pint of water is a good formulation to apply to a warm surface. When the desired color is produced (or slightly darker), dip the sculpture into water and use steel wool on it. Do not steel wool a hot bronze or it will

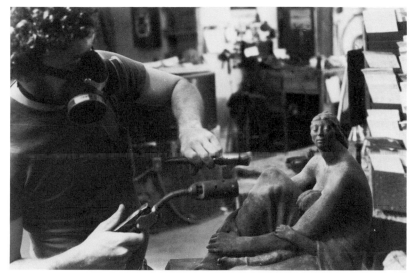

Brushing on the patina at Shidoni Foundry.

assume a silvery-lead look that is almost impossible to remove. Obviously, the less color that is rubbed off, the darker the work will remain. This liver of sulphur solution is good as a base formula, one that other chemicals can be applied over. Liver of sulphur can be applied to a cold surface and still offer good results, although the application takes longer than for a warm surface.

Another basic patina is *ferric nitrate.* One large spoonful to one pint of water will produce the proper solution. Apply to a warm surface, also. It is good over liver of sulphur for producing a darker golden brown. By itself, it often tends to be a light or golden brown.

To patina aluminum, the sculpture can be soaked in a diluted solution of acetic acid, though I do not recommened it. The acid creates a dull, middle-tone grey, flat surface. If a greater contrast is desired, use a good acrylic enamel black spray paint. Either wet-wipe it for a medium grey surface,

or allow it to dry and then wipe it for a sharp contrast. The paint seeks recess surfaces; therefore, the work receives a good deep color. The dark finish can partially be removed by rubbing it with steel wool.

Good quality, hard, noncoloring paste wax will help keep fingerprints at a minimum and retain or enrich the surface color. The best waxes are Johnson's (clear) paste or Treewax (clear). The waxes can be applied once the patina has been completed by reheating the work and applying the wax over it in a liquid hot state. The heat of the piece will draw the wax into its pores creating a good color.

Fritz Scholder, **Woman with Mask,** *1985. Bronze, 18" tall.*

If the surface needs a slight glaze or richer color, Esquire or Kiwi brown shoe polish works very well. While it does not dramatically change most color, shoe polish adds a rich glaze that becomes a permanent part of the sculpture.

Fritz Scholder demonstrates the value of contrasting surface colors and textures in his *Woman with Mask*. Because of the light versus dark, the mask takes on new significance.

The chemicals mentioned in this chapter are relatively safe to use. However, using an excessive amount over a prolonged period of time in a poorly ventilated room could cause hazardous results. Please research and remember all hazards inherent in the chemical makeups. Many more chemicals and formulas are possible for the experienced patina applicator. Avoid using patina formulas out of textbooks without checking with a chemist, however. Never mix one formula with another foumula or fatal gases can result.

Acids are often used for patination, though they are not recommended. They get fast results, but are often difficult to control as they continue "eating" after the color is finished. Also, they require special ventilation, handling and equipment not otherwise necessary.

Polishing Bronze
Securing a highly polished surface on cast metals requires a great deal of work. A reflective surface requires excellent casting, chasing, spot welding, sanding and buffing. Special finishing is also demanded to retain the luster.

Many of my bronze works require a mirror finish. I follow a definite procedure to secure this finish.

1. The work is cleaned (sandblasted) and flaws (holes) in the metal are spot-welded (TIG) and ground down.
2. The work is then sanded with a pneumatic disk sander using very coarse 24-grit paper followed by 50 and then 80.
3. The work is checked again for defects. They are spot-welded and then carefully removed with a small 5-inch disk grinder.
4. The work is resanded with an 80-grit disk followed by a random orbital sander with 80 grit, 100, 150 and 220 grit.
5. Hand-sanding is begun when there are no more flaws to spot- weld. I begin with 220 grit, the same grit as the orbital sander finished with, in order to remove the swirls that the random action left. All hand-sanding is done with wet-or-dry sandpapers and water. The water lubricates the bronze and keeps the paper from clogging. Sandpaper grits of 320, 400, 500 and 600 are used.

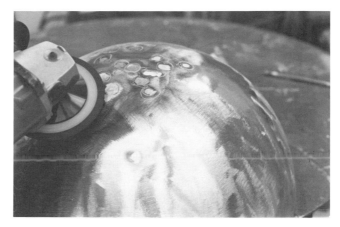

Removing spot welds with a small disk grinder.

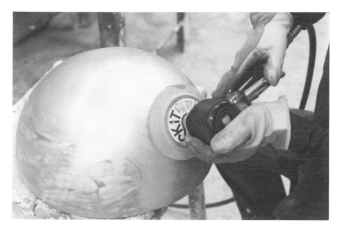

Using a random orbital sander with progressively finer grit sandpaper.

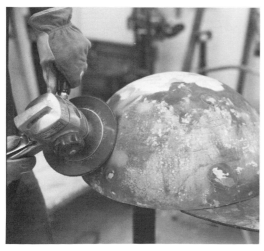

Sanding with a large disk sander and coarse sandpaper.

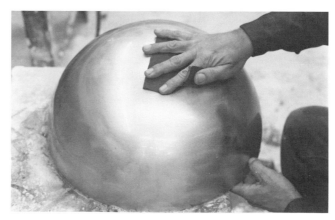

Wet-sanding by hand.

173

Buffing and polishing.

Coating the work with a lacquer can be tricky, depending upon the size of the work. Smaller works can easily be sprayed with an airbrush (use the proper respirator and ventilation). The lacquer must be thinned at least 50% with the correct thinner in order to avoid drips. Larger works are not as easily finished. Take care not to coat the work too heavily or a dull finish devoid of reflection will result. If a problem occurs, the finish can be removed with thinner (wear rubber gloves), then recoated.

6. Afterward the work is buffed with an air buffer (the same as used by automobile finishers) and rubbing compounds. (Smaller works can be held up to a bench grinder fitted with cloth wheels.) The work is finished with a clean buffing head and polishing compound. If any flaws appear, then I go back and re-sand with a coarser grit and repeat the necessary steps.

The finish will not last beyond the first fingerprint or spell of high humidity unless it is coated with some form of protection. Wax will work but lasts only a brief time. The best coating is a lacquer such as Incralac© Lacquer available from Stan Chemicals, Inc.; it is formulated especially for this purpose.

Lost Wax Process

Lost wax casting is the process of placing a mold about an artwork made of wax and then melting out (losing) the wax to leave a hollow form. Hot liquid metal is then poured into the mold to form the sculpture. The two major processes of lost wax casting utilize the investment mold and the ceramic shell mold. Both of these processes use similar methods of preparing the artwork.

Preparing the Artwork

Wax for Modeling. Sculpture wax can be most any kind of wax: beeswax, paraffin or petroleum-based waxes. The latter are most often used since they are the least expensive. Of these waxes, Victory Brown is the most popular microcrystalline wax. Often the sculptor chooses to mix several different kinds of waxes to obtain specific hardness or pliability sometimes producing softer waxes for use in winter and firmer waxes for summer.

There are various ways to work with wax including making wax sheets, using hard cold wax or using warm wax cubes. Since most commercial waxes come in thick heavy sheets too large and thick to use, the best way to work them is to cut or freeze and break cold sheets into smaller pieces and place them into a metal bucket of hot water. Tap water, as hot as possible, will soften the waxes. After soaking about 15 minutes, the cubes are ready to work. Fresh hot water should be added as necessary to keep the wax soft, especially if the wax cubes are large and require a longer soak. Afterward, the cubes are easily packed together and shaped by hand or tools. Once cold, the wax firms up, allowing for finer details to be added. If you choose to work in thin sheets of wax, they are easily made. First, dampen a plaster slab with water (preferably cold), then pour melted wax onto it in the desired thickness. The wax is easy to remove when it solidifies.

Wax-working tools can be quite simple. A table knife or a flattened spoon serve well. There are several commercial tools available, including those in the shape of a spatula, wire-end tools, boxwood tools, small dental-type tools for very fine detail and so on. A portable butane torch, wax candle or gas burner flame can help achieve a smooth surface. (CAUTION: *The wax surface can be destroyed quickly by hot flames. Also, heated wax will adhere to skin and burn it.*)

The works pictured demonstrate different uses of wax. Mirtala's *The Narrow Gate* still has the feel and look of a large slab of wax, while Buckner's *Rosanna* is extremely fluid. Gross's *Night Rain III* shows evidence of the use of fingers as tools.

Warming chunks of wax in hot water.

Pouring melted wax on dampened plaster.

Removing cooled wax sheet from plaster slab.

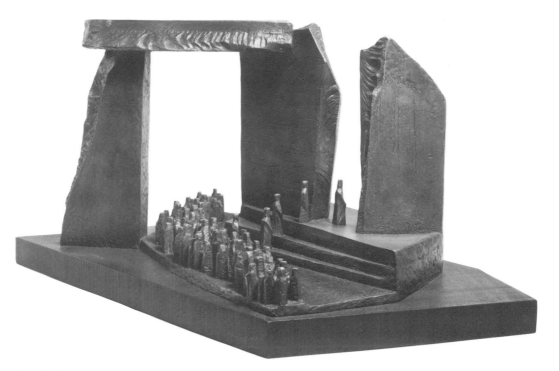

Mirtala, The Narrow Gate. *Bronze.*

Hal Buckner, Rosanna. Bronze 9″ tall × 22″.

Charles Merrill Gross, Night Rain III. Bronze, 16″ × 18″.

Selecting the Mold System. A wax original can be used without any type of preliminary molding when using plaster investment or ceramic shell processes, unless an edition is desired. A thin wax original of even thickness (preferably not over 1/4 inch or 3/8 inch) is ready for immediate venting and spruing. This procedure is *solid casting* (no core or hollow inside).

If the work is to be one-of-a-kind, is too thick or too solid to cast with a core, but is too small to slush out, then it can be *hand-cored.* Cut the piece in two and hollow it out to about 1/4 inch thickness. Add core pins (1″ to 2″ long wires inserted through the wax wall, for the core mix to rest upon, and left hanging outside the wax for the mold material to grip) and then completely fill the inner part with a core mixture (a formula is given later in the chapter). Either leave open the opening (which is preferable) or seal it with wax and a 1/4 inch finished surface. *The slush shell* is used if the wax original is large or has a large volume; it needs to be cast with only a thin, outer shell. In order to achieve this, the work must have an opening that will allow room for core filler, or ceramic shell (if ceramic shell process), to be added to the interior. If a ceramic shell has a large opening, slurry can be dipped for the interior in the same manner as the exterior and allowed to dry completely between each coat. The inside will attach itself to the outside for strength. (Fiberglass dipped in slurry can be added at the lip for extra strength.)

Though rubber molding is preferred for edition works, the sculptor can make the mold out of plaster. (Consult chapter 4 for piece molds.) The mold must avoid undercuts and have an opening large enough for the wax to enter and be drained. The plaster mold is thoroughly wetted and then immedi-

Pouring wax into small plaster molds.

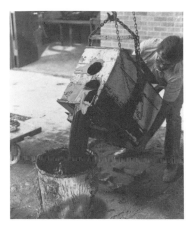
Slushing a large mold with the aid of a hoist.

Large automatically controlled wax melter.

Roasting pot used a a wax melter.

atley slushed after the surface water soaks in. The resulting work requires some cleanup and is soon ready for the addition of the running gate.

Maintaining the wax at a good slush or pouring temperature is essential. A large wax melter with thermosetting controls is ideal but not always available. A large roasting pot with temperature controls also is very useful. If neither of these are available, then the wax can be melted over a burner in a large container with high walls to avoid flaring up. The melting wax must be watched closely and the burner turned

off immediately after the wax has melted to avoid fires. The wax must then be left to cool to the point where a skim is beginning to form. At that time, it is ideal slush wax that is good for 5–15 minutes use before it has to be reheated.

Adding the Pouring Gates. A structure must be in place whereby the molten metal can enter the mold. A *pouring gate* (also known as a *running gate, runner system* or *gating system*) is a series of passages that allow the metal to flow into the cavity left by the lost wax. This system is constructed of wax and consists of a pouring cup, sprues, runners and vents. (A number of pouring gates are illustrated in the demonstrations in this chapter.)

The wax *pouring cup* should be placed at least 2 inches above the highest point on the sculpture for

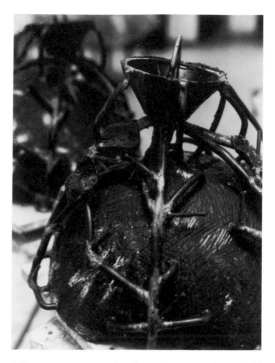

The runner system in place. Later castings of this work were completed with fewer sprues.

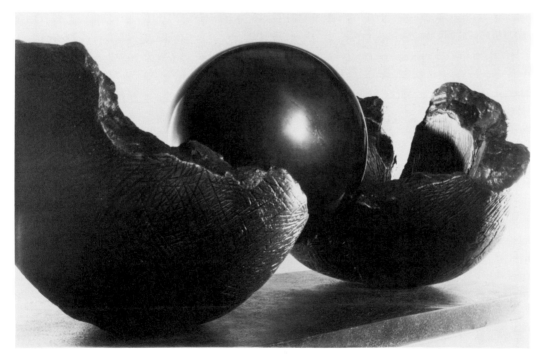

Arthur Williams, Open Seed. *Silicon bronze, 16″ tall × 32″ long × 16″ wide.*

bronze, higher for aluminum. The sprues—the passages through which the metal flows—are then placed in different locations on the work depending upon the size, shape, surface texture and thickness.

Ordinarily, the major *sprues* are placed on the bottom or lower part of the sculpture. This positioning allows the metal to flow uninterrupted down to the bottom, then to rise up through the mold. On a small work, the metal can fill through the top, since it will fill quickly without the possibility of freezing (solidifying) before the pour is over. On a larger work, if the metal enters through the top, it will splash around the mold. Since the mold is colder than the metal, small splashes may solidify and block the flow of other metal, causing air pockets and an unfinished surface.

Runners connect the sprues to the mold cavity. Before adding the runners, the sculpture is placed in a position where it has the fewest undercuts (parts that will trap air and not allow metal to enter).

The *gating system* is easily attached since it also is made of wax. A heating iron most often is used to apply heat directly to the joint. Some waxes are designed to be extremely sticky when heated and produce adhesive qualities that provide additonal strength to the joint. Care must be taken not to harm the texture or shape of the sculpture when adding the pouring gate.

There is no rule as to where to place runners except to place all of them in the same direction. However, sculptors need to remember that runners will have to be removed by chasing. The surface is then cleaned or textured to fit the rest of the work. Thus, it is a good idea to place them on convex areas, since they are easier to clean after the metal freezes.

The distance between runners is determined by the wax thickness, size of the work and so on. There is a growing trend for larger and fewer runners.

The *vents*, or risers, are passages that allow the escape of air and gases. They are added last and are attached to the upper parts of the work. Usually, two or three air vents are adequate for a small sculpture, more are required on a larger work. All undercuts should have risers that allow the air to escape while the metal enters. The vents can be smaller in diameter than the sprues. On a very large work, it is good to use hollow risers in order to allow the wax to burn out and quickly escape.

The J-MAC Precision Waxer is used for venting and spruing with a wide range of instantaneous heat. Courtesy of J. F. McCaughin Co.

Hollow vents.

The wax needs to be at room temperature and must remain that way until the mold is placed in the burnout furnace. Heat causes the wax to expand and cold causes the wax to shrink. If the wax shrinks or expands, it may fracture the mold material.

As the metal enters the empty mold, it pushes the air and gases out through the vents. If the poured metal flows out the vents, this indicates that the entire mold, sprues and vents are filled, and the casting will be successful.

Plaster Investment Mold

Sculptor William N. Beckwith demonstrates the lost wax investment mold process by using plaster investment. He is producing an edition of ten bronzes entitled *Temple Drake* from an original plastilene figure on an aluminum wire armature.

Molding Process. The sculptor divided the figure in two parts, split at the waist to make a flexible mold. (See chapter 4 for flexible molds suitable for wax.) After removing the original model, the mold is reassembled and held in place in the mother mold with a small rope. The mold is filled with 150° Victory Brown microcrystalline wax, which is then poured back into the melting pot. This procedure is repeated until several layers of wax are slushed into the mold. As each layer builds up on top of the previous layer, the thickness becomes a uniform 3/16 inch. Once the wax has cooled, it is removed from the mold and retouched.

The wax figures are prepared for the investment mold. The wax vents and sprues are constructed and attached to the artwork by heating a metal tool and welding the pieces together. Only one-half of the runner length is added at

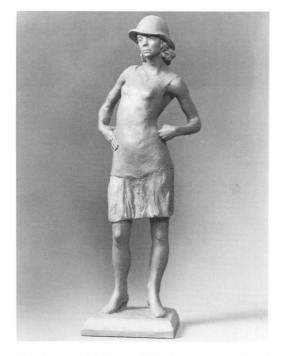

Plastilene model from which the wax models will be made. Photograph: Bill Martin.

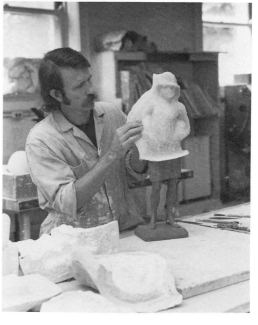

A two-part flexible mold is prepared. It will be supported by a plaster mother mold. Photograph: Bill Martin.

this time in order to facilitate the addition of plaster investment.

Wire is used for core pins. (This wire can be inexpensive mild steel or more substantial stainless steel.) These will hold the core in place as the wax is melted. The sculpture has a dried coat of liquid wax as a surface treatment to help the adhesion of the investment mixture. The wax is now ready for investment plaster.

The investment mixture must be mixed properly in order to withstand the high heat of the bronze. Plaster is added to room temperature water until the mixture is opaque on the hand. Masonry sand is added to the plaster in equal proportion to the plaster. This mixture is used for the surface detail cast. All successive coats need to be slightly more than one-third plaster to one-third sand to one-third Zonolite (a

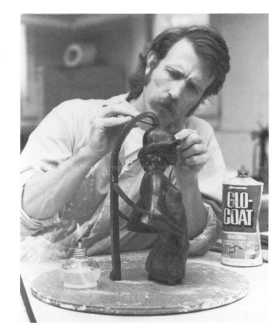

Constructing the runner system. Photograph: Bill Martin.

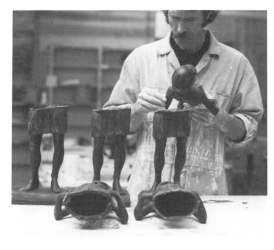

The wax models are retouched. Photograph: Bill Martin.

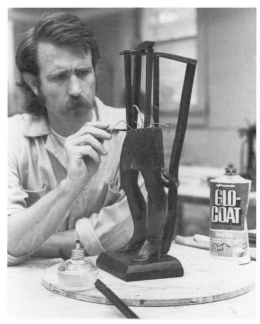

Core wire pins will hold the core material in place when the wax melts. Photograph: Bill Martin.

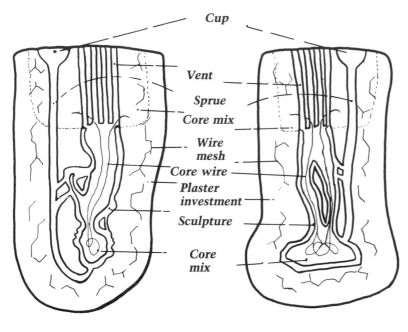

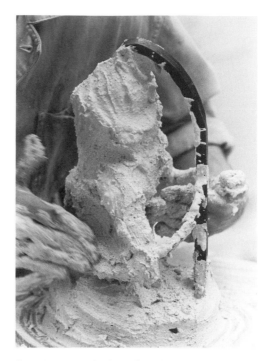

Cup

Vent

Sprue

Core mix

Wire mesh

Core wire

Plaster investment

Sculpture

Core mix

Cross-sectional diagram of the wax model and gate system within the investment mold.

The mixture is thickened with Zonolite and added with the hands. Photograph: Bill Martin.

refractory often found in garden nurseries).

The first layer is thrown by hand (see chapter 3) or brushed on in order to achieve a complete surface cover. The detailed area (eyes, mouth) is blown to eliminate any trapped air bubbles. Next the Zonolite mixture is added in successive layers. (*NOTE:* Never leave the first or early layers to dry out, because they will layer in the heated mold. Always try to finish a mold in one sitting.) After the mixture has been built up to 1 1/2 inches around the form, a layer of chicken wire is wrapped about the form. It is then covered with another layer of investment and inverted. Six additional inches of vents and sprues are added. Steel wire is placed in the core cavity to help as a reinforcement and to hold the core in place after the meltout.

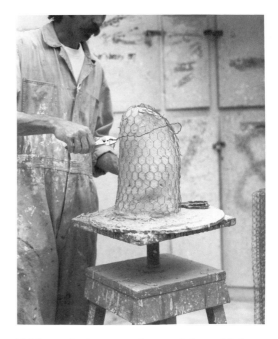

Chicken wire is wrapped around the molded form. Photograph: Bill Martin.

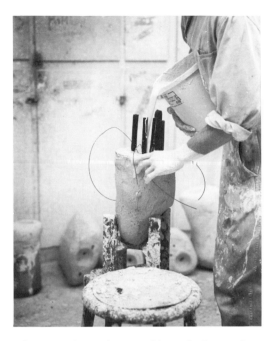

The core mixture is poured into the inverted mold. Photograph: Bill Martin.

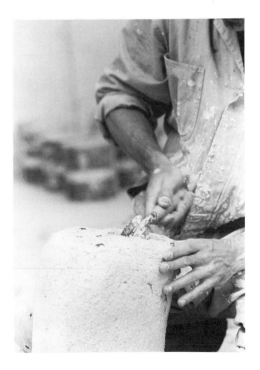

A pouring cup is cut into the plaster. Photograph: Bill Martin.

A loose mixture of plaster, sand and Zonolite, in equal parts, is poured into the cavity to form the core, making sure that all air has been allowed to escape (rocking or tapping the mold helps). More mold mixture is added to the upper portion of the mold where the vents and sprues are. A final layer of chicken wire is overlapped on the old mix but even with the top of the new mix. The wire is held in place with a mild steel wire.

The last layers of investment mixture are applied and a pouring cup (coffee cup size) is cut into the plaster before it has time to reach full strength. Note that the sprues are cut level and each one is visible. The mold is rubbed smooth for easier maneuvering and in order to avoid the possiblilty of loose investment pieces falling into other molds during burnout.

Burnout. The burnout furnace can be any one of several varieties. It can be a ceramic kiln with a reinforced floor, insulation bricks stacked about the mold with a portable burner or, in this case, a burnout furnace especially constructed for wax meltout. The one pictured is a natural gas updraft furnace, (which I helped to build 18 years ago).

The molds are usually placed in the furnace upside down (with the cup to the bottom) while they are still wet, allowing the steam from the water investment mixtures to help melt the wax and keep it from being absorbed into the investment mixture. The furnace door is stacked shut with firebrick. The molds must slowly be taken to a dull red color, less than 1500°. This ensures that all wax has been melted out. It is good to have a drain on the furnace floor to collect the melted wax in order to reuse it and avoid possible fires. Pyrometric cones are used to check

The molds are placed in the furnace upside down so the wax can be collected for reuse. Photograph: Bill Martin.

temperatures (Pyrometric cones are small ceramic pieces that stand upright and will bend and melt at precise predetermined temperatures.) Beckwith runs the furnace with the top vent open at its lowest setting for 20 hours. Next, the flue's opening is slowly closed as the burners are gradually turned up for the next 12 hours. The first cone goes down at 1200°, and the furnace is held at that temperature to allow a heat soaking of the molds. After a period of time, the temperature is raised until the 1400° cone is down. The gas and air mixtures are gradually reduced. There should be no flames from the molds, and they should now be pure white, dry and calcined. Finally, idle temperature is achieved. Now the mold is ready for metal.

Casting. The furnace is lit and readied for the casting. The burnout furnace door is slowly opened to prevent thermoshock to the molds. As the molds are removed, they are turned right side up and buried in a sand pit. (Insulated gloves must be worn.) Care must be taken not to get sand into the molds as it is slowly built up about the mold. Sand helps insulate the mold and serves as a stop-gate to possible mold leakage.

The metal is poured. The sculptor leaves the undisturbed mold in the sand pit overnight. Once the mold is removed from the sand pit, the casting is broken out of the mold by means of hammers, chisels, wire cutters and the like, taking care not to scar the casting. Wire brushes, high-pressure water and sandblasting can all be used to remove the investment. Beckwith uses a grinder to eliminate the sprues and vents.

Finishing. The figures are chased with hammers and chisels, grinders, files and sandpapers. Chisels are used to remove small flashings. The sculpture is then welded together with an oxyacetylene torch and a bronze rod. After the weld is completed, it is ground and chased back to the original shape and texture. The piece is cleaned and then a hot patina is applied, as illustrated earlier in this chapter. Highlighting is done with very fine steel wool. A thin coat of clear paste wax is applied and buffed. The final work is pictured.

The molds are placed right side up in the sand pit and the pour begins. Photograph: Bill Martin.

Chasing the sculpture. Photograph: Bill Martin.

The investment mold is broken off. Photograph: Bill Martin.

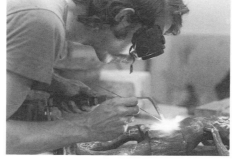

Welding the parts together. Photograph: Bill Martin.

The sprues and vents are ground off. Photograph: Bill Martin.

William N. Beckwith, Temple Drake. Bronze, 24" tall. Photograph: Bill Martin.

Ceramic Shell Mold

The ceramic shell mold is another investment process similar to plaster. However, it is composed of a ceramic investment material and uses additional equipment and procedures. The resulting works produce a better surface with fewer defects; consequently, the finishing time is greatly reduced.

Slurry Mixes and Cores. At the heart of the process is a slurry mix, the investment, made of small particles of fused silica placed in a liquid colloidal silica. The problem is to keep the particles suspended because they readily settle out and can harden. The most common process is to keep the ingredients suspended by constant mixing with a machine called a slurry mixer. Another way is to mix small amounts of slurry as needed, but this method often produces a lot of waste. The third way is to use Shell Spen, a suspended slurry mixture offered solely by Shell Spen International Manufacturers. However, the cost is high compared to other mixes.

Slurry mixes vary and new products are regularly introduced. It is best to contact individual manufacturers for the best formula to use with their products. However, the following is a proven formula:

Slurry Mix (can be scaled down)
　Nyacol 1430 Colloidal, 30 gal. (comes in 55-gal. barrels)
　Ransom Randolph sil 4 silica, 550 pounds (comes in bags of 100 pounds or less)
　Victa-wet wetting agent, 9 ounces
　Antifoam, 4.5 ounces
　Re-dip indicator, 24 pts blb ounces

The mixture can be checked by viscosity (after 12 hours of mixing). It should take 35–40 seconds to pour from a no.5 Zahn cup. More colloidal silica can be added to thin the mixture, or more fused silica can be added to thicken the mixture.

The Ransom Randolph Company offers a new prime coat that renders a good surface for adherence to wax. The commercial name is Primcote. Additives, antifoam and wetting agents are already contained. The only other ingredient necessary is refractory flour.

After the work is dipped, it is ready for the dry coat. Ranco Sil A is used for the dry coating after each of the first three dips.

Ranco Sil B is a heavier silica used for the dry coating after each of the remaining dips (three or more).

Large ceramic shell molds can be cast hollow, without a solid core. However, small works often need cores. Again, it is good to contact manufacturers about the latest available mixes, but the following two core mixes have been proven to work well:

Core Mixes

1. Add one part plaster, one part Ultrocal, two parts fused silica with one part zircon sand and mix. Then add water until the mix is like a heavy thick cream.
2. Using more readily available supplies, add one part plaster, one part clean river bed sand with one part silica and mix. Add water to achieve a heavy thick cream-like mix.

Slurry Mixers. The slurry mixer is designed to keep the heavier particles of the slurry mix in suspension. Usually the container is stainless steel or

fiberglass to prevent corrosion. The blade, which resembles an outboard motor propeller, is on a stainless steel shaft that turns at a slow r.p.m.. The machine has a timer that can run the motor for 5 minutes, for example, and then shut it off for 5 minutes. Larger machines have a timer that allows longer stirring periods when the mixer contains more slurry.

The mixer system I designed has three large, extra heavy-duty fiberglass garbage cans that serve as slurry containers. Two of these are on a belt-driven gear reduction motor with a timer. If necessary, they can easily be raised by means of a winch. Additional machines are pictured. All of them have a large enough capacity to dip big molds.

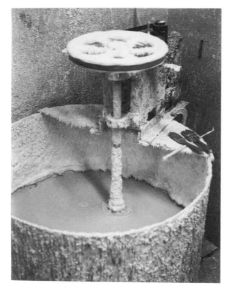

Slurry mixer commercially built by J. F. McCaughin Company.

The slurry mixer used at Rendezvous. It is a simple sprocket reduction motor.

Slurry mixer designed by the author with a winch to lift the blades for larger dippings.

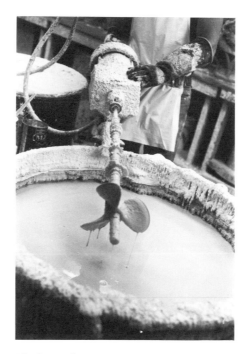

The large slurry mixer at Shidoni has a mixer that can easily be raised and swivelled to one side for large dippings.

A swing door burnout furnace I designed with overhead venting, a long door handle and a roll-out tray. A mold, which has just been rolled out of the furnace glows orange throughout.

Burnout furnace commercially built by J. F. McCaughin Company.

Burnout Furnaces. The burnout is accomplished in a specially built furnace with heating properties similar to a ceramic kiln, but with a reinforced floor to hold the weight of the molds and a drain for letting out the melting wax. It heats at a rapid rate to facilitate the casting but does not exceed 2000°. Though the wax does drain out, the drained wax is seldom reusable in ceramic shell casting.

The molds must be put in this furnace while the temperature is in excess of 1000°, preferably over 1500°. The furnace remains on during this process, so the molds are placed cup down on a stainless steel tray that can quickly be inserted into the furnace. The furnace is closed as rapidly as possible; the high temperature must be instantaneous in order for the wax to melt immediately without fracture to the mold. Never should the temperature drop below 1000°.

There are four basic types of burnout furnaces:

1. The *swing door* furnace has a vault-type door that can be opened and closed rapidly. A tray to hold molds often is moved into and removed from the furnace by means of a metal cart.
2. The *overhead door* furnace allows rapid operation and loading similar to the swing door.

3. The *raised* furnace fits over a floor of molds. Counterbalanced weights make lifting easy.
4. The *raised floor* furnace has a floor that is loaded with molds and then slides up into the furnace.

The time for burnout may vary slightly, depending on the size, number or kind of mold. Most small molds can be completley burned out within a 45-minute period. However, large molds may take over an hour to dewax completely. When completed, the mold must glow orange throughout. It should not have any dark places on it anywhere. (If a small blue flame is visible from the mold openings, the wax has not been completely burned out.)

If core molds are left in the furnace for too long a period, they begin to weaken, and any metal pins used in the core will gradually disintegrate. However, molds with an inner core must be burned out longer, perhaps twice as long, as those without a core, in order to eliminate the moisture contained within the core. (A wet core will cause a miscast and possibly an accident during the casting process.)

After the burnout, the mold is removed from the furnace. Though the molds are now lighter, they are difficult to handle due to the extreme heat. Be careful. (If the molds have fractures or cracks, they can be patched with a heat-setting cement or a mixture of slurry wettened fiberglass.)

Raised burnout furnace built by Rendezvous.

Raised floor burnout furnace built by Shidoni.

189

A prewarmer built by sculptor Terry Gilbreth.

A fiberglass mother mold is secured.

The wax model is removed from the mold.

Prewarmer. Most foundries place the molds in a prewarmer after they have cooled down. It usually is a large gas-heated container in which the molds are heated uniformly, prior to casting. A lid usually is added to maintain the heat. Red-hot firebricks placed in a sand pit prior to casting will accomplish similar results as a prewarmer. The molds are reheated in the burnout furnace and then covered with the sand.

The Rendezvous Bronze Works of Buffalo Gap, Texas, demonstate a ceramic shell mold casting. The work is *F.D.C. Eagle* by Robert Taylor. The original model was done in modeling clay and is being cast in a large edition.

Molding Process. The mold is made of Smooth-On flexible mold material. To serve as a support mold (mother mold), this foundry often uses fiberglass reinforcing molds. They take less time to make, are lighter and easier to handle, even with a work this small. However, making fiberglass molds requires excellent ventilation, chemical respirators and rubber gloves. It also involves the use of chemicals. (For more information about mother molds and flexible molds, see chapter 4.)

Once the flexible mold is prepared and cleaned, it is given a coat of urethane release agent. It is reassembled in the fiberglass mold and ready to be poured with wax. The pouring wax is Victory Brown and PX 20 Pink slab, mixed 50/50 for hardness. The wax is first poured at 200°, then 180°, 175°, and the last pour is at 150°. The final thickness is 3/16 inch.

Those four successive coats of wax have a cool-down time of 10 to 15 minutes between each coat. After the wax has cooled, the piece is carefully removed from the mold.

Because of the thin delicate wing structure, this work requires many runners, seemingly an excessive number, in order to allow the liquid metal the access required by such thin areas. (Most ceramic shell works require few runners and are easily vented.) A pouring cup with 3/16 inch walls is attached. Bent core pins, made from 030 stainless steel MIG welding wire, are placed through the center of the work to hold the core in place. The core itself will be added later.

The wax model is first dipped in a solution of xylene (or a mixture of 50% denatured alcohol and 50% acetone) to be ready for the ceramic slurry dip. This solvent cleans any trace of grease off the surface so the slurry will adhere. The model is then sprayed with water for a final cleansing and allowed to dry.

The work is dipped into the slurry (the mixture of suspended silica and binders), drained, quickly coated with dry silica and allowed to dry. Rather than coating pieces by hand with dry silica, the works can be placed in a fluidized bed. In a fluidized bed, compressed air is expelled upward and causes the sand to float, providing a simple method to coat a mold. After drying, the piece is coated with liquid colloidal silica and dipped into the slurry again. Respirators must be worn to avoid breathing the silicas. The process is repeated for three dips, then a more coarse dry silica (mulgrain) is used for several coatings. After the final dip, the work should be about 1/4 inch thick or thicker.

Rendezvous now clears out the inside of the pouring cup, cuts a hole in the hollow sprue, and pours in a core mixture. This procedure helps to avoid a solid casting in the middle. The wax now can be removed.

The runner system is constructed.

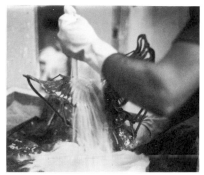

The model is coated with dry silica while still wet with slurry.

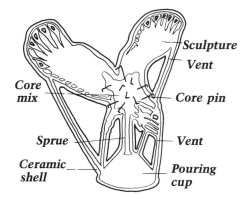

Cross-sectional diagram showing the model and gate system.

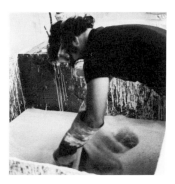

Using a fluidizer bed for a rapid coating.

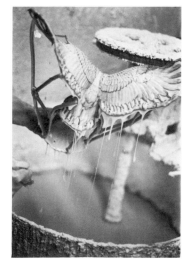

The model is dipped into slurry.

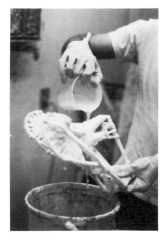

Liquid colloidal silica is poured over the dry model.

The glowing mold is removed from the furnace.

Sandblasting to remove the ceramic shell.

Burnout and Preheating. Wax is burned out in the burnout furnace. The molds are placed in this preheated furnace at a temperature from 1500° to 1800° with the pouring cup open and down. This temperature causes the wax to melt immediately, avoiding mold breakage from slow expansion. The time for burnout may vary because of the heat and mold size; this one takes 45 minutes. The mold is now removed from the furnace.

Rendezvous allows the molds to cool down to check for cracks. If necessary, they are patched with a heat-setting cement. Next, the molds are reheated in a gas-operated prewarmer to temperatures of about 750°. The molds are left in the prewarmer and the hot metal is poured.

Finishing. Breakout time varies. It can be soon after a casting or at a much later time. Our demonstration mold sets for 1 hour before the breakout. Immediate breakout would endanger the casting since the metal is considerably weaker in the red-hot stage. Safety glasses and gloves should be worn when breaking off the molds.

Cleaning tools can be hammers, chisels, screwdrivers; a welding chipping hammer is ideal. The mold and pouring cup can be struck but not the bronze sculpture.

The pouring gate (the entire system of vents and sprues) is removed. A light sandblasting helps remove the shell. The work is welded, chased and patinated with a coat of liver of sulphur, followed by a coat of ferric nitrate for a more golden color. The work is waxed and mounted for final viewing.

Robert Taylor, F.D.C. Eagle. Silicon bronze, 16″ wingspan.

Sand Casting

Sand casting can be a very simple or very complicated process, depending upon the exact method chosen. All processes involve packing sand around the sculpture pattern, then burning out the pattern with hot metal or disassembling the sand mold, taking out the pattern and reassembling the mold. A more complex sculpture may require a core to be added prior to reassembly. Since the sand is porous, only minimal venting is necessary, but the porous sand creates a rougher surface on the casting than that which results from investment casting.

Commercially available aluminum flask consisting of the cope (top piece) and the drag (bottom piece).

Home-made flasks. Courtesy Rendezvous Bronze Works.

Basic Sandcasting Tools

The *flasks* are containers to hold the sand and the original work. They are at the heart of pattern making. The cope, which is the top container, and the drag, the lower container, must be perfectly aligned. Commercial light-weight aluminum flasks are available. However, if budget is a problem, sculptors can construct their own flasks out of wood.

Speed riddles, also called *power riddles*, are used to mix, aerate and screen molding sand. They can be used with either water or petroleum sand. Sand preparation time is greatly reduced by the use of speed riddles.

Hand riddles are used for sifting the sand, especially the print coats, the sand that is next to the model. They can be purchased or made with different size screens.

Typical *molders tools* consist of a lifter, trowels, a rammer, spoons and gate cutters.

Speed riddles are used to mix and screen sand.

Hand riddles are used to sift the sand.

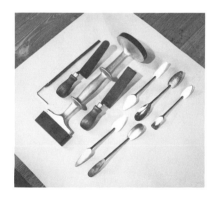

Molders tools. Photos this page courtesy McEnglevan, except where noted.

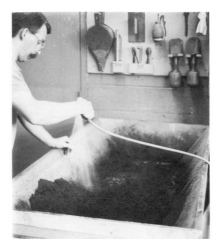

A small amount of water is added to the green-sand and it is mixed with shovels.

The sand is put through a power riddle.

Properly tempered sand holds together when squeezed and breaks cleanly.

Green-Sand Casting

This sand casting method is a quick and easy way to cast patterns and works that normally do not require great detail. The cost is minimal since the sand is reusable. The following demonstration shows a match plate pattern, but other patterns are cast much the same way. Jim Cooke is the instructor in this demonstration.

To prepare the sand, it must be mixed with a small amount of water. In order to facilitate the mixing, a power riddle is used to help agitate the sand into smaller pieces. The sand is properly tempered when a fistful can be squeezed together, then broken, leaving a clean break and no mud on the hands.

The pattern (sculpture model) is placed between the flasks. The pattern is usually of a hard material (e.g. plaster or wood) that is halved and reassembled on either side of a flat plate (board) so that each piece is cast without undercuts. The pieces are placed on the plate with removable dowel pins so that they

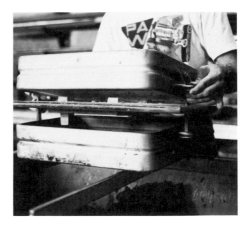

The pattern is placed between the cope and drag on the flat plate.

can be removed easily from the plate and later lifted from the sand by the pins. The halves must line up, top to bottom, in order to be properly aligned when cast. Also, they must line up with the flask pins on the cope (top) and drag (bottom). The pattern and plate should already have been shellacked or otherwise coated to help the surface be removed from the sand. The release agent is placed in a small bag and dusted onto the surface.

The pattern in the drag portion is now riddled with sand through a small mesh screen to secure a better surface. Once the pattern is completely covered, a larger mesh screen is used to speed the process. The sand is rammed, and then the excess is scraped off with a strike-off bar. The flask is now inverted with the other side of the match plate up and the drag placed on a hard flat surface. The process now is repeated in the cope side and the flask is separated.

Release agent (talc or chalk) is applied to the pattern and plate.

The sand is rammed into the flask.

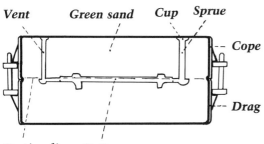

Cross-sectional diagram of the pattern and runner system.

Excess sand is removed with a strike-off bar.

The flask is separated when both sides have been prepared.

195

A hollow pipe is used to form a vent sprue and pouring cup.

Removing the pattern.

The sprue and vent are gated to the pattern.

The cope is now vented and sprued using a hollow pipe by slowly twisting and slightly rocking it into position and then removing it. A pouring cup also is formed. Once the pattern is removed, the sprue and vent are gated to the pattern. The cope and drag are united, being pinned together. The flask is now placed down ready to pour.

The pour is easy and has good results as metal appears out the vent, demonstrating a filled form. After a period of time (15 minutes or so), the mold is easily taken apart revealing the piece with runners still attached, ready to begin the finishing process.

Casting a one-piece pattern is a very similar process. Place the drag upside down on a hard flat surface. The one-piece pattern is placed in the drag and coated with a release agent. Riddle the drag full of sand, ram it up and strike it off. Fill the cope with riddled sand, ram it up and strike it off. Slowly remove the pattern from the drag with draw pins. Cut a riser and sprue in the cope and a pouring basin and gate in the drag. Reassemble the flask. The work is now ready to pour.

The pour is successful, indicated by the metal appearing at the vent.

The cast piece is ready for finishing.

Carving Sand for Casting

Flask-packed sand can be carved and then liquid metal flowed over into it. This method is ideal for reliefs, though the metal will freeze rapidly, faster possibly than is expected, and the details often suffer.

Also, two separate and open-ended flasks (cope and drag) can be easily carved and cast. After one flask is packed and carved, the other flask is packed and carved, allowing for the thickness and fit of the design. Care should be taken that they are carefully measured for joining fits in the flask. When the cope and drag are finished and a sprue and vent have been made, then the flask is reassembled and cast.

Resin Sand Mold

Sculptor Geoffrey Broderick demonstrates the cored resin sand (chemically bonded) mold process. His original work is in plaster and this will be a one-of-a-kind casting. Since plaster can stick to sand, he brushes it with graphite powder as a release agent.

He uses PetroBond, an oil-based sand, as an inert ingredient to ram against the work, hold a seam line and eliminate undercuts.

A flask is especially designed for this particular piece. Since the final mold will have resin sand, the flask does not have to remain on the piece and can be made from almost anything capable of initially supporting the mixture. The flask should be large enough to allow several inches around each side and bottom of the work. (Later the runners will be added on one side of the allowed space.) The top needs little space since the pressure is not too great at that point. This mold will have three sides.

A generous portion of the PetroBond is shoveled in. The piece is placed into the sand, and the sand is packed around

it. A spoon is used to pack and smooth the sand against the piece. The seam line is positioned to avoid any undercuts. Since this piece is to be cored, it must have openings at the top and bottom. Small mounds of PetroBond are placed at the top and bottom of the piece. These mounds later will serve as openings for the core to be rammed (tightly packed) into. They will also serve to hold the core in place.

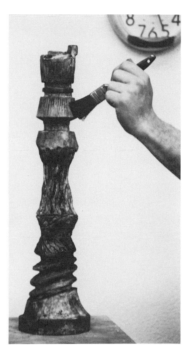

Applying graphite powder as the release agent.

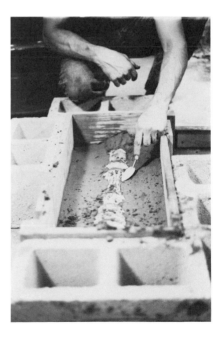

PetroBond is packed around the plaster original. Notice the mound of sand at the top of the piece that will form an opening for the core.

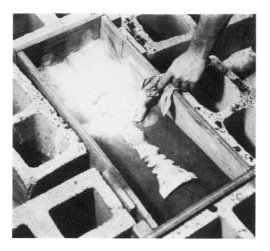

Talc is applied as a release agent before the resin sand is added.

A mixer for combining resin sand with bonding chemicals.

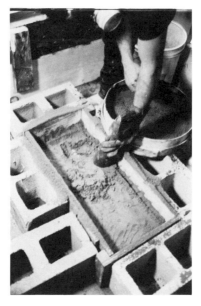

The resin sand mixture is rammed over the talced original and PetroBond.

The work is cleaned by blowing off the loose sand. An old sock filled with talc is used to powder all of the surface including the flask. Talc is used as a release agent.

The resin sand that will form the mold (Pep Set) now must be mixed. The sand and red iron oxide are added directly with the chemical bonding mixture into the mixer. The oxide helps the sand retain its integrity when the hot bronze touches it. The mixture of the chemicals is crucial and should be weighed. The mixture determines the working setting time and strength. (CAUTION: *A chemical-filtering respirator and rubber gloves should be used. The chemicals are dangerous to touch and to breathe.*) The mixture for the Pep Set used in this demonstration is 1 pound A, 1 pound B, 5 milliliters catalyst and 200 pounds clean silica sand. (Check with manufacturers for other particular mixes.)

A wire mesh sifter is used to apply the mixed resin sand print coat on the piece in order to obtain a good surface. The sand should be rammed over the surface, packed lightly at first, then gradually rammed harder until the mold is the necessary thickness. The sand sets overnight for maximum curing time.

Once hardened, the mold piece is removed to one side, the PetroBond is cleared away and the flask is readjusted so that the second mold part can be made. The sand is talced and more PetroBond is rammed into the second side in the same manner as described earlier for the back side. When the second part has cured, the process is repeated for the third and final piece. After the entire mold is hardened, the three pieces are taken apart and the plaster pattern is removed.

The piece is now ready for a core. Foam that is from 3/16–1/4 inch thick is cut to the shape of the sand relief and then taped together. The core will fit against the foam. When the foam is removed, there will be adequate space between the mold and the core for the bronze to flow.

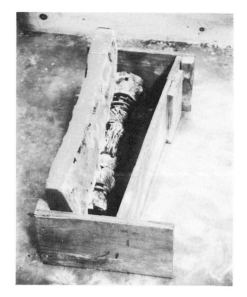

The PetroBond is removed when the resin sand is cured. The flask is readjusted to make the next mold piece.

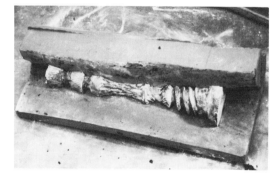

After the second part of the mold has cured, the PetroBond is removed.

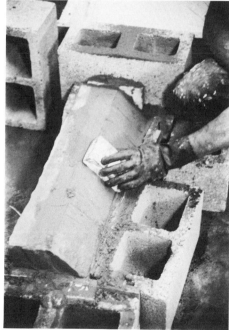

The final mold piece is made with the resin sand.

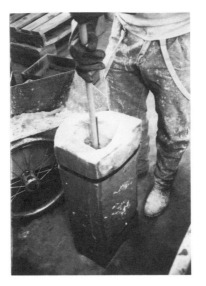

Ramming the core.

The mold is now ready to put back together. Once reassembled, the mold is banded on keyed marks with metal strips for extra strength. The core is made of a heavier grit sand and a weaker mix of chemicals to allow metal shrinkage into the core. A reinforcement bar is added to the core for strength. The mixture is carefully rammed into the core. After the core has cured, the mold can be taken apart and the foam removed. The runner system is marked and ground out for the bronze to flow into the piece. A die grinder can be used, or it can be done by hand using a square grinding stone.

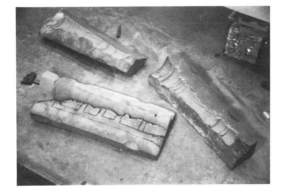

The mold is separated and the runner system is ground out.

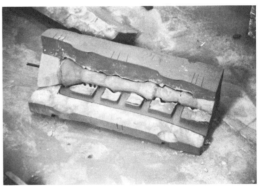

The core is put into place and the mold will be bonded together.

The outer surface and core is painted with core wash to help the surface. Commercial core washes are available, but they can be easily prepared using a mixture of 50% graphite and 50% alcohol.

The sculptor places the mold back together with the core in place and bands it. The mold is banded to hold it together tightly. On this work, a pouring cup is prepared and glued on top of the main runner with heat-setting glue. It is now ready to accept the hot metal.

Once cast, the mold is taken apart (broken) to expose the casting. The finished work is pictured.

Pouring molten metal into the mold.

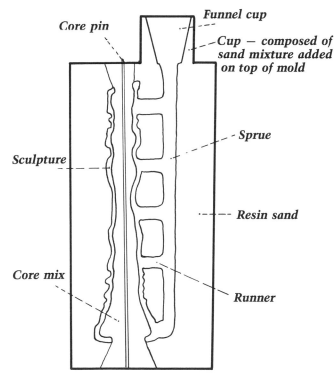

Cross-sectional diagram showing the cavity and runner system.

Core pin

Funnel cup

Cup — composed of sand mixture added on top of mold

Sprue

Sculpture

Resin sand

Core mix

Runner

The mold is broken off.

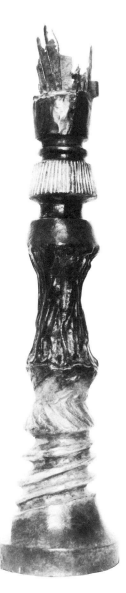

Geoffrey Broderick, Candle Holder. Silicon bronze, 23" tall.

Direct Displacement with Petroleum Bonded Sand

This process consists of packing petroleum bonded sand about a material that will be completely burned out (displaced) by molten metal. Green-sand also would work for direct displacement, but petroleum sand is chosen for our demonstration. Petroleum sand requires no other additives, and thus is very immediate for this quick process. The material to be diaplaced must be easily burned out without leaving residue in the solidified metal. Acceptable substances include Styrofoam (*not* urethanes, which produce highly poisonous lethal fumes when set afire), very lightweight balsa, a limited amount of corrugated cardboard, straw and other lightweight combustible materials.

The petroleum bonded-sand process is demonstrated with Jack Maxwell as the instructor and sculpture student, Keith McBee as the artist. Styrofoam

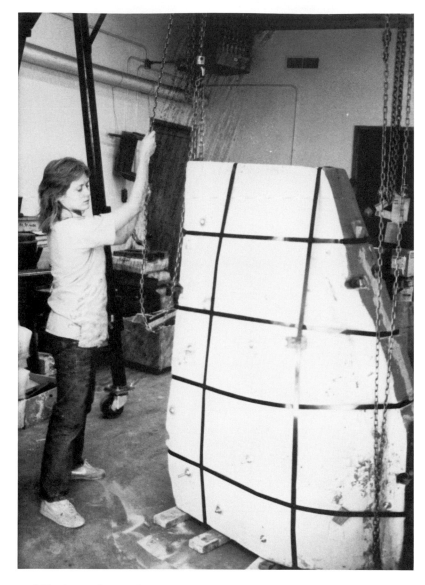

A Shidoni Foundry worker prepares a large sand mold. Sand molds are known for extremely large single casting.

Keith McBee makes his model from Styrofoam.

has been chosen as the displacement material.

The form is easily vented and sprued in preparation for the sand. The lower part of a 55-gallon drum is used for a flask. About 2 inches of sand is riddled into the bottom in preparation for the pattern. The Styrofoam piece is inserted and held in place as sand is riddled and rammed about it. Care must be taken to pack the sand tightly over all parts of the work. When near completion, only the vent and sprue show at the top. A pouring cup is formed about the sprue. The work is now ready to pour. Since petro sand contains a certain amount of oil, it produces smoke during burnout, as does the burning Styrofoam.

After sitting about 20 minutes, the work is broken out without a problem. It is now ready to begin the finishing process.

Sometimes the sculptor does not want all of the material to burn out. The results can be quite interesting as in Ted Rose's sculpture.

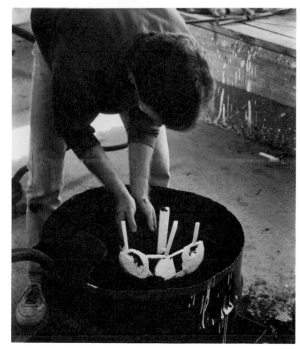

Sand is riddled and rammed around the styrofoam piece.

The sand is packed tightly until only the vents and sprue are visible.

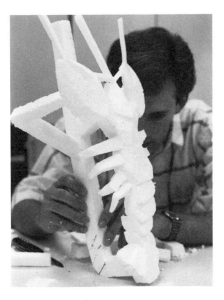

The Styrofoam is vented and sprued.

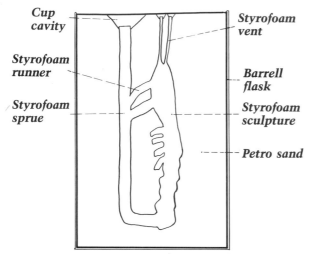

Cup cavity

Styrofoam runner

Styrofoam sprue

Styrofoam vent

Barrell flask

Styrofoam sculpture

Petro sand

Cross-sectional diagram of Styrofoam model and runner system.

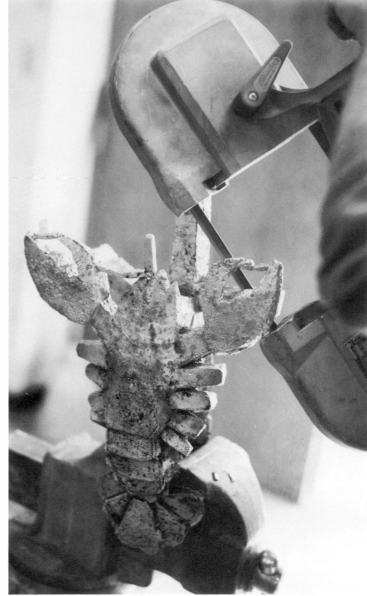

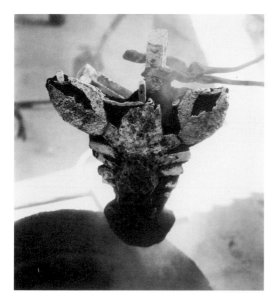

Removing the casting from the sand.

Cutting off the runner system.

Ted Rose, Friday's Night Broken Box. *Cast aluminum, 34" × 34" × 8" deep.*

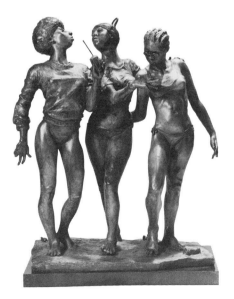

Joseph Sheppard, The Three Graces. *Cast bronze, 21" tall. Photograph: Tadder.*

Stanley E. Marcus, Piping Hot Jazz. *Cast and welded aluminum and musical instrument, 84" tall × 27" × 15".*

Harry Geffert, **The Creation of Eve's Consciousness.** *Bronze, 17″ tall × 130″ × 100″.*

Max S. DeMoss, Demetria, Demetria, Mother,
Daughter, Novice, But for the Icarus Flight?, *1986.*
Cast bronze and steel, 52″ tall × 16″ × 25″.

Colette Hosmer, A Destructive and Injurious
Rodent. *Silicon bronze,*
12¾" tall × 9½" wide × ½" deep.

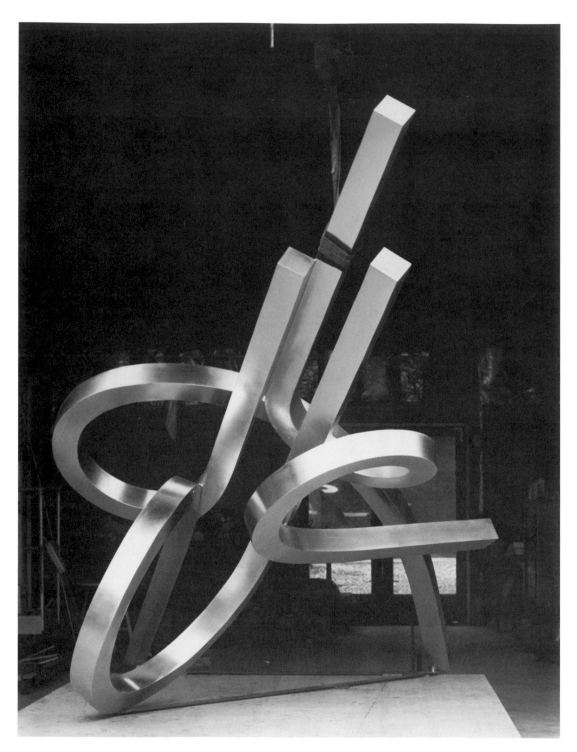

Jean Woodham, Interchange. Brass, 9′9″ × 14′ deep × 9′ wide, in studio. Sculpture now at Central Connecticut State University, New Britain, Connecticut.

9

METAL FABRICATION

- Metals
- Metal Cutting
- Oxyacetylene Cutting
- Arc Cutting
- Forming Metals
- Methods of Joining Metals
- Oxyacetylene Welding
- Arc (Electrode) Welding
- MIG Welding
- TIG Welding
- Metal Finishing

Some of the largest and most diverse sculptures of this century are made of fabricated metals. Sculptors continue to learn the possibilities of this medium as technology continues to advance. Consequently, metal fabrication is one of the most popular media available today.

In order to understand the use of fabricated metals, this chapter discusses the metals themselves and how to cut, form and finish them. Examples are given of all of the major techniques.

Metals

Either a metal is pure, or it is an alloy, two or more metals combined to create a metal with new properties. Some pure metals are iron, copper, lead and aluminum. Ordinarily, their alloys are less flexible (malleable) and harder, but the new properties may make the alloys easier to work with. They may be easier to weld, for example. Alloys are divided into two categories: ferrous containing iron (steel for example) and nonferrous, containing no iron (brass). The most commonly used pure metals and alloys are listed in the following discussion.

Aluminum is a pure metal, but generally only aluminum alloys are used for fabrication in order to achieve the hardness, weldability and other characteristics that are desirable. Aluminum has a low melting point and will collapse (slump) under too much heat, around 1100 F. It does not change its color when welded, it is lightweight, and it is corrosion-resistant. It is readily available in sheet form, thus making it a favorite metal of sculptors. Aluminum can be brazed, soldered and welded, though it must be very clean for each process. On larger works the best welding techniques include MIG and

TIG (discussed later in the chapter). The welding rod must be carefully selected for the alloy chosen. A properly prepared surface readily holds paints, though an unprotected surface oxidizes, forming a dusty-looking, dull film on the surface.

Brass is an alloy of copper that contains a large amount of zinc. It has a golden color and usually contains other metals that make it hard. The melting temperatures vary but are higher than for bronzes. Brass can be soldered and brazed; it can also be welded with a MIG or TIG (though not as easily as bronzes).

A patina forms more slowly on brass than on bronzes. Brass is preferred for highly polished work, but the finish will not last without a protective coating.

Bronze is an alloy of about 90% copper with tin and other metals. It is much harder than its parent metal. Because it conducts heat so well (heat spreads out everywhere), smaller works are often brazed or soldered, while larger works are TIG or MIG welded. The melting points vary, depending upon the alloys. The most popular sculptural sheet bronze is silicon bronze which melts in the 1800°F range. The finish is usually an applied patina instead of paint (see chapter 8). Because of its heaviness, brittleness and cost, bronze is not so readily used as other metals.

Lead is the most malleable metal used for sculptural purposes. It has a low melting point in the 600°F range and requires little heat to melt or fuse it. It serves as a good material for hammered sculpture. The finish oxidizes to a dark dull gray. (CAUTION: *Lead and hot lead fumes are poisonous. Good ventilation is a necessity and the final sculptures should not be within reach of a small child.*)

David L. Deming, Centurian II. *Painted steel, 14′ × 5′ × 6′.*

Harriett Matthews, Gypsy's House II. *Oxyacetylene and arc welded steel, 48″ × 39″ × 53″.*

Bill Barrett, Bravo. *Welded sheet bronze, 6' tall × 4' × 3'.*

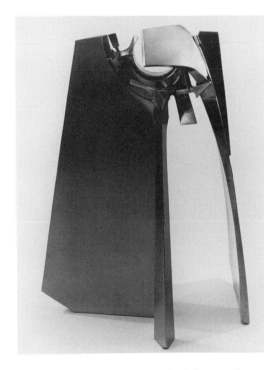

Tom Morandi, Sierra Foxtrot. *Stainless steel, 4' × 2½' × 2½'.*

Iron is usually known as *cast iron* (as cast iron skillet, for example) or *wrought iron*, which is used in forging. Cast iron is very brittle and melts at about 2100°F. Wrought iron is easier to shape but melts in the 2800°F range. Cast iron is seldom welded except by a skilled welder, since it is easily cracked by the welding heat. Wrought iron is more commonly used for welding purposes. Both surfaces readily rust and are usually painted after sandblasting.

Steel, an alloy of iron, is available in several alloys, but the most common ones used by the sculptor are mild steel, Cor-Ten steel and stainless steel.

Mild steel is a low-carbon machinable steel available in many shapes. The most useful stock are sheet, plate, pipe, bar and angle. Sculptors most often use 1/8-inch, 3/16-inch or 1/4-inch thick mild steel in 4 foot × 10 foot sheets, though a multitude of other thicknesses and sizes are available. It melts in the 2600 °F range and is especially good for oxyacetylene and arc welding. It is very strong, heavy and readily available at reasonable prices. Mild steel can easily be prepared for a painted surface.

Cor-Ten steel readily forms a surface rust that prohibits further deeper rusting. This oxidized surface provides a natural rust color and texture that protects the underlying steel. Welding is easy, and the inexpensive arc welder generally is used. The welding rods should be those designed for Cor-Ten, or the welds will not have the same rust protection that the Cor-Ten structure has. Since there is no reason to paint Cor-Ten, the finish is usually sandblasted and left to age naturally.

Stainless steel maintains its surface best of all the steels. It is also more expensive, perhaps five to ten times more than ordinary steel (depending upon the shape of the metal). It is difficult to

work and melts in the 2700°F range. Cutting it without a plasma cutter (discussed later in the chapter) is a long and tedious process. It is often arc welded with an ordinary arc welder, but the TIG or MIG is preferred. Stainless steel is available in several sizes and shapes (like mild steel) and also in different finishes (even with a mirror finish). It requires much more working time than ordinary steel but is stronger and is only slightly affected by the elements.

Galvanized sheet iron is readily available in very thin sheets. It is actually a mild steel coated with zinc, a process known as galvanizing. It is good for outdoor use; however, over a long period of time, galvanizing does oxidize and sometimes rusts through. Most gauges over 16 gauge can be worked by hand. Anything over 22 gauge is almost too limp to use. (A metal gauge is illustrated later in the chapter with other metalworking tools.) Tin snips, hacksaws and saber saws are often used for cutting galvanized sheet iron. It can be formed by metal brakes and rolls. Most tools necessary to work lighter gauges are found in sheet metal shops. Riveting is a common way of joining the metal. The welding methods are brazing and spot welding. (CAUTION: *The galvanizing burns off during welding. The fumes are toxic and special ventilation is required.*)

Wire in almost any size and length is used for sculptural purposes. The most commonly used ones are steel roll wire, copper roll and zinc-plated steel roll. Obviously, there are numerous ways of constructing with wire by itself or by adding other materials to it. The following demonstration provides a good example of how to use wire.

Sculptor Connie Herring demonstrates her wire technique using copper wire. The process she uses is direct and requires no special tools. Her only ex-

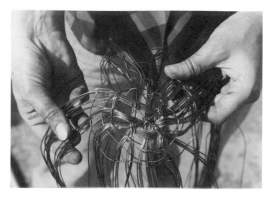

The beginning weave is secured with a single wire that is used to continue the weaving. Photograph: S.R.H. Spicer.

Other woven sections are added to the original piece. Photograph: S.R.H. Spicer.

The completed sculpture is buried in a pen of wadded newspapers, which will be burned. Photograph: S.R.H. Spicer.

pense is for no.17 clear plastic-coated copper wire, which she divides into six bunches with eight wires in each bunch. She begins to weave the wire groups as if she were starting a basket. She secures the beginning weave with one separate wire to hold all the groups together. With this wire, she continues to weave, eventually breaking all of the groups back to their separate, individual wires.

Hanging the piece from the ceiling, she continues by adding other sections, constructed in the same way as the original. Some of these added pieces are placed inside the work and some on the outside. She continues weaving wire around the entire piece. After finishing the sculpture, she places it in a chicken wire pen outdoors with wadded newspapers all about. The papers are burned, and so is the plastic coating. When finished, she quickly hoses down the piece with water in order to cool it and to bring out a multitude of colors on the wire. The final sculpture is pictured. (**Take proper safety precautions to avoid toxic fumes given off by the burning plastic coating if you try this.**)

Metal Cutting

Metal cutting is accomplished in many ways other than with heat. Thin metals can be cut with hand saws, shears and the like, and heavier metals can be cut with cutoff saws, grinders and so on. Knowing which tool to use can save time, energy and tool costs. A *hand hacksaw* can be used in hard-to-reach places and is good for small precise cuts. A good all-around blade has twenty-four teeth per inch and is capable of cutting thin metals. Blades with more teeth are used for even thinner metals; blades with fewer teeth are

Connie Herring, Untitled. *Copper wire,*
69″ × 25″ × 25″.

Hacksaws.

used for thicker, softer metals. Cheap blades will not last because they are made of poorly tempered steel.

Tin snips are used for cutting small works of very thin metal and for making unusual cuts. They are hard to use on a large piece of metal; it is difficult to make a long cut. Notching tools designed for small cuts can be handy. (CAUTION: **The edges left by shears are sharp and sometimes jagged.**)

Pneumatic and electric shears and *nibblers* are easy tools to operate, though they are also limited to use on certain thicknesses of metal. A nibbler, which makes very small cuts, produces less distortion than shears, though it removes only a thin strip of metal. Nibblers are also available for cutting heavier metals.

The *hand-held circular saw* and *table saw* with a metal-cutting blade are used for making straight cuts on thin metals. (See chapter 7 for the operation of these saws.) Either abrasive disks or metal blades can be used on these saws. An abrasive disk—(a fiber blade embedded with abrasive particles—can cut many metals, but it is unpleasant to use because abrasive particles are thrown off as it cuts. A metal blade is simpler to use but costs more. (CAUTION: **Since both blades cause a great show of sparks, do not work near sawdust or other flammable materials. Eye protection is mandatory.**)

The *saber saw* is an excellent tool for cutting thin metals, especially if turns or odd cuts are needed. The work must be held firmly (preferably clamped), and the cutting operation should proceed at the saw's pace, or blades will be broken. The size of the blade is determined by the metal, as with hacksaw blades. These saws can be either electric or pneumatic.

The *horizontal metal-cutting band saw* is a fine tool for cutting angle iron and pipes, but is limited by the jaw size. It will not cut beyond the width of the wide-open jaws. Though it appears slow, it steadily produces a clean cut with many different angles available. Depending upon the saw, a cutting oil on the blade is very helpful. Most saws have an automatic cutoff switch that stops the blade once the cut is made. (CAUTION: **Never attempt to adjust the work with the blade in motion.**) Vertical band saws are also used with

Metalworking tools: left to right, aviation snips, two tin snips, notching tool, hand seamer (for bending) and a sheet-metal gauge.

Saber saws.

Horizontal metal-cutting band saw.

metal-cutting blades. (See chapter 7 for this saw.)

The *abrasive cutoff saw* is an excellent tool for rapid cutting of pipe and angle iron. It, too, is limited by the jaw size. Since the abrasive blade is literally spent in the cutting process, it decreases in diameter, which reduces the capacity of the saw to smaller cuts. Thus several blades need to be kept on hand. (CAUTION: *The work must be firmly clamped to the machine, and the operator must wear a face mask because of the flying abrasive particles and sparks.*)

Squaring shears can complete clean cuts but are limited by the size of the machine to certain thicknesses and widths of metal. There is no distortion in the cut metal, and the machine operates with precision and ease. The foot-operated squaring shear is the tool usually found in sheet metal shops.

Hand-held grinders are good tools to clean surfaces, remove welds and to cut with, as needed. The most common ones are electric and either 7- or 9-inch, though they are both heavy and somewhat cumbersome. The smaller 5-inch tools, especially the professional ones, are easier to use in most instances. The grinding disks (blades) are made either thin for cutting metal or thick for abrasive grinding. The thin ones should not be used for grinding, since they can break easily. The grits are of a standard coarseness unless otherwise specified. Wire brushes can also be placed in these machines for rapid removal of surface imperfections and rust. The required coarseness of the brush and shapes is determined by the problem encountered. Also, a sanding disk can be placed on a rubber backing and used in the grinder for heavy sanding requirements. Pneumatic grinders are available, though pneumatic tools are primarily used for sanding purposes.

Abrasive cutoff saw.

Squaring shears.

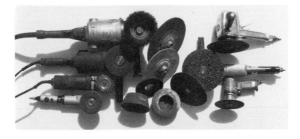

Hand-held electric and pneumatic grinders with wire brushes and abrasive disks.

(CAUTION: *Eye protection is mandatory. The revolutions per minute of the grinding disk or wire wheel should always be higher than or equal to that required by the tool.*)

A homemade clamp for holding sheet metal.

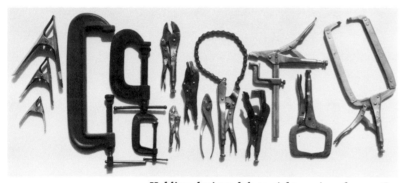

Holding devices: left to right, spring clamps, C clamps and a variety of vise clamps, including a pair of pliers.

Acetylene cylinders (short) and oxygen cylinders (tall).

Holding devices for metalworking are important, and a multitude of them are available for specific tasks. A sheet-metal clamp is pictured with the metalworking tools (second tool from the right). Also illustrated is a large screw-type clamp that I made for use with large works; it can hold about 1000 pounds. Since most work is smaller than this, the smaller clamps are common. A variety of small clamps are pictured.

Oxyacetylene Cutting

Cutting with a torch involves heating the metal to a molten state and then adding a fast stream of oxygen to ignite the metal and blow it away as *slag*, oxidized residue, leaving a *kerf*, slit, in the metal.

Only ferrous metals are cut by a torch, but all ferrous metals do not cut the same. Stainless steel and cast iron take special skill and technique. Thus the following discussion is centered on cutting mild steel.

Equipment
The basic oxyacetylene equipment consists of one oxygen cylinder (tank), one acetylene cylinder (tank), an oxygen regulator, an acetylene regulator, hoses, torch, a lighter, goggles or masks, gloves and tip cleaners. (Safety masks and gloves are pictured later in this chapter in the welding section.)

The oxygen cylinder usually is larger than the acetylene tank since twice as much oxygen is ordinarily used. The fittings to the cylinders are different. All oxygen fittings turn clockwise to tighten or close and all acetylene fittings turn counterclockwise to tighten.

The cylinders are stored with heavy screw-on caps. Before putting on the regulators, each cylinder valve should be slightly opened for one second to blow away any accumulated dirt on the valve seat.

The pressure regulators are mounted directly on the cylinder valve. The gauges show the total pressure of the contents (amount left in the tank—the higher listings). The working pressure for oxygen is more than for acetylene. The acetylene and oxygen working pressure depends upon the metal thickness, oxygen and tips. Each of the regulators is adjusted by a linear-handle adjusting screw. When the screw is "loose" or out, no gas or oxygen is released. To turn on, the screw is tightened inward until the desired pressure is achieved. The screw stiffens as the pressure is increased. This is a good warning not to tighten it too tightly. (CAUTION: *Keep the regulator screw loose, off, until the cylinder valves are opened to let gas into them. Otherwise the regulators may be damaged. Also, the maximum acetylene pressure should never be more than 15 psi.*)

The hoses are joined together after leaving the regulators. The red hose is acetylene and the green hose is oxygen. Since the threads are different on each hose (right or left-handed), they cannot be misfitted. The cutting torch consists of a mixing handle (body), two gas valves (acetylene and oxygen) and cutting head with tip. The cutting tip comes in different sizes for different thicknesses of metals. Though large tips can be used on thin metals, they waste fuel and create wide kerfs. (Kerf is the cut or width of cut.) Smaller heads are preferred. Examples of tips are a no.000 for 1/8-inch metals with a .04 kerf, and a no.8 for 12-inch thickness with a .41 kerf width. I use a no.00 at a .05 kerf for most general-purpose welding with lighter metals (1/8-inch to 3/8-inch thickness). The tip is placed in the cutting head and tightened with a wrench. The tip should be kept clean.

The regulator is attached to the cylinder valve.

The flow of gas or oxygen from the cylinder is regulated by an adjusting screw.

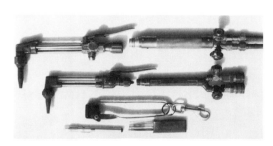

Oxyacetylene cutting equipment: top to bottom, two heads with tips near handles, spark lighter, soapstone marker, cleaning tips.

Operation

These steps should be followed when operating oxyacetylene equipment:

1. Have heavy gloves and dark goggles within reach and ready to put on for safety and to see the correct flame.
2. Turn the oxygen cylinder valve handle all the way open.
3. Turn the oxygen regulator to read the desired setting.
4. Turn the acetylene cylinder valve one-half to one full turn. Set the regulator to the proper pressure. More oxygen is required for cutting than for welding. With a no.00 tip, the oxygen regulator is set at about 25 psi flow pressure, and the acetylene is set at about 5 psi flow pressure.

After putting on proper eye protection, make certain the oxygen valve on the torch handle is wide open but closed on the cutting head, then open the acetylene valve about one-eighth turn. Hold the striker to the tip of the torch and ignite the gas. Turn up the acetylene until just after the smoke goes away. The best setting is just prior to the flame leaving the tip. Add oxygen by adjusting the oxygen valve on the cutting head. Adjust the flame to a neutral flame with cutting lever depressed. (See the welding discussion in this chapter for a neutral welding flame; it is the same for cutting.) After cutting, the acetylene gas should be turned off first, then the oxygen.

Opening the acetylene valve on the torch handle.

Adjusting the oxygen valve on the cutting head.

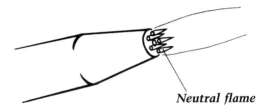

Neutral flame

Oxyacetylene cutting flame.

Cutting with the torch.

The torch is normally held at the same angle (perpendicular) as the metal is. Both hands should be used to steady the torch. Most cutting is done from side to side with the tip at a very slight angle in the direction of the cut. The initial neutral flame should be slightly above the surface (about 1/8-inch to 1/4-inch) and held still until the metal is cherry red. The cutting lever should be depressed slowly and as the cut is made, the torch is moved in the direction of the cut. If the torch is moved too fast, the metal cannot maintain the heat and the cutting action will stop. If the torch is moved too slowly, the slag will fuse together and not clear the kerf.

Cutting from the end of a sheet of metal is easy, but beginning within the piece requires special preparation. On a relatively thin piece, the metal is preheated with the neutral flame, then the tip of the torch is lifted straight up (to avoid flying sparks and slag) and the oxygen level is fully depressed. If the metal is not completely pierced, then either the metal was not fully preheated or the oxygen cutting pressure needs to be increased. Extremely thick metal can be pierced by drilling a hole in it first.

Oxyacetylene equipment varies from one brand to another, so the manufacturer's recommendations about operation and safety should be studied and observed. The following general cautions and guidelines apply to all equipment:

1. **Handle cylinders with care; always keep the caps on them while transporting and keep them chained upright in a ventilated area for storage.**

2. **Acetylene is explosive. It has no natural odor, so the manufacturer adds a sweet odor to detect leakage. Check for it.**
3. **Oxygen does not burn, but it can cause oil or grease to explode into flame. *Never* have grease or oil near oxygen.**
4. **Take care where the hoses are placed; check them regularly for burns.**
5. **Always maintain good ventilation.**
6. **Wear eye protection at all times. (Sunglasses are *not* a substitute for welding goggles.) Gloves, aprons and proper shoes are also necessary.**
7. **Check all equipment regularly for leakage. This can be done by applying a mixture of soap and water to the fittings to see if escaping gas forms bubbles.**
8. **Never check for leaks with a flame.**

Sculptor John Massee uses an oxyacetylene torch as a primary tool for making his sculptures. For metals up to 2-inches thick, he uses a center punch to splinter a small piece of metal. This splinter and the punch mark will heat faster than the surrounding thicker metal, enabling him to make his cut through the middle of thick metals without predrilling. He prefers to use heavy tips to cut with since they cut so quickly, even though they leave a wider kerf. The particular work pictured is not that thick. He begins cutting from his drawing on the metal. After completing the oxyacetylene cutting, he welds the works together. Two of his finished works are pictured. They very well demonstrate the positive cuts of a torch as well as the negative cuts.

The sculptor cuts around the outlines he has drawn on the metal.

John Massee, Railing at the Gods. *Cut and welded steel, 14' tall × 7' × 6'. Note the positive shapes atop this sculpture. In the background, Centaur Plaque with Ladies, 14' tall × 8' × 5', illustrates the sculptor's negative cuts.*

John Massee, Various Wheelies, *including* Cleopatra, A Few Guys, Carpathian Club. *Cut steel, 5' to 7' tall. Photograph: Tincher.*

Arc Cutting

If absolutely necessary, an ordinary *arc welder* (described later in this chapter) can become a metal cutter by using a high amperage setting with a large rod. The *electrode cut* or *carbon arc* is best for this purpose, however, they do not produce a very clean cut. As a rule, using an arc welder is not a good way to cut metal.

A *plasma cutter*, on the other hand, does an excellent job of cutting metal, especially stainless steel. The machine is small and simple to operate, but requires a compressor. Compressed air is connected to the machine and sent through a lead (usually 20 feet long) to the torch. These leads also carry current from one of two settings, high or low, depending upon the metal's thickness. The torch has a trigger that sends out the arc, an electrical discharge, with a stream of high-pressure air, which quickly and easily cuts the metal, blowing the slag out as it does. The cuts are so clean and quick that they often resemble a shear cut, especially in thinner metals. Since the cut is so immediate, chrome can be cut with hardly any burn back (burning beyond the cut), and a flat wooden board can be used as a straightedge guide without catching fire. There is seldom slag to clear away. A plasma cutter cuts stainless steel almost as rapidly as ordinary steel. The drawbacks are the initial machine cost and the constant replacements to the cutting torch head parts; they are not inexpensive. There are also limitations to cutting thicknesses. Depending upon the machine, only sheets of even thicknesses will cut well. (See the last demonstration in the chapter for a work that required the plasma cutter for cutting.)

Miller Plazcut, Jr., a small plasma cutter with leads and torch. Larger plasma cutters also are available.

Michael Malpass, Square Column, 1985. Iron and steel, 6′ tall.

Michael Malpass, **Screaming Medusa.** *Iron and steel forged, 20" diameter.*

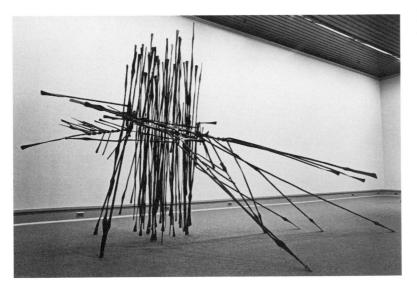

Art Oakes, **Plunge into Thee.** *Forged steel, 14' × 6' × 8'8".*

Forming Metals

Metal forming is accomplished by hot forming or cold forming. The well-equipped metal former has a special furnace and tools, but most sculptors possess only an oxyacetylene torch for the heating of metal. Examples of heavy metal forging (hot forming) are Michael Malpass's *Screaming Medusa* and Art Oakes's *Plunge into Thee.*

Cold forming is usually accomplished with a bending brake, a machine for bending and folding sheet metal, and a roller, a machine for rolling sheet metal. A bender, a machine for bending rod, tube, bar and so on, is sometimes used as well. Forming blocks, wood or steel blocks used as forms about which sheet metal is hammered into shape, and sandbags, bags filled with sand and used in the same manner as forming blocks, are also used for cold forming.

A soft metal like a thin gauge copper can be cold-hammered on a wood block, sandbag or anvil to create any number of shapes. A ball peen or special metal-chasing metalworking hammer is often used for this purpose. The work can be hammered about the desired area or directly on it with overlapping blows.

For heavier metal, or metals that require heat before bending, a "rosebud" head for the oxyacetylene torch is a great help. It spreads the heat more evenly over the work and helps prevent accidental burning through. In most instances, wood forms and sandbags do not work well with heat.

The resulting shapes are often trimmed and riveted or welded together as in Nina Winkel's *Mystic Birth* and Jane Gilmor's *Do you Live Alone II.*

A bending brake for bending or folding sheet metal.

A roller for rolling sheet metal.

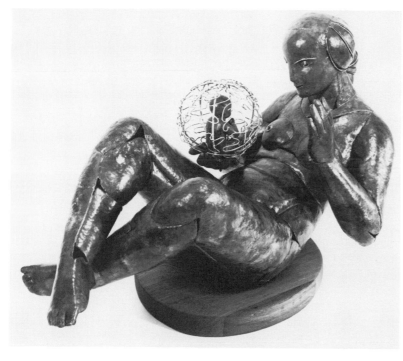

Nina Winkel, Mystic Birth. Copper and brass, 18" × 28" × 16"; a good example of hammered and welded metal. Photograph: Anthony Cosen Fino.

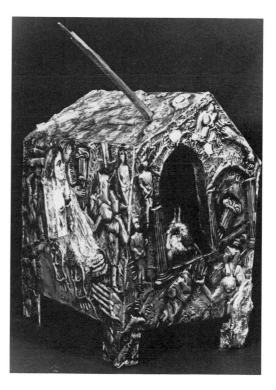

Jane Gilmor, Do You Live Alone II. Aluminum repousse, wood and found objects, 18" × 9" × 11".

Sheet-metal screws: left to right, machine screw, thread-forming screw, self-drilling screw.

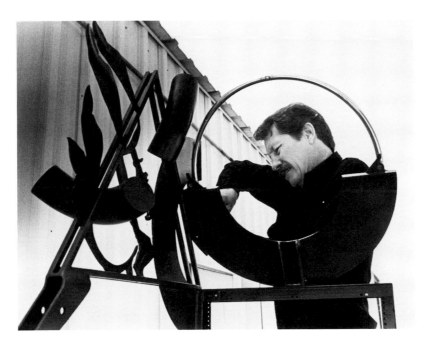

Sculptor Bob Privitt fastening metal on House of the Black Triangle 6. Welded steel and aluminum, detail of 90″ tall piece.

Bolts: left to right, a carriage bolt (most often used in wood), hexagonal head, Phillips head, countersunk head, round head.

Methods of Joining Metal

Metals can be joined by using a number of different connectors and by welding. The following discussion focuses on joining methods other than the major welding techniques, which will be covered as separate topics.

Screws and Bolts

Screws and bolts are commonly used to join metal. There are three kinds of self-tapping screws that are often used to join thin sheet metals: The *machine screw* is inserted into a predrilled hole that will allow a tight fitting. A *thread-forming screw* cuts threads into a hole previously drilled approximately two sizes smaller. The *self-drilling screw* not only cuts the threads, but the hole also. It has a hexagon head and is inserted into metal with the use of pneumatic or electrical tools.

Bolts come in a variety of kinds and shapes. Some bolts have special hardening. The ordinary bolt has no marking on the head, while the hardened bolt has markings indicating the hardness. The most common bolt is the stove bolt with a hexagonal head for use with a wrench or socket. Also available are the Phillips head, countersunk screw head, and the round head. The threads are usually coarse, called NC (National Coarse), though sometimes they are fine, called NF (National Fine). Always check to be sure that the chosen bolt and its nut are of the same thread type.

Bolt heads: left to right, two marks on the head indicate stainless steel; the marks on the center bolt indicate a hardened steel bolt; the bolt on the right is a normal steel bolt.

Rivets

Riveting is a desirable way to fasten most thin metals or other materials to metal when heat or other fasteners or connectors cannot be used. Most small blind (pop) rivet tools are inexpensive and can be purchased in a local hardware store. They are easily operated. Insert the rivet into the tool, then insert it into the predrilled holes of the two pieces to be joined. Squeeze the handle of the tool to bring up the inner pin, causing the rivet to flatten on the back side of the work. Many tools also clip off the long shaft, leaving the short inert inner piece in place. Larger riveting machines can be power-operated.

Tap and Die

Often the sculptor wants a threaded hole (for a bolt or screw) or a shaft that can be inserted into such a hole or nut. These can easily be made with a tap and die set. Taps cut threads on the inside of holes and dies cut threads on the outside of shafts. Taps are tightly inserted into a handle that makes threads in a predrilled or punched hole. The hole must be smaller than the tap, a size found on a tap chart, or approximately two or three sizes smaller than the desired thread. A cutting oil is added as the tap is turned. The tap is tightened, loosened and tightened repeatedly until the job is finished.

Dies are also placed in a handle and started on a preselected rod. The rod must be from two or three times larger than the die (as found on a die chart) and slowly turned with cutting oil added, backing off some, re-oiling and continuing until the thread is complete.

These tools are especially good for working on bronze and aluminum castings for a perfect patina metal match and solving base-mounting problems. Consult the chart included in the tap and die set for the proper size drills, taps and dies for a perfect match.

Hand riveter.

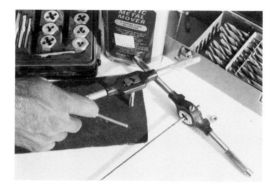

Cutting threads with a tap.

Glue

Gluing is another method of joining metals. It is preferred when there is risk of heat warpage (from welding), for delicate jobs and for attaching different media to metal, especially on indoor sculptures. Epoxies are the favorite glues either in a putty form or a thin watery consistency. Cyanoacrylates (super glues) are also used, but less often. Epoxies come in two parts that are mixed in equal proportions. Setting times vary from 5 minutes to overnight. The metal must be clean and have a slight tooth before the application of glue. Sanded epoxies take many finishes.

Spot Welding

Electric spot welders can be stationary or portable. The portable welding gun is handy, but it offers little depth for long sheets whereas the stationary welder does. These are used mainly on thin galvanized steel. The metals are over-lapped and placed between the jaws of the welder. The jaws (two points) are activated by a foot control that brings them together, arcing on the metal and producing a strong clean weld.

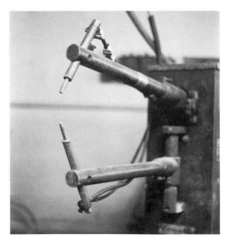

Electric spot welder.

Oxyacetylene Welding

Oxyacetylene welding produces temperatures of approximately 6000°F. Acetylene is mixed with oxygen to reach high temperatures that melt and fuse two metal surfaces together. This process is also used for cutting and heat bending, as described earlier in the chapter. Depending upon the rods and fluxes used, most metal can be welded. The more common metals for this purpose are steel (alloy, carbon and stainless), aluminum, bronze and brass. Cast iron and magnesium are seldom welded by this method.

Equipment

Oxyacetylene welding requires all of the oxyacetylene cutting equipment described earlier, except the cutting head. It is removed from the handle and replaced with the welding tip. The coupling nut should be tightened with hand pressure only. The welding tip is chosen depending upon the size and type of work the sculptor will do. A good tip for light work would be a no.3 for metal from 1/8-inch to 3/16-inch thick with an oxygen pressure of about 4-7 psi and an acetylene pressure of about 3-6 psi. Heavier works require larger tips because larger tips produce more heat.

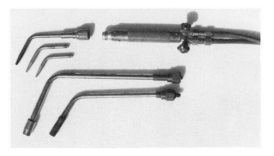

Three tips for welding next to the handle with valve controls. Two long-shaft heating tips.

Standard welding gear: left to right; leather apron and gloves, chipping hammer, soapstone marker, wire brush, arc-welding helmet, dark safety shield, two spark starters, tip-cleaning wires.

Oxyacetylene welding rods; the lighter colored ones are flux coated.

Fume collector with exhaust fan.

Operation

The operational steps are similar to oxyacetylene cutting. (Refer to that discussion earlier in this chapter.) A list of proper procedures follows:

1. Wear dark welding goggles or mask to protect the eyes and to be able to see the correct flame.
2. Turn the oxygen cylinder valve handle all the way open.
3. Turn the oxygen regulator to the desired setting.
4. Open the acetylene cylinder valve about one turn and then set the regulator to the desired setting.
5. Holding the torch in one hand and the lighter in the other, open the acetylene knob about one-eighth of a turn and light the torch.
6. Adjust the oxygen to a neutral flame. The equipment is now ready to weld.
7. After welding, turn off the acetylene torch valve first, then the oxygen.

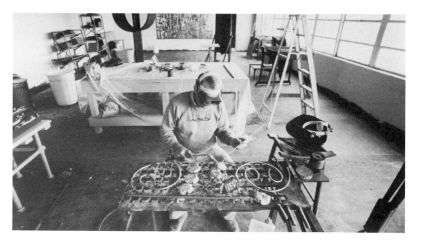

Harris Sorelle oxyacetylene welding in his studio.

Lighting the torch.

Neutral flame.

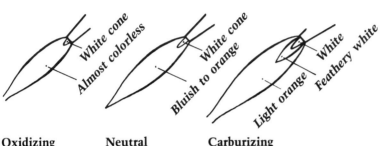

Oxidizing
Flame

Neutral
Flame

Carburizing
Flame

Oxyacetylene flames.

Surface Welds

Grooved Welds

Typical welding joints.

If the equipment is to be left unattended, the tanks need to be shut off and the lines bled. After the cylinders are closed, reopen the acetylene torch valve until the pressure gauge shows a zero, then close the valve and do the same for the oxygen. Loosen the regulator screw to close the system completely.

Flames

A neutral flame has a blue inner cone without any feathery edges and an almost colorless flame that burns about 6000°F, depending upon the purity of the oxygen. A reducing (carbonizing, also called carburizing) flame has a dull inner cone with an intense white feathered edge contained in a light orange flame and burns at about 200°F lower that the neutral flame. An oxidizing flame has a shorter inner core with a bluish to orange flame. It burns above the neutral flame by about 200°F. A pure acetylene flame (no oxygen) is very feathery and emits a lot of smoke.

Welding

Once the metal has been selected, cut and formed, the type of welding necessary is more obvious. The three common types are fusion using a filler rod, brazing and soldering.

Fusion with a filler rod. Metal thicker than 1/8-inch may require beveling for additional strength, depending upon the type of welding joint used. Once the metal joints are prepared, cleaned and held in place (if necessary) and the correct filler rod is close by, a neutral flame should be obtained. The work is now ready to be welded.

If the joint is long, a series of tacks—small welds used to hold the

metal together until the large weld is finished—need to be made along the joint. These will keep the metal in place; otherwise, the sheet will draw down to tighten or separate.

The two welding techniques are the forehand (the most common) and the backhand. The forehand technique is moving the torch in the direction it is pointed. The backhand method is moving the torch in the opposite direction from where it is pointing.

The torch is held at a 45° angle to the metal and moved in a small circular motion, advancing about 1/16-inch in each motion. The cone flame should ordinarily be about 1/8–1/6-inch from the metal. The two joints are puddled (melted into a puddle), filler rod is added and fused into the joint. The rod is dipped in and out as needed. When the end is in sight (within 1/2-inch), the welding tip is slightly raised, and more filler rod is used to finish off with a good end to the weld.

The tip should be kept clean by inserting a tip-cleaning wire into the tip orifice from time to time. Otherwise, the tip may backfire, or pop, from being dirty or from working too close to the metal. If the metal is overheated, a hole will appear. Also, if the metal is overheated, the joint will be brittle and porous with little strength. If the metal joints are not hot enough and a filler rod is added, the surface will show metal deposits that are not properly fused. A good weld looks nice and has a definite pattern.

Brazing. Brazing involves using a filler rod with a melting point of 1100° F or higher. Usually the rod is an alloy of copper, some form of brass or bronze. Because of the color variations, brazing is often used in an ornamental fashion.

The metal must be clean, as pre-

Fusion with a filler rod.

Torch movement for oxyacetylene welding.

Welds: left to right, not enough heat, good weld, too much heat.

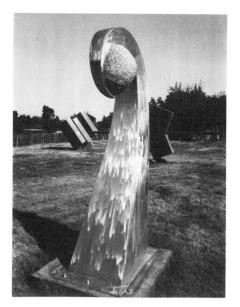

T.C. Hicks, Essay. *Stainless steel and granite, 46' tall × 28'.*

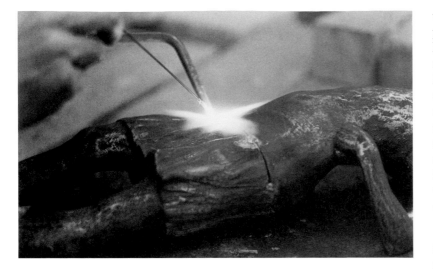

Sculptor William Beckwith brazing silicon bronze. Photograph: Bill Martin.

viously discussed, coated with flux and preheated to a dull red. The rod is heated and placed into the flux. As the rod is introduced to the hot metal, the flame melts the rod, and it easily flows over the surface without melting the metal being welded. Flux-coated rods are preferred to those that must be dipped in flux, but they are more expensive. They ensure a more even mix of flux and rod and save much time in welding. Because of the fumes produced when brazing, ventilation is a must.

Soldering. Soldering is a method of using a metal with a low melting point to join together metals of a higher melting point, often too thin to weld any other way.

The actual solder material often comes as rolled wire made of a tin-lead mixture with a melting point of slightly over 400° F. It has an inner core of rosin or acid that is corrosive and needs to be neutralized with a bath of water. Some soldering material does not contain a flux and one must be added to the surface after cleaning and prior to heating. Though an acetylene and air mixture is sometimes used, most often the materials are welded together with an electric soldering iron. (Plumbers must often use a propane torch for soldering copper fittings.) The parts to be joined need to be cleaned with a grinder, emery cloth, sheet paper or steel wool. The surface is preheated to a temperature slightly higher than the melting temperature of the solder. As the solder is added, it will melt on contact. If the parts are clean and the correct flux is present, the preheated parts will draw the solder material between the two metal parts by capillary action. Often a buildup of solder is desired for shapes like boxes, however.

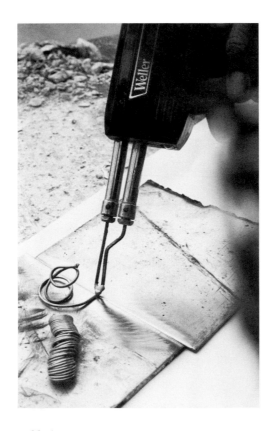

Soldering.

Silver solder is used to maximize the strength of soldered joints. The melting points range over 1300° F. A separate flux must be applied to the welded surface and to to the silver. An oxyacetylene torch with a small tip is often used. An acetylene-air mixture is used sometimes as well. This process is actually more correctly called brazing, because of the high temperatures involved.

Observe all cautions previously given for handling oxyacetylene welding equipment.

Good examples of cutting and piecing work together are shown in the accompanying illustrations. Found metals and scrap metals from a local junkyard are a quick, easy and inexpensive source from which to begin welding. The use of chrome parts in Jon Bedford's and

Irene Rousseau, Modulated Passage #1; uses welding rods in a linear pattern with no other metal present.

Jean Woodham, Argus. Welded steel, 3' × 20" × 15"; a good example of using welding rods as the major source of metal.

Ron Koehler, Dreamer. Welded steel, 30" × 24" × 21". This figure is made of small pieces of steel welded by the oxyacetylene method.

Sidney Buchanan's sculptures show two approaches to handling welded joints. Bob Privitt's work demonstrates a simplicity of objects, while Michael Malpass's shows a diversity. A theme of objects is illustrated in David Cargill's piece. When creating works from found objects, student's are cautioned to plan their designs carefully or they will wind up with "junk" sculpture. (CAUTION: *When cutting or welding found containers, find out what the contents were. It is possible that heat can cause an explosion or deadly gas.*)

Jon G. Bedford, Coyote. Welded chrome bumpers, 18" tall × 6" × 6". Private collection.

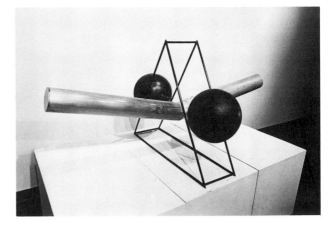

Bob Privitt, Model for a Big One. Found objects and welded metals, 32" × 42" × 70".

David Cargill, Old Medical Tools. Found objects, 30" tall.

COLOR GALLERY

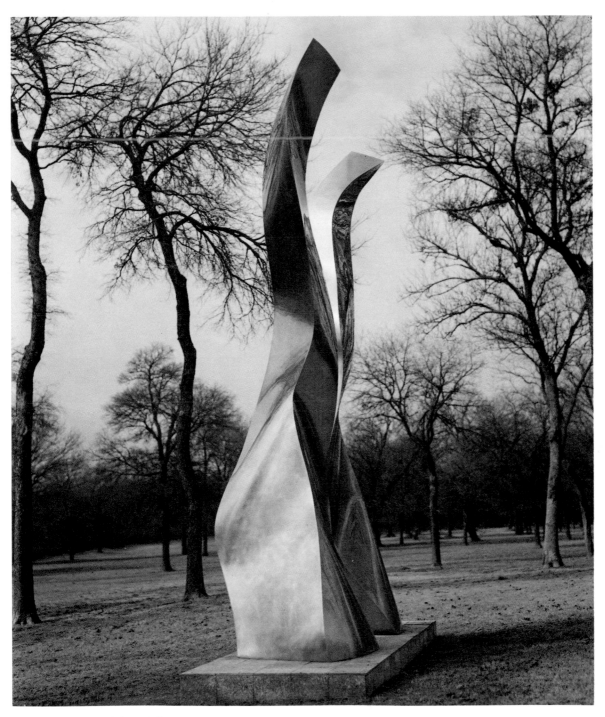

Ali Baudoin, Untitled. *Stainless steel.*

Charles Umlauf, Reclining Nude. *Turkish onyx, 10″ high × 22″ long. Collection of Dr. and Mrs. D. J. Sibley. Photograph: Mears.*

Michael Bishop, Table Top Dancer. *Hardwoods and oil-based enamels, 29″ × 10″ × 23″.*

Marilyn Lysohir, Bad Manners. Clay, life-size.
Collection of Mr. and Mrs. Louis Taubman.

Sandy Skoglund,
Revenge of the Goldfish.
Installation.

Arthur Williams, Genesis. Pressed and welded steel, 7' tall × 12½' × 12½'.

Larry Bell, Wind Wedge. Glass, 6' tall × 20' × 14'. Nelson Park, Abilene, Texas.

Tom Coffin, Cleopatra. *Cast bronze.*

Bob Howell, Footstool. *Clay, 46″ tall.*

Luis Jimenez, Howl. *Fiberglass, 5′ tall.*

Dawn Stubitsch, Untitled. Cast resin, 8″ × 12″ × 8″. Instructor: Arthur Williams.

Duane Hanson, Football Player. Vinyl, life-size.

Arthur Williams, Illusion II. Cast resin, life-size.

Sallie and Walt Carlson, Lace Collar. *Cast paper, 16″ × 11½″.*

Bonnie Lucas, White Rock. *Assemblage on fabric, 49″ × 34″ × 3″.*

Flo Hatcher, Lendora's Black Affair. *Handmade papers, bronzing powders, gold leaf, pastels, lacquers and birdshell. Photograph: Clark Broadbent.*

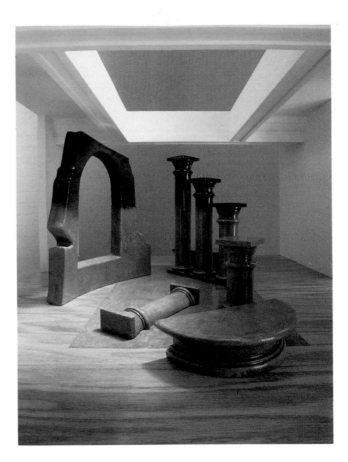

Barbara Grygutis, Model for Fugue Installation. Wood 25″ tall. Final installation at University of Northern Colorado, Greeley, Colorado.

Arthur Williams, Fractured Seed. Silicon bronze, 46″ × 42″ × 42″.

*Sidney Buchanan, Untitled. Welded chrome
bumpers, 7′ tall.*

*Michael Malpass, Janus. Iron and steel, 5′ tall.
Combines found objects and forged metal by
welding and a tremendous amount of grinding.*

233

Arc (Electrode) Welding

Electric arc welding is welding produced by an extremely strong current of electricy that passes from a metal electrode (rod or wire) to the joint, or from the joint to the electrode. When the electrode touches the metal, an arc is created of such high intensity that the metal is easily melted and fused together. The arc is literally a controlled short circuit. Some of the advantages of arc welding are quick welds, deep penetration and the lack of metal distortion since the heat is so rapid. Since the spark is brighter and spatters further than in conventional welding, a darker glass shade on the welding helmet is necessary. Heavier gloves, a heavier shirt, usually leather sleeves, a leather apron and a special arc-welding helmet are needed to protect the welder from infrared rays that can cause eye and skin damage in a matter of seconds. (CAUTION: *Never look at an arc without the proper welding shades.*)

Equipment

Welding machines are listed by amperage. The most popular AC (alternating currect) welding units are the 180- and 250-amp welders that take a 50-amp circuit. These "cracker boxes," as they are known, take up to 225-amp electricity. They are very useful, especially for smaller objects. All welders have a duty cycle, the time the welder can run at a certain amperage without damage to the machine. On these small machines the cycle is relatively brief for large rods of high amerage, but quite adequate for small rods with little required amperage. The manufacturer's operational suggestions should be followed.

The larger amperage machines (such as 440) offer AC and DC (direct current)

Small arc-welding machine.

and most often require three-phase electricity, not always available to small studios. The advantages over the smaller machines are the more precise capacities for deeper welds on thicker metals and a larger variety of metals that can be welded. Though AC welders produce a good stable arc, extremely thin metal is difficult to weld without burning holes in the metal. Direct current produces a smooth weld and also allows the welder to have straight polarity where the flow of current is from the rod to the work for deep penetration, or reverse polarity where the flow of current is from the work to the rod for shallow penetration, which is excellent for thin materials.

Electrodes (rods) are available for a wide variety of sizes, metals, penetrations, welding angles, surface treatment and structural use. The flux on the rod melts, keeping a protective gas about the weld until the fluid freezes. The flux then becomes slag (glassy covering) that must be chipped off before addi-

Electrodes for arc welding.

Electrode holder and ground clamp.

tional welds or surface finishing can be completed. (CAUTION: *Flux fumes can be hazardous. Good ventilation is a necessity.*)

The fluxes help to determine the purpose of the rod as does the metal. Rods are identified by their American Welding Society numbers. A 7018 rod is used because of its hydrogen content. It is ideal for welding things that vibrate or move because of its ability to give with stress. However, the most common general-purpose rod is the 6011. It works in every position with good penetration, though not well under vibration or stress. A 6013 is used for thin materials where deep penetration is not required. A 7024 is especially valuable to the sculptor for a beautiful weld or for touchup work. Known as a drag rod, it does not penetrate very deeply and must be used on a level surface. Other rods are available for different metals. All are found in different diameter sizes with the most common useful size being ⅛ inch with a length of 12 inches. Some rods, like the 6013, are available in very small diameters. A good welding supply house carries a large selection and is well versed in rod usage for special purposes.

In order to prevent deterioration, the rods should be kept in a warm, dry location.

The *leads* (welding cables) are usually long enough for welds at a distance of over 20 feet from the machine, though longer cables are readily available. The machine ends of the cables have special plugs, a rapid sure connection into the welder, while the work ends have a holder or clamp. The electrode holder (often called the "stinger") is shielded from metal contact except for the spring jaws that hold the electrode. The ground clamp is made of bare metal with a strong spring clamp to hold tightly onto the metal surfaces.

When the machine is turned on, the holder should not have an electrode in place. This precaution is to avoid a severe shock or harm to the welder.

A *chipping hammer* and *wire brush* are necessary to chip the slag and clean it off the surface of the weld. Take care while chipping hot slag to avoid burns or eye damage.

Welding

The *welding process* is begun by setting the machine's amperage control. The operator needs to refer to the manufacturer's suggestions (sometimes printed on the machine). All machines have a positive off/on control. After the leads have been connected and the correct setting has been made, the machine is ready for welding.

The following cautions must be observed:

1. **Never operate an arc welder if you are wet or are in a wet or damp area.**
2. **Make sure there is good ventilation. It is vital.**
3. **Never use an arc welder near flammable materials of any sort.**
4. **Make sure you are familiar with the metal you are welding. Any part of a container that ever contained flammable liquids or fumes should not be welded, nor should any enclosed tank without vent holes (to avoid any built-up pressure).**
5. **Regular clothing is not adequate. Wear heavy clothing specially designed for welding.**
6. **Check all machinery for wear and proper grounding before beginning to weld.**

Electrode angle while welding.

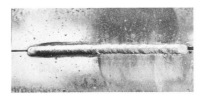

Electrode motion while welding.

After the ground clamp has been fastened to the work, the machine can be turned on. An electrode is then inserted in the holder.

Striking an arc is the act of touching the electrode to the metal in order to start the welding process. It must be done quickly and then the electrode immediately raised slightly, less than ⅛ inch, from the metal surface for the welding. If the rod sticks to the metal, lift the holder with a twist in order to remove the rod. If that does not work, then release the rod from the holder to break the current. Then you can remove the rod safely by hand without danger to you or the machine. If the rod is held too high, the arc will cease, and it must be restruck. Hold the rod at a slight angle while welding. Move the rod in a slight circular or zigzag motion as the weld progresses through the joint. This pattern is known as laying a

A good arc rod weld with flux removed on the right side.

bead, the width of which is determined by the size of the rod used and the amount of movement of the electrode. If additional weld is needed, the spent flux or slag must be removed with a chipping hammer before the next pass on the bead. **Since the flux is now like glass, it can cut the skin and should be treated with care. Safety glasses are a necessity.**

MIG Welding

Metal Inert Gas (MIG) welding—also referred to as GMAW or gas metal arc welding—is much the same as regular electrode arc welding except the stick electrode has been replaced by a continuous wire electrode with a shielded inert gas that serves to protect the welded area. (The gas operates similarly to flux.) The wire-feed speed (on a separate motor drive) and the amperage are selected and turned on by a trigger on the handle. MIG welding has several advantages:

1. There are no rods to replace.
2. Generally, the bead does not have any slag so the weld does not have to be chipped before new passes. Some larger wire feeds have an inner flux that can be welded over but can easily be removed first.
3. The gas allows more varieties of metals to be welded (the gas mixture may have to be changed).
4. A steady bead is easier to maintain.
5. Little precleaning is necessary due to the gas shielding.
6. The wire rolls are easy to change, and little-used wire can be purchased on small 10-pound rolls. (Not all wire can be welded with the same gas.)

MIG welding has some disadvantages as well:

1. The equipment is expensive and requires a continuous gas supply.
2. The length of the wire hose operates best at less than 15 feet from the wire feeder (though the feeder can be portable).
3. The welding tips need frequent cleaning.

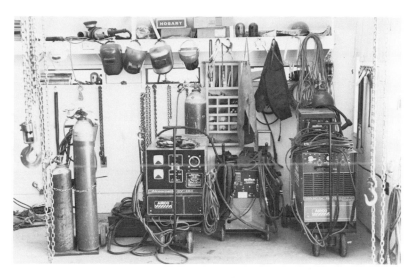

Some of the author's welding equipment: left to right, oxyacetylene tanks, portable MIG wire-feeder case, heavy-duty three-phase MIG welder, heavy-duty plasma cutter, TIG welder with radiator on top (to cool the water flowing through the TIG head). Notice the helmets, clamps, and safety clothing in the background.

Inside view of the MIG portable wire feeder. Pictured is a large roll of wire in use. To the left is a small spool of wire not in use.

MIG welding torches for light or heavy work. Both fit on the same machine. If a nozzle dip is used for the torch, the torch requires less cleaning.

A very smooth MIG weld with the thin flux cleaned off on the right side.

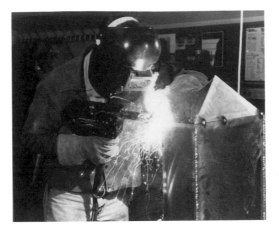

Sculptor Robert Griffith welding with a portable MIG wire-feeding gun. These are especially useful when a tall sculpture has to be welded.

4. The handle and hose weigh considerably more than the electrode holder, though smaller rigs are available for lighter welding tasks.
5. The MIG will not tolerate any type of wind near the tip. It absolutely must be used in calm air, or it is completely ineffective, producing a weak, pitted weld.

The operation of the MIG requires more adjustments than the regular arc welder. The amperage must be selected for the weld intended; the wire-feed speed must be adjusted to suit the size wire used; and the gas flow must be set. With the ground clamp in place, the arc is immediate and easily maintained. The bead produced should be smooth. The manufacturer's operating instructions should be consulted, since there is great diversity among the different brands of MIG welders.

TIG Welding

Tungsten Inert Gas (TIG)—also known as GTAW or gas tungsten arc welding—is excellent for bronze, aluminum, stainless steel and other metals of an exotic nature. This is the machine generally used at metal-casting foundries. The operation of manually adding filler rod and fusing it into the work is like the operation of oxyacetylene welding, except the tungsten tip of the torch serves as an electrode. The tip arcs with a protective inert gas (most often argon), shielding the weld from oxides being formed. Consequently, there is no slag or flux with which to contend; the result is a beautiful weld. The water-cooled torches are lighter in weight than the air-cooled ones. The newest torches have trigger controls mounted directly on them. While the leads vary in length, they are usually less than 20 feet long.

The tungsten tips vary but are similar in size to the rods used. The best all-around size is $\frac{3}{32}$ inch. The currents must be adjusted for the metal used: AC is used for aluminum and DC straight polarity is used for bronze and stainless steel. The flow meter regulator must be set according to the tip size.

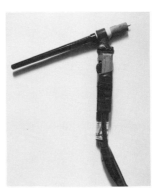

TIG torch.

Machine-pressed curved sheets.

TIG flow meter regulator.

The pieces are trimmed with a plasma cutter.

The machines are easy to operate based upon the manufacturer's suggested settings of amperage and gas flow. Occasionally, the tungsten tip must be removed and ground on the fine wheel of the bench grinder in order to maintain the correct point for welding. The arc is easily struck by slowly lowering the tip near the work with the ground clamp in place. (If it is lowered too low and sticks to the work, it must be removed and reshaped on the grinder wheel.) An arc can easily be maintained, but the surface must be clean. Since the machinery can weld exotic metals, good ventilation is necessary to avoid hazardous fumes. Air currents should not flow directly across the torch, however, or the gas will be removed from the tip.

The following demonstration shows a large fabrication and the steps involved in its completion. This same process can be used for much smaller works. The work demonstrated is made of ¼–⁵⁄₁₆ inch steel.

Because of the shape of the final piece, some of the original parts had to be machine-pressed into curved sheets. Though these are designed to fit toget-

Stephen Daly, Man Talking, 1986. Steel, bronze and graphite on paper, 68″ × 33″.

The pieces are welded together with a MIG welder.

The base is cross-based to add strength. Flat steel sheets will cover the base.

Sandblasting the surface so it will hold a primer.

The work is fitted together, then welded. The center sphere was primed prior to mounting.

her, they do require special handling. They are cut with a plasma cutter in order to avoid warpage. (The quick cold cut keeps the shape.) Pieces on the larger sections weigh about 270 pounds and are trimmed to weigh about 240 pounds each. (There are many cutting scraps left.) These trimmed pieces are assembled into an inner and outer wall with large sections of metal separating them. All edges have been V-grooved for hidden welds. A large three-phase MIG welder is used to secure a rapid, even weld. Every weld is ground even with the surface. A small 5 inch grinder is preferred for this long task.

The base of this work is about 20 feet long and will support several thousand pounds, so it is constructed of C channel steel, cross-braced much like a

truck bed with every seam completely welded. The base top is added; it is ¼ inch steel and V-grooved for hidden welds. The pieces are assembled, and each one is sandblasted to hold a good surface primer.

The finish requirements are demanding because a reflective surface is the end goal. The center sphere is primed and sanded to a 400 grit smooth finish. The outer shell is to have a textured finish and does not require sanding past 80 grit. The final finish of acrylic automotive lacquer is sprayed on. Two more coatings of urethane are added for longer life.

Since the work is structurally strong, it is transported in one piece to the site and raised with no problems. The sculpture is bolted into place on a prepoured concrete foundation in a very brief time. The final work is pictured.

Arthur Williams, Birth. Welded and pressed steel, approximately 19½' long × 8½' wide × 9' tall. University of Texas Medical Branch of Galveston, Texas. Photograph: Dustin Williams.

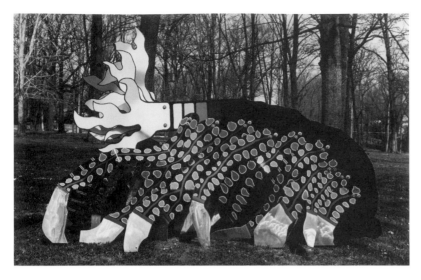

Barry Gunderson, Bluebart. *Painted aluminum, 6′ × 10′ × 4′.*

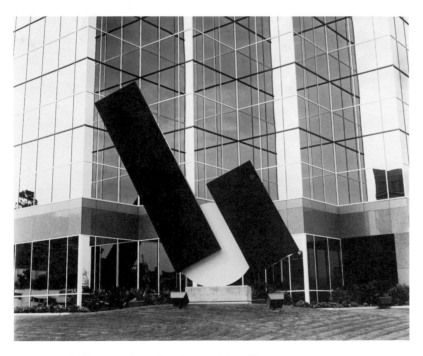

James Mitchell, Sunroads. *Painted steel, 23′ tall × 18′ × 5′. Collection of Sunroad Enterprises, Inc., San Diego, California.*

Metal Finishing

Bronze, aluminum and stainless steel are weather-resistant, but even these are often used in a design that requires some special surface finishes other than the natural surface. Regular sheet steel is the most popular metal used for sculpture, but it requires a surface coating, generally in the form of paint. In order to prepare the surface for paint, it must be cleaned and have some texture capable of holding the paint. All oils, greases, waxes and dirts must be removed prior to painting. Though a degreasing compound can be used, the metal also can be dipped into chemicals, sanded, steel-wooled, wire-brushed, steam-cleaned or sandblasted.

Portable steam cleaners are useful for larger jobs that already have a desirable surface but need cleaning. They are easy to operate according to the manufacturer's suggestions.

Sandblasters are excellent for large tasks that would benefit from a more textured surface. The sand is driven into the surface with great force. It offers a fine texture better capable of holding finishing materials than is produced by other cleaning methods. Different sand grits are available, depending upon the job and the machine. I most often use a no.3 sand for larger steel works. (CAUTION: *The sand bounces back on the operator. Protective eyewear and clothing and a proper respirator are mandatory.*)

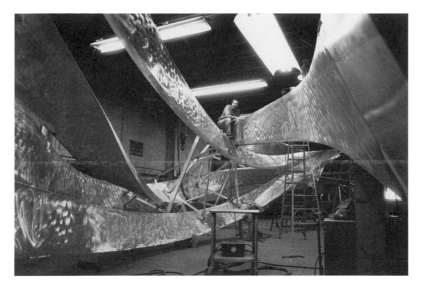

Bruce White, Delphin, *in progress before final surface painting.*

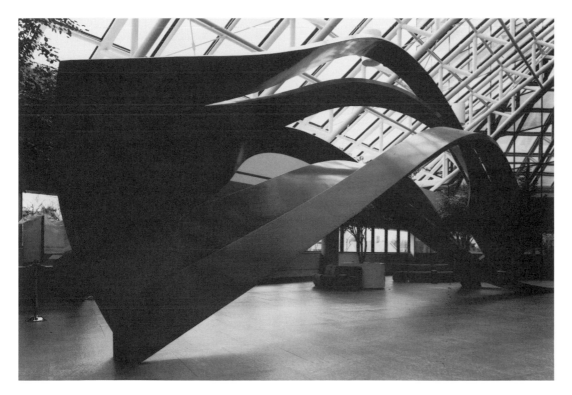

Bruce White, Delphin. *Aluminum, 22′ tall × 52′.*
Department of Art, State of Illinois, Willard Ice
Revenue Building, Springfield, Illinois.

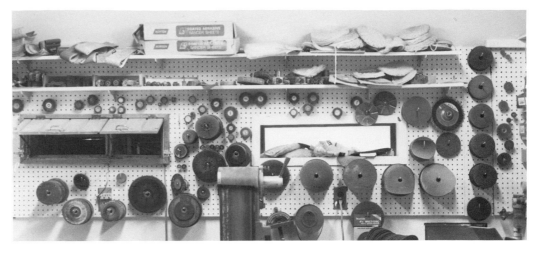

Part of the author's abrasion room and supplies. (Notice the rear fan exhaust opening to the left.) These supplies are used throughout the creation of a sculpture but especially in the preparation for surface finishing.

Portable steam cleaner.

A properly outfitted sandblaster with a sandblasting machine. A sandblasting room is in the background.

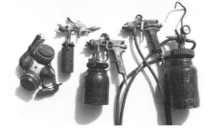

Painting equipment: left to right, chemical mask, touch-up spray gun, normal one-quart gun, hose gun with two-quart container.

Five-gallon airless spray rig.

Spray Painting

The typical aerosol spray can be useful for small pieces or for minute details. The sprays available are diverse and they dry rapidly. However, you should never be in a rush. Leave enough time between applying coats to avoid drips and to allow proper drying of individual layers. Good ventilation is a necessity.

Compressor operated spray guns are the most common type used. Compressors can be relatively small and portable, and a multitude or spray guns are available for use with them. (See chapter 6 for a discussion on air compressors.) A pressure control and water filter are essential for spray painting.

The spray gun is easily operated, though practice is necessary to achieve good results. The gun consists of an air hose, a canister for paint, a head with nozzle and controls and a handle with the trigger. The air-control valve is the top knob on the head to the rear of the gun. It controls the volume of air, which can be adjusted to create a fine mist to a heavy volume of spray. The lower rear knob is the fluid-control valve, which regulates the amount of paint that is let into the air stream. There is no perfect setting, since all paints and mixtures are different. The paint manufacturer's instructions must be closely followed. However, as a rule, the pressure is adjusted to 35–45 pounds, and the gun is held from 8 to 12 inches from the surface. The spray pattern should be even, with a continuous flow of paint. Practice is the best teacher. Avoid too thick of a coat, or the paint will sag. It also will sag if not enough drying time is allowed between coats.

Airless sprayers are becoming popular. They are a completely self-contained unit. The larger ones can operate in a single five-gallon drum

Bruce Beasley, Arristus. *Stainless steel, 14′ tall. Collection of Djerassi Foundation, Woodside, California.*

Helen Escobedo, Coatl. *Painted steel I-beams, 19½′ × 49¼′, National University of Mexico Center, Mexico City.*

without stopping. The spray hose is often long but does not affect the spray gun. Airless sprayers are best used for heavier paints such as water-based latex, though special nozzles are available for more refined oil-based paint. Special care must be taken to clean out the hoses and gun completely after each use.

Paints

Some paints (lacquers) dry very rapidly, but are more toxic to use and cannot be placed over other products. Most all paints require thinners, and some require as much as 50% thinner for spraying. Enamels are still a favorite but require a longer drying time. Works coated with enamel must be kept in spraying booths or otherwise protected until they are dry. The new epoxy and

urethane paints require special mixing but are relatively simple to use. Their finishes are very hard and long-lasting.

The primer coat is of utmost importance since all other coats must adhere to it. Among the special products are primers that are mixed with catalysts to form heavy sandable surfaces that help hide small flaws, primers designed especially for metal where rust could be a problem, and primers that can be used directly on rust to form a hard surface that no longer will rust.

Before selecting a paint, consult a paint dealer. The dealer can direct you to a product that will suit your material, requirements, equipment and experience.

The following cautions and procedures should be observed when spray painting:

1. **Wear a chemical respirator designed for paint fumes.**
2. **Always paint in a well-ventilated area.**
3. **Do not use oil-based paints near any flame or other possibility of fire.**
4. **Spray paint drifts; expect any object near the sculpture to be coated. (Lacquer dries almost on contact and does not drift except for dust.) Take special care to note where the spray is drifting.**
5. **Use a spray booth when possible.**
6. **Do not handle paints without gloves since several (lacquer, in particular) do enter the skin by osmosis.**
7. **Protect your skin, eyes and hair from the spray. You will save yourself from possible toxic reaction to the paints. Clean-up efforts will be reduced as well.**

Jean Woodham, Morning Sun. *Welded bronze, 6½' tall × 5½' × 5½', General Electric Credit Corporation, Stamford, Connecticut. This is one of the three adjoining fountains. Photograph: Arthur d'Arazien.*

David L. Deming, Terrestrial Gest. *Stainless steel and brass, 7´ ×7½´ × 7½´.*

Arthur Williams, Illusion III. *Cast resin, 27" × 12" × 9".*

10

PLASTICS

- Safety Precautions
- Sheet Plastic
- Built-Up Surfaces
- Casting

Modern plastic materials provide a medium for some of the most beautiful sculptures that can be made. Plastics give the sculptor the raw materials to create figurative forms so lifelike that they can be mistaken for the real things. Forms can be so transparent and light-reflective that they are almost invisible, or even blinding with colors that range from dull to bright and from the most opaque to the most transparent.

Plastics discussed in this chapter include synthetic materials that are either thermoplastic or thermosetting. Thermosplastics soften when heat is applied and become hard when cooled. The process can be repeated, and each time the material will soften when heated and then harden when cold. The better known plastics are acrylics, vinyls, nylons and polystyrenes. Thermosetting plastics are liquids that become permanently hard when mixed with a catalyst that creates a chemical reaction or when heat is applied. The more common ones are polyesters, epoxies and silicones. Depending upon which type of plastic is chosen, they can be laminated, formed, carved, impregnated or cast.

Safety Precautions

Plastics offer some of the most exciting possibilities in sculpture, but the materials and methods required can also pose some of the most hazardous conditions possible. However, if proper safety precautions are observed, plastic sculptures can be safely created.

1. **Read and observe all instructions given by the manufacturers. The chemicals and processes for every**

Ron Kostyniuk, Foothills Series, *Plexiglas.*

plastic vary. Special handling of some sort will be necessary for each plastic.

2. Good ventilation is absolutely necessary to remove fumes. Otherwise, these toxic and flammable vapors could linger. The ventilation system should pull the fumes away from the sculptor's face.

3. Proper respirators are required. If odor of any chemical can be detected while wearing a respirator, then the respirator is either incorrect or no longer effective. Simple dust masks are *not* adequate.

4. Avoid skin contact. Wearing rubber gloves (disposable surgical gloves will work) and clean long-sleeved clothing for complete body protection. Chemicals often attack a

Harriet FeBland, Mystic. *Plexiglas, 9¼" tall × 12" × 12". Private Collection.*

sculptor by osmosis - absorption through the skin. Always shower after working with plastics.

5. Protect the eyes at all times. Goggles are adequate, but full face masks also protect the entire face. Some chemicals may require eye protection as part of the respiratory equipment.

6. When possible, select catalysts or plastic materials that are less toxic or hazardous.

7. Sculptors with highly allergic reactions should be extremely cautious around the chemicals and methods used for plastics forming. While some people have no problems when working with plastics, others respond with violent reactions and skin troubles.

8. Burning plastics release suffocating and toxic fumes. Spontaneous combustion is easily induced by leftover chemicals or cleaning materials if they are placed improperly in a waste container. The container must be metal and placed out-of-doors where the contents can be disposed of properly.

9. Never proceed unless you know what to expect. Always be cautious.

Charles A. Kumnick, Midnight Lace, *1985. Acrylic, Steel, Brass, Copper, 17" tall × 25" × 20" Collection of Sheila Nussbaum.*

Sheet Plastic

Sheet acrylic furnishes the best optics of the plastics available. Acrylic is used for aircraft windows, sun windows, light fixtures and even eyeglasses. Many opaque colors are available, but the transparent colors, especially clear, are the most popular in use. Though sheet acrylic can be purchased in thickness from $\frac{1}{16}$ inch to over 4 inches, the most common size is $\frac{1}{4}$ inch and comes with a protective cover. Acrylic is best known by the brand names Plexiglas and Lucite.

Tools

Few tools are needed to work with sheet plastic. The tools used in woodworking or metalworking are the most common ones. Depending upon the design, a band saw, saber saw or power drill may be used. (See chapter 7 for the use of tools.) When sawing plastic, metal-cutting blades are best used at a slow revolution in order to avoid melting the plastic to itself on the blade. (CAUTION: *Always wear eye protection and a respirator when machining plastics.*)

Common sandpaper is used for finishing, especially the wet-or-dry type. The final polishes or buffing can be completed with an upright buffing wheel, flexible shaft or hand buffer. The revolution should be slow (less than 2500 rpm), or the buffer will melt the surface. Minimum pressure should be exerted with tripoli buffing compound, a rubbing compound, or a white polish (available at auto supply stores and boat dealerships).

Acrylic sheets can be cemented together with ethylene dichloride, a solvent cement, usually applied from a hollow needle (easily found at plastics suppliers, drug stores and veterinary supply houses) or a bottle with a special applicator tip. (CAUTION: *Chemicals such as ethylene dichloride require careful handling, excellent ventilation and a proper safety respirator.*) This solvent literally melts into the surface to provide a strong joint.

Kitchen ovens, burners or blow torches can be used with care to soften an acrylic sheet into a limp state in which a new shape can be formed. (CAUTION: *Acrylic will combust at high temperatures, emitting flames and toxic gases and resulting in a disfigured surface.*) Gloves should be worn when handling hot acrylic. Temperatures need not exceed 275 F. to manipulate the sheet easily.

Forming

Sheet acrylic has a thin protective paper or plastic cover on it, so a design can be drawn on the cover with a soft grease pencil. However, it is preferable to use a cut-out pattern to avoid unnecessary laboring on the sheet which may cause a scratch on the surface. Also, a precut pattern gives the sculptor an idea of what the work will look like after it is bent into shape. The cover should not be removed until the work is finished or just before it is to be heated in an oven. The work can be slowly sawed with power tools. Make sure that the surface of the power tool that touches the sheet is clean and covered with tape or otherwise smooth to avoid scratching the surface. Thin sheet acrylic can be deeply scribed with a sharp knife and broken on a straight scribed line. Be careful however, because the pieces flying off the break are unpredictable in thicker sheets up to $\frac{1}{4}$ inch. Drills are easy to use to add holes for a design. The edges of the surface can be sanded with air tools, a hand sander or power drills with small sanding drums. Files,

not rasps, and sandpaper can help define the edge. If total transparency is desired, then the edges must be hand-sanded to 600 grit and buffed.

Sculptor Harriet FeBland begins her work by making several straight cuts into Plexiglas to produce a number of small pieces. She sands these pieces with the protective cover still on. The thin pieces of Plexiglas are easily glued together with ethylene dichloride in a small bottle with a specialized tip. The "weld" is quickly formed by capillary action where the pieces touch. The pieces must be held together until the joint is firm. Though tape can be used, care must be taken to avoid placing the glue near the tape, or it will follow the tape.

Joining pieces with ethylene dichlorides.

Heating

After the sheet acrylic has been cut, remove the protective cover. Place the plastic in the oven, set at a temperature of 275 F°. Watch the piece until it begins to turn limp. Put on gloves, remove the plastic and bend it to shape. Acrylic sheet can also be heated with a propane torch or stove top burners; however, take care to keep the flame at a distance and move the piece constantly to avoid a burned surface and fire.

Sanding sheet plastic. Photograph: Harriet FeBland.

The protective cover is removed. Photograph: Nicholas Roukes.

Nicholas Roukes, Neos. *Acrylic, 24″ × 9″. Work in progress. Photograph: Nicholas Roukes.*

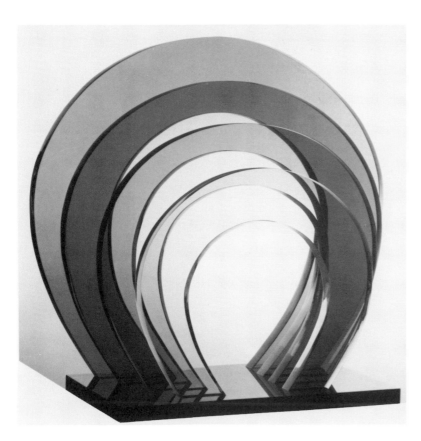

Lolo Sarnoff, Gateway to Eden. *Plexiglas, 36″ × 34″. National Museum for Women in the Arts, Washington, DC. Photograph: Breger and Associates.*

Sculptor Nicholas Roukes peels off the protective cover on his design prior to inserting it into the oven. This design is pictured after it has been bent into shape. The tall plastic rod ends are heated and then bent to shape with pliers. The work is cemented together with methyl methacrylate. (Observe the manufacturer's safety advice when using this substance.)

Lamination

Laminating acrylic sheet can create beautiful effects but takes much patience and finishing time as compared to the forming process.

Sculptor Malcolm Jones demonstrates how he laminates acrylic sheets and blocks together. Since he uses large thick pieces, he requires special equipment and time that would not be necessary for smaller, thinner works.

After selecting his design and scale, he begins cutting his stock, some 4 inches thick, from cast acrylic sheet. He applies Weld-on 40 glue to these pieces, then places his work in a vacuum chamber to degas (get rid of air bubbles). The two-part catalyzing glue takes about 20 minutes to set. (CAUTION: *This glue is extremely toxic; note the very heavy duty gas mask and latex gloves that he is wearing.*) When the glue has sufficiently set, he trims the new piece with a band saw. He has adapted a Rockwell saw for his purposes, and has designed a stable, horizontal working surface with a saw that tilts about it. Thus, he can better control heavy works. He prefers a skiptooth blade with 6 teeth per inch for acrylic. (Sears now sells a tilting band saw.)

After the pieces have been shaped, he places them in a special oven at 175° F for up to three weeks to cure. This process is known as annealing—a slow

Cutting acrylic sheet.

A heavy-duty respirator is essential when gluing.

Trimming the laminated piece.

Placing the work into a custom-designed oven for annealing.

Checking for flaws.

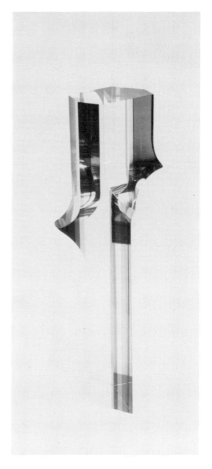

Malcolm Jones, Micron Series: A. Acrylic, 40″ tall × 8″ × 6″.

heating up, soaking with heat and slow cooling down. It prevents cracking, crazing and breakage from occurring because of internal stresses from heat.

Once the work is out of the oven, he continues to shape it by using a jointer. Notice the small place toward the top right of the work that he has polished out to check for internal flaws. Next he begins with wet-sanding the piece grit and works his way up to completion using dry grits and a machine when

possible. He stops at 600 grit and finishes with 30 and 15 micron polishing paper. Finally, he machine buffs the work with a fine white polishing compound to achieve his final results.

The beginner should not attempt to use large, heavy sheets of acrylic or an annealing oven. Small works can be placed in a regular oven for shorter periods of time at low temperatures. Take care that the heat does not distort the work. It is best if early works are not annealed, unless it is absolutely necessary. If stresses show after the piece has been buffed, it can be annealed and rebuffed. A vacuum chamber is ideal for degassing the work, but not always available. Air bubbles can be kept to a minimum by creating small works and by carefully squeezing out the glue from the center.

Body filler and hardener are ready to mix together with mixing spreader. This small amount will harden rapidly.

Built-Up Surfaces

In order to achieve a greater volume or to have a surface that can be manipulated, some plastic materials are ideal. The most common materials are body fillers for small areas and fiberglass for larger areas or molding.

Body Filler

The most readily available plastic material is auto body filler, most commonly known as Bondo. It generally comes in a can along with a tube of hardener. It has tremendous adhesion ability, particularly to clean metal. It is mixed according to instructions on the container, and can be placed on wire, sheet metal, wood (see chapter 7) or even cardboard. Though each layer should not exceed ³⁄₁₆ inch, layers can be built up to be thick and dimensional. Bondo is easy rasped and sanded to

Peter Forbes, Fast Moves. *Resin putty (bondo) and acrylic paint, 16″ tall × 13″ × 16″. Photograph: Courtney Frisse.*

Kerry Vesper using a wire brush to shape laminated Styrofoam.

finish and can be covered with acrylic paint, as Peter Forbes has done in *Fast Moves*.

Sculptor Kerry Vesper uses Styrofoam as a base for body filler. After he selects his design, he builds up the sheet Styrofoam by laminating it with water-based contact cement. (*Note:* Regular contact cement will literally eat through the Styrofoam. Weldwood acrylic latex contact cement is a good type to use.) Next he shapes it in various ways. A wire brush is used for quick removal, and a Surform rasp is also used for shaping. He coats his work with a paintable epoxy resin to seal it; otherwise, the bondo would melt the Styrofoam. (Three coats of Elmer's glue or three coats of latex housepaint also serve as a good seal.)

After the sealer is cured, the sculptor builds up the surface with body filler to a thickness of 1 inch. (**CAUTION:** *Body filler should be used with proper ventilation.*) It is a good rule never to mix more body filler than you can spread

out in 2 minutes, since it dries so quickly. Direct sunlight and high room temperature cause the body filler to set rapidly; high humidity slows the setting time.

Body filler is easiest to work within the first 30 minutes after it cures. Afterwards, it becomes very hard, but still filable and sandable. After the final shape has been filed, it is sanded up to 400 grit and sprayed with acrylic enamel for a hard high-gloss finish.

Laura Ruby, **Bones Sculpture I.** *Resin, 8′ tall × 6′ × 6′.*

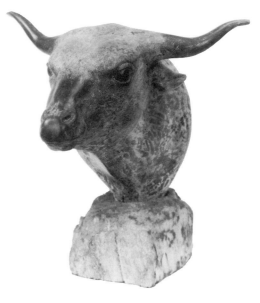

Patricia L. Verani, Toro. Polyester resin, 24″ tall × 22″ × 20″. Photograph: F.J. Sullivan.

Kerry Vesper, Kibishi, 1986. Fiberglass and acrylic enamel, 14″ × 10″ × 7″.

Types of fiberglass: left to right, three types of matt weave (heavy, medium, fine), thick matt, thin matt, veil (top) and fiberglass strand (bottom).

Fiberglass

Fiberglass is another material commonly used for built-up surfaces. The thin flexible glass fibers are saturated with a catalyzed liquid polyester resin or liquid epoxy to form a hard shell. The glass laminating fabrics come in a variety of types and weights. Matt weave is a fabric with heavy weave on one side and matt on the other that is used to provide strength. Other weaves are used depending upon the strength and thickness desired. Expandable weave is used over objects extending in different directions. Matt is easy to saturate whether thick or thin. The most delicate fabric is veil, which is much like tissue paper. It often is the first fabric used in order to conform better to the contours without trapping air. Fiberglass strand is also available, but generally used in a special chopped spraying machine for industrial work.

The catalyzed polyester resin or hardener-epoxy mixture formulas supplied by the manufacturer should be followed. (Please follow the appropriate safety precautions.) Some epoxies can be mixed fifty-fifty with the hardener and are easier to use than the resins, though they are much more expensive. Both mixtures are extremely strong. Resins take much less catalyst and tend to keep a tacky surface longer, Resin is used more often than epoxy.

Polyester resins use the hardener methyl ethyl ketone peroxide, which will cause instantaneous blindness upon contact with the eye. Extreme care must be used with this product. Even though you wear gloves, they should be washed quickly if anything spills on them. Otherwise you could inadvertently wipe your forehead or accidently brush your eyes with the chemical. Goggles are a must. (CAUTION: *All chemicals of these types are hazardous to one's health. Excellent ventilation, respirators and rubber gloves are a necessity. Also, these chemicals are extremely flammable.*) Most resins and hardeners require room temperature (70°) in order to set up properly. Mix in proper containers—not Styrofoam or wax. Acetone is a good chemical for cleaning tools, and such, but never use it on human skin. Denatured alcohol is best for cleaning the body followed by a final cleansing with soap and water.

Fiberglass can be laid over many types of armatures, including plaster, wood, sealed Styrofoam, cardboard and chicken wire. There are two basic methods to use on an armature.

1. Spread the cloth over the armature. Mix small batches of resin and quickly brush or roll each on the fabric until the desired thickness is achieved. Roll the piece or otherwise apply pressure to release all air bubbles.
2. Use small strips of matt or cloth, 1 inch by 2 inches to 4 inches by 6 inches. Cut and dip the strips in resin, using kitchen tongs, and then place them on the armature.

Apply a finish resin (gel coat) as the final color coat. The finish can be sanded, primed, painted, polished or buffed depending upon the design.

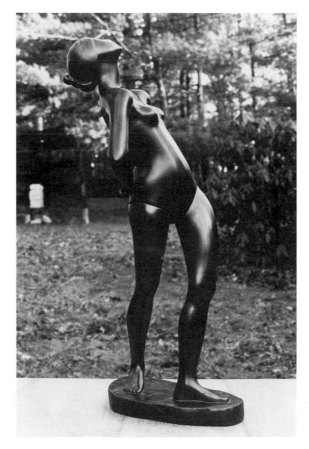

Lu Stubbs, Young Woman Twisting. *Polyester resin, 23".*

Chicken wire armature bent to sculpture's shape. Photograph: Michael David Fox.

Armature covered with resin-soaked fiberglass. Photograph: Michael David Fox.

A resin mold can easily be formed from resin-coated cardboard. After the smooth top coat is completely dry, it should be repeatedly waxed with hard paste wax and buffed. Apply coats of polyvinyl alcohol (PVA), and it is ready for the gel coat, the heavily pigmanted coat, which can be brushed on. After it is dry (but not over 8 hours), fiber cloth can be added as necessary. Be sure to work out all air bubbles. After the material has hardened, it is easily removed from the mold, especially if it is still warm after hardening.

Sculptor Michael David Fox uses chicken wire for his armature, then covers it with matt fiberglass that has been saturated with resin. When dry, he applies body filler to build out the shape. Nearing completion, he fills pits with an automotive finishing plastic putty filler. He finishes the sculpture by wet sanding and applying acrylic with polymer paint for makeup and decoration.

Plastic putty filler is used to fill pits. Photograph: Michael David Fox.

Michael David Fox and his sculptures in his family room. All are life-size. The completed Dog Tired Woman *is in the foreground.*

Sculptor Muriel Castanis has her own unique way of using epoxies. She works with epoxy-soaked cloth that she uses to drape all kinds of objects for her sculptures. These include chairs, bathtubs, boxes and even motorcycles. Using a mannequin, she covers it with plastic wrap and then carefully places the cloth, previously submerged in epoxy, on the form. Time is of the essence, since she must complete the shape in about 20 minutes. The texture, direction of weave, and heaviness of fabric help to determine her design. Her method of working produces sculptures that are rigid and yet very lightweight. On her largest works, fiberglass is placed over aluminum armatures.

Muriel Castanis carrying one of her lightweight works made of cloth and epoxy.

Muriel Castanis, Untitled. *Cloth and epoxy,*
6'4" × 4' × 2'.

Arthur Kern, Silent Myth. *Polyester resin,*
87" tall × 26" × 88".

Casting

Vinyl (EVA, Ethylene Vinyl Acetate)

Sculptor Duane Hanson finishes his figurative work to such a detailed degree that the viewer can walk right up to one of his creations and try to talk with it.

He begins his work by applying a Dow Corning silicone rubber mold material on a live model, one section of the body at a time. A fast-acting catalyst is used. Once the rubber is cured, he applies a plaster mother mold over it to keep the shape. All parts of the body are done in the same manner, including the head. Once the mold parts are removed, he pours vinyl (a mixture of Elvax from E.I. Dupont) into the silicone rubber molds. Repairs to the vinyl castings are made with a soldering iron. Finally, all the vinyl body parts are fitted together. He finishes the surface by airbrushing and, adding hair and articles of clothing. (For more information on body casting, see chapter 4.) (CAUTION: *Only the most experienced moldmaker should use live models to form molds from. Do not attempt to use mold materials on the human body without a complete knowledge of the materials and their compatibility with body casting.*)

Applying silicone mold material.

Applying the plaster support mold over the rubber.

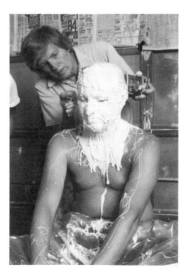

Molding the head.

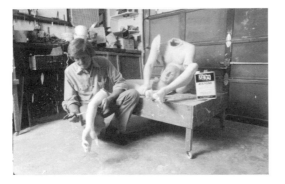

Repairing the vinyl castings.

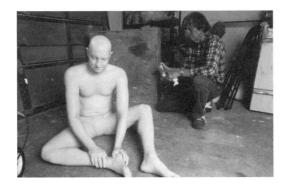

The vinyl work assembled, ready for the surface treatment.

Duane Hanson, Jogger. Vinyl, life-size.

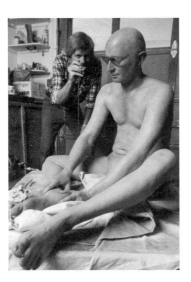

Airbrushing the surface.

Carole Jeane Feurman, Surfer. *Resin and oil,*
20" × 16" × 19".

Duane Hanson, Postman. *Vinyl, life-size.*

Epoxy

Sculptor Angela Lane uses epoxy in her work. Beginning with a clay model, she makes a plaster mold in which to cast the epoxy. (See chapter 4 for information about molds.) The mold is tied together while drying in order to avoid warpage. Once dry and clean, the mold interior is coated with PVA (polyvinyl alcohol). Next, she brushes the epoxy into each separate piece to a thickness of about 1/4 inch, finishing the last coat with a sheet of fiberglass. Then she places a bead of epoxy on each seam and puts the mold back together, squeezing out the bead into the cavity. Once the mold is removed, she cleans the seam and prepares the surface. Ordinarily, she casts her works with colorant added to the epoxy. However, this time she chose to apply aluminum bronzing powder with an airbrush. The resulting final surface is dramatic.

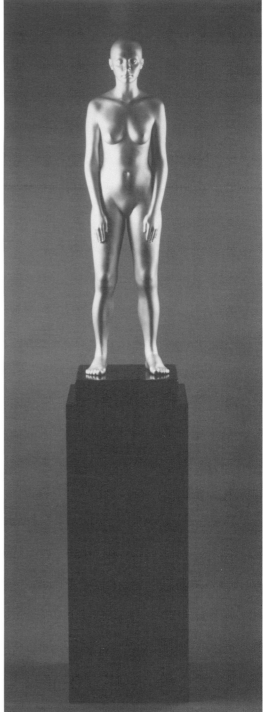

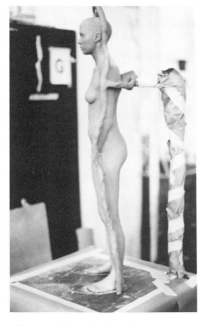

Clay model ready for plaster.

Aluminum bronzing powder is applied by airbrush.

Angela Lane, Symmetry, 1983. Epoxy, 72″ × 15″ × 15″. Photograph: Melville McLean.

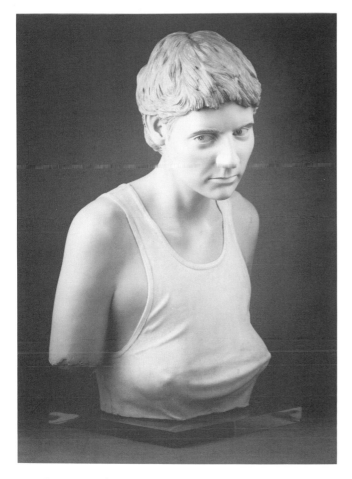

Angela Lane, Leah, 1983. Epoxy, 28″ × 18″ × 16″. Photograph: Melville McLean.

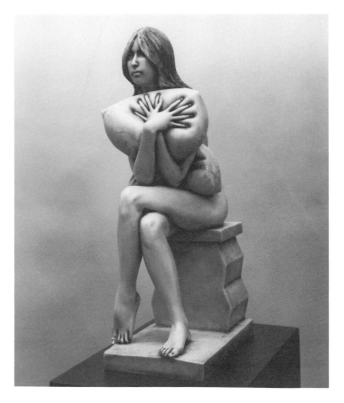

Lloyd Glasson, Gayle Breaking. Polyester, 18″ tall.

Resin

Sculptor Michael David Fox uses liquid casting resin as his medium for *Queen Shesucaro*. (Refer to chapter 4 for the making of the mold for this work.)

Beginning with a clean dry mold, he sprays the inside with an enamel for a color coat and then applies two coats of clear matte medium, allowing each coat to dry completely. This material is a good mold sealer and separator. He then brushes several coats of liquid casting resin on the inside and reinforces them with several strips of fiberglass matt cloth that has been soaked in liquid resin. The reassembled mold is sealed with body filler to avoid leakage. Additional resin is poured into the cavity to achieve a 1/2-inch thickness. Though the head is 24 inches high, it weighs only 7 pounds.

The waste mold was carefully removed with stone-carving tools. Old dental tools were used to remove the intricate mold pieces. The surface is in two colors because the color coat has a tendency to adhere to the resin. As he continues, he fills pits with body filler and plastic putty. Using wet-and-dry sandpapers, he finishes the surface, sprays it with a pink enamel, adds makeup with acrylic paints and puts on a wig. Since his five-year-old daughter thought the sculpture looked like a witch, he decided to change his approach and refinish the work. The final surface was sprayed with several coats of black enamel from 1½ to 2 feet away in order to create a matte, orange-peel surface that would absorb and reflect the light. It appears metallic grey and blue-black.

Color coat and separator are applied to the mold.

The casting removed from the mold.

The original finished sculpture.

Michael David Fox, Queen Shesucaro. Brushed liquid resin and acrylic, 24" tall.

Thixotropic, or thickened, polyester resins are often used in much the same way as liquid resins or epoxies. A perioxide catalyst is stirred into a small amount of resin and then the mixture is applied. More batches are mixed as they are needed. The mixture is brushed into both halves of a mold until a thickness of about ½ inch is achieved. After the halves are cured, they are placed together with more of the mixture added to the seams through the opening in the bottom. (See chapter 4 for the opening of the pictured mold.)

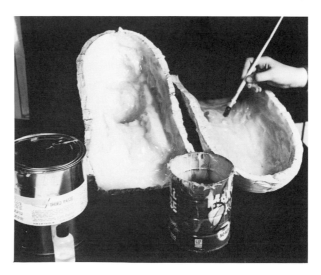

Brushing on thixotropic polyester resin. Photograph: Nicholas Roukes.

269

Clear Resin. I use clear liquid casting resin for my work. The two most critical aspects of the works are the molds and the catalyst mixture.

I like to use a silicone rubber mold with a thickness of 3/8 inch in order to stabilize the heat buildup. Some works take over 30 gallons of casting resin and the heat needs to remain uniform without rapid cooling. The mold must be carefully designed to avoid undercuts, since the resin will shrink about 5%. The making of the mold for this particular demonstration was illustrated in chapter 4. Notice the large mold lip that helps to stop leakage. Heavy denim fabric soaked in plaster and laid on top of the entire seam after the mold has been bound together is an additional barrier against leaks. After the mold has been leveled, the resin is mixed.

Working with resin requires latex gloves, good ventilation, a proper respirator and a certain amount of patience. I purchase resin in 55-gallon drums and mix it in large new (unused) plastic garbage containers. Though smaller mixes can be stirred by hand, for large amounts I use a mixer, like that used for mixing plaster or clay, with stainless steel blades and a slow rpm to avoid too many air bubbles. Colorant is mixed in first, then after 5 minutes the catalyst is added. Since the catalyst is organic peroxide, utmost care must be used when handling it. The amount used is determined by the thickness of the sculpture. The thicker the piece, the less catalyst is used; the thinner the piece, the more catalyst is used. Marble dust, stones or other material can be added before the catalyst, but I choose not to.

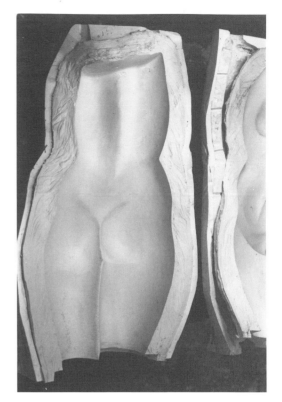

Silicone rubber mold.

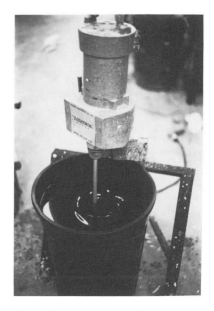

An upright mixer is used for large mixes in a new flexible garbage container.

I use from 1/4 of a drop of catalyst per ounce to 3 drops per ounce. Experimentation is the only sure teacher. Too little catalyst results in a cloudy Jello-like substance and too much results in a pile of fractured plastic. (CAUTION: *Never work with a large quantity of resin until you have gained the necessary experience.*) Humidity and temperature can change the mixture drastically, even double or halve it. The resin mixes for 10 minutes and then sits another 10 minutes to help release the built-up air bubbles.

Since the mold is silicone rubber, a release agent is not necessary. (If it were plaster, PVA or another release agent would be needed. The resin is poured into the mold through a filter funnel. Enough resin should have been mixed to allow for additional fillup when all the air bubbles escape. (CAUTION: *The mix is very toxic directly over the mixing container and mold, particularly as the chemical reaction is taking place. Good ventilation and the proper respirator are necessities.*) I babysit the mold for several hours, pouring in additional mix from the original lot as the air bubbles leave. The mold pictured begins to thicken in 6 hours, becomes Jello-hard in 10 hours, rubber-hard in 12 hours and sets in 16 hours. After setting, the casting takes 8 hours to cool. Total time from pour to removal is 24 hours.

The work can easily be taken from the mold. It can be annealed (rapidly cured) in direct sunlight for less than 8 hours. (Any more direct sunlight will yellow the resin.) The surface is rather "gunky" and sometimes tacky, but once the inner plastic is hard, the work can be completed.

After the resin has cured, the mold is taken apart. Here, the fabric strips used to seal the mold are removed.

Four resins representing finishing steps. Left to right: fresh out of mold, surface removed, after hand sanding, after buffing.

Finishing resin castings requires a great deal of effort. Notice the picture of the four steps to mold finishing. The surface can be removed by power tools or by hand, depending upon the design and the skills of the artist. If the design requires much work, sharp rotary grinders and sanders (demonstrated in chapter 7) can be used to change the form drastically, though careful molding is preferred. This surface was worked primarily with air tools. Once the surface is clean, sanding is begun. Though the work can be wet-sanded, I prefer to dry-sand the piece to 220 grit and then finish with wet-sanding to 600 grit.

Slow-revolution power buffers are essential. I use rubbing compound to rid the work of sanding marks and then finish with a white polishing compound.

Resin castings can be cleaned with rubbing alcohol and soft tissue and dusted with an ostrich feather duster. Never clean them with a commercial window cleaner (they contain abrasives). Castings can be displayed in indirect sunlight or under a distant spotlight but never in direct sunlight for that will cause colored castings to change color and clear castings to yellow.

Power tools are often used to shape resins and acrylics.

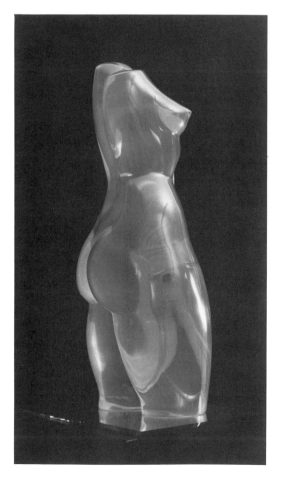

Arthur Williams, Tamar. *Cast resin, 28″ tall.*

Acrylic Casting

Sculptor Bruce Beasley is the creator of the largest transparent acrylic sculpture in the world. *Apolymon* weighs 13,000 pounds. He devised the methods for producing such a large work, which are trade secrets. Only one firm in Santa Ana, California, is licensed to do large-scale industrial acrylic castings. Construction of the mold is essential, but at the heart of acrylic casting is the use of an autoclave, a high-pressure and high-temperature oven. It is required to control precisely the temperature of the acrylic during casting to avoid boiling the liquid. Shrinkage is also a problem that requires much pre-planning and expertise on the part of the sculptor. The sculptor had to custom-build a very large annealing oven to accommodate such a massive work.

As with resins, much time in finishing is required. It took Beasley and an assistant seven months to sand and polish *Apolymon*.

Pouring acrylic into mold. Photograph: Joanne Leonard.

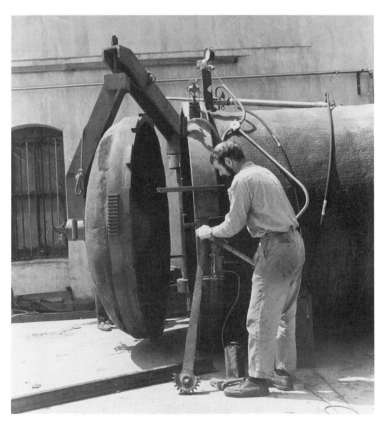

Large (78″ diameter) autoclave for monumental cast acrylic sculptures. Photograph: Joanne Leonard.

273

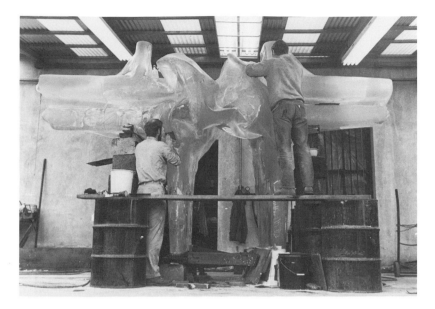

Sculptor Bruce Beasley and an assistant sanding
Apolymon. *Photograph: Joanne Leonard.*

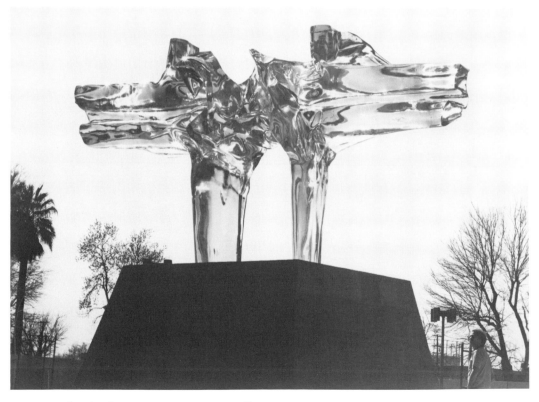

Bruce Beasley, Apolymon, *1967–70. Cast acrylic,*
15′ wide, 13,000 lb.

A milling machine is used to ensure optically true reflections. Photograph: Joanne Leonard.

Bruce Beasley, Dodecker, Cast acrylic, 18" tall.

Frank Gallo, Oriental Girl. Cast paper, 50″ tall × 41″ wide.

11

PAPER

- Tools, Materials and Processes
- Casting Paper
- Armatured Paper

To say that paper is a new art medium is not accurate. To say that it is becoming a popular sculpture medium is true. Though it has been used in various ways throughout the centuries, only recently have sculptors taken an interest in paper as they begin to explore the three-dimensional uses of it. Of all the media in this book, using paper for sculptural purposes has little available sculpture reference material. At a time when the toxicity of chemicals is a great concern, using paper in sculpture is a nice change. The cost is minimal, and the process is reasonably easy.

Paper can be handmade, store bought, molded or modeled, plain or painted, used by itself or with other media. There are numerous possibilities. However, there are also limitations. Paper by itself is not as durable or strong as most sculpture media if left exposed to ordinary elements. Even with special sealing, it is still an indoor medium.

Making paper from plants is rather tedious and time-consuming, but it has its rewards. Each plant has its own color and texture and is ordinarily found in nature free for the taking. Once the plants are harvested and processed, they produce unique paper that the sculptor knows is first-hand color, mixture and texture. However, the process requires selecting, trimming and cooking the fibers as well as beating them. Though a food blender can be used for beating small quantities, a Hollander paper beater is best for larger quantities. This machine was invented in Holland for beating plants and cloth into a refined pulp suitable for paper-making. Not only is the machine very expensive, but the beating process takes time and also creates unusual odors best kept from living quarters.

This chapter will not cover how to form sheets of handmade paper. That is

Ted Ramsay, Untitled. *Cast paper with cotton, pigment and clay, 74″ diameter. Photograph: Cindy B. Ramsay.*

a complete process within itself, and there are other sources of information readily available about making paper (see Bibliography). It is assumed that the sculptor already knows how to make paper or will use commercially prepared pulp, as many sculptors do. This chapter furnishes information for the sculptural application of the paper medium once the pulp is secured.

Kevin Lyles, Stacked Column. *Cast paper, oak and string, 7½′ tall × 10″ × 10″. Photograph: Jim Brey.*

Tools, Materials and Processes

The process of making paper sculpture requires simple materials, tools and processes. They may be unfamiliar to the ordinary sculptor, however, so the tools, terms and processes are briefly defined.

Pulp is the material that is produced by cooking and heating plant fibers or cloth. The term as used in this chapter refers to a product that is ready to use for making sculpture. The pulp itself can be one of several fiber families and several specific consistencies. Long-fiber pulp is better for sheet paper because of the strength of longer fibers. Short-fiber pulp is generally used for forms with more dimension.

If no pulp is available, a good grade of printmaking paper or Strathmore pad can be shredded, soaked and thoroughly beaten to be used for sculptural purposes. Tear the paper into small strips (1–1¼ inches wide) and boil them in water for several hours in order to relax the sizings that bond the fibers together. When cool, beat the mixture into short fiber lengths. A food blender can easily do this within 60 seconds.

Karl Umlauf, Legend Series XXXIX. *Cast paper, 70″ tall × 38″ × 3″.*

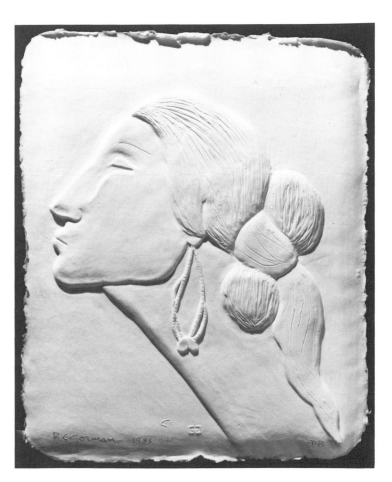

R. C. Gorman, Angelina. *Cast paper.*

Cotton linters are short cotton fibers found closest to the cotton plant's seed. "Cotton content" paper is primarily composed of cotton linters. It is the preferred fiber for paper pulp, since it is more dimensionally stable. It does not shrink.

Methylcellulose (CMC) is used as an adhesive to help the pulp stay together by bonding fiber to fiber. It also makes the dry paper hard. It is good to use when the paper is not formed with the sheet-forming techniques that require pressing. Some wallpaper paste powders contain a large percentage of CMC.

Sizing is added to the pulp to ensure interfiber bonding. It helps hold the paper fibers together. It also helps to protect the work from environmental pollution.

A *screen mold* is a wooden frame with a fiberglass, aluminum or brass screen on it. It resembles a screen window with one side completely flat. The *deckle* is a wooden frame that fits around the outer edges of the top of the screen mold. When pulp is placed inside the deckle, it holds the pulp while allowing the water to drain through the screen mold. The deckle is then removed to reveal a sheet of pulp.

Couching is transferring the newly formed sheet of pulp on the mold screen to an absorbent surface such as felt or woolen blankets. This is done to remove excess water from the pulp sheet.

There are several ways that sculptors have used paper in recent years. Most are simple and often combine other processes such as mold making and armature use. Poured or sheet pulp can be cast in a rigid mold. A paper sculpture can have a hidden armature for support and an exposed armature often is utilized as part of the design. The armature may be molded on or added to, resulting in a paper sculpture.

Casting Paper

Commercially prepared liquid pulp comes in tightly packed containers with CMC and sizing (if requested). Since the pulp is tightly packed, water has to be added to it to make it a workable liquid. After water has been added, it should be blended together until there are no balls of pulp. A food blender can help but is not necessary.

Castings can be made from various mold materials such as plaster, rubber, epoxy or even found objects.

Dry plaster molds may not need a release agent, depending upon the use of a sizing or CMC, which serve as adhesives. However, silicone spray can help. If many castings are to be done, the plaster should be coated with three or four thin coats of shellac and then waxed with a heavy paste wax. Silicone spray does not protect the plaster as well as shellac does.

Rubber or silicone molds will make more castings but can present special problems due to their flexibility. Also, they need to be stored in a cool place in order to avoid shrinkage and deterioration. No release agent is needed for these molds. Since the molds are so flexible, they will bend and depress, even in the mother mold. If too much pressure is placed on them while adding the paper, a torn place may occur in the casting.

Hard epoxy molds hold up the longest and require no release agent. The toxicity involved in creating these molds is the most serious problem. (Refer to chapter 10 for safety precautions when using epoxy.)

Paper can be added in two distinct ways. Either place the pulp directly into the mold, or couch it using the mold and deckle to form a sheet that is added to the mold.

Placing pulp directly into the mold

Coco Gordon, Skin of Myself. *Flax, lifesize.*

Commercial pulp.

A blender can be used to mix pulp with water.

Pouring pulp into a mold.

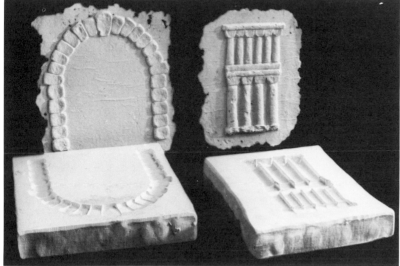

William Disbro's paper castings and plaster molds, 10″–12″ tall.

Removing a deckle to reveal a sheet of pulp.

Screen mold and deckle.

The mold and deckle are submerged in a vat of liquified pulp.

Raising the mold and deckle from the vat.

A thin sheet of pulp.

may be necessary when a mold is very dimensional or deep in order to avoid tears in the paper. After the pulp is added, it is thoroughly sponged then allowed to dry. CMC is used for bonding. This method does not result in the strong bonding that sheets provide since the fibers cannot line up as well as in the sheet method.

Making a mold and deckle is quite easy. A mold is simply a wooden frame, normally made from 1 inch by 2 inch boards. One side is covered with an aluminum, brass or fiberglass screen that is drawn tight and stapled to the sides. A deckle is an additional frame that is open on both sides. It is placed on the top of the screen where the pulp is temporarily trapped. Then the deckle is removed to allow the sheet to be couched.

Using the mold and deckle is simple. The mold and deckle are carefully passed through a large vat filled with liquified pulp to form a thin sheet. Then the sheet is couched onto felts to be pressed and blotted partially dry prior to being placed into a mold for casting. Smaller torn sheets can be pressed into the casting mold by overlapping torn edges to form one large sheet. However, some artists pour the pulp directly into the mold and deckle for larger sheets.

In order to avoid warpage while the pulp dries, weights are placed on the wet sheet. Since the pulp must have air to dry, the weights should allow air to freely circulate. One method is to position large coated nails through a screen. I prefer to place small chains across the sheet until it dries. These chains are zinc coated to avoid rust.

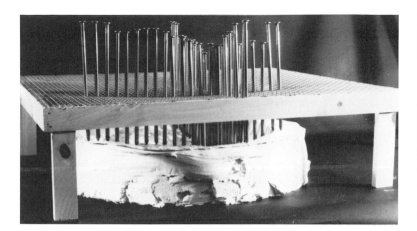

Zinc-coated chains serve as weights.

William Disbro shows a procedure for holding wet castings down in the mold to avoid warpage.

Relief Mold

Sculptor Frank Gallo's *Editions in Cast Paper* demonstrates his method for completing a paper relief casting.

The pulp used is a special blend formulated especially for the particular casting. It is processed in a large Hollander beater. A sizing (synthetic polymer) is used instead of CMC, since his process allows good bonding. A large vat is filled with the liquid pulp. A mold and deckle are passed through the vat to gather the pulp. This is done in one complete motion, completely submersing the mold and deckle. This method helps the pulp fibers to align into a stronger sheet. The water is allowed to drain through, and the mold is removed. The paper is then couched onto a felt and placed into a three-ton press.

Gallo's artwork has been done in modeling clay to achieve the surface quality that he wants. He makes a silicone mold from the clay model and, finally, an epoxy mold to have the strength necessary for his editions. The epoxy does not require any release agent. It is this mold that the paper is placed in.

Paper press.

Overlapping torn sheets.

The small sheets of paper have torn edges so they will blend better and adhere to the other sheets as the process is continued. Each sheet is individually laid out and pressed into the mold using a mechanic's parts brush with some sponging. The overlapped edges are carefully pressed together. Once all the sheets are out and pressed into place, a second layer is placed on the top in the same manner. This time the joints are in different, overlapping places. If this process is correctly completed, the joints cannot be seen in the final work. The work is sponged to remove additional moisture.

The sculptor created a "bed of nails" for holding the paper in place while drying. it consists of large wire mesh screen with long gutter nails loosely hanging down through it. (Corrosive nails must be coated to prevent rust spots.) This screen is hung over the mold and lowered directly onto the paper, with only the nails touching the paper. Since the nails are loose, they hold the high and low paper in place, keeping it from curling or waffling while drying. The overnight drying process utilizes large fans and humidifiers. Once the paper is dry, it is easily removed by hand. Notice how thin the two-ply paper is. It is equivalent to a heavyweight printmaking paper. The final result of this particular casting is *Innocence.* Another example of Frank Gallo's more dimensional work is also pictured.

Pressing in pieces with a brush.

Bed of nails.

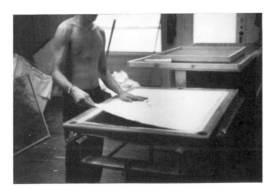

Removing paper from mold.

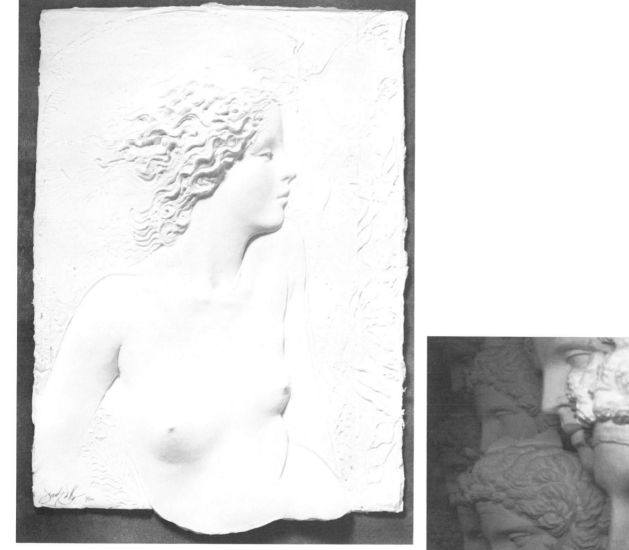

Frank Gallo, Innocence. *Cast paper,*
32" tall × 24" wide.

Frank Gallo works in
progress.

Plaster mold. Photograph: Connie Herring.

Plaster Mold

Sculptor Connie Herring demonstrates the casting process using a plaster mold. (See chapter 4 for mold making.) She uses commercial pulps with her own additions of some fabrics and various dyes.

Beginning with a positive plaster mold made from a clay model, the sculptor cleans and dries it. No mold release agent is necessary. Pulp is added to the surface by hand. She builds up the casting to a thick layer, using a sponge to press the pulp in place and to remove water. In order to add a more coarse texture, she throws additional pulp to the pressed layer without pressing it with a sponge. Varying the texture further, she adds pulp from a flexible ketchup bottle. Inserting small seashells adds a personal touch.

Once the paper is completely dry, she removes the mold. Depending upon the humidity, the curing process takes 2 to 3 weeks, since she allows the work to dry naturally without the aid of fans. She desires additional color, so she coats the inside surface with gesso and paints it with acrylics. The final work is pictured.

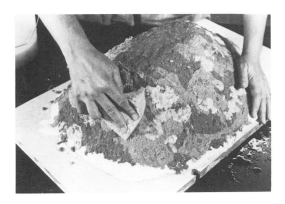

Pulp is pressed on with a sponge. Photograph: Rosalie Lemme-Johnson.

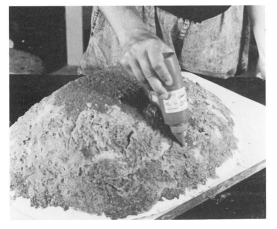

Applying pulp that will not be pressed. Photograph: Rosalie Lemme-Johnson.

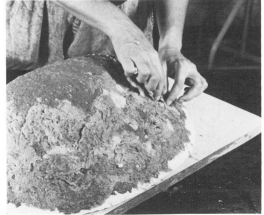

Adding seashells to the surface. Photograph: Rosalie Lemme-Johnson.

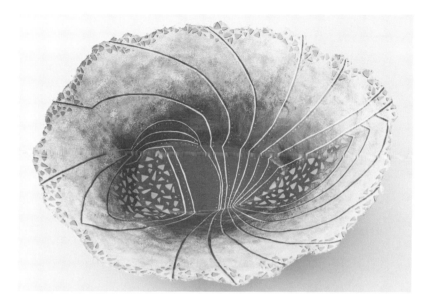

Connie Herring, Untitled. Cast paper, 5½" tall × 21" × 17". Photograph: S. R. H. Spicer.

Found Object Mold

Sculptor Lilian A. Bell demonstrates her procedure for making paper sculpture using her own pulps processed from mulberry, milkweed, manilla, gampi and other plant fibers. Her mold screen is made with 40-mesh bronze screen.

Using her prepared pulp, she adds a synthetic polymer formation aid that helps to keep fibers more evenly distributed in her solution. She pours it into a shallow mold and rocks it to disperse the pulp. She drains the water and adds more pulp, repeating the process in succession. From four to six layers are built up for strength. Draining the water for the final time, she adds a fabric backing to help remove the pulp from the screen.

The fabric backing is removed from the pulp sheet after a towel has blotted off the excess moisture. The new sheet is strong, pliable and tear-resistant. She places the wet sheet over a rock slab.

Pouring solution into screen mold. Photograph: Glenn Hashitani.

Wet paper is pressed onto the shape with a towel. Photograph: Glenn Hashitani.

Lifting off the casting. Photograph: Glenn Hashitani.

(She notes that usable, natural and human-made forms abound for this purpose. Even on-site surfaces and forms such as metal gratings, cement surfaces, rocks and brick can be used.) She does not use a mold release agent. She blots the pulp sheet as it is pressed into cavities and allowed to dry naturally. This will take from 24 to 48 hours due to the humidity and pulp thickness. (She prefers not to use forced drying with artificial heat or fans due to the shrinkage and warpage that can result.) After the casting is completely dry, she carefully lifts the casting from the form. It will neither stick nor warp during removal.

After she completes the rest of the pieces involved in the sculpture and removes them from the object molds, she applies additional color. The rock casting is dyed with India ink. Often she adds contrasting colored chalk for a patina and spray paints or dyes the pulp prior to casting. The assembled finished work is pictured.

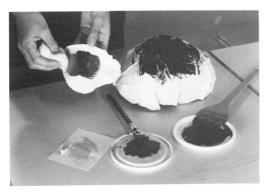

Applying color. Photograph: Glenn Hashitani.

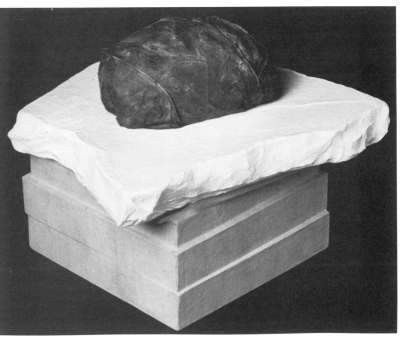

Lilian A. Bell, Quenched Rock. Cast paper, wood and mixed media, 13″ tall × 17″ × 16″. Photograph: Glenn Hashitani.

Deep Mold

Timothy High demonstrates his technique for a fully three-dimensional cast sculpture using paper.

After his work is completed in modeling clay, he divides the work for casting into a two-piece latex mold and a four-piece mother mold. (See chapter 4 for mold-making information.) After the mold is complete and cleaned out, he reassembles the mold into two halves.

He uses a short unbeaten cotton linter fiber that comes commercially prepared in sheet form (Twin Rocker cotton linter #270, 24″ × 36″ water leaf sheets). He tears eighteen sheets into shreds, places them under water in a specially reworked washing machine that has the inner basket removed. (An unadapted washing machine will clog up.) He adds CMC (by using Golden Harvest wallpaper paste) at 1 cup per 5 gallons for the sizing. This mix is agitated overnight until it has the consistency of thin applesauce.

Using spray silicone as a release agent, he thoroughly coats the latex surface of the mold. He adds pulp to the lower places first, constantly blotting the areas with a natural sponge using great pressure. Notice that he overlaps the mold edges for joining purposes later in the process.

After the entire surface has been sponge blotted to remove excess moisture, he places a hardware cloth over the mold and inserts welding rods. These rods have been dipped into white paint to prevent rust. They are used to hold the paper in the mold in order to avoid distortion from shrinkage while the work is drying. The work dries naturally within a 2-week period of time. The average casting thickness is ¼ inch to ⅜ inch.

A latex mold and plaster mother mold.

Pulp is pressed into the mold with a sponge.

Welding rods keep the casting from shrinking as it dries.

The two halves are joined together.

He takes the paper out of the mold and places the two halves together. He cuts them to match and then adds Sobo (PVA) glue to the inside using corsage pins (thin stainless steel pins) from the inside to hold them in place. Also, he places wax paper over the joints on the outside (to avoid sticking to any glue) and adds a foam rubber cushion at pressure points; then he binds the two pieces together with several laps of dry cotton string. While the mold is held with the string, he takes the pins out while the glue is still wet.

After allowing the mold to set overnight, High takes off the string and touches up the seam with 320-grit sandpaper to hide the joint. Any glue that shows is sanded off.

This piece is part of a large installation. The detail and the installation are pictured.

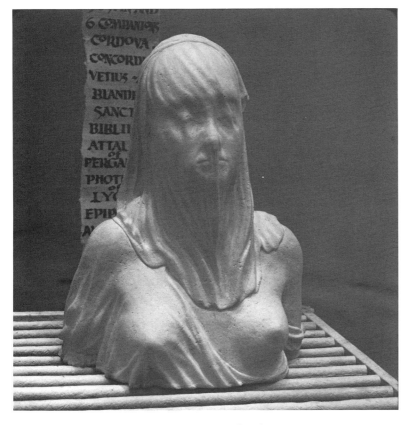

Timothy High, King's Kite III. *Cast papter, detail,*
25" tall × 15" × 9".

Timothy High, King's Kite III. *Mixed media*
installation with paper.

Armatured Paper

Stacked-Sheet Armature

An armature using stacked-sheet assembly requires a great deal of paper and much time to complete. The form is literally made of hundreds of thin sheets of paper placed together. If the sculpture is large, thousands could be required to finish the work.

Sculptor Claire Jeanine Satin uses a pulp of 100% cotton for her sheet formation. She places her pulp on an unframed screen to allow the moisture to escape. Once formed, she hangs the sheets to dry with a fan. Due to the large number of sheets required, this is the only way to dry them without using a tremendous amount of floor space.

Once dried, the different sized sheets are placed together on a wooden armature designed to present the flat sheets in a new sculptural volume. She mounts them on a wall in a grouping to create a high relief. The final work is pictured.

Sheets are formed on unframed screening.

Claire Jeanine Satin, In Situ Interlock. Paper, dyes, wood and mylar, 7' tall × 10' × 1¼'. Main Library, Broward County, Florida.

Coco Gordon pours pulp over exposed steel armature. Photograph: Helmut Becker.

Exposed Armature

Depending upon the sculpture, sometimes armature materials become an integral part of the design. This reinforced paper armature is a rigid armature that adds visual interest to the paper. Sculptor Coco Gordon demonstrates one of her works using reinforcement as part of the design.

The fibers she uses are long cotton fibers for good adhesion to the reinforcement. She pours fiber over the wire screen, keeping a bucket underneath to catch the excess. She repeats this until the desired result is obtained. Then she shapes the wire to form her sculpture. This procedure accounts for the different directions of the fibers on her finished works. She forms pianos, chairs and other objects this way.

Coco Gordon, Sail Piano. *Paper pulp, wire, marine blue and wind-up toys, baby-grand size. Photograph: Helmut Becker.*

Modeling Armature

Sculptor Aaron Royal Mosley demonstrates the use of readily available materials in an ingenious way in order to create a large, lightweight hanging sculpture with the armature method. He uses an internal hidden armature.

Using readily available computer printouts, he shreds them in a paper shredder. The new strips are soaked for about a week and then placed into a clay mixer with water to be thoroughly soaked and returned to the pulp stage. Borax (to keep insects away), wheat paste (a binder) and bleach (to prevent fermentation) are added. The mixture is then taken from the machine.

The armature has already been formed from a ¼-inch steel rod mounted on chicken wire covered with a steel frame. The new pulp is pressed into the wire mesh to achieve the form. The outer skin is prepared in an electric blender and then brushed on for the surface coat.

After several days' curing time, the work is dry. The surface is given a coating of linseed oil, mineral spirits and a permanent dye. The glasses are made from a ³⁄₁₆-inch mesh hardware cloth with pulp and carpenter's glue for binder. The final work is pictured on the next page.

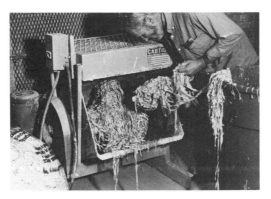

Putting soaked shreds into a clay mixer.

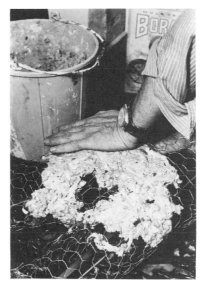

Pressing pulp into the chicken wire armature.

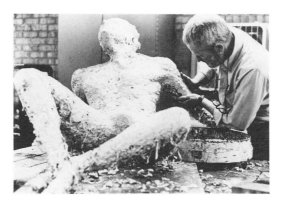

Shaping the surface of the armature.

Brushing on the surface coat.

293

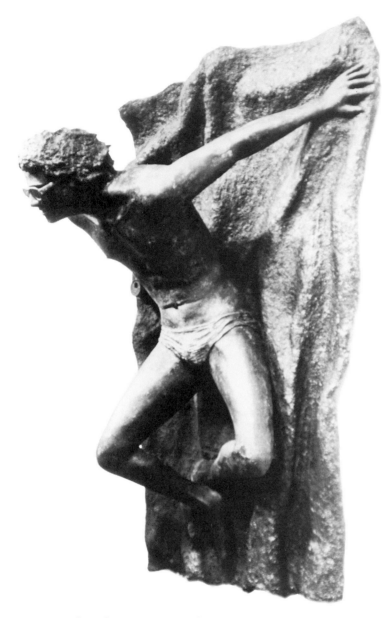

Aaron Royal Mosley, St. Laguna. Oil-tempered paper on steel armature, 6' tall × 3½' × 2¼'.

Student work. Cynthia Shaw, Reese's Cup. Paper with cardboard armature, tempera and varnish, 6" tall × 24" × 16". Instructor: Charles H. Bohn. Photograph: Christine Cilley.

Sylvia Wald, Bird Mask I. *Painted Japanese kochi paper over wire and string armature with colored glass, 15" × 17" × 8".*

Winifred Lutz, What Closes Here Opens Elsewhere. *Cast flax paper, gampi paper, sycamore wood, 66" tall × 24" × 24".*

Dolly Unithan, Rain. *Etched prints on paper, wax, bamboo, twine, 66" × 50". Photograph: Manu Sasoonian.*

Richard Newman, Demeter's Dilemma. *Mixed media.*

12

MIXED MEDIA

- Assemblage
- Construction
- Environmental
- Installation
- Demonstration

In the twentieth century, and especially in the last decade, sculpture has involved many media and techniques at the same time, on the same piece. This frustrates any system of classifying artists either by medium or by technique. The artists within this realm have terms for their own method of working that do not parallel fellow artists' thoughts, though the processes may be the same. It is with this in mind that this chapter was born. It features assemblage, construction, environmental, installation and other mixed media work.

The definitions of these terms vary, depending upon the source and the artist. The definitions included in this chapter should provide some clarification.

Assemblage

An assemblage is a sculpture assembled from found objects. The objects can be made by humans or nature. They can be gathered and placed together in many ways with other more sculptural material serving as binders or backdrops.

Construction

A construction is a sculpture made of many parts. Usually it is created from raw materials, though found objects are often included. Many processes are used—cutting, gluing, forming, painting. The most common media are wood and metal. These processes and materials are normally associated with the construction industry.

Sandy Skoglund, Radioactive Cats. *Multimedia installation. The cats are made from chicken wire and plaster and painted green. The environment is painted gray. The people are real, though not present during the exhibit, leaving the viewer to assume their place.*

Margaret Prentice, A Small Sacrifice Will Do. *Mixed media, 24″ tall × 20″ × 66″. This is a mechanical sculpture. The viewer moves a small handle along the bottom of a track to cause the figures to turn and the brooms and scrolls to sweep across the floor.*

Environmental

An environmental sculpture is a large-scale sculpture that encourages the viewer to move into or about it. The materials vary, but they are often basic permanent materials from the building trades such as brick, metal and wood. Sometimes the sculpture is constructed of impermanent materials for a temporary display.

Installation

An installation is a large-scale sculpture created on the site for special effect or for the reaction of the viewer rather than participation (as in environmental sculpture). It is seldom created to be permanent. Oftentimes it is very delicate and untouchable; it is usually viewed from a distance.

It is often difficult to tell a student how to work on a particular piece of sculpture, but nearly impossible to instruct how to create a mixed media work. The possibilities are just too great. All methods and materials should be considered and the choice should be made by the sculptor according to a particular personal idea.

This chapter presents sculptures that illustrate a combination of much of the media and techniques discussed in the preceding chapters. Only one work is used as a demonstration piece. It was chosen because it epitomizes the idea of building upon the information given in the previous chapters.

The works pictured were chosen because they present a broad range of ideas that a student may consider. All works are listed as the sculptors preferred, though the viewer may disagree. Often, the sculptures do not fall within the given definitions.

Bonnie Lucas, Something Blue. *Assemblage with fabric as a medium, 13″ × 10″ × 2″ Photograph: D. James Dee.*

The sculptor prepares working drawings.

Priming with gesso.

Spray painting the finished wood form. *Soldering welding rods.*

Riveting metal pieces to wood form.

Jack Maxwell, Day/Night Watch. *Construction, 3' × 2' × 3'.*

Demonstration

Sculptor Jack Maxwell demonstrates the creation of his *Day/Night Watch,* a construction that is an excellent example of how many tools, techniques and media can be used together. Without the skill and knowledge to operate the tools safely, as stressed throughout the text, the sculptor could not accomplish this. Refer to earlier chapters for the use of specific tools mentioned.

He starts with several designs and working drawings. He finds this approach best when he is planning a construction.

He begins his construction in wood using small pieces of softer woods, such as pine. Most of this work requires the use of the table saw. Though some nailing is necessary, white carpenter's glue is preferred. When the individual parts are completed, he sands them, then primes them with gesso for a thick undercoat.

The sculptor cuts a stump with a chain saw, then further refines it by using a band saw and finishing it with wood-carving tools. He fills, sands and finally spray paints it. Using silver solder, he solders together small welding rods in a circular fashion. He uses rivets to join the completed wood and metal with precut, predrilled metal. He completes the other required metalwork and then uses a spray gun to paint all of the wooden surface except the columns. These he chooses to stain lightly and oil. The completed construction is illustrated.

Jennifer McMakin, **Gumball Machine.** *Wood, metal, plastic, cork and water, 20" tall. Instructor: Larkin Maureen Higgins.*

Michael L. Aurbach, **Final Portrait: Electrician.** *Sheet steel, electrical hardware, plywood and rubber (interior), 4½' tall × 2' × 6'.*

James Killy, **Chet's Clock** *(in opened position).*

James Killy, **Chet's Clock** *(closed crate). Poplar wood, cherry wood and cast bronze, 30" × 13" × 11".*

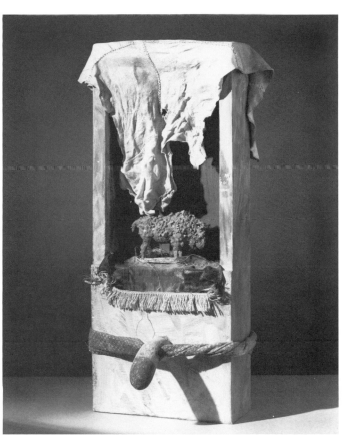

Gordon Wagner, Firaskew. *Assemblage,
76" tall × 39" × 33". Photograph: Janice Felgar.*

Fritz Scholder, Forgotten Altar. *Mixed media,
20" tall.*

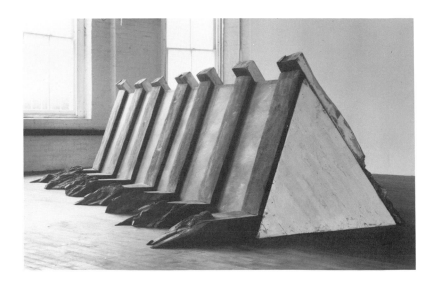

Ursula von Rydingsvard, Ignatz Comes Home.
*Cedar, paint, and lead, 4' × 12' × 6½'.
Photograph: David Allison.*

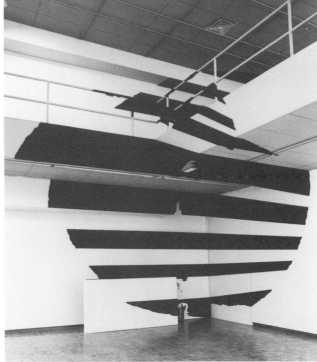

Thomas Macaulay, Installation at Wright State University Gallery, *Dayton, Ohio. Paper, push pins, tape, portable walls and ladders, 24' tall. This is an example of viewer involvement in an installation. As the viewer moves, the work changes into other three dimensional forms.*

Judy Pfaff, N.Y.C. B.Q.E. *(Whitney Biennial).*
Painted steel, fiberglass, plastic and laminated
wood, 35′ × 15′ × 5′. Photograph: Holly
Solomon Gallery.

Stuart J. White, A Real Piece of Americana.
Polyester, wood, and working clavichord,
42″ × 52″ × 38″. Photograph: Armen Shamlian.

Nancy Holt, Stone Enclosure: Rock Rings, *detail.*

Nancy Holt, Stone Enclosures: Rock Rings. *Hand-quarried rock from a mountain 65 miles from the site, 10′ tall, 40′ outer rim diameter. Western Washington University grounds, Bellingham, Washington.*

Phyllis Yes, Por-she,
1984. Mixed Media.

Patricia A. Renick, Life
Boats/Boats About Life,
*1979–82. Mixed media,
5′ to 7′ long.*

Barbara Rothstein, Passage. *Mixed media, 55″ tall × 36″ × 32″. Photograph: Linda Cohen.*

13

PREPARATION FOR EXHIBITION

- Preparing for Display
- Packing Sculpture
- Installing Large Sculptures
- Arranging an Exhibit
- Photographing Sculpture

The sculptor is a unique artist who has problems in preparing for an exhibition that are not faced by other artists. The sculptor may have carved, cast, welded or modeled a beautiful work only to be unable to mount it adequately, or to discover that mounting destroys the intent of the piece. The gallery refuses to show the sculpture without more stability. Arriving at the exhibit area, the sculptor is horrified to find that not only does the gallery not have stands, but they thought that stands were part of a sculptor's work and responsibility to furnish. Or, worse yet, the exhibit director had comforted the sculptor with reassurances that plenty of stands are available. The sculptor arrives to find stands akin to apple crates with no variety of height or size, painted a decade ago with colors rejected from a paint sale.

The exhibit director did not know that the sculptor wanted "special" lighting; after all, the lighting is nicely focused along the wall where it should be (to exhibit paintings). Perhaps the sculptor is to share a show. How could he or she expect to take the lighting away from a painting that depended on it so much more? Or, "What do you mean you don't have something for the walls? What will we do? We have never had a show with blank walls! The place will just be empty without some art"!

This scenario occurs after the sculptor has feverishly packed the work, sometimes in a special crate for each sculpture, only to find pieces damaged in shipment. After all, the freight company does not ordinarily ship "art" and the sculptor should be grateful that they accepted the job at all, even though they refused to insure the sculptures since they were "heavy" art.

"What do you mean, help you unload? As you can see my secretary

and I are they only ones available, and it certainly is not our job."

The crane arrives to install a sculpture, and the crane operator refuses to set up until a cash fee is paid since the sculptor is from out of town. Then he must sign a waiver, just in case there is an accident. So the bolts in the concrete base do not fit? How can the sculptor blame the contractor? After all, exact tolerances are unheard of for things that are going to be mounted like light posts!

The gallery wants transparencies, and, yes, a slide is a transparency, but no, that is not what they want. This is not the show they saw in the slides; those sculptures were brighter with more color in the pictures.

To a young sculptor who has never had an exhibit, these situations are unfamiliar. Experienced sculptors know first-hand, however, that exhibits can go as badly as described. Though everything may not be perfect, many problems can be avoided with proper preparation. That is what this chapter is all about.

Preparing for Display

A sculpture may look perfect in the sculptor's studio, but it is seldom ready for display without special mountings or stands. Preparation of these often requires additional work. The *base* is a construction on which the lower part of the sculpture rests. Heights vary, but bases usually are square or round. A base lends stability and cosmetic appeal to a piece, and can hide some of the mechanics required of a specific work. Not all sculpture should be placed on a special base. Often the work itself has a built-in support capable of giving the sculpture the stability it needs and, visually, the sculpture may not need an additional appendage.

The *plinth* is similar to the base. It is more shallow and much broader, much like a table top. A plinth lends stability to the work but is designed more to isolate it from the surroundings.

The *stand* is the structure on which the sculpture, with or without plinth or base, is displayed. The stand is placed on the floor and is seldom attached to

James McGrath, Shadow, 1987. New Mexico basalt, 4" tall × 11" × 7." Photograph: Ed LaBane. The base has been incorporated skillfully as an integral part of the work.

the sculpture, though it may be. A stand can help hide many mechanical or electrical operating devices that some sculptures require. Stands vary in height depending on the sculpture involved; they can be quite tall or only inches from the floor.

Mounting. The process of mounting a sculpture on a plinth or base depends upon the sculpture. A simple method of bolting normally is used:

1. When possible, the sculpture should be slightly flattened to fit the base. A rounded object can have a small flat spot without causing visual damage.
2. The size of bolts needs to be determined. For small lightweight work, 1/4-inch are sufficient, but large heavy works need 1/2-inch bolts. (There must always be at least two bolts or a bolt and an anchor rod. Otherwise, the sculpture will twist from its original setting.) Drill the holes into the sculpture.
3. Use epoxy (the common choice) to glue the bolts. Fast epoxy will set in 5 minutes and will support weight in 30 minutes with nearly full strength overnight.
4. The base or plinth, usually made of wood, is oiled, stained, painted or coated with laminate. Fit it to the work, mark the hole locations and then drill from the top surface of the plinth to the bottom. Mount the sculpture temporarily to check alignment. Turn over the plinth and enlarge the bolt hole with a large wood bit in order to countersink the nuts to the bolt. A good mounting will not show the mechanics of it.

An anchor rod and a bolt extending from a sculpture.

Using a large wood bit on the plinth.

The means of mounting is undetectable.

Some sculptures require screws coming from the base into the sculpture. The procedure is much the same, except they are not ordinarily glued in, and the holes (in the sculpture) are made smaller to accommodate the screw threads. The screws are fastened from the countersink hole in the plinth or base.

Building a stand. Making a stand is not complicated. The four sides and the top ordinarily are made of plywood or particle board (pressed wood). Plywood is often painted and the particle board covered with plastic laminate (Formica, for example).

The construction of a stand is pictured from the bottom. The corners have short two-by-two's glued to them for squareness and support. Feet are used to help stabilize the stand. (A foot is a metal or plastic-covered screw or nail used to elevate and level the stand.)

Plastic laminate is applied to previously assembled wood stands in the same way that kitchen counter topping is installed. Apply contact cement to both the laminate and the wood stand and allow each to dry about 30 minutes or until no longer tacky. Then press the two surfaces together. The pieces must be in perfect alignment because once contact is made, they cannot be moved.

A router must be used to trim the laminate. Some experience with the tool is helpful, but a router is easy to use with carbide laminate-trimming bits. The cost of a laminated stand is about three times more expensive than a painted stand, but it lasts much longer and needs no further upkeep.

If the stand is to be painted, first fill any holes or depressions with wood filler and then prime the stand with wood sealer. The final coat should not be bright. Normally, painted stands are flat black, charcoal gray or creme white. These colors are complementary for many different sculptures. A good stand should show off the sculpture without drawing undue attention to itself.

Bottom view of a sculpture stand.

Shipping crates.

Using plastic bubble wrap for protection.

Packing Sculpture

Making certain that sculpture can be transported to its destination is a chief concern for the sculptor. The weight, size and fragility of a work helps to determine the packing strategy. Also, the method of shipping—car, truck, air, commercial or personal—influences the packaging decision. Shipping overseas and by freight require substantial crates such as those pictured. They should be made from as lightweight a material as possible, without sacrificing strength to carry the weight. They should be glued in addition to being nailed or bolted together. Lining the crates with Styrofoam helps absorb the shocks that occur in shipping. Wrapping the work itself in foam rubber inside the box is helpful. Bubble Wrap also is an excellent wrapper. It is a soft plastic sheeting with small pockets of trapped air that cushions and conforms to the shape of the sculpture and absorbs shock. Whatever the packing materials used, the sculpture must be sturdily packaged, and the crate should be easily opened such as with wood screws. If sculptures must travel extremely long distances, boxes can be banded with nylon or metal straps (found at lumberyards).

A sculpture safely nestled in a beanbag.

There are two highly successful ways to carry sculpture personally over short distances. One method is to wrap the pieces with nothing but blankets. The other method I often use is to place the work in a loosely filled beanbag. The reusable bag readily conforms to the shape of the sculpture and encases it firmly while allowing extra fast loading and delivery.

Expandable polystyrene is becoming popular as an alternate method of packing. It consists of two liquids that are mixed together in equal parts. In a matter of seconds, the mixture expands

over fifty times in volume. Before using this material, wrap the sculpture with heavy sheet plastic and hold it in a cardboard box. The sculpture must be well wrapped prior to adding the polystyrene, because the polystyrene will adhere to almost any sculptural material. Pour in the liquid around the wrapped sculpture so it solidifies to fill half the box. Place an additional sheet of plastic over the sculpture and the solid polystyrene, then add more mix to fill the rest of the space in the box. The sculpture is encased in a form-fitting package of two parts. Though it is sometimes difficult to open, it is a good packing material. (CAUTION: *The fumes given off during polystyrene expansion are toxic. Good ventilation is necessary.*)

Large outdoor sculptures loaded on trucks must be securely tied down with nylon straps or chains. Generally, the truck driver knows how best to do this. A gentle reminder that the sculpture

surface must not be scarred is helpful. For wide loads, special permits and insurance are required. (These expenses should be considered when pricing a work.)

Installing Large Sculptures

The installation of a large-scale sculpture requires preparation and planning. In order to support such a work, a special foundation is often needed. It must be in place before delivery of the sculpture, preferably twenty-one days for concrete strength. Since the installation may be a distance away from the sculptor's studio, he or she may have to rely on others to follow written instructions. Assuming that the sculptor has prepared an accurate blueprint, the job is seldom more than a small task for a reliable contractor. Herein lies a problem: Because of the small amount of concrete required, a less-than-knowledgeable worker often is assigned the task while other more experienced workers continue on more demanding jobs. The sculptor should assume that the bolts and such will not fit exactly and prepare for it. When possible, sculpture should include some form of adjustment for erection problems. I often form a welded steel structure that I call a *root*, which fits the sculpture exactly. I give it to the contractor to place into the foundation prior to pouring.

The crane operator will require cash if the sculptor is from out of town. The sculptor must be prepared to pay or make other plans. I *always* require the buyers to pay for the crane and operator, since they live in the same town and are more familiar with the available services.

A large load of James Mitchell's steel sculptures ready to be taken to an exhibit.

Haydn Davies finalizing his Space Composition *for the head office of Bell Canada, facing Trinity Square. This painted aluminum sculpture had to be welded on location.*

Larry Bell installing Wind Wedge, *a glass sculpture located at Nelson Park in Abilene, Texas. It is placed into a specially designed concrete base that holds water beneath the work. (See Color Gallery for the completed work.)*

Appropriate welders, laborers and even traffic policemen may have to be used. All of these people must be notified and arranged for in advance. Are right-of-way or installation permits required? Is insurace required prior to installation? What if the sculpture is damaged during erection? Who pays? All of these factors must be figured into the price of the sculpture.

The author installing Image in Stone. *The crane had to raise the bronze and limestone work 60' straight up in order to clear existing trees. Photograph: Helen Lea.*

Arranging an Exhibit

The exhibit director has definite ideas about how things are to be and so does the sculptor. Though they need to work together, ultimately one must be in charge. Ordinarily, it is the director, since he or she knows the lighting, floor and wall space, and the exhibit is in the director's building. However, arranging the exhibit is a mutual task, particularly in the case of installations and special works.

A good lighting situation occurs when there are more lighting fixtures than are needed. Since most exhibit spaces have movable track lighting, rearranging the light is no great problem. Getting a good lighting situation is not easy, though. The placement of the sculpture becomes vital.

A good director expects suggestions and helps with arrangements and lighting. Certainly sculptors would prefer to handle their own delicate work rather than turn it over to someone else to move about.

Davis Sorenson's L'arc Déplacé, 1986 *is a laminated fir piece (1600 lb, 36′ long) and a painted aluminum beam (10″ × 10″ × 56′). The design and installation took much planning. It is located at the University of Sherbrooke, Quebec, Canada. Photograph: Perry Beaton.*

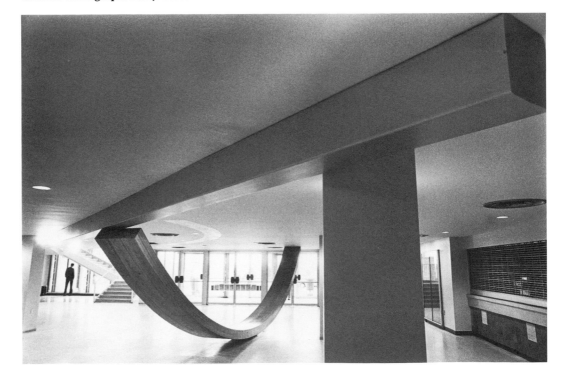

There is no established formula for arranging an exhibit, but there are a few guidelines:

1. Display the works at different heights when possible.
2. If there are a lot of works in a little space, group the sculptures together that complement each other.
3. Avoid lining the walls, sculpture is three-dimensional and should be visible from all sides.
4. Plan the lighting; avoid blinding the viewer.
5. Be certain that all delicate or frail work is protected.
6. Never place a work directly in a normal pedestrian walkway.
7. Do not place works in front of paintings. Plan locations that complement and contrast other work.
8. If sharing a show with another artist, the exhibits should be mutually beneficial; both should have appropriate space and lighting. Plan it together.

Enzo Torcoletti's one-man show at the University of North Florida displays well-placed lighting, good stand variety and well-organized works.

Photographing Sculpture

In order to acquire the best information for this section, I collaborated closely with professional photographer Larry C. Saunders to discuss the photographing of sculpture. He has generously shared his expertise and personal photographs.

Nancy Holt, Sun Tunnels. *Great Basin, Utah. This is a large view of her sculpture, without choice lighting and without a choice point of view.*

Nancy Holt, Sun Tunnels, *1973–76. Total length: 86' This photo demonstrates what natural lighting at the right time of day can do. Also, the point of view chosen makes the sculpture come to life.*

The Sculptor as Photographer

The camera is a tool for the sculptor much like other tools. It is a necessity for documentation and representation. Good photography qualifies sculptures for entry into juried shows, museums, gallerys, private collections, publications and commissions. Often, even work of excellent quality is not given the chance for first-hand evaluation until images of the piece have been scrutinized and approved. Artists are frustrated knowing their work is not evaluated solely on its own merits, but rather on the technical and aesthetic quality of the photographic images submitted. Consequently, good accurate photography is a must.

It is impossible to communicate all the elements of sculpture into a print, so the sculptor must decide what aspects of the piece should be communicated through the photograph. This process requires the artist to function as photographer or compromise by relinquishing control of the image-making process to a photographer. The latter is not always the best way. Even if a photographer displays some of the

sculptor's feelings and insight, it may not necessarily be a good union. Sculptors have difficulty directing photographers since their entire basis of vision differs. They are directing a three-dimensional point-of-view into a two-dimensional image.

It is not easy for the sculptor to photograph the piece accurately, but it is the goal. While it is true that a bad photographic representation can lower expectation, certain photographic techniques can enhance a piece that, in person, might be disappointing. Photos should be truthful, especially in a juried situation, where inaccurate images might result in rejection. Misleading techniques that enhance sculpture are colored lights or flash, special effects filters, unusual perspectives combined with special lenses and so on. These may produce a photographic representation that is not consistent with the piece's normal appearance. Such techniques should be avoided or used with great care.

Sculpture should be photographically documented prior to an exhibit. If possible, give photographs to the exhibit director to be sent to special audiences and clients who might not otherwise be present.

Even though the exhibit space may have good lighting and arrangement, each piece needs to be pictured separately without competition from other works, viewers or cluttered backgrounds.

Allan J. Sindler, Greystone. *Pumice, 5'. Millerton, New York, summer. This photo and the next illustrate how time of year affects the outdoor sculpture.*

Allan J. Sindler, Greystone. *This photo, taken in winter, could demonstrate to a client how enjoyable a sculpture can be year-round.*

Three major camera formats: left to right, 35mm, medium-format, 4″ × 5″ format. Photograph: Larry C. Sanders.

Cameras

When a sculptor selects a camera, the format (film size) is a primary concern.

The 35mm SLR (single-lens-reflex) is the most popular camera because of its through-the-lens viewing, lens interchangeability, automation, compactness and low cost. It produces 35mm slides, the format most requested by juries for shows, collections, galleries and museums. The 35mm also offers the widest selection of readily available film for any application or shooting situation.

Medium-format SLR's use 120 or 220 size roll film to produce a negative or transparency from 2¼ × 1⅞ inches (6 × 4.5 cm) to 2¼ × 2¾ inches (6 × 7 cm). This camera's larger format produces images of superb resolution,

superior to 35mm for publication or reproduction applications. Medium-format is the perfect compromise for most high-quality photography, combining compactness, through-the-lens viewing and ease of operation. The price of a good quality medium-format camera is more than twice the cost of a good quality 35mm. The camera is expensive, but the film is the least expensive transparency acceptable for publication applications. Even though the camera is easily hand-held, a tripod is advisable.

The *4 × 5 inch large-format* camera produces the most desirable transparency for publication. The 4 × 5 inch camera uses sheet film to produce negatives or transparencies of this same large proportion for extreme detail and clarity. It is the most expensive format of the three cameras listed. Based on a 35mm slide as a point of reference, a large-format transparency would be approximately six times the cost. The camera requires the use of a tripod for stability and proper control.

Lenses

A "normal" *50mm lens* sees the world in a manner similar to the naked eye, whereas a wide-angle's shorter focal length sees much more than the naked eye. This increased coverage has a direct effect on perspective when the camera-to-subject distance is changed. Wide-angles place dramatic emphasis on the foreground while pushing away the background. This expanding effect on a sculpture makes the piece seem larger, separates it from any background, and creates an imposing perspective on linear surfaces.

A *telephoto lens* creates the opposite effect. Its longer focal length has an angle of coverage much narrower than the human eye's. This decreased coverage makes objects seem closer together when viewed at a distance. The telephoto lens collapses space while the wide-angle expands it. The telephoto brings separate forms together to create unity.

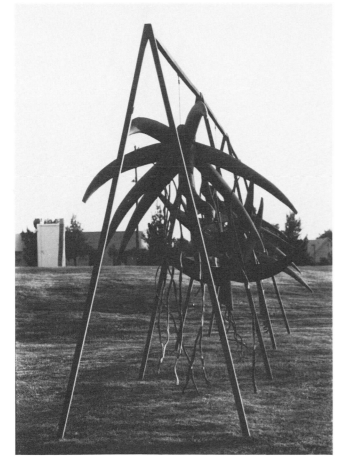

Phil Simpson, Earth, Sea, Sky. *Welded steel. Photo taken using a wide-angle lens. Photograph: Larry C. Sanders.*

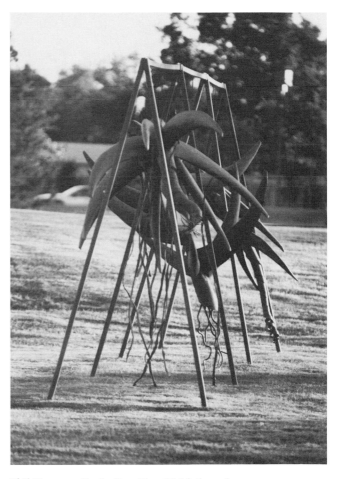

Phil Simpson, Earth, Sea, Sky. *Welded steels. Photo taken using a 200mm telephoto lens. Photograph: Larry C. Sanders.*

Film

Film selection is simplified by the specific results desired: fine grain for excellent detail, accurate color (when color is used) and the highest overall

Same detail taken with high-speed film and blown up to 8″ × 10″.

Details from the top right corner of Williams's Family (pictured later). This photo is a low-speed film blown up to 8″ × 10″.

quality. To this end, one should use the slowest film (lowest ISO or film speed) possible under a specific lighting situation.

For daylight or electronic flash color photography, slide films in the 25–100 ISO range and print films in the 100–200 ISO range are best. Should tungsten (incandescent) light be used, a film balanced for that type of light (3200 degrees on the Kelvin color temperature scale), like Kodak Ektachrome Tungsten, will produce natural color. Regular daylight color films used under 3200K light will skirt to orange unless an 80A (blue) filter is employed. Even with filtration, daylight films may produce less than accurate color. (Note: 5400K is average daylight.)

Black-and-white films will function normally under either daylight, tungsten or fluorescent light sources. The primary determining factor in making a selection will be grain and film resolution. A slow-speed film will obviously produce the best results for reproduction.

It is wise to experiment and learn what a particular film will do and will not do.

Lighting Equipment
The awareness of light's effect on a sculptural form, and the control of this light is essential to successful photography. The repositioning of a single light source can alter the perception of a form's shape and texture.

Comparison of Floodlighting to Electronic Lighting. In addition to available daylight, which cannot be controlled but can be modified, the photographer can use artificial light—electronic flash or floodlights (tungsten).

Floodlights have a number of positive aspects:

1. The constant light makes positioning easy, since changes are immediately visible on the subject.
2. They are lightweight and portable.
3. They are inexpensive.
4. Since the light is constant, exposure can be determined by the camera's light meter or a hand-held light meter.

Floodlights also have some negative points:

1. Photo floods produce excessive heat, making them uncomfortable to work around and hazardous near combustible materials.
2. Light output is relatively low and will not permit the use of small working apertures unless slow shutter speeds are used.

3. The color of light produced by a tungsten light changes over its life. The older the lamp, the warmer (red) the light produced becomes.
4. Tungsten light is not balanced for a daylight film. Uncorrected, the pictures produced will be orange to red in color. Daylight films require an 80A color-correction filter, or a tungsten-balanced film like Kodak Ektachrome Tungsten 160.

Electronic flash offers the following positive characteristics:

1. Electronic flash has tremendous power, permitting the use of small aperture openings for greater depth-of-field, and slower films for finer grain and better color saturation.
2. Electronic flash is balanced for daylight. No color correction is necessary with any daylight film.
3. Electronic flash has a consistent output for easily repeated results.

Electronic lighting in a good arrangement while taking a photograph of Clint Hamilton's one-man show at the Abilene League of Artist's Gallery, Abilene, Texas. Photograph: Larry C. Sanders.

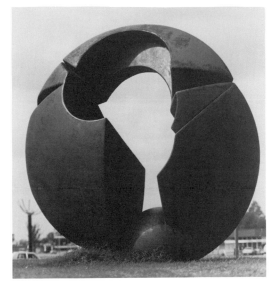

John Brough Miller, Biomorphic Form. *Welded steel. Courtesy of the Abilene Cultural Affairs Committee, Abilene, Texas. In this point of view the sculpture is the center of attention. Photograph: Larry C. Sanders.*

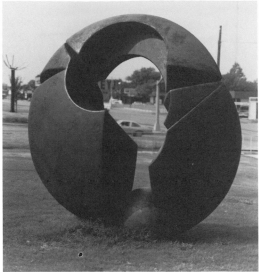

John Brough Miller, Biomorphic Form. *Welded steel. Courtesy of the Abilene Cultural Affairs Committee, Abilene, Texas. Notice how the background clutter in this photograph detracts from the sculpture. Photograph: Larry C. Sanders.*

4. No heat is generated.
5. New units are very portable and easy to use on location.

Electronic flash has negative aspects as well:

1. Most multihead flash systems are much more expensive than their tungsten counterparts.
2. Even with modeling lights, electronic flash might result in unexpected glare or surprise shadows. For the beginner, results are difficult to visualize.

Lighting Styles

Light coming from the front of or from a close distance to the camera eliminates shadows that create a feeling of depth, making a subject appear flat. This style of lighting is often referred to as "pancake lighting" for that reason. Front lighting is undesirable for most sculpture, since it fails to communicate depth and special relationship. A direct camera flash will automatically produce this style of lighting.

Side, top and bottom light all produce light that emphasizes texture and form by creating dramatic highlight and shadow contrast. A single light source results in very bright highlights with deep shadows. Though a light placed at any right angle to the lens will result in similar results, side and top light is preferred to bottom light, since subjects are seldom viewed with a lower light.

Backlighting places the main light behind the subject, emphasizing shape, but caution must be used to avoid obscuring important subject detail in shadow. Placing a light directly behind the subject is a "rim lighting" technique that outlines the subject with a thin line of light separating it from a dark backround. Rim lighting is an attractive alternative to shooting a dark subject in front of a light background. Care must be taken to prevent the rim light from shining directly into the lens, as this will result in detail-obscuring lens flare.

Indoor Lighting. The photographer will usually establish a key (main) light, simulating the sun, a fill light to reduce highlight and shadow contrast and possibly a background light to lighten the background or create a rim-light effect. Lighting is planned as follows:

1. The main light position for the best modeling of the subject is established. This will require consideration of camera placement and subject position as well. The process is simplified by having the subject on a rotating base (turntable).
2. After the main light has been positioned, the fill light is placed to lighten shadow details. The fill should not eliminate shadows, just lighten them.
3. Backlight or rim light is created by the position of the ground light.
4. The exposure is determined by either an incident continuous light meter for floodlights or an electronic flash meter.

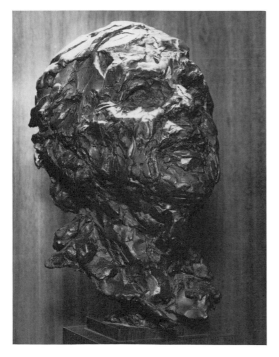

Robert Berks, **Tommy Clack.** *Bronze, life-size. Civic Center, Abilene, Texas. This illustrates lighting as the sculpture sits on display.*

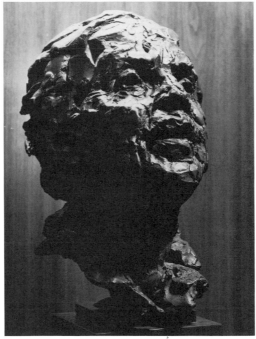

This photo illustrates a top diffused light with an additional top main light to one side. Photographs: Larry C. Sanders.

325

Arthur Williams, Mother with Child. *Mesquite, 12" tall × 22" × 14". This illustrates rim lighting when using a dark background with a dark sculpture in the foreground. Photograph: Larry C. Sanders.*

Arthur Williams, Family. *Alabaster, 12" tall × 17" × 17". This illustrates backlighting on a light-colored sculpture. Photograph: Larry C. Sanders.*

Outdoor Lighting. Much sculpture photography is done outdoors. Daylight can be modified by using reflectors, but cannot be otherwise controlled. A time of day should be scheduled that will prevent backlighting and offer the best modeling of the subject. Generally the best times for outdoor sculpture photography are early morning and late afternoon. The low sun angles complement colors and bring out the best textures. Avoid allowing the light meter to read the sky. The light meter should be read from a close reading to ensure accurate exposures. A lens shade should be used to prevent lens flare. An orange or red filter will maintain separation between blue skies and clouds in the background. A polarizing filter can be used for both color and black-and-white films.

These do-it-yourself guidelines do not preclude the use of a professional photographer. However, when a young sculptor first begins, the cost of a photographer is prohibitive. Also, looking through the lens of a camera can help a sculptor to see the works as others will. Often a picture needs to be taken at a particular time and place as well, especially to document the progress of a piece. I now have all my own equipment and only occasionally ask for outside help.

Mary Miss, **Field Rotation,** *1981. Wood, steel, gravel, earth, 7′ deep × 60′ × 60′. Governors' University, Park Forest South, Illinois. Photographing environmental sculpture presents challenges such as catching the right light and finding an appropriate point of view.*

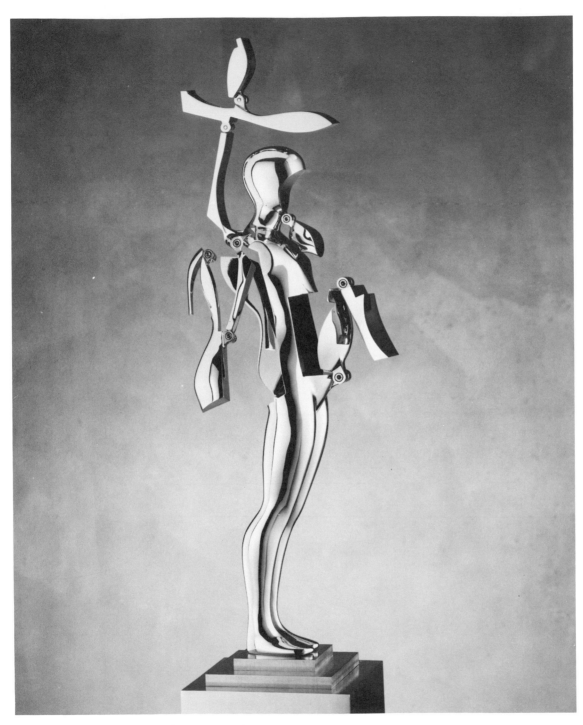

Ernest Trova, FM/24″ Overhead Figure. Stainless steel, 33″ tall × 7″ × 7″.

14

CAREERS IN SCULPTURE

- Full-Time Sculptor
- Related Vocations
- Epilogue

In proportion to the number of practicing sculptors, few are earning a living as full-time sculptors. No one seems to know exactly why one sculptor survives and another fails. Some say that it is because of wealth, a gallery, a critic or just plain talent. The truth is that there are very few artists who are wealthy prior to becoming sculptors. Sculpting is not a trouble-free, easy profession, so if a sculptor is already wealthy, it is easier to give up and forego the problems than to persist. Critics cannot make or break an artist. They can offer temporary help or temporary pain. As for galleries, they can be most helpful, but if a gallery exhibits poor quality work or is simply poor at business, ultimately it will close. Talent is a necessity, but there are many artists of great talent who are unable to earn a living through their art.

The question remains: Why do some sculptors make it and others do not? What are the career possibilities in sculpture?

Before writing this chapter, I sought special advice from those most involved with sculpture. I prepared three different questionnaires to send to galleries, museums and to individual sculptors.

Forty-five galleries advertising sculpture in one issue of a major art magazine were chosen to receive the gallery questionnaire. The response was poor at 30%. Fifty museums were selected from all over the United States; half were large museums and half were small. The response was fair at 60%. Based on preliminary photos sent to me from sculptors participating in this book, seventy-five were selected from all media forms to answer a questionnaire. They were asked to send unsigned responses since candid answers were requested. The response was excellent at 90%.

These questionnaire answers were not intended to be complete nor scientific. Rather, they were solicited to provide some informal help with this chapter. The help was good, particularly that received from the sculptors. Many answers correlate, which helped me to formulate a perspective on careers in sculpture. Throughout the chapter, significant results will be given.

In order to best understand sculpture careers, this chapter is divided into two sections discussing the full-time sculptor and related work involving sculpture.

Full-Time Sculptor

Earning a living solely from sculpture work is the goal of most sculptors. However, it is not a goal easily fulfilled. There are four major requirements for success: personal qualities, physical environment, business sense and sales ability.

Personal Qualities

The following four personal characteristics are common to successful sculptors:

1. Perseverence is an absolute necessity. The going gets rough, lonely and very difficult. The sculptor must have the dedication to stick it out.
2. Singleness of purpose is a personal quality that means formulating the goal of working full-time and then actually doing it. If time is divided, then time is eliminated.
3. A lot of work is required, involving long hours and much effort. Perfecting and marketing sculpture requires time and practice.

4. Ability (talent) is necessary for all of the personal qualities, but ability by itself is a wasted gift. Good training will expediate talent.

Physical Environment

The physical requirements entail the facilities, tools and materials utilized by the sculptor.

Good *facilities* include the space required for each sculpture technique, adequate storage space, safety features, heating and cooling sources, privacy and good ventilation. Most sculptors have only a few of the facilities listed. Ventilation, work space, and safety features are absolute necessities. Usable, adequate space is determined by the medium involved. Some sculpture shapes require great height; others do not. If stone or wood is used, high-power ventilation is a must, and yet the sculptor also has the privilege of working outdoors.

Welding must be done in structures that are approved for fire safety as well as special heavy electrical wiring. Storage is needed in varying degrees, again, depending upon the medium chosen. A wood carver generally has several stumps in the aging process and they take up space. Plastics must be stored in a room that is kept cool. While heating and cooling may not affect one person's work, it greatly aids others. Temperature regulation may be a necessity for the chosen technique such as working with resins and paper.

To make a facility perfect, privacy is also a requirement. The sculptor needs a place to think and create, without worrying about the safety of an onlooker.

Some sculptors also include a display area for potential buyers as part of their facilities. This works well with some but does not for others. The best way to

*Studio of Jean Woodham in Westport, Connecti-
cut. The studio is 40' high and is pictured with
a welded bronze work in progress entitled*
Scholar's Sphere, *a commission for the Harry S.
Truman High School, New York City.*

331

Studio of the author in Abilene, Texas. Since the warm season is long, much work is done outdoors. There is a steel in progress under the indoor/outdoor hoist; a stone is in progress beneath the 40' long outdoor hoist. The second floor is a private showroom. An additional acre is allocated for outdoor sculptures.

Sculptor Dolly Unithan in her studio loft in SoHo, New York. Photograph: Manu Sassoonian.

use such a space is by appointment only.

The beginner should not be frustrated by lack of facilities. Seldom do sculptors begin in perfect studios. Many, myself included, are lucky to have begun in a garage. As a sculptor's work and sales progress, adequate studio space can be found.

Proper *tools* allow the sculptor more time to create and fulfill creations. A hammer and chisel can do much for stone carving; however, if the sculptor is going to earn a good living by working with large stones, hoists and pneumatic tools are essential. Stainless steel welding ordinarily requires a TIG welder, plasma cutter and other specialized tools.

The beginner should not be overwhelmed by tools. It is wise to buy one chisel at a time. As your work progresses, your opportunities will increase and so will your knowledge, ability and supply of tools.

Materials must be considered by the beginner. The full-time sculptor needs plenty of good materials that are readily available. If you are a wood carver, good sources for wood are essential; a nearby wooded area is very helpful. A welder may wish to weld sheet bronze or stainless, both of which are quite expensive. The beginner had best start with welding scrap metals. If you wish to carve in stone, begin with nearby found stones. However, as the beginner's career advances so will the material requirements.

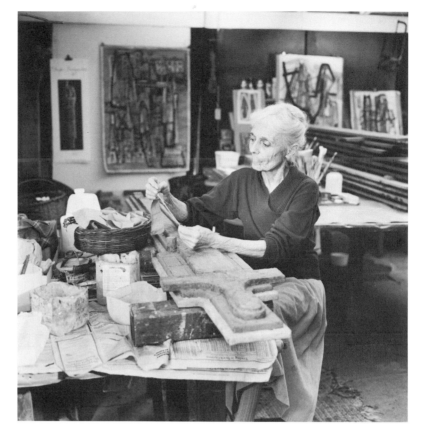

Sculptor Clyde Connell in her studio working on her Bound People *series. Photograph: Neil Johnson.*

The author at work. Multiple hoists and carts are necessary for the work area for moving large, heavy sculptures.

Business Sense

Good business practice involves the organization of a portfolio, learning about promotion and record keeping for taxes and insurance.

An artist cannot exist today without a portfolio. Though the portfolio may primarily consist of slides, transparencies and photographs are also often required. (See chapter 14.) A systematic storage system from which to retrieve photographic materials is essential. A sculptor must be up-to-date and have these materials ready for presentation so that opportunities will not be missed. A good portfolio consists of slides, an accurate and current resumé and exhibit records.

The artist may wish to be left alone, but self-promotion is necessary for success. No matter how good a sculpture is, unless potential buyers know about it, it is worthless for earning a living. Promotion takes planning. Good brochures are deemed to be the best form of advertising by 71% of the sculptors questioned. Advertisements placed in art magazines were rated high but are

Sculptor Dalton Maroney at work on King Big Bite *using pine and redwood in his studio area.*

extremely expensive. The sculptor should let the local newspaper know when he or she is exhibiting. To be a credible businessperson, a business card is a necessity. Since the customer must contact the sculptor, a telephone is taken for granted. All contacts should be filed and former customers should be notified of upcoming shows. (Former customers are the best buyers.)

Insurance is often overlooked, but without it, the sculptor is courting disaster. If outside labor is required, the sculptor may be responsible for injuries (and creating sculpture has many potential hazards). Is the sculpture protected from onlookers? What if the facility burns down? There are tool thieves and transportation breakage. Insurance must be considered, because it is a constant, costly item.

Taxes exist, even if the sculptor is struggling to exist. There are city and state sales taxes and federal income tax. It is imperative that the sculptor keep accurate written records in order to prove the expenses involved with making sculpture. If outside labor is used, then the sculptor needs an employer's tax identification number. If the sculptor sells work from his or her studio, another special tax number is required.

Sales Acumen

Sales are consummated either from personal sales, galleries, representatives or museums.

Personal sales are the sales most often relied upon by sculptors. Of those surveyed, 92% stated that they constantly made personal sales. These come from prospective clients visiting the studio to view finished pieces or to watch works in progress, commissions requiring a unique piece for the buyer, or special exhibitions such as juried exhibits, local shows, art fairs, artists' leagues and so on. It depends upon the sculptors as to what works best. Some welcome visitors into their studios and

Sculptor Maria Alquilar packing for San Luis. Photograph: Rick Samsel.

have a good display area, while others resent the encroachment upon their privacy. Some choose commission work only, since the income can be more steady if work is lined up. Others dislike commissions because of having to work closely with the buyer.

Commissions require a contract. Depending upon the material and labor cost, the down payment can be from one-third to one-half, with half of the balance paid when the work is half-finished and the remainder paid upon delivery and installation. At no time should a commission be started without a deposit and clear understanding as to the payment schedule, material, size, form and delivery date.

Galleries are the second most common way to sell sculpture. Sixty-nine percent of the surveyed sculptors use them. A good gallery takes care of many of the business aspects of sculpture. A gallery owner is a skilled marketer with connections and can ultimately prove to be a close friend to the sculptor. However, most sculptors in the survey who regularly deal with galleries were not always favorable toward them. A poor gallery does not promptly pay the sculptor, depends solely upon walk-in traffic, charges too much, physically mishandles work, and seeks to impose their ideas upon the sculptor's work with little interest in or actual understanding of sculpture. As a

result, several sculptors have stopped using galleries altogether.

Gallery commissions vary. Of the sculptors surveyed, approximately one-half paid a 40% commission and one-half paid a 50% commission with a few at 30%. The galleries charging 50% almost always took care of shipping, while those charging 40% did not. When the gallery obtains a commission for the sculptor, only a few charge the full commission; most charge at least 10% less (making 30% the normal). It is interesting to note that some galleries vary the commission charges depending upon the artist. The young sculptor should be cautioned never to work with a gallery attempting to charge more than 50%. The relationship cannot grow due to the high cost of sculptural materials and the obvious lack of consideration for the sculptor.

Galleries are often territorial and require exclusive sales rights within a given area such as a city, region or even a state. This can be a problem if a clear understanding between sculptor and gallery is not reached. It would be idiotic to have national exclusive sales with a gallery unless they offered a guaranteed income.

Applying at a gallery the first time requires a written resumé and a slide resumé. There is no clear indication of what galleries prefer in an artist, but almost all surveyed want a good portfolio and a sculptor with a reputation and some innovation. They prefer a professional, positive, ambitious artist as opposed to an egocentric, temperamental artist. All responses but two preferred a brief resumé and one page of slides. They dislike confusion, poor English, bad photography and sloppy portfolios. All but one gallery prefer the artist first approach them with a letter.

Maria Alquilar, Bien Venida y Vaya Con Dios. *Clay and metal, 15' tall × 9' × 7'. U.S. Port of Entry, San Luis, Arizona.*

Jun Kaneko, Polka Dot Sidewalk. *Enamel on concrete, Museum of South Texas, Corpus Christi, Texas. Photograph: George Gongora, Corpus Christi* Caller-Times.

The Abby Aldrich Rockefeller Sculpture Garden,
Museum of Modern Art, New York City.
Photograph: Scott Frances.

The Marion Koogler McNay Art Museum, San
Antonio, Texas. Photograph: Jim Keller.

Galleries have many sculptors trying to "get in." It is frustrating for the young artist even to get an appointment for an interview. It is also time-consuming for the gallery constantly to review work, especially if there is just no space available. Before sculptors approach a gallery, they need to know that their work will fit in with works already in the gallery and that the price ranges are similar. If a sculptor is not able to secure a gallery, he or she must remember that even though galleries must have artists to exist, artists do not need galleries to exist.

Art representatives (agents) can be beneficial if they have good connections, represent good artists and do not represent too many artists. Generally, their fees are considerably less than galleries at 15% to 30%. It is interesting to note, however, that not one gallery surveyed wanted to work with an agent. Many agents do not deal with galleries, but deal directly with clients for the artist. These agents charge higher fees.

Museums greatly enhance the marketability or reputation of a sculptor but by themselves, offer few sales for the sculptor. Since their purpose is primarily that of education, sales are not even secondary. Oftentimes, they will not post a price list for the works and require potential buyers to contact the artist personally for any sales information. Only 8% of the sculptors surveyed expect to make money at museums.

According to the museum survey, the best way to approach them for an exhibit is to submit a resumé and one page of slides with a cover letter, followed by a request for an appointment. The museums choose sculptors based on portfolios, reputation, references and, sometimes, the needs of particular theme exhibits.

Most museums listed education, exhibit record and collections as the most important ingredients in a good resumé. Sculptors too often use poor English and submit resumés that are too long.

The income of sculptors vary. Of those questioned, 50% were full-time. Of all the sculptors, full- and part-time, 30% earn $5,000 or less per year; 15% earn less than $10,000; 17% less than $20,000; 3% under $30,000; 8% at near $40,000; 6% at $50,000; 3% at $75,000; and 14% at $100,000 or more.

Of the sculptors earning over $100,000, 30% work with fabricated steel, 20% with bronze, 20% with wood, 10% with stone and 20% with several media. Thirty percent did not use galleries. Ninety percent said that word-of-mouth was their best form of advertising.

Related Vocations

Teaching
Teaching can involve work in private studios, museums or community groups, but is usually connected with colleges or art schools and secondary or primary schools.

Colleges and art schools offer the teacher more time to be creative, though good teaching is demanding work. The classroom hours vary with the institution from 12 to 30 hours per week, with an average of 18. (These hours refer to actual time spent in the classroom. The instructor spends many more hours than this in preparation time.) This schedule allows the instructor time to spend with students as well as complete personal work. Ordinarily, the school furnishes some studio space, though it is seldom adequate for the sculptor. The availability of tools is a plus. The pay varies from good to poor

Instructor Charles Gross with a college class at the University of Mississippi foundry preparing wax for plaster investment casting.

A steel fabricator working on the base of Genesis at the author's studio. Most fabricators work with large organizations, but some work directly for sculptors. The author prefers to hire fabricators to work in his studio so he can keep close watch on the working process.

depending upon the institution, but it offers continual security. This may sound great to a novice, and it can be, but it has definite drawbacks.

1. Students can drain the professor of his or her own ideas. Sometimes instructors consciously or unconsciously work through students to fulfill their own creative process. This leaves them with no reason to complete some ideas.
2. Working with sculpture most of the day, especially with others, is very taxing. It takes a great deal of dedication to continue at night on personal work.
3. Some administrators can be an asset; many are not. They would prefer a sculptor to wear a suit and tie and be on every committee possible. They don't want an instructor in blue jeans hoarding time away from academics in order to create personal sculpture.
4. Even though there can be time available to do personal work, administrators have a way of arranging classes so that the instructor seldom has solid blocks of time to finish work except over extended periods of time.

The requirements for college teaching vary. The Master of Fine Arts (M.F.A.) is the accepted terminal degree in studio arts. It is obtained after the Bachelor of Arts (B.A.) or Bachelor of Fine Arts (B.F.A.) degree. Altogether, the necessary education could take from 6 to 8 years to complete, depending upon specific degree requirements. Sometimes an art department wants a well-known artist to teach in lieu of one with academic background, though a combination is preferred. Obtaining the first teaching job is the hardest step, since there are many more available degreed artists than there are jobs. An excellent portfolio is a necessity to secure a good position. It is also quite beneficial if the prospective teacher can rely on someone already at the teaching institution to provide an excellent reference.

Under the best circumstances—with good pay, fine facilities, few courses to teach, good administrators—teaching in an institution is a desirable position. Under the worst conditions—a heavy teaching load, poor facilities, poor pay, insensitive administration—the job can be demoralizing to a sculptor.

Teaching primary art requires specific certification by the state involved and at least a B.A. degree. It takes a person who loves children and enjoys watching their early attempts at creativity. Seldom do these teachers continue to practice art personally, since they find full satisfaction in teaching, and the job is full-time. The pay varies but can be good, and the summer months are available for personal growth.

Teaching secondary art also requires specific certification by the state and at least a B.A. degree. Depending upon the school system involved, the level of artwork can be quite good. In completing this book, I was amazed by the level of some students' work and the freedom some instructors had in working with their students. Many secondary art teachers continue personally to create works of art, but it is difficult. As with college teachers, high school students can drain an instructor of ideas, and good teaching takes full-time work and planning. The pay varies and is sometimes better than college teaching. Jobs are ordinarily available, and previous experience is not a requirement for employment.

Additional related work can be divided into two major categories: white-collar, nonphysical, and blue-collar, physical, jobs.

White-Collar Professions

White-collar workers include gallery owners, gallery directors, critics, museum directors, curators, lecturers, agents and the like. To do well at any of these jobs requires full-time work and leaves little time for personal expression in sculpture. Some trained artists adapt very well to these jobs, particularly those who enjoy the business end of art or who enjoy meeting people. The pay depends solely upon the job and can range from very little to very much.

Blue-Collar Professions

Blue-collar workers include fabricators, assistants, restorers, set designers, interior designers, graphic designers,

founders, enlargers and the like. These jobs require varying degrees of physical labor. Some artists prefer these jobs because of the chance to associate with artists and the opportunity to use one's hands to help in fulfilling artwork. Some artists have developed a particular skill, such as welding, and enjoy the work even more than being the originator of the sculpture. The pay and work conditions depend completely upon the particular job.

Unrelated jobs abound depending upon the personal aptitudes of the sculptors. Many sculptors work at entirely different vocations while completing sculpture. They could be anything from a lawyer to a house painter. It is difficult to make the time necessary to create, but it is possible. The largest problem is frustration felt by some who intend for these unrelated jobs to be only temporary, until they can become full-time sculptors.

Grants are a possible source of income but are not to be counted on,

Hilario Moroles, Jose Moroles and assistants working in Jesús Bautista Moroles's studio. Large heavy works often require a number of assistants. Photograph: Brad Steiner.

since the grantor (usually represented by a committee) and funding are based on individual tastes. Many grants have helped artists, and some artists have even found ways, primarily through publicity, to ensure grants.

Epilogue

There was a special section on the questionnaire for sculptors to remark candidly about their personal frustrations and rewards. Their responses have been collected to share with all sculptors and potential sculptors.

The following frustrations were common:

1. The business aspects of marketing and dealing with people
2. Dealing with galleries
3. Physical problems of transporting and installing work
4. Not making much money and taking so long to be paid
5. Seeing whom they consider "phony artists" making it big
6. Not enough time to do their sculpture

The rewards were seldom monetary. They were very personal, as the following responses indicate:

1. The freedom to explore and express new ideas
2. The challenge to put an idea or feeling into a visual context
3. The exhilaration, satisfaction and personal gratification of beginning a sculpture and then seeing it completed
4. Afterward, the sincere responses expressed by others

Foundry personnel at Johnson Atelier in the process of pouring molten gray iron. Foundry work consists of many jobs; pouring metal is just one of them. Photograph: Philip Smith.

In a climate where so much emphasis is placed on fast foods, disposable tools, fads and the new and different, it is difficult to retain one's sculptural values. To be new and different is not necessarily to be better. Innovation is always good, but not as an end-product. Substance must be evident, not imagined. Sculpture must stand on its own merits. Good sculpture does not need validation by a written thesis or a critic's approval.

There are new processes and media available to sculptors, and they should try them. They should also be aware, however, that new processes often involve traditional media being refined and improved. If a sculptor's choice is for his or her work to be a private personal type of therapy, that is all right. But if sculpture is to be publicly displayed, and the sculptor plans to earn a living from it, then new and improved techniques must be explored.

Why artists elect to spend their lives doing sculpture is personal. Creating sculpture is a calling that cannot be avoided. Many sculptors are literally in love with working in their studios, touching materials; the actual process and progress of working with sculpture is their whole existence. As one sculptor best stated it for many others, "It is a beautiful profession."

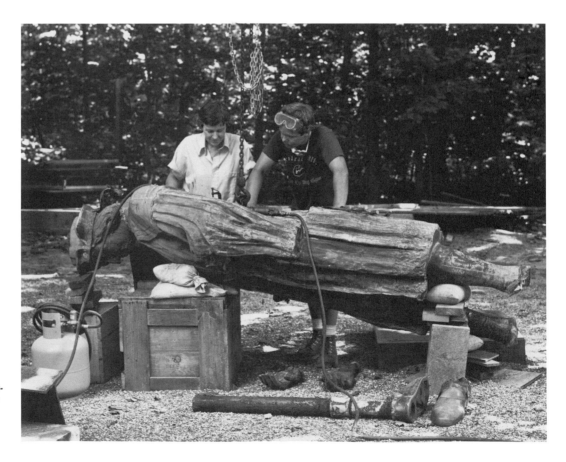

Nita Sunderland and Kevin Lyles of Sunderland Associates, Peoria, Illinois, working on a restoration of a sheet copper Christopher Columbus first completed in 1893. The project included armature fabrication, new pedestal, new parts and cosmetic repair. Photograph: Richard W. Deller.

Chyrl Savoy's Sculptural Structures *for Molluscan Myriad.* This was a collaboration between the sculptor and Sunny Savoy Cigarroa, director of the Dance Company Impulso.

Gigi Guadagnucci, Marble Statue, 1986. 35" tall.
Photograph: Benvenuto Saba.

APPENDIX

Tools and Materials: Sources

Bibliography

Sculptors, Instructors, Students

Tools and Materials: Sources

Using local sources for tools and materials saves time and freight, and ensures a more personal guarantee of satisfaction. The *Yellow Pages* offers a good listing for local outlets. These sources include hardware stores, lumber yards, auto supply stores and ceramic shops, as well as art supply dealers. *Sculpture* magazine and *Sculpture Review*, listed in the Bibliography, are also good sources for addresses and information about new supplies and suppliers.

This section lists popular sources from across the United States, arranged alphabetically. A brief description of supplies and services is provided. If a catalogue is available, a *C* is listed with the Tools and Materials list. Business telephone numbers also are given, including 800 numbers.

The novice sculptor is advised to shop comparatively by investigating product details and prices. Some suppliers offer excellent materials at tremendous savings.

Adhesive Products Corp.
1662 T. Boone Ave.
Bronx, NY 10460
212-542-4600
Adhesives, epoxies, resins, mold materials

Alcan Powders and Pigments
901 Lehigh Ave.
Union, NJ 07083
201-851-4500
Nonferrous metal powders—copper, bronze, etc. *(C)*.

American Art Clay Co., Inc.
4717 West Sixteenth St.
Indianapolis, IN 46222
800-428-3239
317-244-6871
Kilns, wheels, clay, glazes, tools *(C)*.

American Machine & Tool Co., Inc.
4th Ave. and Spring Street
Royersford, PA 19468
215-948-0400
Hand, power and carving tools *(C)*.

A.R.T. Studio Clay Co.
Alpine Division
1555 Louis Ave.
Elk Grove Village, IL 60007
800-323-0212
312-593-6060
Clay, glazes, kilns, wheel, tools, equipment *(C)*.

Bailey Pottery Equipment Corp.
CPO 1577
Kingston, NY 12401
800-431-6067
914-339-3721
Kilns, wheels, tools, brushes, stains, slip equipment *(C)*.

Baja Onyx, Marble and Granite
524 Calle Primera, #1004
San Ysidro, CA
619-428-6127
Natural stone sculpture bases and pedestals*(C)*.

Beaver Engineering
200 Weeden St.
P.O. Box 348
Pawtucket, RI 02862
401-728-4710
Beaver visible grinders and grinding wheels *(C)*.

Belmont Metals, Inc.
330 Belmont Ave.
Brooklyn, NY 11207
718-342-4900
Alloys for art and jewelry casting *(C)*.

The Berea Hardwoods Co.
125 Jacqueline Dr.
Berea, OH 44017
216-243-4452
Exotic wood carving blocks *(C)*.

Bethlehem Steel Corporation
701 E. Third St.
Bethlehem, PA 18016
215-694-2679
Manufacturer of steel products*(C)*.

Binks Manufacturing Company
9201 West Belmont Ave.
Franklin Park, IL 60131
312-671-3000
Airbrushes, color changers and airbrush accessories *(C)*.

Robert Bosch Powertool
100 Bosch Blvd.
Newbern, NC 28560
800-334-5730
919-636-4200
Bosch electrical tools, accessories

Brent Pottery Equipment
(A mfg. div. of American Art Clay Co., Inc.)
4717 West Sixteenth St.
Indianapolis, IN 46222
800-358-8252
317-244-6871
Wheels, slab, rollers, extruders *(C)*.

Brodhead Garrett
4560 East 71st St.
Cleveland, OH 44105
800-321-6730
Air and electric tools, abrasives, general supplies

Brookstone Company
127 Vose Farm Rd.
Peterborough, NH 03458
603-924-7181
Hard-to-find tools *(C)*.

Bryant Laboratory, Inc.
1101 5th St.
Berkeley, CA 94710
800-367-3141
415-526-3141
Chemicals for patination and etching of metals *(C)*.

Buck Brothers
P.O. Box 192
Millbury, MA 01527
508-865-4482
Wood chisels, carving tools *(C)*.

W. J. Bullock, Inc.
P.O. Box 539
Fairfield, AL 35064
205-788-6586
Brass, bronze, aluminum ingot, raw materials

Cadillac Plastic and Chemical Co.
143 Indusco Ct.
Troy, MI 48083
800-521-4004
313-583-1200
Plastic basic shapes: sheet, rod, tube *(C)*.

Cal Oak Lumber Co.
1000 Cal Oak Road
Oroville, CA 95965
916-534-1426
Hardwood lumber, molding

Carborundum Abrasives Company
6600 Walmore Road
P.O. Box 350
Niagara Falls, NY 14304
716-695-8120
Sandpaper sheets, belts, discs, etc. *(C)*.

Carriage House Paper
Brickbottom Building
1 Fitchburg St. C207
Somerville, MA 02143
617-629-2337
Handmade paper and papermaking supplies
(C).

Cathedral Stone Co.
2505 Reed St., N.E.
Washington, DC 20018
202-832-1135
Indiana and Texas limestone for carving

Center Lumber Company
P.O. Box 2242
85 Fulton Street
Paterson, NJ 07509
201-742-8300
Moldings, pine, cherry, basswood, mahogany

Ceramics & Crafts Supply Co.
490 Fifth St.
San Francisco, CA 94107
415-982-9231
Tools, clay, glazes, chemicals, equipment,
stains

Ceramic Store, Inc.
702 Richmond Ave.
Houston, TX 77006
713-524-3244
Ceramic equipment, supplies *(C)*.

Ceramic Supply of NY and NJ, Inc.
534 LaGuardia Pl.
New York, NY 10012
800-423-7787
212-475-7236
Clay, kilns, building material, tools, supplies
(C).

Circle K Products
20814 S. Normandie Ave.
Torrance, CA 90502
213-320-4218
RTV silicone rubber, mold-making compounds
(C).

City Chemical Corp.
132 West 22nd St.
New York, NY 10011
800-CIT-CHEM
212-929-2723
Chemicals for patinas and gums and waxes
(C).

Colorado Alabaster Supply
1507 North College Ave.
Fort Collins, CO 80524
303-221-0723
Sculpture-quality alabaster: pink, white, gray
(C).

Cope Plastics
4441 Industrial Dr.
Godfrey, IL 62035
800-642-1792
Plastics: sheets, rods, tubes, resins *(C)*.

Cutter Ceramics
11908 Old Baltimore Pike
Beltsville, MD 20705
800-331-4777
301-595-0720
Retail ceramics and supplies *(C)*.

Cutter Ceramics
47 Athletic Field Rd.
Waltham, MA 02254
617-893-1200
Clays, glazes, tools, kilns, equipment *(C)*.

Cutter Ceramics
Rt. 8, Box 36-A
Raleigh, NC 27613
800-527-9620
919-782-1320
Clay, chemicals, glazes, tools, equipment,
books *(C)*.

Dayton Electric Manufacturing Co.
5959 W. Howard St.
Chicago, IL 60684
312-647-0124
Motors, compressors, general tools

Delta International Machinery Corp.
246 Alpha Drive
Pittsburgh, PA 15238
800-438-2487
Woodworking machinery and accessories *(C)*.

Del Val Potters Supply Co.
Queen St. & Ivy Hill Rd.
Wyndmoor, PA 19118
215-233-0655
Clay, raw materials, tools, equipment *(C)*.

Design-Cast Corporation
P.O. Box 134
Princeton, NJ 08542
609-890-1010
Man-made stone-casting materials

The DeVilbiss Co.
P.O. Box 913
Toledo, OH 43692-0913
800-DEV-4448
Professional paint, coating spray guns

Dieu Donné Papermill, Inc.
3 Crosby Street
New York, NY 10013
212-226-0573
HMP, rag, paper pulps

Douglas & Sturgess, Inc.
730 Bryant St.
San Francisco, CA 94107
415-421-4456
Mold materials, tools, supplies *(C)*.

Dow Chemical Co.
2030 Willard H. Dow Center
Midland, MI 48643
517-636-1000
Resins, plastics, chemicals

Dow Corning
P.O. Box 0994
Midland, MI 48643
517-496-6000
Mold materials, adhesives

DRI Industries
Box 28114
Warrensville Heights, OH 44183
800-372-5282
Hardware, small shop supplies

E.I. duPont de Nemours Co., Inc.
1007 Market Street
Wilmington, DE 19898
800-441-7515
E.V.A. castables, ejection molding plastics

Dynabrade, Inc.
72 East Niagara St.
Tonawanda, NY 14150
800-828-7333
716-694-4600
Abrasives, power tools, grinding, deburring,
polishing *(C)*.

Eager Plastics, Inc.
3701 S. Halsted
Chicago, IL 60609
312-927-3484
Liquid thermosets for molds and plastic
castings *(C)*.

Eutectic Corporation
40-40 172nd St.
Flushing, NY 11358
718-358-4000
Welding and brazing supplies

Farmer's Copper & Industrial Supply, Inc.
202 37th Street
P.O. Box 2649
Galveston, TX 77553
800-338-0103
409-765-9003
Metal alloys *(C)*.

Fillmore and Garber, Inc.
1742 Floradale Ave.
S. El Monte, CA 91733
818-579-2060
Abrasives, burrs, die grinders, mounted points

E. B. Filter and Co.
P.O. Box 242
Mifflinburg, PA 17844
717-966-3871
Abrasives, polishing and casting
equipment and supplies *(C)*.

Flatlanders Sculpture Supply
1993 East U.S. 223
Blissfield, MI 49228
517-486-4591
Stone, wood carving, molding tools, materials
(C).

The Foredom Electric Company
Route 6
Bethel, CT 06801
203-792-8622
Foredom flexible shaft rotary power tools *(C)*.

Foundry Service and Supply Co., Inc.
7 Greenwood Place
Pikesville, MD 21208
301-486-6238
Foundry supplies, no-bake binders, mold
washes

Frank Mittermeier, Inc.
3577 East Tremont Ave.
P.O. Box 2
Bronx, NY 10465
212-828-3843
Wood-carving tools, stones, books, wood *(C)*.

Freeman Manufacturing & Supply Co.
3152 S.E., Loop 820
Fort Worth, TX 76140
800-792-1047
Foundry equipment supplies, pattern supplies

Frog Tool Co., Ltd.
700 W. Jackson Blvd.
Chicago, IL 60606
312-648-1270
Woodworking and woodcarving tools, books
(C).

Garrett Wade Co.
161 6th Ave.
New York, NY 10013
800-221-2942
212-807-1757
Specialty tools, finishes for working wood *(C)*.

Gawet Marble, Inc.
Route 4 West
P.O. Box A Center
Rutland, VT 05736
800-323-6398
802-773-8868
Marble, tools, tin oxide, epoxies

George E. Adamy Company
19 Elkan Rd.
Larchmont, NY 10538
914-834-6276
Concrete and H-M paper: additives, coatings,
colorants *(C)*.

Georgia Marble Co.
Blue Ridge Ave.
Nelson, GA 30151
404-735-2591
Blocks, slabs, domestic quarrier *(C)*.

Gold's Artworks, Inc.
2100 N. Pine St.
Lumberton, NC 28358
800-356-2306
919-739-9605
Papermaking supplies *(C)*.

W. W. Grainger, Inc.
5959 W. Howard St.
Chicago, IL 60648
914-347-6800
Large and small hand and power tools,
supplies

Granite City Tool
11 Cooper Ave. N.
P.O. Box 368
St. Cloud, MN 56302
800-328-7094
612-251-8600
Chisels, air tools, sandblasters, diamond saw
blades *(C)*.

Granite City Tool Co.
5–11 Blackwell St.
P.O. Box 411
Barre, VT 05641
802-476-3137
Stone-carving tools and supplies *(C)*.

Granitech Research
Box 226
Brookline, NH 03033
603-673-5297
Stone, metal, wood, safety supplies *(C)*.

GranQuartz, Inc.
Catto St. Box 731
Barre, VT 05641
802-476-7935
Carbide tools, diamond tools, polishing
machines

A. P. Green Industries
Mexico, MO 65265
314-473-3626
Fire clays, fire bricks, castables, insulation

J. S. Guerin and Company
510 Townsend St.
San Francisco, CA 04103-4982
415-431-6050
Plaster, cement, casting plaster, Hydrocal

Harbor Freight
3491 Mission Oaks
Camarillo, CA 93011
800-423-2567
805-388-3000
Hand tools, machinery, air tools, hydraulics
(C).

Hard-to-Find Tools
(See Brookstone)

Highland Hardware
1045 N. Highland Ave. N.E.
Atlanta, GA 30306
404-872-4466
Woodworking tools and supplies

Hilgartner Natural Stone Co., Inc.
101 West Cross St.
Baltimore, MD 21230
301-752-4832
Fabricate and install stone and sculpture bases

Hobart School of Welding Technology
Trade Square East
Troy, OH 45373
513-332-5559
Welding training *(C)*.

Independent Foundry Supply Co.,
6463 E. Canning St.
City of Commerce, CA 90040
213-723-3266
Complete foundry supply house

Indiana Limestone Co., Inc.
405 I St., P.O. Box 72
Bedford, IN 47421
800-457-4026
812-275-3341
Limestone quarriers and fabricators

Industrial Abrasives Co.
642 N. 8th St.
Reading, PA 19603
800-222-2292
Sanding supplies, accessories, tools, merchan-
dise *(C)*.

Industrial Arts Supply Co.
5724 W. 36th St.
Minneapolis, MN 55416
612-920-7393
Plastics for casting, injection, rotational
vacuum forming *(C)*.

Industrial Plastic Division
Diversified Plastics Suppliers, Inc.
309 Canal St.
New York, NY 10013
212-226-2010
Plastics, sheet, casting resins, moldmaking
supplies, fiberglass

Industrial Products Co.
21 Cabot Blvd.
Langhorne, PA 19047
800-562-3305
215-547-1900
Industrial safety supplies *(C)*.

Industrial Safety & Security Co.
1390 Neubrecht Rd.
Lima, OH 45801
800-537-9721
419-227-6030
Industrial safety products *(C)*.

Johnson Gas Appliance Co.
520 E. Avenue NW
Cedar Rapids, IA 52405
319-365-5267
Metal-casting furnaces *(C)*.

Kindt-Collins Company
12651 Elmwood Ave.
Cleveland, OH 44111
800-321-3170
216-252-4122
All types of waxes *(C)*.

Kinney Vacuum Company
495 Turnpike St.
Canton, MA 02021
617-828-9500
Vacuum equipment

Leichtung, Inc.
4944 Commerce Parkway
Cleveland, OH 44128
800-321-6840
216-831-6191
Woodworking hand tools, Lervad Workbench,
hardware *(C)*.

P. K. Lindsay Co., Inc.
63 Nottingham Rd.
Deerfield, NH 03037
603-463-8311
Portable air compressors and sandblasting
machines *(C)*.

L & R Specialties
202 E. Mt. Vernon
Box 309
Nixa, MO 65714
417-725-2606
Clay, chemicals, books, tools, equipment *(C)*.

J. F. McCaughin Co.
2628 N. River Ave.
Rosemead, CA 91770-3395
800-255-9271
818-573-3000
Tools, supplies, equipment for investment
casters *(C)*.

Lee S. McDonald, Inc.
P.O. Box 264
523 Medford St.
Charlestown, MA 02129
617-242-2505
Fine hand papermaking equipment, supplies
(C).

Maine Oxy-Acetylene Supply Co.
P.O. Box 25
Auburn, ME 04210
800-442-6320
207-784-5788
Welding, safety equipment, industrial specialty
gases

Marble Institute of America, Inc.
33505 State St.
Farmington, MI 48024
313-476-5558
Technical information, quarry names and
addresses

Marble of America, Inc.
1100 Colebrook Dr.
St. Louis, MO 63139
314-533-1002
Marble blocks, carving, granite blocks

McEnglevan Heat Treating & Mfg. Co.
708 Griggs St.
P.O. Box 31
Danville, IL 61834-0031
217-446-0941
Furnaces, heat treat furnaces, fluxes, ac-
cessories (C).

McPherson Art Supplies
3214 Elk St.
Port Huron, MI 48060
313-982-7334
Microcrystalline sculpting wax (C).

Merit Abrasive Products, Inc.
201 W. Manville St.
P.O. Box 5447
Compton, CA 90224
800-421-1936
213-639-4242
Abrasive specialty items, coated abrasive pro-
ducts (C).

Micro-Mark
340 Snyder Ave.
Berkeley Heights, NJ 07922
201-464-6764
Hard-to-find tools (C).

Midwest Shop Supplies, Inc.
P.O. Box 3717
Sioux City, IA 51102
800-831-5904
Industrial arts shop supplies and equipment
(C).

Miller Electric Manufacturing Co.
P.O. Box 1079
Appleton, WI 54912
414-734-9821
Arc welding equipment (C).

Milwaukee Electric Tool Corp.
13135 West Lisbon Rd.
Brookfield, WI 53005
414-781-3600
Portable electric tools (C).

Minnesota Clay Co.
8001 Grand Ave. So.
Bloomington, MN 55420
800-328-9380
Clay, glazes, kilns, wheels, tools, accessories
(C).

Mixing Equipment Co.
135 Mt. Read Blvd.
Rochester, NY 14611
716-436-5550
Lightning mixers, pumps

Monsanto Company
Inorganic Chemical Div.
800 N. Lindberg Blvd.
St. Louis, MO 63167
314-694-1000
Resins, colloidal silica

Montoya/MAS International, Inc.
435 Southern Blvd.
West Palm Beach, FL 33405
407-832-4401
Sculpture stones, tools, bases, bronze casting
(C).

Multi-Chem, Inc.
200 Piedmont Court
Doraville, GA 30340
404-448-8083
Microcrystalline waxes, plasters, epoxies

Nalco Chemical Company
Metal Industries Div.
9165 S. Harbor Ave.
Chicago, IL 60617
312-933-3700
Colloidal silica

Nasco
901 Janesville Ave.
Fort Atkinson, WI 53538
800-558-9595
414-563-2446
Art supplies and teaching aids (C).

R. A. Ness & Company
8888 N. Milwaukee Ave.
Niles, IL 60648
312-824-0565
Machinery, electrical and manual hand tools,
router bits

New England Stone
Providence Pike
Smithfield, RI 02917
401-232-2040
Granite

New York Marble Works, Inc.
1399 Park Ave.
New York, NY 10029
212-534-2242
Marble, granite, onyx

North American Mfg. Co.
4455 E. 71 St.
Cleveland, OH 44105
216-271-6000
Manufacturers' industrial combustion, con-
trols, equipment (C).

Northern Hydraulics
801 East Cliff Rd.
Burnville, MN 55337
800-533-5545
612-894-8310
Hydraulic equipment, air compressors,
sandblasters

Paramount Ceramic, Inc.
220 N. State St.
Fairmont, MN 56031
800-525-7434
507-235-3461
Glazes, tools, equipment, brushes, electrical,
misc. (C).

Paxton Beautiful Woods
14200 Chef Menteur Hwy.
P.O. Box 29387
New Orleans, LA 70189
800-325-3421
504-254-1550
Domestic and exotic hardwood lumber and
veneer (C).

Pearl Paint Co., Inc.
308 Canal St.
New York, NY 10013
800-221-6845
212-431-7932
Art and graphic supplies (C).

Perma-Flex Mold Co., Inc.
1919 E. Livingston Ave.
Columbus, OH 43209
614-252-8034
Mold materials (C).

Petrolite Specialty Polymers Group
6910 E. 14th St.
Tulsa, OK 74112
918-836-1601
Waxes

Philadelphia Pottery Supply
835 Morris St.
Philadelphia, PA 19148
215-463-2344
Clay, plaster, gas and electric kilns, supplies
(C).

Polyproducts Corp.
28314 Hayes Ave.
P.O. Box 306
Roseville, MI 48066
313-774-2500
Cold cast bronze with epoxy resin (C).

Polytek Development Corp.
P.O. Box 384
Lebanon, NJ 08833
201-236-2990
Liquid rubbers and plastics for casting (C).

The Pottery Supply House Ltd.
2070-2060 Speers Rd.
P.O. Box 192
Oakville, Ontario L6J 5A2
CANADA
416-827-1129
Kilns, furnaces, equipment, elements, service,
consulting (C).

Powermatic
Morrison Rd.
McMinnville, TN 37110
615-473-5551
Stationary woodworking machine tools *(C)*.

Premier Wax Co., Inc.
3327 Hidden Valley Dr.
Little Rock, AR 72212
501-225-2925
Wholesale sculpture and casting waxes

Protective Coating Co.
1341 N. van Buren St.
Allentown, PA 18103
215-432-3543
P.C.7 epoxy *(C)*.

Pulmosan Protective Equipment
P.O. Box 622
Reading, PA 19603
800-345-3479
Personal protective equipment, eyes,
respiratory, hearing *(C)*.

Pyramid of Urbana
2107 North Highcross Road
Urbana, IL 61801
800-252-1363
217-328-3098
Papermaking and ceramic supplies and equipment *(C)*.

Quinn Studios
2925 East Saint Johns Rd.
Phoenix, AZ 85032
602-992-4253
Stone, wood, tools, supplies, bases, restoration *(C)*.

Ransom and Randolph
120 W. Wayne St.
Maumee, OH 43537
419-893-9497
Solid mold and ceramic shell mold materials *(C)*.

The Refractories Institute
301 5th Ave. Building
Suite 326
Pittsburgh, PA 15222
412-281-6787
Refractory booklet for laymen

Remet Corporation
P.O. Box 278
Bleachery Place
Chadwicks, NY 13319
315-737-7381
All consumables for investment casting process *(C)*.

R & R Dentsply
120 W. Wayne St.
Maumee, OH 43537
419-893-9497
Investment and ceramic mold materials,
manufacturer *(C)*.

Rock of Ages Corporation
P.O. Box 482
Barre, VT 05641
802-476-3115
Granite blocks for sculpture

Ruemelin Manufacturing Co., Inc.
3860 N. Palmer St.
Milwaukee, WI 53212
414-962-6500
Abrasive blast equipment, welding fume exhausters *(C)*.

Saunders Foundry Supply, Inc.
Route 301
P.O. Box 265
Cold Spring, NY 10516
914-265-3631
Supplies, equipment for molding and casting
bronze *(C)*.

The Sawmill
510 Sycamore St.
P.O. Box 329
Nazareth, PA 18064
800-345-3103
215-759-2837
Domestic and imported lumber, sawn veneer
(C).

Sax Arts and Crafts
2405 S. Calhoun Rd.
P.O. Box 51710
New Berlin, WI 53151
800-558-6696
Tools, books, equipment, clay, stone, metals
(C).

Sculptor's Supplies Co.
99 E. 19th St.
New York, NY 10003
212-673-3500
Stone, wood, plaster, wax, carving and modeling tools *(C)*.

Sculpture House, Inc.
30 East 30th St.
New York, NY 10016
212-679-7474
Wood carving, stone carving, clay, mold
materials *(C)*.

Sculpture Studio and Foundry
1150 Clare Ave. #102
West Palm Beach, FL 33401
407-833-6950
Casting, moldmaking, stone finishing, tools

Severance Tool Industries, Inc.
3790 Orange
P.O. Box 1866
Saginaw, MI 48605
517-777-5500
Rotary grinding bits, custom-made bits

S-G Metals Industries, Inc.
2nd & Riverview
P.O. Box 2039
Kansas City, KS 66110
913-621-4100
Aluminum and brass ingots

Shellspen International, Inc.
P.O. Box 113
Sarasota, FL 34230
800-223-8546
813-951-2545
Foundry and art supplies for bronze casting
(C).

Sherry's/Western Ceramic Supply Co.
948 Washington St.
San Carlos, CA 94070
415-592-2333
Glazes, clay, tools, kilns, wheels, underglazes
(C).

Silicones, Inc.
1020 Surrett Dr.
Box 363
High Point, NC 27261
800-533-8709
Silicone rubber for moldmaking *(C)*.

Silvo Hardware Co., Inc.
611 N. Broadway
P.O. Box 92069
Milwaukee, WI 53202
800-331-1261
414-272-6080
Professional hand and power tools *(C)*.

Skil Corporation
4300 W. Peterson Ave.
Chicago, IL 60646
312-286-7330
Power tools

Small Corporation
P.O. Box 948
Greenfield, MA 01302
800-422-4183
Acrylic covers and bases *(C)*.

Smith Equipment
Div. of Tescom Corporation
2601 Lockheed Ave.
Watertown, SD 57201
605-882-3200
Little torch-cutting and welding equipment

Daniel Smith Inc.
4130 1st Ave. S.
Seattle, WA 98134
800-426-6740
Fine-art materials *(C)*.

Smooth-On, Inc.
100 Valley Road
Gillette, NJ 07933
201-647-5800
Polysulfide, polyurethane molding compounds
(C).

Soapstone for Sculpture
P.O. Box 3241 U. Station
Charlottesville, VA 22903
804-293-6858
Black sculpting soapstone, variety of
hardnesses

Southwest Stone
P.O. Box 1345
Cedar City, UT 84720
801-586-4892
Alabaster, many colors

StanChem, Inc.
401 Berlin St.
East Berlin, CT 06023
203-828-0571
Incralac, protective coatings

351

Standard Ceramic Supply Co.
P.O. Box 4435
Pittsburgh, PA 15205
412-276-6333
Moist clay bodies, tools, glazes, chemicals *(C)*.

Stanley Tools
600 Myrtle St.
New Britain, CT 06050
800-262-2161
203-225-5111
Hand tools

Stratford Clay Supply Ltd.
245 Griffith Rd.
P.O. Box 344
Stratford, Ontario
CANADA
519-271-5371
Kilns, glazes, wheels, kiln shelves *(C)*.

Superior Rotary Tools, Inc.
P.O. Box 14086
Dayton, OH 45414
513-278-9123
Rotary abrasive supplies

SynAir Corporation
P.O. Box 5269
2003 Amnicola Highway
Chattanooga, TN 37406
800-251-7642
615-698-8801
Flexible urethane molding systems

TALAS
213 West 35 St.
New York, NY 10001-1996
212-736-7744
Tools, chemicals, fabrics, adhesives, boxes *(C)*.

Thermal Ceramics
Old Savannah Rd.
P.O. Box 923
Augusta, GA 30903
404-796-4200
Insulating firebrick, kaowool, castables, insulating castables

J. M. Thomas Co., Inc.
227 Highland Ave.
Westmont, NJ 08108
609-858-5400
Fiberglass and plastic tools *(C)*.

3M Company
St. Paul, MN 55144-1000
612-733-1110
Abrasive supplies

Tools Unlimited
P.O. Box 5757
Toledo, OH 43613-0757
800-472-1900
Electric and air tools, sandblasters, hand tools *(C)*.

Trend-Lines
375 Beacham St.
Chelsea, MA 02150
800-343-3248
Discount power and stationary name-brand tools *(C)*.

Trinity Ceramic Supply
9016 Diplomacy Row
Dallas, TX 75247
214-631-0540
Clays, tools, plasters, ceramic chemicals *(C)*.

Tropical Exotic Hardwoods of Latin America
P.O. Box 1806
Carlsbad, CA 92008
619-434-3030
Exotic hardwoods, lumber, logs, squares, burls *(C)*.

Trow and Holden Co., Inc.
45–47 S. Main St.
P.O. Box 475
Barre, VT 05641
800-451-4349
802-476-7221
Pneumatic, stone-carving tools, custom design, retempering *(C)*.

Twinrocker, Inc.
P.O. Box 413
Brookston, IN 47923
317-563-3119
Pulp, fiber, pigments, molds, books, additives *(C)*.

U.S. General Supply Corp.
100 Commercial St.
Plainview, NY 11803
516-349-7275
General tool supplies

United States Gypsum Co.
101 S. Wacker Drive
Chicago, IL 60606
312-606-5582
Industrial plasters and gypsum cements

Unnatural Resources, Inc.
4 Byron Road
N. Caldwell, NJ 07006
201-228-5384
Thermoplastics for sculpture, armatures, wax *(C)*.

Vermont Marble Company
61 Main St.
Proctor, VT 05765
802-459-3311
Marble sculpture blocks

Vermont Structural Slate Co.
Box 98
Fair Haven, VT 05743
800-343-1900
802-265-4933
Quarry and fabricated colored slate

Vetter Stone Company
P.O. Box 38
Kasota, MN 56050
507-345-4568
Stone for sculpture blocks and bases

Vic Industrial Corp.
P.O. Drawer 12610
Knoxville, TN 37912
615-689-4721
Abrasives, adhesives, tools, maintenance products *(C)*.

Victor Equipment Co.
P.O. Box 1007
Denton, TX 76202
800-426-1888
817-566-2000
Welding equipment *(C)*.

Waage Electric, Inc.
820 Colfax Ave.
P.O. Box 33
Kenilworth, NJ 07033
201-245-9363
Wax melting pots

Waller Bros. Stone Co.
P.O. Box 157
McDermott, OH 45652
614-259-2356
Scioto sandstone, building stone

Watco-Dennis Corporation
19610 Rancho Way
Rancho Dominguez, CA 90220
213-635-2778
Penetrating oil-resin sealer for wood *(C)*.

Westwood Ceramic Supply Co.
14400 Lomitas Ave.
City of Industry, CA 91746
818-330-0631
Ceramic supplies and equipment *(C)*.

Willson Safety Products
P.O. Box 622
Reading, PA 19603-0622
215-376-6161
Respiratory, eye, hearing and head protection products *(C)*.

W. L. S. Coatings, Inc.
13413 S. Broadway
Los Angeles, CA 90061
213-538-2155
Epoxy paints, polyurethane paint

Jack D. Wolfe Co.
2130 Bergen St.
Brooklyn, NY 11233
718-495-2065
Modeling clays, plasters, tools, supplies *(C)*.

Wolverine Foundry Supply Co.
1109 Decker Rd.
Walled Lake, MI 48088
313-669-4211
Coatings, adhesives, binders *(C)*.

Wood Carvers Supply, Inc.
9610 First View St.
P.O. Box 8928
Norfolk, VA 23503
804-583-8928
Carvers tools, books, supplies *(C)*.

Woodcarvers Supply Co. Store
3056 Excelsior Blvd.
Minneapolis, MN 55416
612-927-7491
Wood-carving tools and books *(C)*.

Woodcraft Supply Corp.
41 Atlantic Ave.
P.O. Box 4000
Woburn, MA 01888
617-935-5860
Woodworking tools, books, supplies *(C)*.

Wood Finishing Supply Co., Inc.
1267 Mary Drive
Macedon, NY 14502
315-986-4517
Finishes, dyes, gold leaf, resins, asbrasives *(C)*.

Woodline—The Japan Woodworker
1731 Clement
Alameda, CA 94501
800-537-7820
Japanese and Western woodworking hand tools
(C).

Woodworker's Supply of NM
5604 Alameda Pl., NE
Albuquerque, NM 87113
800-645-9292
Machinery, hand tools, router bits, plans *(C)*.

Yates Manufacturing Co.
1615 West 15th St.
Chicago, IL 60608
312-666-9850
Waxes

Bibliography

Ammen, C. W. *Lost Wax Investment Casting.* Blue Ridge Summit, Pennsylvania: Tab Books, 1977.

Ammen, C. W. *The Metalcaster's Bible.* Blue Ridge Summit, Pennsylvania: Tab Books, 1980.

Andrews, Oliver. *Living Materials: A Sculptor's Handbook.* Berkeley: University of California Press, 1983.

Armstrong, Jane B. *Discover in Stone.* Charlotte, North Carolina: East Woods Press, 1975.

Arnheim, Rudolph. *Art and Visual Perception.* Berkeley: University of California Press, 1974.

Auerbach, Arnold. *Modelled Sculpture and Plaster Casting.* San Diego: A. S. Barnes & Co., 1977.

Badley, Robert E. and William R. Walter. *Basic Principles of Metal Casting.* Danville, Illinois: McEnglevan Training and Manufacturing Co., 1984.

Baldwin, John. *Contemporary Sculpture Techniques: Welded Metal and Fiberglass.* New York: Reinhold, 1967.

Bann, Steven, Editor. *The Tradition of Constructivism.* New York: Viking Press, 1974.

Barazani, Gail Coningsby. *Safe Practices in the Arts and Crafts.* New York: College Art Association of America, 1978.

Beardsley, John. *Earthworks and Beyond.* New York: Abbeville Press, 1985.

Beasley, Bruce, *An Exhibition of Acrylic Sculpture.* San Francisco: M. H. deYoung Memorial Museum, 1972.

Beecroft, Glynis. *Carving Techniques.* New York: Watson-Guptill, 1982.

Beecroft, Glynis. *Casting Techniques for Sculpture.* New York: Charles Scribner's Sons, 1979.

Bell, Lilian S. *Plant Fibers for Papermaking.* McMinnville, Oregon: Liliaceae Press, 1988.

Bentham, Graeme. *Creative Wood Sculpture from Natural Form.* Poole, England: Blandford Press, 1978.

Block, Jonathan and Jerry Leisure. *Understanding Three Dimensions.* Englewood Cliffs, New Jersey: Prentice-Hall, 1987.

Brody, Harvey. *The Book of Low Fire Ceramics.* New York: Holt, Rinehart and Winston, 1980.

Bunch, Clarence. *Acrylic for Sculpture and Design.* New York: Van Nostrand Reinhold, 1972.

Burnham, Jack. *Beyond Modern Sculpture.* New York: George Braziller, 1968.

Calder, Alexander. *Calder: An Autobiography with Pictures.* New York: Pantheon Books, 1977.

Carstenson, Cecil C. *The Craft and Creation of Wood Sculpture.* New York: Scribner, 1971.

Castle, Wendell and David Edman. *The Wendell Castle Book of Wood Lamination.* New York: Van Nostrand Reinhold, 1980.

Chaney, Charles and Stanley Skee. *Plaster Mold and Model Making.* New York: Van Nostrand Reinhold, 1973.

Clarke, Carl Dame. *Metal Casting of Sculpture and Ornament.* Butler, Maryland: Standard Arts Press, 1985.

Clarke, Geoffrey and Stroud Cornock. *A Sculptor's Manual.* New York: Van Nostrand Reinhold, 1970.

Coleman, Ronald L. *Sculpture: A Basic Handbook for Students.* Dubuque, Iowa: William C. Brown, 1980.

Colson, Frank A. *Kiln Building with Space-Age Materials.* New York: Van Nostrand Reinhold, 1975.

The Complete Work of Michelangelo. New York: Reyenl and Corpus, n.d.

Constantine, Albert J., Jr. and Harry J. Hobbs. *Know Your Woods: A Complete Guide to Trees, Woods and Veneers.* New York: Scribner, 1987.

Descharnes, Robert and Jean-Francois Chabrum. *August Rodin.* New York: Viking Press, 1967.

Frid, Tage. *Tage Frid Teaches Woodworking.* Newtown, Connecticut: Taunton Press, 1979.

Frith, Donald E. *Mold Making for Ceramics.* Radnor, Pennsylvania: Chilton, 1985.

Goldwater, Robert. *What is Modern Sculpture?* New York: Museum of Modern Art, 1969.

Grubbs, Daisy. *Modeling a Likeness in Clay.* New York: Watson-Guptill, 1982.

Hammer, Frank and Janet Hammer. *The Potters' Dictionary of Materials and Techniques.* New York: Watson-Guptill, 1986.

Hedgecoe, John and Henry Moore. *Henry Moore.* New York: Simon and Schuster, 1968.

Heller, Jules. *Paper-Making, The White Art.* Chalfont, Pennsylvania: Scorpio Publications, 1980.

Hitchcock, Howard. *Out of the Fiery Furnace.* Los Altos, California: William Kaufmann, 1985.

Hockney, David. *Paper Pools.* New York: Harry N. Abrams, 1980.

Hopper, Robin. *The Ceramic Spectrum.* Radnor, Pennsylvania: Chilton, 1984.

Hughes, Richard and Michael Rowe. *The Colouring, Bronzing, and Patination of Metals.* New York: Van Nostrand Reinhold, 1983.

Irving, Donald J. *Sculpture: Material and Process.* New York: Van Nostrand Reinhold, 1970.

Jackson, Harry. *Lost Wax Bronze Casting.* New York: Van Nostrand Reinhold, 1979.

Kelly, James J. *The Sculptural Idea.* Edina, Minnesota: Burgess International Group, 1981.

Koretsky, Elain. *Color for the Hand Papermaking.* East Hampton, New York: Carriage House Press, 1983.

Langland, Tuck. *Practicing Sculpture.* Englewood Cliffs, New Jersey: Prentice-Hall, 1988.

Lanteri, Edouard. *Modeling and Sculpting Animals.* New York: Dover Publications, 1985.

Lanteri, Edouard. *Modeling and Sculpting the Human Figure.* New York: Dover Publications, 1985.

Lawrence, Arnold Walter. *Later Greek Sculpture and Its Influence on East and West.* New York: Hacker Art Books, 1969.

Lawrence, John R. *Polyester Resins.* New York: Reinhold, 1960.

Lawrence, W. G. *Ceramics Science for the Potter.* Radnor, Pennsylvania: Chilton, 1972.

Lewis, David. *Constantin Brancusi.* London: Academy Editions, 1974.

Lindquist, Mark. *Sculpting Wood.* Worcester, Massachusetts: Davis Publications, 1987.

Lucchesi, Bruno. *Modeling the Figure in Clay.* New York: Watson-Guptill, 1980.

McCann, Michael. *Health Hazards Manual for Artists.* New York: Nick Lyons Books, 1985.

Malstrom, Margit. *Terracotta: Sculpture by Bruno Lucchesi.* New York: Watson-Guptill, 1977.

Marshall, Richard and Suzanne Foley. *Ceramic Sculpture: Six Artists.* Seattle: University of Washington Press, 1981.

Martin, Judy. *Longman Dictionary of Art.* White Plains, New York: Longman, 1986.

Meilach, Dona Z. and Elvie Ten Hoor. *Collage & Assemblage.* New York: Crown Publishers, 1973.

Meilach, Dona Z. *Contemporary Art with Wood.* New York: Crown Publishers, 1968.

Meilach, Dona Z. *Contemporary Stone Sculpture.* West Cheser, Pennsylvania: Schiffer, 1987.

Meilach, Dona Z. *Creative Carving.* Chicago, Illinois: Contemporary Books, 1969.

Meilach, Dona Z. and Don Seiden. *Direct Metal Sculpture.* New York: Crown Publishers, 1966.

Meyer, Frederick Robert. *Sculpture in Ceramic.* New York: Watson-Guptill, 1971.

Midgley, Barry. *The Complete Guide to Sculpture, Modeling and Ceramics: Techniques and Materials.* New York: Chartwell Books, 1982.

Miller, Richard M., Editor. *Figure Sculpture in Wax and Plaster.* New York: Dover, 1987.

Mills, John William. *The Technique of Sculpture.* North Pomfret, Vermont: David & Charles, 1985.

Nelson, Glenn C. *Ceramics: A Potter's Handbook.* New York: Holt, Reinhart and Winston, 1971.

Newman, Thelma R. *Plastics as Sculpture.* Radnor, Pennsylvania: Chilton, 1974.

Nigrosh, Leon I. *Claywork.* Worcester, Massachusetts: Davis Publications, 1986.

Nigrosh, Leon I. *Low Fire: Other Ways to Work in Clay.* Worcester, Massachusetts: Davis Publiucations, 1980.

Norman, Percival Edward. *Sculpture in Wood.* New York: St. Martin's Press, 1973.

Olson, Lynn. *Sculpting with Cement: Direct Modeling in a Permanent Medium.* Valparaiso, Indiana: Steelstone Press, 1983.

Orchard, David. *The Techniques of Wood Sculpture.* Cincinnati, Ohio: North Light Books, 1985.

Padovano, Anthony. *The Process of Sculpture.* New York: De Capo Press, 1986.

Panting, John. *Sculpture in Fiberglass.* New York: Watson-Guptill, 1972.

Prince, Arnold. *Carving Wood and Stone.* Englewood Cliffs, New Jersey: Prentice-Hall, 1981.

Read, Sir Herbert Edward. *A Concise History of Modern Sculpture.* Westport, Connecticut: Praeger, 1964.

Rhodes, Daniel. *Clay and Glazes for the Potter.* Radnor, Pennsylvania: Chilton, 1973.

Rhodes, Daniel. *Kilns: Design, Construction and Operation.* Radnor, Pennsylvania: Chilton, 1969.

Rhodes, Daniel. *Pottery Form.* Radnor, Pennsylvania: Chilton, 1976.

Rich, Jack C. *Sculpture in Wood.* New York: De Capo, 1977.

Richter, Gisela Marie August. *The Sculpture and Sculptors of the Greeks.* New Haven: Connecticut: Yale University Press, 1970.

Rickey, George. *Constructivism: Origins and Evolution.* New York: George Braziller Inc., 1967.

Robinette, Margaret A. *Outdoor Sculpture: Object and Environment.* New York: Whitney Library of Design, 1976.

Rood, John. *Sculpture with a Torch.* Minneapolis: 1968.

Roukes, Nicholas. *Masters of Wood Sculpture.* New York: Watson-Guptill, 1980.

Roukes, Nicholas. *Plastics for Kinetic Art.* New York: Watson-Guptill, 1974.

Roukes, Nicholas. *Sculpture in Plastic.* New York: Watson-Guptill, 1968.

Sax, N. Irving. *Hazardous Chemicals Desk Reference.* New York: Van Nostrand, 1987.

Schoder, Raymond V. *Masterpieces of Greek Art.* New York: New York Graphic Society, 1965.

Schwartz, Paul Waldo. *The Hand and Eye of the Sculptor.* Westport, Connecticut: Praeger, 1969.

Sculpture (magazine) by subscription to International Sculpture Center, P.O. Box 19709, Washington, DC 20036. Recommended for keeping up-to-date with current sources, techniques, forms and ideas about content. Tel: 202-965-6066

Sculpture Review is a good quarterly magazine for the figurative approach and as a general resource. It is published by The National Sculpture Society, 15 E. 26th St., New York, N.Y. 10010. Tel: 212-889-6960

Seitz, William Chapin. *The Art of Assemblage.* New York: Museum of Modern Art, 1961.

Simonds, Herbert Rumsey and James M. Church. *A Concise Guide to Plastics.* Melbourne, Florida: Robert E. Krieger Publishing, 1975.

Slobodkin, Louis. *Sculpture: Principles and Practice.* New York: Dover, 1973.

Speight, Charlotte F. *Hands in Clay.* Gloverville, New York: Mayfield Books, 1983.

Speight, Charlotte F. *Images in Clay Sculpture, Historical and Contemporary Techniques.* New York: Harper & Row, 1983.

Strachan, Walter John. *Towards Sculpture: Drawings and Maquettes from Rodin to Oldenburg.* Boulder, Colorado: Westview Press, 1976.

Struppeck, Jules. *The Creation of Sculpture.* New York: Henry Holt & Company, 1952.

Studley, Vance. *The Art and Craft of Handmade Paper.* New York: Van Nostrand Reinhold, 1977.

Toale, Bernard. *The Art of Papermaking.* Worcester, Massachusetts: Davis Publications, 1983.

Trier, Edward. *Form and Space.* Westport, Connecticut: Praeger, 1968.

Two Hundred Years of American Sculpture. New York: Whitney Museum of American Art, 1976.

Untracht, Oppi. *Metal Techniques for Craftsmen.* New York: Doubleday, 1975.

Verhelst, Wilbert. *Sculpture: Tools, Materials and Techniques.* Englewood Cliffs, New Jersey: Prentice-Hall, 1973.

Versatile Products for Creative Application. Chicago: United States Gypsum Co., 1987.

Walker, Aidan. *Wood Polishing and Finishing Techniques.* Boston: Little, Brown, 1985.

Wechsler, Susan. *Low Fire Ceramics: A New Direction in American Clay.* New York: Watson-Guptill, 1981.

Woody, Elsbeth S. *Handbuilding Ceramic Forms.* New York: Farrar, Straus & Giroux, 1978.

Young, Ronald D. and Robert A. Fennell. *Methods for Modern Sculptors.* San Rafael, California: Sculpt-Nouveau, 1980.

Zaidenberg, Arthur. *Sculpting in Steel and Other Metals.* Radnor, Pennsylvania: Chilton, 1974.

Zelanski, Paul and Mary Pat Fisher. *Shaping Space: The Dynamics of Three-Dimensional Design.* New York: Holt, Rinehart and Winston, 1987.

Sculptors, Instructors, Students

Index